DIE PARKETT-REIHE MIT GEGENWARTSKÜNSTLERN / THE PARKETT SERIES WITH CONTEMPORARY ARTISTS

Book Series with contemporary artists in English and German, published three times a year. Each volume is created in collaboration with artists, who contribute an original work specially made for the readers of Parkett. The works are reproduced in the regular edition and available in a limited and signed Special Edition.

Buchreihe mit Gegenwartskünstlern in deutscher und englischer Sprache, erscheint dreimal im Jahr. Jeder Band entsteht mit Künstlern oder Künstlerinnen, die eigens für die Leser von Parkett einen Originalbeitrag gestalten. Diese Werke sind in der gesamten Auflage abgebildet und zusätzlich in einer limitierten und signierten Vorzugsausgabe erhältlich.

PARKETT NR. 88 ERSCHEINT IM OKTOBER 2010 • PARKETT NO. 88. WILL BE PUBLISHED IN OCTOBER 2010.

Für Aboinformationen besuchen Sie bitte www.parkettart.com oder kontaktieren Sie uns via info@parkettart.com / For further information regarding subscriptions please go to www.parkettart.com or contact us at info@parkettart.com.

Zürichsee Druckereien AG (Stäfa) Satz, Litho, Druck / Copy, Printing, Color Separations

PARKETT-VERLAG AG ZÜRICH MARCH 2010 PRINTED IN SWITZERLAND ISBN 978-3-907582-47-3 ISSN 0256-0917

HEFTRÜCKEN / SPINE 85–87: JOSH SMITH

Cover / Umschlag: KATHARINA FRITSCH, 2ND STILL LIFE / 2. STILLLEBEN, 2009/2010, see page 60 / siehe Seite 60. (PHOTO: IVO FABER)

Back Cover / Rückseite: ANNETTE KELM, UNTITLED, 2009, c-print, mounted on aludibond, 27 1/2 x 22 3/4" /

OHNE TITEL, C-Print auf Aludibond, 70 x 58 cm.

Cover Flap / Umschlagklappe: CERITH WYN EVANS, TALVINDER, YOU'LL NEVER GUESS, IT'S THE PACIFIC OCEAN AGAIN, 2007,

installation White Cube Gallery, London / Installationsansicht.

Inside cover flaps: KELLEY WALKER, UNTITLED + 180 OR 180 HUE, 2007, digital print and goldleaf on laser-cut steel; UNTITLED, 2006,

digital print and goldleaf on laser-cut steel, 58 x 1/8" each / OHNE TITEL + 180 OR 180 HUE, Digitaldruck und Blattgold auf lasergeschnitte-

nem Stahl; OHNE TITEL, Digitaldruck und Blattgold auf lasergeschnittenem Stahl, je 147,3 x 0,4 cm.

Page 1: CERITH WYN EVANS, installation view, 2009, deSingel, Antwerp / Installatiosansicht. (PHOTO: JAN KEMPENAERS)

(All images slightly cropped / Alle Bilder leicht beschnitten.)

PARKETT Zürich New York

Bice Curiger Chefredaktorin / Editor-in-Chief; **Jacqueline Burckhardt** Redaktorin / Senior Editor; **Bettina Funcke** Redaktorin USA /
Senior Editor US; **Mark Welzel** Textredaktion und Produktion / Editing and Production; **Hanna Williamson · Simone Eggstein** Graphik
/ Design, **Trix Wetter** Graphisches Konzept / Founding Designer (–2001); **Catherine Schelbert** Englisches Lektorat / Editorial Assistant
for English; **Claudia Meneghini Nevzadi & Richard Hall** Korrektorat / Proofreading

Beatrice Fässler Vorzugsausgaben, Inserate / Special Editions, Advertising; **Nicole Stotzer** Buchvertrieb, Administration / Dis-
tribution, Administration; **Mathias Arnold** Abonnemente / Subscriptions; **Jeremy Sigler** Redaktionsassistenz USA / Associate
Editor US; **Andrea Urban** Vorzugsausgaben, Inserate und Abonnemente USA / Special Editions, Advertising, and Subscriptions US;
Grace Jensen Praktikant / Intern

Jacqueline Burckhardt – Bice Curiger – Dieter von Graffenried Herausgeber / Parkett Board;
Jacqueline Burckhardt – Bice Curiger – Dieter von Graffenried – Walter Keller – Peter Blum Gründer / Founders

Dieter von Graffenried Verleger / Publisher

www.parkettart.com

**PARKETT-VERLAG AG, QUELLENSTRASSE 27, CH-8031 ZÜRICH, TEL. 41-44-271 81 40, FAX 41-44-272 43 01
PARKETT, NEW YORK, 145 AV. OF THE AMERICAS, N.Y. 10013, PHONE (212) 673-2660, FAX (212) 271-0704**

EDITORIAL 87

Die in dieser Ausgabe von *Parkett* vorgestellten Künstlerinnen und Künstler setzten auf ganz unterschiedliche Weise ihr in hohem Mass entwickeltes ästhetisches Raffinement ein, um mit Formen und Bildern und deren eingefleischten Bedeutungen zu spielen. Dies kann befreiend und feierlich erscheinen, wie auch in ein beklemmendes Aufspüren und Entlarven münden, aber genauso Autonomie freisetzen, wie auch versteckte Potenziale sichtbar machen. So unterschiedlich die künstlerische Arbeit von Katharina Fritsch, Annette Kelm, Cerith Wyn Evans und Kelley Walker sich ausnimmt, es flackern momenthaft immer wieder Berührungspunkte auf in den Seiten dieser Ausgabe.

Bereits vor zwanzig Jahren hat *Parkett* Katharina Fritsch eine Collaboration gewidmet. In der Zwischenzeit sind zahlreiche ihrer hypnotisch wirkenden Skulpturen entstanden, die sich auch zu Raumensembles fügen, im Dialog mit grossformatigen Siebdrucken – leuchtend immateriellen Bildern. Zuweilen scheint es, als ob die Farben und die Bilder ein starkes Eigenleben führen, um sich aber gleichzeitig sublim und alltäglich aneinander zu reiben. Wie sehr in ihren Arbeiten eine kollektive Phantasie angesprochen ist, zeigt Jean-Pierre Criqui, der dabei die Rolle der Tiere in Fritschs Werk untersucht, als einem «Zusammentreffen von Innerlichkeit und Andersheit» (S. 55).

Nicht die Farbe, sondern das Licht macht sich Cerith Wyn Evans gefügig, um mit diesem auf von Konventionen befreite Art «Botschaften» zu vermitteln. Zuweilen sendet er sie auch hinaus ins Universum, wenn mit potenten Scheinwerfern in Morsezeichen literarische Zitate, in Lichtstaccato übersetzt, in den Nachthimmel gebeamt werden. In seiner Edition für *Parkett* verwendet Cerith Wyn Evans Neonlicht. Entstanden ist ein schlichtes, mathematisches Gleichheitszeichen für die Wand, in welchem die Kühle der Sprache mit warmer, ja heisser, Wunschenergie angereichert ist.

Beim Betrachten der Photographien von Annette Kelm «kollabiert eine Einordnung mittels der ästhetischen wie konzeptuell definierten Erkennungszeichen ebenso wie die Suche nach Inhalten und Erzählungen», schreibt Beatrix Ruf in ihrem Text mit dem Titel «Allerlei Wendungen» (S. 149). Es ist eine eigene Schönheit in Kelms photographischen Bildern, welche wie Malerei in Prozessen des Komponierens und Verwerfens entsteht.

Kelley Walker wiederum arbeitet in seinen Bildern, Objekten und Installationen mit stark vordefinierten Bedeutungen von vorgefundenen Bildern und Materialien. So sehr, dass dies den Künstlerkollegen und Autor Glenn Ligon veranlasste, von Kelley Walkers «Rassenproblem» zu schreiben (S. 23). Es ist ein «Rassenproblem» in Anführungszeichen, eine Obsession, die sich mit einem kulturellen, amerikanischen Dilemma beschäftigt. Zugleich umkreist Johanna Burton in einer detaillierten Beschreibung das Entstehen einer Ausstellung von Kelley Walker, und sie beschreibt, wie dabei die «Pionierrolle» des Künstlers, «nicht normative Geschichten, Triebe und Ästhetiken in den Mittelpunkt [zu] bringen», vielfach reflektiert wird (S. 73).

The artists presented in this issue of *Parkett* cultivate a highly sophisticated aesthetic as they come to terms with the entrenched meanings of forms and images. Demonstrating a remarkable autonomy and bringing to light hidden potential, their work can be liberating and awe-inspiring but equally disturbing and unsettling. Katharina Fritsch, Annette Kelm, Cerith Wyn Evans and Kelley Walker each chart highly distinctive territory of their own and yet, in the pages of this issue, we come across sparks that jumpstart moments of mutual contact.

EDITORIAL 87

Twenty years ago *Parkett* already devoted an issue to Katharina Fritsch as a Collaboration artist. She has since created numerous sculptures of hypnotic impact, some united as ensembles in space that enter into a dialogue with large-format screenprints—luminously immaterial images. At times, her colors and images seem to lead a life of their own, which does not, however, prevent them from clashing with each other in a fashion as sublime as it is ordinary. The extent to which her works address our collective fantasies is pointed out by Jean-Pierre Criqui, whose study of the role animals play in this oeuvre reveals a "conjunction between interiority and otherness" (p. 50).

It is not color but light that Cerith Wyn Evans bridles, ignoring all convention in using it to communicate "messages." He even exploits the universe as his picture support, shooting powerful spotlights into the night sky to create a staccato of light that beams literary quotations in Morse code. Evans' edition for *Parkett* consists of a wall-mounted equal sign that radiates the warm, indeed hot, energy of wishes in a ploy to enrich the coolness of the neon idiom.

In Annette Kelm's photographs, viewers will be disappointed if they seek to rely on "classification by means of aesthetic and conceptually defined recognition factors" or engage in a "quest for content and narrative," as Beatrix Ruf puts it in her essay titled "Twisting and Turning" (p. 149). The singular and self-contained beauty of Kelm's photographed images emerges—like painting—in processes of composing, selecting and rejecting.

In his pictures, objects, and installations, Kelley Walker works with the patently predefined meanings of found images and materials—so much so, that his artist colleague and writer Glenn Ligon speaks about Kelley Walker's "Negro Problem" (p. 23). It is a "race problem"—in quotes—an obsession that takes on a cultural, American dilemma. Describing in detail how Walker plans an exhibition, Johanna Burton inquires into the way in which the artist as "pioneer" renders "ostensibly 'non-normative' histories, desires, and aesthetics central and visible" (p. 68).

Bice Curiger

Misappropriation:
In Defense of the Real Adolf Dietrich

RICHARD PHILLIPS

KRONENHALLE

I was first introduced to Adolf Dietrich's (1877–1957) work in 2003 by the artist Peter Fischli following a dinner at the legendary Kronenhalle restaurant in Zurich. After our meal, I accompanied Peter on a tour of the restaurant's collection where, after seeing works by Matisse, Kandinsky, Braque, and Picasso, I was led into a dining room on the second floor and shown a pencil drawing of two squirrels in a tree. I was told that the drawing was by an early twentieth-century artist considered a "Swiss national treasure." I was surprised by the drawing, struck by the unique qualities of realism carried out by the artist's extraordinary sensitivity to light and tone and by his democratic recording of detail, from the squirrel's fur to the trees' bark to the snow's melting surface. There seemed to be a willingness to invest in the life of the image far beyond any initial painterly representation. The effect of such commitment to rendering drew out the specificity (and thus psychology and attitude) of place and of the animals, which, imbued with such intensity, seemed to take on human quali-

ties. Within the context of works by modern masters, all with their recognizable styles, Dietrich's drawing truly stuck out, seeming all the more masterful.

While Dietrich may have been a "national Swiss treasure," I soon came to the realization that it was a reputation he'd acquired for the wrong reasons. In my mind, he was, and still is, a completely misunderstood artist. Since there are no texts on Dietrich in English, I have been at the mercy of whatever limited information I have been able to find (or have had translated into English), all of which claimed the artist, whose work stylistically shared some of the formal traits of so-called "naïve artists," to be an "outsider artist." Such mislabeling certainly has had a negative effect on the trajectory of Dietrich's career and has severely limited his international exposure to a broader, critically engaged audience.

In 2004, with little more than a rough idea of his output and very little knowledge about the artist's biography (and a great deal of misunderstanding, I later determined), I began work on a large-scale painting after Dietrich's ZWEI EICHHÖRNCHEN (Two Squirrels, 1948). The piece, titled SIMILAR TO SQUIRRELS (2004), was intended for an exhibition at Le Consortium in Dijon themed around represen-

RICHARD PHILLIPS is an artist who lives and works in New York.

6

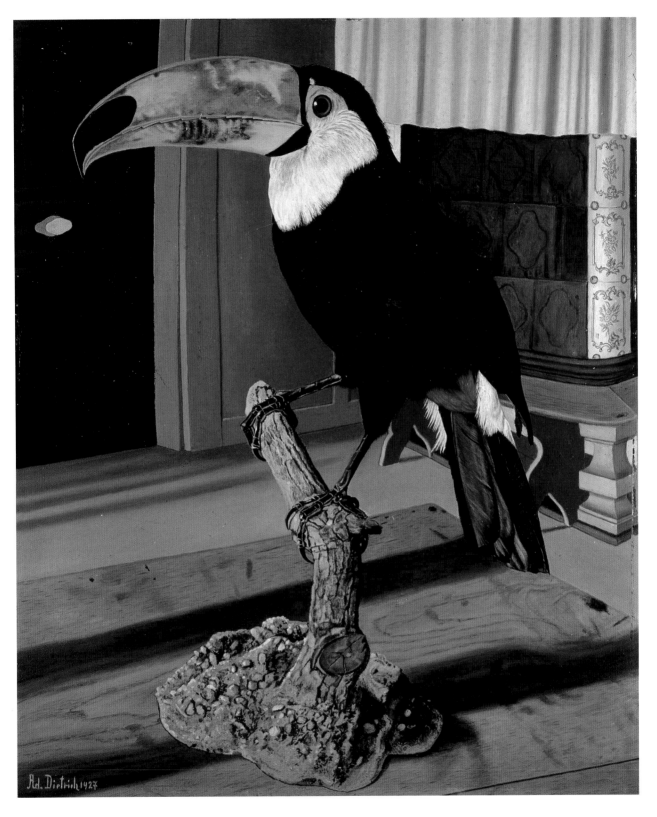

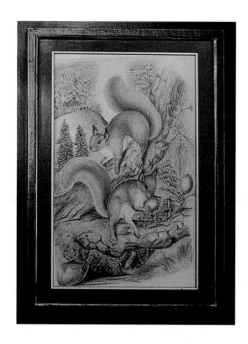

ADOLF DIETRICH, TWO SQUIRRELS, pencil
on paper, 18 x 11 ¹/₂" / ZWEI EICHHÖRNCHEN,
Bleistift auf Papier, 46 x 29 cm.
(PHOTO: RESTAURANT KRONENHALLE AG, ZÜRICH)

tations of identity and nation states. As I worked on my painting, my goal was to amplify those qualities which, in my mind, formed the basis of Dietrich's highly idiosyncratic construction of the real. While devising my composition, I followed Dietrich's use of elevated perspective, which allowed for a candid gaze upon the subject from high up in the trees and created an unmitigated relationship between viewer and subject. The goal was simply to put the "act of looking" and "nature" on the same footing.

TRAVEL

Since 2004, my fascination with Dietrich has continued to grow, and finally, a few months ago, when in preparation for writing the article you are currently reading, I decided it was time to pay a visit to Switzerland's Kunstmuseum Thurgau, home to one of the largest Dietrich collections in the world. Upon my arrival to the museum in Ittingen—having taken two trains, a bus, and walked a long distance down a

country road to get there—I saw, in person for the first time, many of the paintings I'd previously only experienced as reproductions in books. Along with the extraordinary pieces being exhibited, I was fortunate enough to be taken by the museum's curator, Markus Landert, to see many of the works in the estate that were not on view—paintings, drawings, photographs, sketches, notes, and letters. This exposure to the depth of material in the archives entirely changed my perceptions of the artist. It made me see, for one, that Dietrich may not have been as much of an outsider as people thought (and still think), and that there may be another version of the events of his life that contradicts what we know of him and his art.

Walking into the gallery, I confronted two Dietrich portraits, one picturing him as a stern, elderly man, and another—much tougher in nature—of his elderly father. The dates of these two paintings and their subjects immediately revealed one misconception: that Dietrich didn't begin painting until late in life. In fact he completed his first paintings in 1902 at the age of twenty-five. I then began to focus on many of the other works installed around the gallery, thrilled by my first opportunity to see so many of Dietrich's strengths as an artist operating all at once and in full view. It occurred to me that one of Dietrich's most popular subjects—a local Bernese Mountain Dog named Balbo, who appears in many paintings—in many ways steals the show. The dog is simply more disarming (not to mention charming) than all of the other human portraits put together. In the famous GELBROTER ABENDHIMMEL (Yellow-Red Evening Sky, 1925), there is a luminous, orange sky amidst an array of unusual cloud and tree formations. The landscape is punctuated by a bunny running through the lushly painted foreground epitomizing the Rousseauian goals of the Neo-Romantic movement. The classic SCHIFFSSTEG IM WINTER (Boat Pier in Winter, 1940) opens onto a barren icescape with a decaying dock and a pair of swans—all articulated with Dietrich's typical complexity, highlighting a certain depth of emotion: what I might call his unique portrayal of deathly absence. As art historian Christoph Vögele wrote in 1994: "Dietrich saw his own living conditions mirrored in the seasonal bareness and coldness, abandonment and emptiness; his existen-

tial fears of poverty and war, his feelings of loneliness."[1] After seeing this body of work in person, it was easy to understand how Dietrich came to be associated with the late-New Objectivism and Neo-Romantic movements.

Landert informed me that Dietrich was the youngest of four brothers and that he was from a very poor family. While his brothers left home seeking employment in larger towns and cities, Dietrich stayed in Berlingen to help support his parents, which meant running their small farm and tending to their single cow and goat. For additional income, he worked as a lumberjack and at a local textile mill. Nevertheless, he showed talent in his art and was encouraged by his elementary school teachers to pursue his artistic abilities. Looking at his earliest watercolors, one can see how committed he was to being taken seriously as an artist; he borrowed freely from popular publications, designing his own Nouveau Art borders in order to give them a "contemporary" look. Some of his earliest paintings combine still life imagery with romantic motifs. Their palettes are extremely saturated in hue and have remarkable intensity, as is the case with HERMELIN UND TOTE MÖWE IN MONDSCHEINLANDSCHAFT (Ermine and Dead Seagull in Moonlight Landscape, 1908), a nocturne that pictures an ermine and a hanging bird.

I made an interesting discovery while comparing the front and back of many works, where I found clear evidence of the artist's poverty. His supplies must have been limited, forcing him to make use of all surfaces. In one work on paper, for example, there's a highly detailed rendering of a tiger (inspired by a trip to the zoo) with two disassociated landscapes drawn on the back of the same sheet. Early drawings—one of his father and another of a hare—reveal the artist's unusual sensitivity both in charcoal and chalk on toned paper. Pencil drawings likewise display his ability to create atmosphere, which he carried over to his paintings on cardboard and wood panel. Dietrich's sketchbooks show how extensive and relentless he was at recording all sorts of compositional ideas, as well as keeping detailed notes on color, time of day, and even weather—all of which facilitated his early Romantic works and his methodical transition to the "Swiss Picturesque."

Yet, along with his conventional painterly exploration, he also conducted more audacious experiments, such as allowing children to finish his drawings for him in order to capture their unselfconscious expressiveness. Dietrich never made paintings from these particular drawings (what if he had?), as he considered them finished works on their own, a kind of side project used to provide a playful critique to his more stable working method. Where he combined disparate, often contradictory aspects of his practice, he did so with specific, refined intentions. He brought together, for example, direct observation (usually still life) with the landscape notations he'd recorded in his sketchbooks. As Dietrich's colleague and fellow

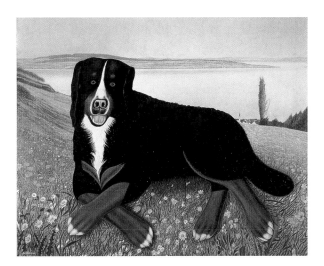

ADOLF DIETRICH, BALBO LYING IN THE MEADOW, 1955, oil on fiberboard, 35 ¹/₂ x 40" / BALBO AUF DER WIESE LIEGEND, Öl auf Pavatex, 90 x 101,5 cm. (PHOTO: KUNSTMUSEUM THURGAU, ITTINGER MUSEUM)

ADOLF DIETRICH, WINTER AT LAKE CONSTANCE, 1941, oil on cardboard,
18 x 23 ¹/₂" / WINTER AM UNTERSEE, Öl auf Karton, 46 x 59,5 cm.
(PHOTO: KUNSTMUSEUM THURGAU, ITTINGER MUSEUM)

New Objective painter Georg Schrimpf said in ref-
erence to their similar working process: "Although I
draw the composition of a landscape outside with a
few strokes in a sketchbook, I paint the oil paintings
later when I'm alone and everything is quiet around
me; I don't merely paint the landscape I see, but the
landscape that I see inside me."[2]

ART WORLD
Around the year 1916, Dietrich was discovered by
the German art dealer Herbert Tannenbaum, who
represented the artist until 1937 when he had to
flee the Nazis. Sales made during these years led to
a period of modest prosperity for Dietrich, allowing
him to make a major acquisition—a camera—that
wound up having a significant effect on his working
process for the rest of his career. The use of photo-
graphy galvanized Dietrich's commitment to the pic-

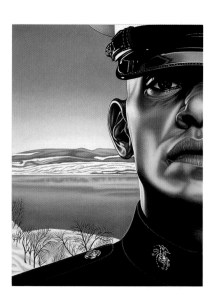

RICHARD PHILLIPS, MESSAGE FORCE
MULTIPLIER, 2009, oil on canvas,
78 x 58 ¹/₂" / MEINUNGSVERSTÄRKER,
Öl auf Leinwand, 198,1 x 148,6 cm.
(PHOTO: GAGOSIAN GALLERY, NEW YORK)

turesque and to the process of recording subtle shifts in atmosphere.

Together with his notational sketches, the small black-and-white photos he took became further tools for refining his imagery. This led to the production of a few extremely detailed, photo-realistic paintings, including a portrait of a toucan titled, PFEFFER-VOGEL (Toucan, 1927), and a still life of taxidermied ducks called GROSSES STILLLEBEN MIT ENTEN, EIS-VÖGELN UND FISCHEN (Large Still Life with Ducks, Kingfishers, and Fish, 1925). He also created larger and more complex drawings, which he then transferred onto cardboard or panel and traced repeatedly until they were entirely worn out.

The medium of photography also played a part in Tannenbaum's effort to introduce Dietrich's work—to "campaign" him, so to speak—to a broader audience. Part of this involved showing his work to Franz Roh, who immediately championed Dietrich, referring to him as a kind of naïve realist, and thus the embodiment of the ideals of New Objectivity and the Post-/Anti-Expressionist movement. In 1925, Dietrich's work was included in an exhibition of New Objective artists at the Kunsthalle in Mannheim: "Neue Sachlichkeit: Deutsche Maler nach dem Expressionismus" (New Objectivity: German Painters after Expressionism). It was then that Tannenbaum and Roh hatched a scheme to promote Dietrich as the New Objectivity's "Rustic" Rousseau. A photographer was immediately sent to Berlingen to begin the myth-building process by staging the artist in a variety of tableaus all of which portrayed him as a hermit living in the forest and painting in a small dilapidated woodshed. Misleading photos were also taken of the artist painting outdoors, which he did do but only rarely. He was fictitiously cast as a man entirely isolated from society, when, in fact, he was quite socially active, living in the center of Berlingen's square, where he was keenly aware of daily town life from the perch of his front window. He also welcomed and regularly entertained visitors, who occasionally commissioned him to paint their portraits. The odd, un-modulated, flat lighting of the portraits is due to the fact that he worked from photographs of his sitters.

Contrary to any portrayal of him as an unsophisticated "outsider" artist, Dietrich was a consummate technician and was always devising new ways of improving his painting and achieving specific visual effects in certain works. Yet, social interaction especially of an intimate nature was difficult for Dietrich, who never married. It can be noted in reading his correspondence that he employed a dating service to help introduce him to women, but to no avail. Significantly, many of the views that he favored for his paintings were also the sites he considered to be most romantically enticing. His efforts in matters of love and intimacy, even while unrequited, further dispel the myth of him as a "loner" intentionally withdrawn from society. Dietrich also happened to be a prolific writer; he wrote more than a thousand letters to friends and admirers of his work.

He is known to have ridden on the back of a friend's motorcycle to Munich—one of his few trips out of Berlingen—where he made a pilgrimage to the Alte Pinakothek to see paintings by Albrecht Dürer. These paintings inspired him to make technically stronger work. Upon his return from Munich, he is said to have invited painters to visit his studio, at which point he asked them, flat out, for advice on how he could improve his methods. With this advice and inspiration his interior world grew exponentially. While, geographically speaking, he was somewhat provincial, his openness, curiosity, social ambitions, and eagerness to achieve technical mastery made him the direct opposite of a naïve/romantic/rustic outsider artist. If anything he was technological, appropriative, innovative, and thus a parallel-modern (though in a more rustic way), which clearly distinguishes him from the metropolitan or at least urban artist culture. His fascination with animals, botany, and atmosphere led to a mode of pictorial representation that was totally animated, if not hyper-animated.

Dietrich developed the ability to use his various sources and techniques to completely synthesize the real. This took him far beyond the painterly mode of careful observation while giving him means to evade strict abstraction. The radicality of his vision might thus be seen as a reinterpretation of the constituent forms of representation for the purpose of creating an advanced emotional and physical connection to places and things. It allowed him to invest sites and animals with an internal realism, animating them

from within and psychologically expanding them beyond what we see on the surface.

The efforts of Roh and Tannenbaum to falsify Dietrich in a way that would bolster his marketability did result in short-term financial gain, but had the lasting effect of severely marginalizing and limiting our access to one of the most important artists of his generation. As a Swiss national treasure he remains to this day a kind of enigma. When Tannenbaum was forced to flee Europe, Dietrich's active relationship with his exploitative dealer abruptly ended although Tannenbaum was able to continue selling the work during the war, thus maintaining the positive and negative effect he was having on the artist.

MECHANIZED WAR

Following World War I, realism in painting split into two camps, or coalesced around two different positions. There was New Objectivity with its pessimism and alienation, and post-expressionist tendencies, which were in favor of an un-idealized representation of the failure of the Enlightenment. Then there was Neo-Romanticism, which turned away from industrial society and represented a nature made vulnerable by the onset of human treachery, a nature seen slipping away. The idealization of the landscape through naïve and neo-primitive styles drifted toward a conservative style that was eventually appropriated by the Nazis and used for propaganda as in Dietrich's inclusion in *NS Frauenwarte*, September 1937, a Nazi lifestyle magazine for women.

The relationship Dietrich's paintings had to either of these concepts is dubious, as he was not a polemical or ideological theoretician; while he was aware of some of the artists involved, he claimed in letters to have no use for them. Instead of using his observations and constructions as a way to communicate the obvious turmoil in society, and thus succumbing to one of the predominant discourses, he used his detailed representation of nature to stabilize the act of looking so that experiencing his art would evoke sustainable emotional and psychological responses beyond that of formal gestures.

The relative simplicity of his auto-didactic work was therefore an alternative to the didacticism of an over-strategized, synthetic formalism. In retrospect,

Dietrich's art can be seen to have been paradoxically built i n t o and o u t o f Weimar art history. While it was made in a rural setting and in the midst of great hardship, Dietrich's art is still a giant achievement of modern art from that time and was only, in fact, marginalized by the efforts of a few. When removed from the context of false mythologies and commercial ploys, the paintings themselves hold the truth of their own making and of a lost thread in modernity. They are neither centered on negotiation with projected future styles nor are they a tactical reprisal of previous genres. Nevertheless, Dietrich strove to make a connection with his audience using a combination of science (photography), media (tourist brochures and magazines), observation (sketches and notations), and technique.

Dietrich's intense focus on the vicissitudes of contemporary life in Berlingen and the deliberate autonomy of his style offer an alternative to the version of events in a hierarchically perceived history of modern art that we have grown accustomed to and accept as fact.

In the wake of World War II and the clash between the aesthetics of expressionism and abstraction—the binary opposition of expressionism and abstraction—the "representational image" was thought of as either reactionary or the result of misplaced propaganda. But the experience of looking at a Dietrich painting in person refutes this fiction outright while illuminating the underpinnings of an alternative reading of history. When I went to Ittingen to see Dietrich's paintings, I had a strong sense that I was independently mending something that had been tethered—tying back together the experience that had been thoroughly cut apart by forces entirely outside the art.

Art professionals with their conduit to history have misappropriated the work of Dietrich, thereby succeeding in being conventionally wrong. When I reached the museum in Ittingen and stood in front the paintings, I knew that it was the exact opposite: that Dietrich, if anything, had been unconventionally right.

1) Christoph Vögele, "Landschaft" in *Adolf Dietrich und die Neue Sachlichkeit in Deutschland* (Winterthur: Kunstmuseum, 1994; Oldenburg: Landesmuseum, 1995), p. 69.
2) Ibid., p. 73.

Zu Unrecht vereinnahmt
Ein Plädoyer für Adolf Dietrich

RICHARD PHILLIPS

KRONENHALLE

Meine erste Begegnung mit dem Werk von Adolf Dietrich (1877–1957) fand 2003 in der legendären Kronenhalle in Zürich statt. Nach dem Essen machte ich mit dem Künstler Peter Fischli einen Rundgang durch die Sammlung des Restaurants. Wir hatten bereits Werke von Matisse, Kandinsky, Braque und Picasso gesehen, als er mich in eine Stube im zweiten Stock führte und mir eine Bleistiftzeichnung von zwei Eichhörnchen auf einem Baum zeigte. Ich erfuhr, dass die Zeichnung von einem Künstler aus dem frühen zwanzigsten Jahrhundert stammte, der als «Schweizer Kleinod» galt. Ich war wie von ihr geblendet, hingerissen von der einzigartigen Qualität ihres Realismus in der Ausführung, dank der ausserordentlichen Sensibilität des Künstlers für Licht und Tonwerte, und von seiner «demokratischen» Akribie im Detail – vom Eichhörnchenpelz über die Baumrinde bis zur schmelzenden Schneeoberfläche. Da war eine Bereitschaft, sich für die Lebendigkeit des Bildes einzusetzen, die weit über den einfachen malerischen Darstellungswillen hinausging. Die Wirkung dieser hingebungsvollen Wiedergabe entzog dem Ort und den Tieren ihren spezifischen Charakter (und damit auch ihre Psychologie und Verhaltensweise); sie waren von solcher Intensität durchtränkt, dass sie menschliche Qualitäten anzunehmen

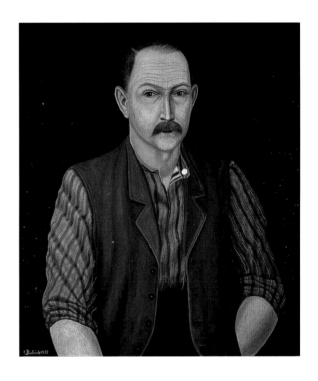

ADOLF DIETRICH, SELF-PORTRAIT, 1932, oil on cardboard, 24 ³/₄ x 21 ³/₄" / SELBSTBILDNIS, Öl auf Karton, 63 x 55 cm. (PHOTO: KUNSTMUSEUM THURGAU, ITTINGER MUSEUM)

RICHARD PHILLIPS ist Künstler. Er lebt und arbeitet in New York.

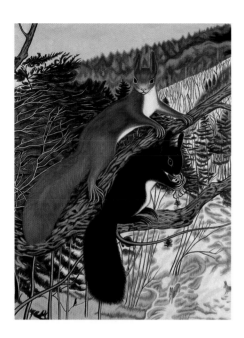

RICHARD PHILLIPS, SIMILAR TO SQUIRRELS
AFTER A. DIETRICH, 2003, oil on linen,
102 x 78" / EICHHÖRNCHEN NACH A. DIETRICH,
Öl auf Leinen, 260 x 198,1 cm.
(PHOTO: GAGOSIAN GALLERY, NEW YORK)

schienen. Im Kontext der Werke moderner Meister mit ihren je unverwechselbaren Stilen stach Dietrichs Zeichnung deutlich hervor und wirkte dadurch noch meisterhafter.

Dietrich mag ein «Schweizer Kleinod» sein, mir wurde jedoch bald klar, dass ihm dieser Ruf aus den falschen Gründen zugeschrieben wurde. In meinen Augen war er ein komplett missverstandener Künstler – und ist es noch. Da es keine englischen Texte über Dietrich gibt, war ich auf die spärlichen Informationen angewiesen, die ich aufzuspüren vermochte (oder ins Englische übersetzen liess); darin hiess es ausnahmslos, der Künstler, dessen Werk stilistisch gewisse formale Ähnlichkeiten mit der sogenannten «naiven Kunst» aufweist, sei ein «künstlerischer Aussenseiter». Diese falsche Etikettierung hat sich mit Sicherheit negativ auf den Verlauf von Dietrichs Karriere ausgewirkt und schränkte seine Chancen, sich

international einem breiteren, kritisch interessierten Publikum zu präsentieren, drastisch ein.

Im Jahr 2004 begann ich – mit einer lediglich groben Vorstellung vom Werk und sehr mageren Kenntnissen über die Biographie des Künstlers (und, wie ich später feststellen musste, in etlichen Missverständnissen befangen) – ein grossformatiges Gemälde nach Dietrichs ZWEI EICHHÖRNCHEN (1948). Die Arbeit mit dem Titel SIMILAR TO SQUIRRELS (Eichhörnchen nach A. Dietrich, 2004) war für eine Ausstellung im Consortium in Dijon gedacht, in der es thematisch um Bilder über Identität und nationale Identitäten ging. Bei der Arbeit am Bild ging es mir darum, jene Eigenschaften zu betonen, die meiner Meinung nach Dietrichs höchst eigenwilliger Konstruktion von Realität zugrunde liegen. Beim Erarbeiten meiner Komposition übernahm ich Dietrichs erhöhten Blickwinkel, was den ungehinderten Blick auf das Sujet von hoch oben in den Bäumen erlaubte und eine unmittelbare Beziehung zwischen Betrachter und Gegenstand schuf. Das Ziel war schlicht, den «Akt des Betrachtens» und die «Natur» auf eine Ebene zu stellen.

REISE

Seit 2004 hat die Faszination, die Dietrich auf mich ausübt, stetig zugenommen. Also beschloss ich vor wenigen Monaten, als ich begann, den Text zu schreiben, den Sie jetzt vor sich haben, dem Kunstmuseum Thurgau in der Schweiz und damit einer der grössten Dietrich-Sammlungen der Welt einen Besuch abzustatten. Nach meiner Ankunft im Museum in der Kartause Ittingen – nachdem ich zwei Züge und einen Bus genommen und dann noch eine Strecke zu Fuss auf der Landstrasse zurückgelegt hatte, – sah ich zum ersten Mal viele der Bilder im Original, die ich bisher nur als Reproduktionen aus Büchern gekannt hatte. Ich sah nicht nur die wunderbaren Werke in der Ausstellung, sondern hatte das Glück, dass mir der Kurator, Markus Landert, auch viele nicht ausgestellte Arbeiten aus dem Nachlass zeigte (Gemälde, Zeichnungen, Photographien, Skizzen, Notizen und Briefe). Dieser Einblick ins Archivmaterial hat meine Wahrnehmung des Künstlers radikal verändert. Zum einen wurde mir klar, dass Dietrich wohl gar kein so grosser Aussenseiter war, wie die

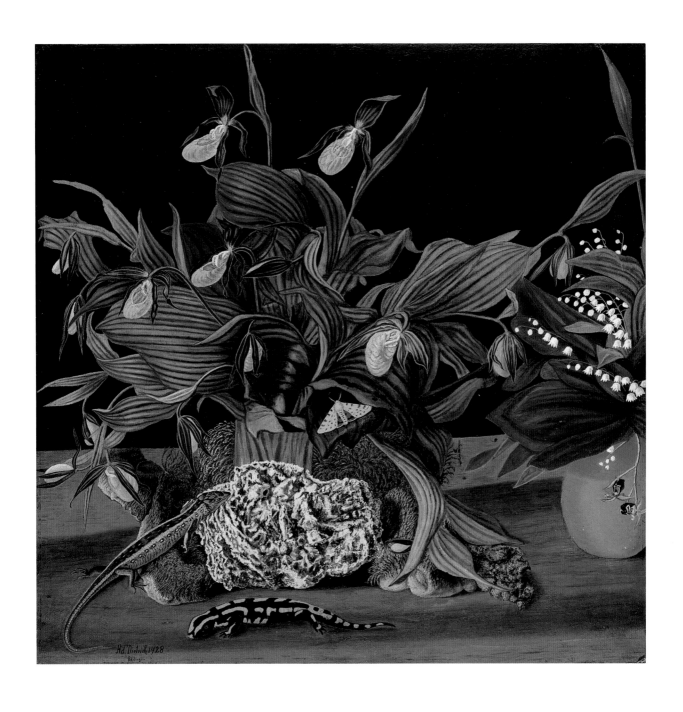

ADOLF DIETRICH, LADY'S SLIPPER, 1928, oil on cardboard, 19 ³/₄ x 19 ³/₄" / FRAUENSCHÜELI, Öl auf Karton, 50 x 50 cm.

(SAMMLUNG BRUNO BISCHOFBERGER, ZÜRICH)

15

Leute dachten (und immer noch denken), und dass vielleicht eine andere Version der Ereignisse in seinem Leben existiert, die dem, was wir über ihn und seine Kunst wissen, widerspricht.

Beim Betreten des Museums sah ich mich zwei Dietrich-Porträts gegenüber, das eine zeigte ihn selbst als strengen, alten Mann, und das andere – sehr viel kompromissloser – seinen bejahrten Vater. Die Entstehungsjahre der beiden Bilder und ihrer Sujets stellten sogleich das Missverständnis richtig, Dietrich habe erst spät in seinem Leben zu malen begonnen. In Wirklichkeit vollendete er seine ersten Gemälde schon 1902, im Alter von fünfundzwanzig. Danach begann ich viele weitere im Museum ausgestellte Werke genauer zu betrachten, fasziniert von dieser ersten Gelegenheit, Dietrichs künstlerischen Stärken gleichzeitig und eins zu eins auf mich wirken zu lassen. Mir fiel auf, dass eines seiner populärsten Sujets – ein lokal bekannter Berner Sennenhund namens Balbo (der in vielen Bildern auftaucht) – den andern in mancher Hinsicht die Schau stiehlt. Der Hund ist schlicht entwaffnender (und natürlich viel charmanter) als alle menschlichen Porträts zusammengenommen. Im berühmten GELBROTEN ABEND-HIMMEL (1925) sieht man einen leuchtend orangen Himmel hinter einer Reihe ungewöhnlicher Wolken- und Baumformen. Die Landschaft wird lediglich von einem Häschen durchkreuzt, das gleichsam als Verkörperung der Rousseau'schen (Henri Rousseau 1844–1910) Ziele der Neuen Romantik über den saftig gemalten Vordergrund hoppelt. Der klassische SCHIFFSSTEG IM WINTER (1940) gibt den Blick frei auf eine unwirtliche Eislandschaft mit einem maroden Steg und einem Schwanenpaar – alles in Dietrichs charakteristischer Dichte dargestellt, die eine gewisse emotionale Tiefe unterstreicht: ich möchte es als seine einmalige Wiedergabe eines tödlichen Mangels bezeichnen. Wie der Kunsthistoriker Christoph Vögele 1994 über Dietrich schrieb: «in der jahreszeitlichen Kargheit und Kälte, Verlassenheit und Leere sieht er die eigenen Lebensbedingungen gespiegelt: seine existentiellen Ängste vor Verarmung und Kriegsgefahr, seine Gefühle der Einsamkeit.»[1] Nachdem ich diesen Werkkomplex mit eigenen Augen gesehen hatte, konnte ich gut verstehen, warum Dietrich mit der späten Neuen Sachlichkeit und neu-romantischen Strömungen in Verbindung gebracht wurde.

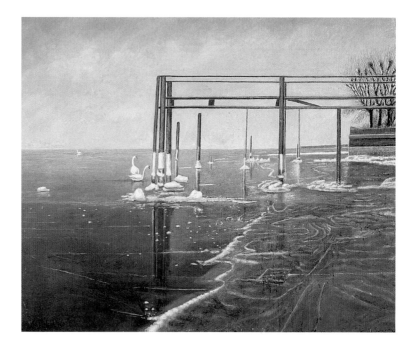

ADOLF DIETRICH, BOAT PIER IN WINTER WITH SWANS, 1940, oil on plywood, 15 $^1/_8$ x 18 $^1/_2$" / SCHIFFSTEG IM WINTER MIT SCHWÄNEN, Öl auf Sperrholz, 38,5 x 47 cm.
(PHOTO: KUNSTMUSEUM THURGAU, ITTINGER MUSEUM)

Landert erzählte mir, dass Dietrich der jüngste von vier Brüdern gewesen sei und aus einer sehr armen Familie stammte. Während seine Brüder von zu Hause weggingen, um Arbeit in grösseren Dörfern und Städten zu suchen, blieb er in Berlingen, um seine Eltern zu unterstützen, das hiess, ihren kleinen Bauernhof zu bestellen und für die einzige Kuh und Geiss zu sorgen. Um etwas dazuzuverdienen, arbeitete er als Waldarbeiter und in einer lokalen Tuchfabrik. Dennoch zeigte er künstlerisches Talent und wurde von seinen Primarschullehrern ermutigt, seiner Begabung zu folgen. Betrachtet man seine ersten Aquarelle, sieht man, wie sehr ihm daran gelegen war, als Künstler ernst genommen zu werden; er entlieh nach Belieben Elemente aus bekannten Publikationen für seine eigenen Jugendstil-Ornamente, damit sie «zeitgenössischer» wirkten. Einige seiner ganz frühen Bilder verknüpfen das Bildvokabular des Stilllebens mit romantischen Motiven. Die Farbpalette ist ausgesprochen satt, reich nuanciert und von bemerkenswerter Intensität, wie etwa im Fall von HERMELIN UND TOTE MÖWE IN MONDSCHEINLANDSCHAFT (1908), ein Nachtstück, das ein Wiesel und einen an den Füssen aufgehängten Vogel zeigt.

Eine interessante Entdeckung machte ich, als ich zahlreiche Vorder- und Rückseiten seiner Arbeiten miteinander verglich und auf eindeutige Spuren der Armut des Künstlers stiess. Sein Materialvorrat muss beschränkt gewesen sein, sodass er gezwungen war, alle Flächen zu nutzen. Bei einer Arbeit auf Papier finden sich beispielsweise die höchst detaillierte Zeichnung eines Tigers (inspiriert von einem Ausflug in den Zoo) und zwei voneinander unabhängige Landschaften auf der Rückseite desselben Blattes. Frühe Zeichnungen – eine zeigt seinen Vater, eine andere einen Hasen – zeugen von der ungewöhnlichen Sensibilität des Künstlers im Umgang mit Kohle und Kreide auf getöntem Papier. Auch Bleistiftzeichnungen verraten diese Gabe, eine Atmosphäre zu erzeugen, die man auch in den Gemälden auf Karton und Holzplatten wiederfindet. Seine Skizzenbücher belegen, wie ausführlich und hartnäckig er alle möglichen kompositorischen Ideen festhielt, enthalten aber auch detaillierte Notizen über Farbe, Tageszeit und sogar das Wetter: All dies begünstigte seine frühen romantischen Werke und seinen methodischen Übergang zu einer Art «Schweizer Pittoreske».

Doch neben seinen eher konventionellen malerischen Studien, beschritt er auch kühnere, experimentelle Wege, so erlaubte er beispielsweise Kindern, seine eigenen Bilder zu vollenden, um ihre unbefangene Ausdruckskraft festzuhalten. Dietrich malte nie Bilder nach diesen speziellen Zeichnungen (Was, wenn er es getan hätte?), weil er sie als eigenständige, in sich geschlossene Werke betrachtete, eine Art Nebengleis im Sinne einer spielerischen Kritik an seiner strengen geregelten Arbeitsweise. Wenn er disparate, oft widersprüchliche Aspekte seines Vorgehens miteinander vereinte, so tat er dies stets in konkreter, raffiniert durchdachter Absicht. So kombinierte er beispielsweise die direkte Beobachtung (gewöhnlich ein Stillleben) mit landschaftlichen Aufzeichnungen aus seinen Skizzenbüchern. Wie Georg Schrimpf, Dietrichs Malerkollege und Mitvertreter der «Neuen Sachlichkeit», zu seiner ähnlichen Arbeitsweise vermerkte: «Wohl zeichne ich draussen die Kompositionen eines Bildes mit ein paar Strichen ins Skizzenbuch; das Ölbild aber – alle Bilder entstehen im Atelier – später, wenn ich allein bin und alles still ist um mich. Denn was ich malen will, ist ja nicht einfach eine Wiedergabe der Landschaft, es ist die Landschaft, wie ich sie sehe und wie sie in mir bleibt.»[2]

KUNSTBETRIEB

Um 1916 herum wurde Dietrich vom Mannheimer Kunsthändler Herbert Tannenbaum entdeckt, der sein Werk bis 1937 betreute, als er vor den Nazis fliehen musste. Die in diesen Jahren getätigten Verkäufe verschufen Dietrich eine Periode bescheidenen Wohlstands und ermöglichten ihm eine grössere Anschaffung zu tätigen, nämlich eine Kamera, die seine Arbeitsweise für den Rest seiner Karriere entscheidend beeinflussen sollte. Das Photographieren weckte schlagartig Dietrichs Hang zum Pittoresken und zum Festhalten subtiler atmosphärischer Veränderungen.

Zusätzlich zu seinen notizartigen Skizzen wurden die kleinen Schwarz-Weiss-Photos, die er nun schoss, zu einem weiteren Instrument der Verfeinerung seiner Bildsprache, was zur Entstehung einiger extrem

detaillierter photorealistischer Gemälde führte, darunter auch das Porträt eines Tucans mit dem Titel PFEFFERVOGEL (1927) und ein Stillleben mit toten Enten, GROSSES STILLLEBEN MIT ENTEN, EISVÖGELN UND FISCHEN (1925). Er machte nun auch grössere und komplexere Zeichnungen, die er dann auf Kartons oder Platten übertrug und immer wieder durchpauste, bis sie völlig verschlissen waren.

Das Medium Photographie spielte auch eine Rolle bei Tannenbaums Bemühungen, Dietrichs Werk einem breiteren Publikum näherzubringen – ihn sozusagen «zu promoten». Dazu gehörte auch, dass er seine Arbeiten Franz Roh zeigte, der sich sofort für Dietrich einsetzte, ihn als eine Art naiven Realisten pries und somit als Verkörperung der Ideale der Neuen Sachlichkeit und der Post-/Anti-Expressionistischen Bewegung. 1925 wurden Dietrichs Werke zusammen mit Vertretern der Neuen Sachlichkeit in der Kunsthalle Mannheim unter dem Titel «Neue Sachlichkeit: Deutsche Maler nach dem Expressionismus» ausgestellt. Daraufhin heckten Tannenbaum und Roh den Plan aus, Dietrich als «rustikalen» Rousseau der Neuen Sachlichkeit zu propagieren. Unverzüglich wurde ein Photograph nach Berlingen entsandt, um die entsprechende Mythisierung in Gang zu bringen, indem sie eine Reihe von Tableaus mit dem Künstler inszenierten und aufnahmen, die ihn allesamt als im Wald lebenden Einsiedler zeigten, der in einem maroden Holzschuppen malt. Es wurden auch irreführende Photos gemacht, die den Künstler beim Malen im Freien zeigten, was er zwar auch tat, aber nur selten. Man entwarf von ihm die fiktive Gestalt eines Mannes, der von der Gesellschaft völlig isoliert lebte, obwohl er in Wirklichkeit ein ziemlich aktives Sozialleben pflegte, zentral am Dorfplatz von Berlingen wohnte und den dörflichen Alltag von seinem Fensterplatz aus sehr genau mitverfolgte. Er empfing und bewirtete auch regelmässig Besucher und malte hin und wieder auf Bestellung deren Porträts. Diese Porträts verdanken ihr seltsames, wenig differenziertes, flaches Licht den Photographien, die er jeweils zu Beginn machte, um seine Modelle festzuhalten.

Entgegen allen Darstellungen, die ihn als ungebildeten «Aussenseiter»-Künstler schildern, war Dietrich ein besessener Techniker und suchte ständig nach neuen Mitteln, um seine Malerei zu perfektionieren und in einzelnen Werken besondere visuelle Effekte zu erzielen. Doch Dietrich tat sich schwer mit zwischenmenschlichen Beziehungen, besonders mit solchen intimer Art, und er hat nie geheiratet. Wenn man seine Briefe liest, erfährt man, dass er, wenn auch vergeblich, einen Vermittlungsdienst beauftragte, der ihm helfen sollte, Frauen kennenzulernen. Umso berührender ist, dass viele seiner gemalten Lieblingsansichten für ihn auch die in romantischer Hinsicht lauschigsten Plätze waren. Seine Suche nach Liebe und Nähe – wenngleich sie nicht erwidert wurde – lässt den Mythos vom bewusst zurückgezogen lebenden Einzelgänger noch fragwürdiger erscheinen. Ausserdem war Dietrich ein fleissiger Briefschreiber; er schrieb über tausend Briefe an Freunde und Bewunderer seiner Werke.

Man weiss, dass er auf dem Motorrad eines Freundes nach München gefahren ist – einer seiner wenigen Ausflüge über Berlingen hinaus – und dass er dort in die Alte Pinakothek pilgerte, um Bilder von Albrecht Dürer zu sehen. Diese Bilder stachelten ihn an, sich technisch zu verbessern. Nach seiner Rückkehr aus München soll er Maler in sein Atelier eingeladen und sie ganz direkt um Rat gefragt haben, wie er seine Arbeitsweise verbessern könne. Durch diese Ratschläge und Anregungen erfuhr seine Innenwelt eine geradezu exponentielle Ausweitung. Obwohl er, rein geographisch gesehen, etwas provinziell war, machten ihn seine Offenheit, seine Neugier, seine gesellschaftlichen Ambitionen und sein eifriges Bemühen um technische Meisterschaft zum puren Gegenteil eines naiv-romantisch-bäuerlichen Aussenseiters. Wenn er eins war, dann technisch versiert, appropriativ, innovativ und damit ein Parallelmoderner (wenn auch auf bodenständigere Art), und dies unterscheidet ihn klar von der grossstädtischen oder zumindest urbanen künstlerischen Kultur. Seine Begeisterung für Tiere, Botanik und Atmosphäre führte zu einer Form der malerischen Darstellung, die durch und durch lebendig war, wenn nicht gar hyperlebendig.

Dietrich entwickelte die Fähigkeit, seine diversen Quellen und Techniken dazu zu benutzen, die Wirklichkeit vollkommen zu synthetisieren. Das ging weit über die malerische Methode der sorgfältigen Beobachtung hinaus und erlaubte es ihm, die strenge Ab-

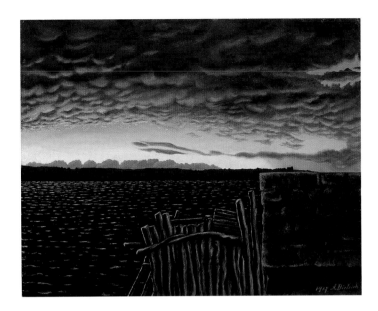

straktion zu vermeiden. Die Radikalität seines Blicks kann daher als Neuinterpretation der darstellerischen Formkomponenten verstanden werden, mit dem Ziel, eine intensivere emotionale und physische Bindung zu Orten und Dingen herzustellen, die Örtlichkeiten und Tiere durch einen Realismus belebt, der sich von innen ausbreitet und wächst und psychologisch über das Sichtbare hinausreicht.

Die Versuche von Roh und Tannenbaum, Dietrich zu verfälschen, um ihn besser vermarkten zu können, führten zwar zu einem kurzfristigen finanziellen Erfolg, hatten jedoch den bleibenden Nachteil, uns den Zugang zu einem der wichtigsten Künstler seiner Generation erheblich zu erschweren und ihn zu marginalisieren. Als «Schweizer Kleinod» bleibt er bis heute eine Art Rätsel. Als Tannenbaum aus Deutschland fliehen musste, endete Dietrichs Beziehung zu diesem ausbeuterischen Händler abrupt, obwohl Tannenbaum auch während des Krieges noch Arbeiten verkaufen konnte und weiterhin seinen sowohl positiven wie negativen Einfluss auf den Künstler ausübte.

MASCHINENKRIEG

Nach dem Ersten Weltkrieg spaltete sich die realistische Malerei in zwei Lager beziehungsweise sammelte sich um zwei unterschiedliche Positionen herum. Da war einmal die Neue Sachlichkeit mit ihrem Pessimismus, ihrer Entfremdung und ihren postexpressionistischen Tendenzen, die sich für eine unbeschönigte Darstellung des Scheiterns der Aufklärung aussprachen. Und dann war da noch die Neue Romantik, die sich von der Industriegesellschaft abwandte und eine Natur zeigen wollte, die durch den an ihr begangenen Verrat des Menschen verwundbar geworden war, eine Natur, die zu entschwinden drohte. Die Idealisierung der Landschaft durch naive und neo-primitive Stile bewegte sich zusehends auf einen konservativen Stil zu, der schliesslich von den Nazis instrumentalisiert und zu Propagandazwecken eingesetzt wurde, wie Dietrichs Vereinnahmung durch die Nazi-Frauenzeitschrift *NS Frauenwarte* vom September 1937 zeigt.

In welchem Verhältnis Dietrichs Bilder zu diesen beiden Konzepten standen, ist unklar, denn er war weder ein polemischer noch ein ideologischer Denker; obwohl er einige der beteiligten Künstler kannte, schrieb er in seinen Briefen, dass er mit ihnen nichts anfangen könne. Statt seine Beobachtungen und Auslegungen dazu einzusetzen, den offensichtlichen politisch-gesellschaftlichen Aufruhr zum Ausdruck zu bringen und sich damit einem der sich anbietenden, herrschenden Diskurse anzuschliessen, verwendete er seine detailgetreue Wiedergabe der Natur

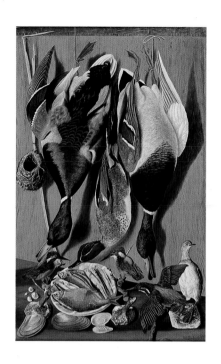

phie), Medien (Touristenbroschüren und Zeitschriften), Beobachtung (Skizzen und Aufzeichnungen) und Technik darum, einen Kontakt zu seinem Publikum herzustellen.

Dietrichs intensive Konzentration auf die Wechselfälle des täglichen Lebens in Berlingen und seine bewusste Autonomie (nicht Abschottung) vermitteln uns ein anderes Bild der Ereignisse und der Entwicklungsgeschichte der modernen Kunst, als wir es gewohnt sind und als Tatsache hinnehmen.

Als Folge des Zweiten Weltkriegs und des Kampfes zwischen den herrschenden ästhetischen Ideen – des Dualismus zwischen Expressionismus und Abstrak-

ADOLF DIETRICH, LARGE STILL LIFE WITH DUCKS, KINGFISHERS, AND FISH, 1925,
oil on cardboard, 32 x 20 ¹/₄" / GROSSES STILLLEBEN MIT ENTEN, EISVÖGELN UND
FISCHEN, Öl auf Karton, 81,5 x 51,5 cm.
(PHOTO: KUNSTMUSEUM THURGAU, ITTINGER MUSEUM)

darauf, den Akt des Sehens derart zu festigen, dass die Begegnung mit seinen Bildern nachhaltige, alles Äusserliche hinter sich lassende, emotionale und seelische Reaktionen auslöste.

Die vergleichsweise Schlichtheit seines offensichtlichen Autodidaktentums war für ihn also wie geschaffen als Alternative zum Didaktizismus eines strategisch überfrachteten, synthetischen Formalismus. Im Rückblick lässt sich Dietrichs Kunst als eine paradoxerweise zugleich in die Weimarer Kunstgeschichte h i n e i n und a u s i h r h e r a u s entstandene verstehen. Obwohl sie in einem ländlichen Umfeld und unter widrigen Umständen geschaffen wurde, stellt Dietrichs Kunst eine gigantische Leistung der modernen Kunst jener Zeit dar und wurde tatsächlich allein auf das Betreiben weniger Leute hin marginalisiert. Sind die Bilder erst einmal aus diesem Kontext falscher Mythen und kommerzieller Machenschaften befreit, wird die Wahrheit über ihre Entstehung und eine untergegangene Tendenz der Moderne in ihnen selbst deutlich. Es geht in ihnen weder um eine Auseinandersetzung mit zukünftigen Stilrichtungen noch um einen taktischen Rückgriff auf frühere Gattungen. Dennoch bemühte sich Dietrich mit einer Mischung aus Wissenschaft (Photogra-

tion – galt die «figürliche Darstellung» entweder als reaktionär oder als Produkt einer verfehlten Propaganda. Doch die Erfahrung, die man beim Betrachten eines Originals von Dietrich macht, widerlegt diese Annahme sogleich und bringt die Grundlagen für eine andere Auslegung der Geschichte ans Licht. Als ich nach Ittingen reiste, um Dietrichs Malerei im Original zu sehen, hatte ich das überwältigende Gefühl, dass ich auf eigene Faust etwas heil machte, was abgeschnürt gewesen war – indem ich eine Erfahrung wieder zum Ganzen fügte, die durch ganz und gar kunstferne Kräfte komplett abgeschnitten worden war.

Die Kunstprofis und ihr Zugang zur Geschichte haben das Werk von Dietrich zu Unrecht vereinnahmt und es geschafft, ordentlich falsch zu liegen. Als ich im Museum in Ittingen angekommen war und vor den Bildern stand, wusste ich, dass alles ganz anders war: Dietrich hatte ausserordentlich richtig gelegen.

(Übersetzung: Suzanne Schmidt)

1) Christoph Vögele, «Landschaft», in Dieter Schwarz (Hg.), *Adolf Dietrich und die Neue Sachlichkeit in Deutschland*, Ausstellungskatalog, Kunstmuseum Winterthur, 1994; Landesmuseum Oldenburg, 1995, S. 69.
2) Ebenda, S. 73.

25 YEARS

PARKETT

THE TRANSATLANTIC CABLE

MARINA WARNER

When Alexander the Great wanted to learn the secrets of the universe, he climbed into a basket, harnessed it to some gryphons, hoisted red meat above their heads—some say it was ox liver (massive!)—and fixed it on spears out of their reach. In this way, as the dragon-birds soared upwards in pursuit of their quarry, the emperor succeeded in having himself lifted high above the earth. When he reached an altitude from which he could survey the world, he realized with some sadness that his vast empire was tiny by comparison with the expanses unfolded beneath him.[1]

The story comes from the Greek Alexander Romance, which appeared not long after the Emperor died in 323 B.C. and became one of the most popular secular books of the Middle Ages, inspiring illustrations in all kinds of media. (His prototype Montgolfier balloon, for example, is depicted in the mosaic floor of the basilica of Otranto made by the monk Pantaleone in 1100 A.D.) The Romance also describes his other quests and adventures: how he traveled to India to talk to the Gymnosophists, holy men who, to contemplate the deepest mysteries, stood on one foot under a banyan tree and lived on air and never cut their hair.[2] Nor did his exploits end with his success at scaling the skies; he had earlier designed a diving bell to take him down to the ocean floor: "I stepped into a glass jar," he writes, "ready to attempt the impossible. As soon as I was inside, the entrance was closed with a lead plug... I got down to a depth of 464 feet... and behold, an enormous fish came and took me and the cage in its mouth

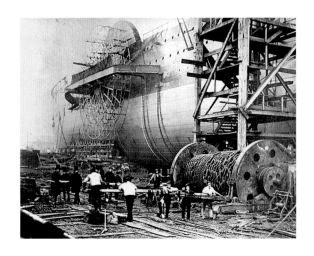

SS Great Eastern before launch, 1858 /
SS Great Eastern vor Stapellauf.

and brought me to land a mile away. There were 360 men on the ships from which I was let down, and the fish dragged them all along. When it reached land, it crushed the cage with its teeth and cast it up on the beach. I was gasping and half-dead with fright."[3] The anonymous author of the Alexander Romance imagined this spectacular, cinematic scene over two thousand years ago.

Sometimes, flying in an airplane in the tropics, it's possible to see the bottom of the ocean: the sun has to be overhead and the water clear, so that light penetrates the surface of the sea rather than slanting across it and bouncing off it. In these circumstances, Alexander in his gryphon-powered flying machine could also have seen vast alpine scenery underwater, deep valleys and steep gulfs forested in deep greens

MARINA WARNER is the author of *Phantasmagoria: Spirit Visions, Metaphors, and Media* (Oxford University Press). She is now writing a book about the impact of the Arabian Nights on modern ideas of magic. She lives in London.

and browns, and tilting away into a breathtaking distance of more mysterious, submerged and lost land masses. At this distance, oil tankers become hairgrips and a sperm whale, a tadpole.

Atlases have for a long time included maps of these submarine ocean worlds, and I find them even more impressive and breathtaking than the corresponding surveys of land—how are they made? How do the cartographers know the peaks and shallows of the intercontinental divide? They no longer add spouting giant sea monsters and mermaids as the old maps used to do, yet it's hard to visualize the world of the ocean without seeing deep sea creatures gliding and coiling there. So many myths and legends have summoned cathedrals of coral, lost continents, drowned cities, Leviathan, the Kraken, Moby Dick. Not to speak of the enchanted population of the sea, Fata Morgana and The Old Man of the Sea, and all those Tritons and Undines, Sirens and Nereids who have been imagined and reimagined by story tellers. But, in the case of the transatlantic cable, it's no wild imagining or legend. It really does still lie on the ocean floor in the Atlantic connecting Europe and America: it is one of those scientific wonders that realized dreams only previously entertained by romancers and mythologists, given to the gods or to heroes like Alexander.[4]

When it first began transmitting messages in the mid-nineteenth century, it led contemporaries to speculate on other means of communicating at a distance: the crisscrossing of the globe by electro-magnetic forces through wires was accompanied by an explosion of hypotheses about the whispers of the dead to the living, thought-transmission between friends in different parts of the world, and other means of disembodied communication and time travel. The telegraph was one of many new telekinetic inventions of the Victorian Age which promised to turn magical thinking into actual possibility.[5] Science wasn't separate from dreams; they were intertwined.

Several artists have entered this field of inquiry where rational enterprise turns fantastic—Susan Hiller, Tony Oursler, Zoe Beloff, and Simon Faithfull, for example, explore in various ways the earliest inventions which tapped into the electro-magnetic field and which have been superseded by the new digital generation of media. Like telegrams and wind-up telephones, the instruments that revolutionized Victorian and Edwardian existence have now become quaint—part of the ruins of civilization. In this sense, that cable under the sea is a modern ruin: it comes up in my mind's eye like a subterranean *Carceri* by Piranesi, or a composition in bones by Frederik Ruysch.

It was brand new, however, when Jules Verne described Captain Nemo in his submarine the Nautilus glimpsing it out of his porthole as he cruised 20,000 leagues under the sea. He was quick off the mark, his book coming out in 1870, four years after the cable was first functioning successfully, and thirteen

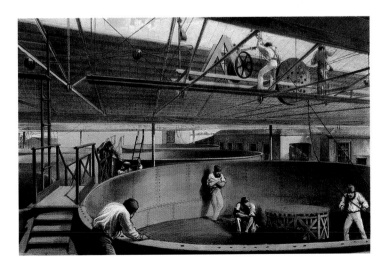

Coiling the cable in large tanks at the works in Greenwich / Aufwickeln des Kabels in grosse Behälter im Werk in Greenwich.

years after the first attempts were made to lay it on the ocean floor by two boats sailing, one from Ireland, and the other from Newfoundland. They were to meet halfway and splice it together.

The sites were chosen because they offered the shortest passage across: in Ireland, Valentia Island, in Foilhommerum Bay, off the coast of County Kerry, provides the westernmost point of Europe; in eastern Canada, the tiny trading post of Heart's Content offered the nearest harbor deep enough to shelter the vessels involved. These were necessarily huge, for the cable itself beggars belief, with a core of multi-ply copper wire, wound with a thick insulating sheath of gutta-percha, followed by tarred hemp, all this then packed into a thick coil of iron until every nautical mile of it weighed more than a ton. And there were over two thousand nautical miles of ocean to cross and consequently to load on board. In addition, there was the winding gear itself, again, by necessity, colossal.

The perseverance the enterprise showed, year after year before the cable began carrying messages, belongs to those stories of frontier heroism, of climbing the highest and bleakest mountains, circumnavigating the globe, walking to the Poles, reaching Mars. The first message, sent in 1858, was seventeen hours in transmission, since a single letter took two minutes. After the cable had been working for two months, an operator threw too much power at it to speed things up and it blew. But the entrepreneur behind the whole endeavor, Cyrus West Field, was tenacious, a new Alexander, all-conquering, insatiable; he took

advice and introduced improvements in the cable design—thicker insulation, more spiraling wires for conductivity, more preservative layers. This cable now grew nearly twice as heavy as the first and the most gigantic seagoing vessel yet built, the SS Great Eastern, was brought in to carry it. It was designed by Isambard Kingdom Brunel, pre-eminent engineer and greatest ironmaster of the Victorian Age.

But there were to be yet more mishaps: on one expedition the crew had paid out one thousand miles of their precious cargo when it snapped again and the end vanished off the stern of the boat into the bottom of the ocean two and a half miles down.

Finally, in 1865, Field rustled up more backers and the Great Eastern set out again, and this time, succeeded. Field then organized a rescue operation on the high seas for the cable that was lost, and against everyone's expectations—looking for a string in an ocean two miles deep—it was located in all that waste of water, grappled to the surface, mended, and laid beside the other one. The twin lines then worked for over a hundred years.

When I was a child and our family made a call at Christmas to my Italian aunt, who had emigrated to Chicago, the line between Cambridge, England, and Chicago gurgled and echoed and we felt we were in Captain Nemo's submarine and could see in our mind's eye the cable lying in the dimness on the ocean floor, a modern, metal sea-serpent winding through weeds and barnacles, through whose long rusted coils our messages were now creeping and rustling.

Valentia is a small island—six hundred people live there now, some of them working in the slate quarry where the Irish artist Dorothy Cross staged a performance of her rendition of Giovanni Battista Pergolesi's "Stabat Mater" (1736) in the summer of 2005; I took the ferry across from the mainland with the rest of a huge crowd to see and hear her piece. We stood at the mouth of the cave in torrents of warm rain, as we listened to a baroque orchestra play from inside the cavern. The cataracts spouting from the sky seemed to be pouring down in sympathy with the ecstatic weeping of the Madonna and the responses to her lamentations, performed by singers in hard hats, oilskins, and gum boots, who had just downed tools

from their work on the rock face. They looked like sailors in a running ocean, while all around us the local slate gleamed a lovely satin black.[6] Laid down in strata that flake smoothly, sculpted into seal-like volumes (Brancusi's LE PHOQUE, 1943) by the rain and wind on that exposed limit of Europe, Valentia slate reaches out in fingers and reefs towards the coastline of America which, equally jagged and stony, seems to have been torn apart from it eons ago. Like a broken ancient inscription that has ended up in two different archaeological collections and needs years of delicate diplomacy to be displayed whole again, the cable united the continents that appear to have been cloven apart in huge convulsions of magma in the age of Pangaea.

It wasn't the first time Dorothy Cross had worked on the remote rocks of Valentia Island. Before her STABAT MATER (2005) she was inspired to make a complex series of works by a local amateur zoologist. Maude Delap was one of those enterprising Victorian women who led quiet and dedicated lives: the daughter of a Valentia pastor, she noticed how the sea brought to the island things from the other side of the world—medusae, whales—and she began to collect specimens, to capture, draw, study—and breed them. She was the first person to succeed in raising jellyfish in captivity.

There's a little museum in Knightstown on Valentia in an old school house, the kind of museum that is fast disappearing in an age of Lottery-funded cultural heritage, interactive digital media, high security, and temperature controls.[7] It displays a wonderfully odd assortment of mementos from local history: the fossilized footprints of a giant prehistoric salamander (sister to the gryphon), a plaster statue of the Virgin Mary, a record of the harsh punishments meted out to bad children in the old days, and a huge wasp's nest made from chewed newspaper. No showcases, lots of dust breeding, and handwritten labels (the statue of the Virgin merely says, "Christianity") do not prepare the visitor for the section that gives the history of the Transatlantic Telegraph station on the island. Sections of the giant cable are scattered about along with lovely intricate machines for reception and transmission (a mirror galvanometer). Examples of the first telegrams, seismic records on yellowing paper, are pinned up on the walls, giving news of the death of a king, the outbreak of war, and other terrible events of modern times. As the needle quivered in response to the pulses coming down the wire, that thick iron rope on the ocean bottom produced the most delicate lacework of messages.

The assemblage creates in effect an archive of the kind that attracts Tacita Dean, Mark Dion, or Mike Nelson: the telegraph materialized the human voice in vibrations along its metal length and turned it into artifact, while the memory of momentous historical change has been preserved haphazardly, but all the more resonantly and richly for that. In the Valentia museum modernity meets antiquarian desuetude, as discoveries that are central to contemporary conditions of reality come packed in poor, trashy stuff. A thimble on display is described as the final piece that connected the two ends of the rope—could anything be more unlikely, more enigmatic?

The Transatlantic Cable was closed down at both ends by Western Union in 1966; through its cold, dark, vast length at the bottom of the Atlantic, America had spoken to Europe, and Europe to America, for more than a century. Satellites began to rocket up into orbit in the stratosphere where, winking and blinking like new planets, they took over the conversation. Soon the airwaves were seething with new ways, more ethereal than before, of talking transatlantically.

1) *The Grek Alexander Romance*, trans. and ed. Richard Stoneman (London: Penguin, 1991), Book II, # 41, p. 123.
2) Ibid., Book III, # 5–6, pp. 131–3.
3) Ibid., Book II, # 38, p. 119.
4) See Wikipedia article on the Transatlantic telegraph cable. http://en.wikipedia.org/wiki/Transatlantic telegraph cable (accessed on Sept. 30, 2009). The material in the article comes from: *Encyclopedia Britannica*, 11th Edition; two works by Arthur C. Clarke, *Voice across the Sea* (1958), and *How the World Was One* (1992); John Steele Gordon, *A Thread Across the Ocean: The Heroic Story of the Transatlantic Cable* (2002); Helen Rozwadowski, *Fathoming the Ocean* (2005), and Tom Standage, *The Victorian Internet* (1998).
5) Roger Luckhurst, *The Invention of Telepathy 1870–1901* (New York: Oxford University Press, 2002), pp. 141–6; and my own *Phantasmagoria: Spirit Visions, Metaphors, and Media* (New York: Oxford University Press, 2006).
6) *Dorothy Cross* (Dublin: Irish Museum of Modern Art, 2005; Milan: Charta Art Books, 2005), pp. 4–64.
7) Valentia Heritage Centre website. http://vhc.cablehistory.org/index.htm

DAS TRANSATLANTISCHE KABEL

MARINA WARNER

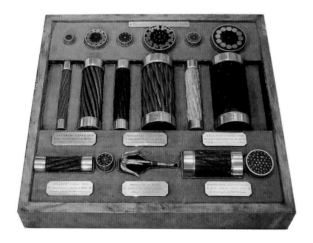

Transatlantic telegraph cables of 1858, 1865, and 1866 /
Transatlantische Telegraphenkabel.

Als Alexander der Grosse die Geheimnisse des Universums erforschen wollte, kletterte er in einen Korb, spannte einige Greifen davor, hob rotes Fleisch – nach Meinung mancher Ochsenleber (enorm!) – über ihren Köpfen empor und befestigte es für sie unerreichbar an Speeren; auf diese Weise gelang es dem Herrscher, da die Drachenvögel sich ihrer Beute nachjagend in die Lüfte schwangen, sich hoch über die Erde tragen zu lassen. Als er eine Höhe erreicht hatte, von der aus er die Welt überblicken konnte,

stellte er mit gewisser Betrübnis fest, dass sein riesiges Reich im Vergleich mit den unter ihm ausgebreiteten Weiten winzig war.[1]

Die Geschichte entstammt dem griechischen Alexanderroman, der, bereits kurz nach dem Tod des Kaisers im Jahr 323 v. Chr. erschienen, zu einem der populärsten weltlichen Erzählstoffe des Mittelalters wurde und die Inspiration zu Illustrationen in allen möglichen Techniken lieferte. Ein ähnlicher Heissluftballon ist zum Beispiel im Mosaikfussboden der Basilika von Otranto, einem 1100 n. Chr. entstandenen Werk des Mönchs Pantaleone, wiedergegeben. Der Roman beschreibt auch seine übrigen dem Erkenntnisgewinn dienenden Reisen und Abenteuer: die Begegnung in Indien mit den Gymnosophisten, heiligen Männern, die, um über die tiefsten Geheimnisse zu meditieren, auf einem Bein unter einem Banyan-Baum standen, von der Luft lebten und nie ihre Haare schnitten.[2] Aber seine bemerkenswerten Taten waren zahlreich. Zuvor hatte er eine Tauchglocke entworfen, die ihn zum Meeresgrund bringen sollte: «Ich stieg in das Glasbehältnis», so Alexander, «bereit, das Unmögliche zu versuchen. Sobald ich drinnen war, wurde die Einstiegsöffnung mit einem Bleistöpsel verschlossen ... Ich sank auf eine Tiefe von 464 Fuss hinab ... und siehe, ein riesiger Fisch kam, nahm mich samt Käfig ins Maul und führte mich eine Meile weit zu Land. Auf den Schiffen, von denen man mich ins Wasser herabgelassen hatte, befanden sich 360 Männer, und der Fisch zog sie alle mit. Als er Land erreichte, zerdrückte er mit den Zähnen den Käfig und schleuderte ihn aufs Gestade. Ich rang nach Luft und war halbtot vor Angst.»[3] Der anonyme Autor des Alexanderromans malte sich diese geradezu kinogleiche Szene vor mehr als zweitausend Jahren aus.

MARINA WARNER ist Autorin von *Phantasmagoria: Spirit Visions, Metaphors, and Media*, Oxford University Press. Sie arbeitet an einem Buch über den Einfluss der Märchen aus 1001 Nacht auf moderne Vorstellungen von Zauberei. Sie lebt in London.

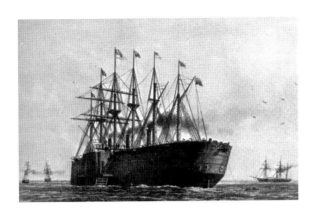

SS Great Eastern, 1863.

Manchmal wenn man in den Tropen im Flugzeug unterwegs ist, sieht man unter sich den Meeresboden: Die Sonne muss über einem stehen und das Wasser klar sein, das Licht tritt dann senkrecht durch die Wasseroberfläche, statt schräg darauf abzuprallen. Unter diesen Umständen könnte auch Alexander in seiner durch Greifenkraft angetriebenen Flugmaschine unter Wasser ausgedehnte Gebirgslandschaften gesehen haben, Täler und steile Klüfte, tiefgrün und dunkelbraun bewaldet und abfallend in eine atemberaubende Tiefe gar noch geheimnisvollerer versunkener und untergegangener Landmassen. Aus dieser Entfernung werden Öltanker zu Haarspangen und Pottwale zu Kaulquappen.

In Atlanten wurden seit Langem Karten dieser unterseeischen Meereswelten aufgenommen; ich finde sie sogar noch beeindruckender und atemberaubender als die entsprechenden Landvermessungen. Wie macht man sie? Woher kennen die Kartographen die Gipfel und Untiefen des Mittelatlantischen Rückens? Sie fügen zwar inzwischen keine riesigen, Wasser speienden Seeungeheuer und Meerjungfrauen mehr hinzu, wie dies bei den alten Karten die Regel war;

aber es ist dennoch schwer, sich die unterseeische Welt ohne darin herumgleitende und sich windende Tiefseekreaturen vorzustellen. So viele Mythen und Sagen haben ganze Kathedralen aus Koralle, untergegangene Kontinente, versunkene Städte, den Leviathan, den Kraken und Moby Dick beschworen. Ganz zu schweigen von den Zauberwesen, die die Meere bevölkern: die Fata Morgana und der Alte vom Meer, sowie die Scharen von Tritonen, Undinen, Sirenen und Nereiden, die von Geschichtenerzählern immer wieder neu imaginiert worden sind. Im Fall des transatlantischen Kabels jedoch haben wir es nicht mit wilder Phantasterei oder Legendenbildung zu tun. Es liegt tatsächlich nach wie vor auf dem Grund des Atlantiks und verbindet Europa und Amerika: Es ist eines dieser Wunder der Wissenschaft, das Träume verwirklichte, denen zuvor nur Romandichter und Mythologen nachgehangen waren, die derlei Wunderwerke den Göttern oder Heroen wie Alexander zudichteten.[4]

Als das Kabel Mitte des 19. Jahrhunderts zum ersten Mal Nachrichten zu übermitteln begann, veranlasste dies Zeitgenossen, über andere Formen und Mittel der Fernkommunikation zu spekulieren:

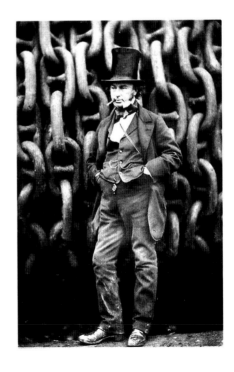

Isambard Kingdom Brunel against the launching chains of the SS Great Eastern, Millwall, 1857 / Isambard Kingdom Brunel vor der Stapellaufkette der SS Great Eastern.
(PHOTO: ROBERT HOWLETT)

TAT-1 (Transatlantic No. 1),
the first transatlantic
telephone cable, 1956 /
Das erste transatlantische
Telephonkabel.

Die Verbindung kreuz und quer über die Erdkugel mittels elektromagnetischer Kräfte ging einher mit einer Flut von Hypothesen über das Geflüster, mit dem die Toten sich an die Lebenden wandten, über Gedankenübertragung zwischen Freunden in verschiedenen Teilen der Erde, Zeitreisen, sowie über andere Mittel der vom Körper unabhängigen Kommunikation. Der Telegraph war eine von zahlreichen neuen telekinetischen Erfindungen des Viktorianischen Zeitalters, die magisches Denken in konkret Mögliches zu verwandeln versprachen.[5] Zwischen Wissenschaft und Traum verlief keine klare Trennlinie, beide waren miteinander verflochten.

Verschiedene Künstler haben sich diesem Untersuchungsfeld, wo rationale Unternehmungen eine Wendung ins Phantastische nahmen, zugewandt: Susan Hiller, Tony Oursler, Zoe Beloff und Simon Faithfull, zum Beispiel, setzen sich auf jeweils unterschiedliche Weise mit den frühesten Erfindungen auseinander, die sich das elektromagnetische Feld nutzbar machten und die mittlerweile durch neue, digitale Medien verdrängt worden sind. Wie Telegramme und Kurbeltelefone sind die Instrumente, die das Leben im Viktorianischen und Edwardianischen Zeitalter revolutionierten, inzwischen zu altertümlichen Kuriositäten – Trümmern der Zivilisation – geworden. In diesem Sinn ist das unterseeische Kabel eine moderne Ruine: Vor meinem geistigen Auge erscheint es wie einer der unterirdischen Carceri von Piranesi oder wie ein Knochenarrangement von Frederik Ruysch.

Es war nagelneu, als Jules Verne schilderte, wie Kapitän Nemo in seinem Unterseeboot, der Nautilus, 20 000 Meilen unter dem Meer unterwegs war und durch das Bullauge seines Fahrzeugs das Kabel erblickte. Verne hatte schnell reagiert, denn sein Buch erschien 1870, vier Jahre nachdem das Kabel erstmals erfolgreich funktionierte und dreizehn Jahre nach den ersten Versuchen, das Kabel auf dem Ozeanboden abzulegen mit Hilfe von zwei Schiffen, die von Irland beziehungsweise Neufundland in See stachen, um sich in der Mitte zu treffen und die beiden Teile des Kabels zusammenzuspleissen.

Die Wahl der Orte hatte sich danach gerichtet, von wo aus die Überfahrt am kürzesten war. In Irland ist Valentia Island in der Foilhommerum Bay, vor der Küste der Grafschaft Kerry, der westlichste Punkt Europas, während sich im östlichen Kanada mit dem winzigen Handelsposten Heart's Content der nächstgelegene Hafen anbot, der tief genug war, um als Anlegestelle für die beteiligten Schiffe zu dienen. Letztere waren zwangsläufig riesig, denn das Kabel selbst spottete jeder Vorstellung mit einem Kabelkern aus mehreren Kupferdrahtsträngen, einer dicken Isolierummantelung aus Guttapercha, gefolgt von geteertem Hanf und das Ganze schliesslich eingepackt in einen dicken äusseren Kabelmantel aus Eisen, bis jedes Stück von der Länge einer Seemeile mehr als eine Tonne wog. Es galt mehr als zweitausend Seemeilen Kabel zu verlegen und also an Bord zu nehmen. Obendrein gab es noch die Abspulvorrichtung selbst, auch diese zwangsläufig gigantisch.

Die Beharrlichkeit, mit der das Projekt Jahr für Jahr weiter vorangetrieben wurde, bis das Kabel schliesslich Nachrichten zu übermitteln begann, ist

eine dieser Geschichten um heldenhafte Pionier- taten wie die Ersteigung der höchsten und ödesten Berge, die Umschiffung der Erde, die Nord- und Südpolerwanderung, die Reise zum Mars. Die Über- tragung der ersten Nachricht im Jahr 1858 dauerte siebzehn Stunden, da für einen einzigen Buchstaben zwei Minuten benötigt wurden. Als das Kabel gerade zwei Monate in Betrieb war, setzte ein Telegraph, um die Übermittlung zu beschleunigen, es einer zu star- ken elektrischen Ladung aus und das Kabel brannte durch. Der Unternehmer Cyrus West Field, der hinter dem ganzen Projekt stand, war jedoch hartnäckig, ein neuer Alexander, eroberungssüchtig, unersättlich. Er liess sich beraten und sorgte für Verbesserungen im Aufbau des Kabels: eine dickere Isolierung, zu- sätzliche spiralgewickelte Drähte zur besseren Leit- fähigkeit, zusätzliche Schutzummantelungen. Dieses neue Kabel war jetzt zweimal so schwer wie das erste, und mit der SS Great Eastern wurde das gigantischste Seeschiff, das bis dahin jemals gebaut worden war, eingesetzt, um das Kabel zu transportieren. Das Schiff war von Isambard Kingdom Brunel entworfen worden, dem herausragenden Ingenieur und gröss- ten Eisenbaumeister des Viktorianischen Zeitalters.

Es sollte jedoch noch weitere Pannen geben. Bei einer Expedition hatte die Besatzung eintausend Mei- len ihrer wertvollen Ladung ablaufen lassen, als das Kabel riss und vom Heck des Schiffes in zweieinhalb Meilen Tiefe auf den Grund des Ozeans verschwand.

Schliesslich trieb Field weitere Gelbgeber auf, und im Jahr 1865 brach die Great Eastern erneut auf, diesmal mit Erfolg. Field organisierte daraufhin eine Bergungsaktion auf hoher See für das verloren gegangene Kabel, und entgegen allen Erwartungen hinsichtlich der Suche nach einer Schnur in einem zwei Meilen tiefen Ozean wurde es in der weiten Wasserwüste ausfindig gemacht, an die Wasserober- fläche geholt, repariert und neben das andere Kabel gelegt. Die beiden Kabel blieben dann mehr als hun- dert Jahre lang in Betrieb.

Als ich ein Kind war und unsere Familie zu Weih- nachten ein Telefonat mit meiner italienischen Tante führte, die nach Chicago ausgewandert war, gluckerte und echote es in der Leitung zwischen Cambridge in England und Chicago, und wir hatten das Gefühl, als befänden wir uns in Kapitän Nemos Unterseeboot und konnten vor unserem inneren Auge das Kabel in der Düsterkeit des Ozeangrundes liegen sehen, eine moderne, metallene Seeschlange zwischen Gräsern und Rankenfüssern durch deren lange, verrostete Windungen nun unsere Nachrich- ten krochen und knisterten.

Valentia Island ist eine kleine Insel. Rund sechs- hundert Leute wohnen jetzt dort, und einige davon

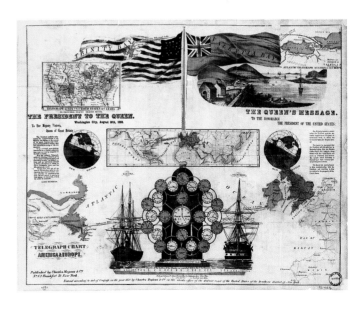

Telegraph Chart, 1858 / Telegraphen-Seekarte.

arbeiten in dem Schiefersteinbruch, wo die irische Künstlerin Dorothy Cross im Sommer 2005 eine Aufführung ihrer Interpretation von Giovanni Battista Pergolesis *Stabat Mater* (1736) inszenierte. Ich setzte zusammen mit dem Rest einer riesigen Menschenschar mit der Fähre vom Festland über, um ihr Stück zu sehen und zu hören. Wir standen am Eingang einer Höhle in strömendem warmem Regen, während wir dem Spiel eines Barockorchesters aus dem Innern der Höhle zuhörten. Die wasserfallartigen Güsse, die vom Himmel niedergingen, korrespondierten, wie es schien, mit dem ekstatischen Weinen der Muttergottes und den Reaktionen auf ihr Wehklagen, dargeboten von Sängern in Schutzhelmen, Öljacken und Gummistiefeln, die soeben die Werkzeuge ihrer Arbeit an der Felswand niedergelegt hatten. Sie sahen aus wie Seeleute in einem strömenden Ozean, während rund um uns herum der örtliche Schiefer sehr schön seidenschwarz schimmerte.[6] Abgelagert in glatt blätternden Schichten, an diesem ungeschützten äussersten Punkt Europas durch Regen und Wind zu Gebilden geformt, die an Seehunde erinnerten (Brancusi's LE PHOQUE, 1943), streckt sich der Valentia-Schiefer in Fingern und Adern der Küste Amerikas entgegen, die, nicht minder zerklüftet und steinig, vor Äonen davon abgerissen worden zu sein scheint. Wie eine geborstene uralte Inschrift, die in zwei verschiedenen archäologischen Sammlungen gelandet ist und jahrelanger

feinfühliger Diplomatie bedarf, um wieder als Ganzes präsentiert werden zu können, verband das Kabel die beiden Kontinente, die allem Anschein nach in der Zeit Pangaeas in gewaltigen magmatischen Erderschütterungen entzweigespalten worden waren.

Es war nicht das erste Mal, dass Dorothy Cross auf den abgelegenen Felsen der Insel Valentia gearbeitet hatte. Vor ihrer STABAT MATER (2005) hatte eine örtliche Zoologin sie zur Schaffung einer komplexen Serie von Arbeiten inspiriert: Maude Delap, die Tochter eines auf Valentia dienenden Pfarrers, war eine dieser unternehmerischen viktorianischen Frauen, die ein ruhiges, hingebungsvolles Leben führten. Sie sah, wie das Meer Dinge vom anderen Ende der Welt zur Insel brachte – Medusen, Wale –, und sie begann, Exemplare zu sammeln, zu fangen, zu untersuchen ... und sie zu züchten. Sie war die erste Person, der es gelang, Quallen in Gefangenschaft heranzuziehen.

In Knightstown auf Valentia gibt es in einem alten Schulgebäude ein kleines Museum, eines von der Art, wie es sie in einer Zeit lotteriefinanzierter Kulturpflege, interaktiver digitaler Medien, hoher Sicherheitsanforderungen und strikter Klimakontrolle bald nicht mehr geben wird.[7] Darin ausgestellt ist eine wunderbar kuriose Auswahl von Zeugnissen der örtlichen Geschichte: die fossilierten Fussabdrücke eines riesigen prähistorischen Molchs (einem nahen Verwandten des Greifen), eine Gipsstatue der Heiligen Jungfrau Maria, ein Dokument mit den harten

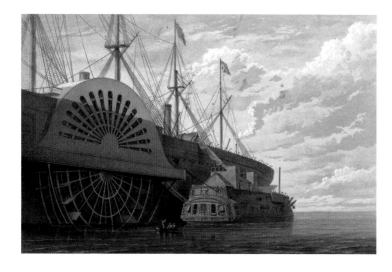

Frigate with freight of cable alongside the SS Great Eastern / Fregatte mit Kabelfracht an der Seite der SS Great Eastern.

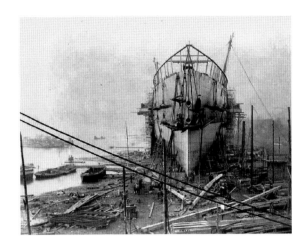

Launch of SS Great Eastern, Isle of Dogs, London, 1858 / Stapellauf der SS Great Eastern.

Strafen, denen unartige Kinder in alten Zeiten ausgesetzt waren, und ein riesiges Wespennest aus zerkautem Zeitungspapier. Keine Vitrinen, aber Staub, der sich überall ansetzt, und von Hand geschriebene Schildchen (jenes zur Statue der Heiligen Jungfrau besagt lediglich «Christentum») lassen den Besucher völlig unvorbereitet auf den Teil treffen, der der Geschichte der Translatlantischen Telegraphenstation auf der Insel gewidmet ist. Dort gibt es einzelne Teile des riesigen Kabels und entzückende Empfangs- und Übertragungsgeräte (einen Spiegelgalvanometer). An den Wänden hängen Beispiele der ersten Telegramme, seismische Aufzeichnungen auf vergilbtem Papier, die vom Tod eines Königs, vom Ausbruch eines Krieges und anderen furchtbaren Ereignissen der modernen Zeit Kunde tun. Mit dem Zittern der Nadel als Reaktion auf die durch den Draht kommenden Impulse erzeugte jenes dicke Seil auf dem Ozeangrund ein allerfeinstes Filigran aus Nachrichten.

Die Sammlung ist tatsächlich ein Archiv von der Art, wie sie Tacita Dean, Mark Dion oder Mike Nelson reizt. Der Telegraph gab der menschlichen Stimme eine materielle Form in Gestalt von Schwingungen, die sich durch seine metallene Länge fortpflanzten, machte aus ihr ein Artefakt, während die Erinnerung an einen historischen Wandel von grosser Tragweite planlos, dafür aber um so beziehungsreicher aufbewahrt worden ist. Im Museum in Valentia trifft die moderne Zeit auf das antiquarisch Ausrangierte, da Entdeckungen, die einmal grundlegend für heutige

Bedingungen der Wirklichkeit waren, in billigem, minderwertigem Zeug verpackt daherkommen. Eine ausgestellte Kausche wird als das letzte Stück bezeichnet, das die beiden Enden des Kabels miteinander verband: Was könnte unwahrscheinlicher, was rätselhafter sein?

Das Transatlantische Kabel wurde 1966 von der Western Union an beiden Enden stillgelegt. Durch seine kalte, dunkle Länge auf dem Grund des Atlantiks hatte mehr als ein Jahrhundert lang Amerika mit Europa und Europa mit Amerika gesprochen. Die ersten Satelliten wurden in eine Erdumlaufbahn in der Stratosphäre geschossen, wo sie, zwinkernd und blinkend wie neue Planeten, das Gespräch übernahmen. Bald brodelte der Äther von Neuem, durch noch ätherischere Mittel des mündlichen transatlantischen Austauschs.

(Übersetzung: Bram Opstelten)

1) *The Greek Alexander Romance*, hg. und übers. v. Richard Stoneman, Penguin, London 1991, Buch II, § 41, S. 123 (vgl. für eine deutschsprachige Ausgabe: Friedrich Pfister, *Der Alexanderroman mit einer Auswahl aus den verwandten Texten*, Beiträge zur klassischen Philologie, Bd. 92. Anton Hain, Meisenheim am Glan 1978).
2) Ebenda, Buch III, § 5–6, S. 131–133.
3) Ebenda, Buch II, § 38, S. 119.
4) Siehe den englischen Wikipedia-Eintrag über das «Transatlantic telegraph cable»: http://en.wikipedia.org/wiki/Transatlantic_telegraph_cable (Zugriff am 30. September 2009). Dieser Beitrag stützt sich auf Informationen aus folgenden Quellen: *Encyclopedia Britannica*, 11. Aufl., den beiden von Arthur C. Clarke verfassten Bänden *Voice across the Sea* (1958) und *How the World Was One* (1992), John Steele Gordon, *A Thread Across the Ocean: The Heroic Story of the Transatlantic Cable* (2002), Helen Rozwadowski, *Fathoming the Ocean* (2005), sowie Tom Standage, *The Victorian Internet* (1998).
5) Roger Luckhurst, *The Invention of Telepathy 1870–1901*, Oxford University Press, Oxford 2002, S. 141–146; sowie die Autorin, *Phantasmagoria: Spirit Visions, Metaphors, and Media*, Oxford University Press, Oxford 2006.
6) *Dorothy Cross*, Irish Museum of Modern Art, Dublin 2005, Charta Art Books, Mailand, S. 4–64.
7) Website der Valentia Heritage Society: www.geocities.com/valentia_heritage/

KATHARINA
FRITSCH

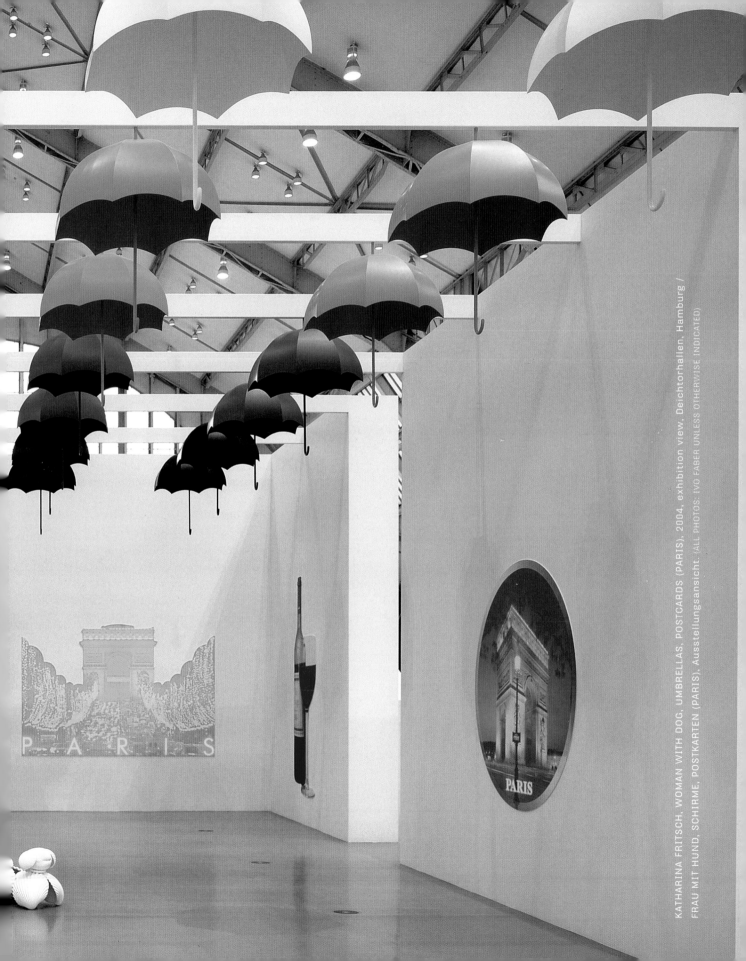

From Out There to Down Here

JESSICA MORGAN

KATHARINA FRITSCH, DISPLAY STAND II,
2001, glass, aluminum, and objects dating
from 1981 – 2001, detail / WARENGESTELL II,
Glas, Aluminium, Objekte, Detail.

Much has been said of the unconscious in the work of Katharina Fritsch. It has been described as "sinister and uncanny"[1] and said to deal with "the dark side of the psyche."[2] From her early representations of rats, a monk, and a ghost, to her recent sculptures of a giant, a snake, and an octopus, the ur-myths and fables supposedly summoned by these forms have generally been thought to lead us unwittingly to assess their—and our own—greater psychological depths. Fritsch's technique is to amplify; her manifestly scrupulous attention to detail, scale, color, and surface allows not only for the immediate comprehensibility of form, but provides one with the sensation of enduring a visitation to the site of a formative experience.

JESSICA MORGAN is curator of Contemporary Art at Tate Modern.

Fritsch's works are thus taken to be madeleines, in the Proustian sense, evoking the lost memory and imaginary world of childhood.

While I am familiar with the sources from which many of Fritsch's representations are thought to be derived, I have never been entirely convinced by the psychoanalytic reading of her work. Perhaps I am separated from the work by a generational, or even a national, sort of schism; I do feel quite far removed from any underlying phobias derived from devils, rats, and religious fables. In the urban London of my childhood, the real threats were burglars, muggers, and random street violence. When I look at Fritsch's RATTENKÖNIG (Rat-King, 1991–93), DOKTOR (1999), or HÄNDLER (Dealer, 2001), my overwhelming impression is of the otherworldly and even hallucinogenic effect of her immaculately modeled, matte surfaces. Their extraordinary autonomy from their surroundings strikes me as ultra-contemporary: rather than appearing like refugees from a recreation of a dance macabre or a German medieval fable, their true home seems closer to commercialized popular culture and to the disarming visual ef-

34

KATHARINA FRITSCH, COOK, 2008, polyester, color, 79 $^1/_2$ x 30 x 40 $^1/_8$"; PHOTOGRAPH 6 (BLACK FOREST HOUSE), 2006/2008, silkscreen, plastic, paint, 110 $^1/_4$ x 147 $^3/_4$", detail / KOCH, Polyester, Farbe, 202 x 76 x 102 cm; 6. FOTO (SCHWARZWALDHAUS), Siebdruck, Kunststoff, Farbe, 280 x 375 cm, Detail.

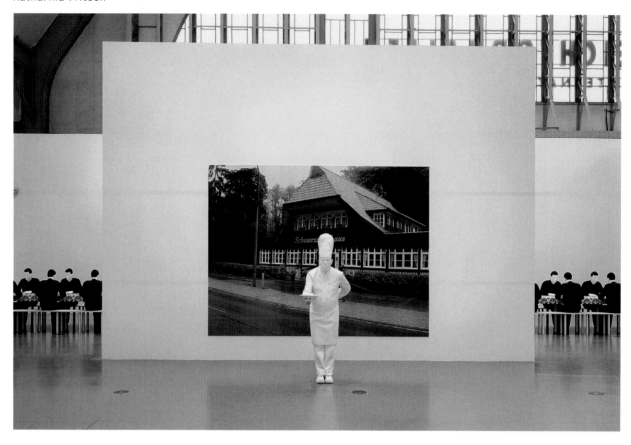

KATHARINA FRITSCH, COOK, 2008; PHOTOGRAPH 6 (BLACK FOREST HOUSE), 2006/2008; COMPANY AT TABLE, 1988, exhibition view, Deichtorhallen, Hamburg / KOCH, 6. FOTO (SCHWARZWALDHAUS), TISCHGESELLSCHAFT, Ausstellungsansicht.

fects of film. Indeed, the manner in which Fritsch's work resists contextualization in the gallery further suggests some form of digitized projection. This disarming quality is also a result of their resolutely non-reflective surfaces that disallow for any absorption of the surroundings, as well as their pristine finish that sets them apart from the viewer and from any non-Fritsch artworks unfortunate enough to be in their proximity. And yet, the unnerving, apparitional quality of Fritsch's work is distinctly its obdurate existence in space; our relationship to it, unlike cinema's immersion, remains one of impenetrability. These presences do not come across as simulacra crafted in a Hollywood prop shop, but as unmistakably unique sculptural objects that evidently refuse to fit into their surroundings.

Initially, Fritsch achieved this kind of isolation of form (or image) by placing toy-like objects and multiples on display stands (WARENGESTELL, Display Stand, 1979–84). These glass-shelved structures invited a comparison to the world of merchandize display, but to my eye, they even more closely resembled the sort of display cases often found in domestic environments—those used by a family to protect and exhibit its most treasured objects—be they tchotchkes or semi-precious objet d'arts. This is confirmed by Fritsch's selection of the artifacts, which suggest the vagaries and eclecticism of a "personalized" collection—including a group of toy sheep, a mirror, and a bead necklace, as well as a most perplexing translucent, large green gemstone that sits mysteriously high up on the top shelf. Only the stands that

contain mass-produced versions of the same object (WARENGESTELL MIT MADONNEN, Display Stand with Madonnas, 1987/1989, or WARENGESTELL MIT GEHIRNEN, Display Stand with Brains, 1989) evoke a more typical consumer display aesthetic; in this case, the objects obscure the stand that lies beneath them. In fact, it is truly the outline of the packed stand (a tower of Pisa that doesn't lean, and an hourglass form) that dominates our impression, rather than any of the individual items contained within in it. Fritsch eventually chose to substitute the vitrine for a more traditional pedestal, but one all the while elevated to monumental proportions to accommodate its over-sized sculptural occupant. ELEFANT (1987), indeed, took tremendous bravura. It was an almost inconceivably grandiose gesture for an artist in her first solo show in Germany, and it quickly established Fritsch's mastery of a form of alienation and of alien forms. The elephant, with its physical attributes—already associated with museology, albeit that of the Museum of Natural History—had long been established as one of the greatest spectacles of the natural world. Fritsch then added to this trope an arresting, dull-green surface. It was a disarming feat, which she took to even greater lengths with her fluorescent-yellow MADONNENFIGUR (Madonna Figure, 1987). The figure stood without a pedestal famously positioned in a Münster public plaza between a department store and the neighboring church. With this work and others like it, Fritsch achieved an otherworldly remove at odds with the dominant interpretation of her work as a projection of our subconscious fears and desires. While dreams and nightmares are characterized by a distortion of reality, Fritsch's figures are outlandish beings separated from contextual grounding.

On the topic of her sculptural work, Fritsch has remarked on her need to "abide by all the various laws of sculpture," despite her desire to ignore such laws and produce instead what she calls "three-dimensional pictures."[3] But what is meant by three-dimensional pictures? Does this term connote a perfectly constructed, immaculate image existing purely within the mind, rather than in our ever-deficient reality? And what precisely is the difference between a flat image and a sculpture in the round? Is it strictly a matter of detail? Fritsch has spoken of her ability to think in pictures, to be versed in a kind of personal interior sign language. This notion of language suggests why her work may be difficult to penetrate for anyone who does not have the linguistic tools to make sense of her system of signs. Nevertheless, this "distancing effect" separates her work from other artists of her generation who have similarly dealt with appropriated objects taken from the everyday. Take, for example, Haim Steinbach, Sherrie Levine, and Robert Gober. Or most notably, Jeff Koons, whose works of the eighties and nineties were often cynically "misunderstood," especially in Europe. In the meantime it has become apparent that Koons' subversive strategy consists more of celebrating popular culture than of criticizing it. Does that put Fritsch in the same camp with Koons?

In my mind, the major difference between the two artists is that Koons makes a deliberate effort at inclusion through the accessibility of his shiny surfaces, overtly sexual subject matter, and reference to toys and popular culture, while Fritsch, conversely,

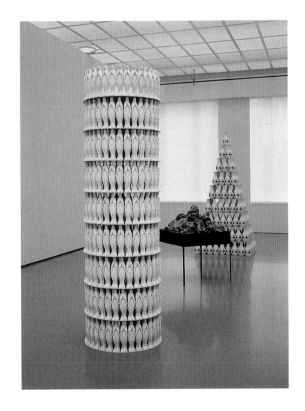

exhibition view, Kunsthaus Zürich / WARENGESTELL MIT MADONNAS, WÜHLTISCH, WARENGESTELL MIT VASEN, Ausstellungsansicht.

detaches her sculptural "pictures" from their origins, making them appear to be frozen in time and out of reach.

With this in mind, it is all the more surprising to see Fritsch's recent work. The sculptures have now been given backgrounds! No longer are we confronted by alien beings dropped from nowhere into our reality. Now there is the suggestion that they have an appropriate home. This impression comes from the monochromatic, large-scale photos (pictures of pictures). For example, in one piece, a nauseating, cake-icing-yellow-colored chef holds an utterly undesirable plate of food in front of what appears to be an equally uninviting restaurant. In RIESE (Giant, 2008), a cement-gray caveman (modeled from a very tall taxi driver from Düsseldorf who stands at 1.95 meters) with an expression of resigned fatalism leans on his Fred Flintstone-like club in front of a dramatic rocky vista. In ST. KATHARINA (2007), a matte black replica of a statue of St. Catherine stands against a wall of lush ivy. While the works retain the sculptural ambiguity derived from their standard Fritschian surfaces and pigmentation, the effect of this new contextualization correlates more to filmmaking. In fact, it was most interesting to read in an essay in the cata-logue for her recent show at Kunsthaus Zurich that Fritsch had had a fruitful and sympathetic conversation with the legendary set designer Ken Adam, who is known for his work on the early James Bond sets (*Dr. No* and *Goldfinger*) and is the person responsible for the otherworldly settings in Stanley Kubrick's *Dr. Strangelove.*[4] What Fritsch's new backgrounds do in combination with the sculptures is not particularly suggestive of the set design genre; however, they are reminiscent of the "blue screen" effects seen in somewhat dated films and television from the sixties and seventies where actors are artificially superimposed onto virtual sets through a trick of the camera/editing room. The photographic images themselves have a suffused light, a scale, and proportions that recall the movie screen. They create an overall effect considerably more driven by narrative than by any single sculptural moment.

KATHARINA FRITSCH, PHOTO (RIVERBANK), 2009, 12-part silkscreen, plastic, paint, 110 $^1/_4$ x 630" / FOTO (FLUSSUFER), 12-teiliger Siebdruck, Kunststoff, Farbe, 280 x 1600 cm.

KATHARINA FRITSCH, BOOTH WITH FOUR
STATUES, 1985/86 / 2001, wood, paint, plaster,
78 ³/₄ x 78 ³/₄ x 110 ¹/₄", detail /
MESSEKOJE MIT VIER FIGUREN, Holz, Farbe,
Gips, 200 x 200 x 280 cm, Detail.

These new works are also extremely funny, though I suspect I am in the minority in finding Fritsch's work humorous rather than strictly serious. I have always found works such as MANN UND MAUS (Man and Mouse, 1991–92) and KIND MIT PUDELN (Child with Poodles, 1995–96) to be amusingly witty, and the recent RIESE (Giant, 2008) and KOCH (Cook, 2008) are even more bitingly sharp in the way that they spoof a certain type of man. It has been noted that Fritsch uses a live model for her sculptures of men while the female forms are derived from preexisting statues, like MADONNENFIGUR, ST. KATHARINA, and GARTENSKULPTUR (TORSO 2005/06). The precision and realism that Fritsch achieves by working from a live model suggests a contemporary, even everyday persona such that even when confronted by the caveman dressed in animal skin we are aware that the subject of her attack was born in the twentieth century. Meanwhile Fritsch's female figures remain sublimely aloof, allowed to rest in the

form of ur-archetypes rather than descending to the level of the here and now. Indeed it seems increasingly the case that Fritsch's particular use of surface treatment—the matte coloring that sets them apart in the gallery—also has a gendered aspect, a subtlety that has progressed in the recent works. While previously male figures such as DOCTOR (1999), DEALER (2001) and MONK (1999) were given appropriate coloring for their somewhat clichéd characters (white, red, and black), the recent male figures are not only less immediately easy to identify as "types" (and thus more subtly penetrating), but are matched with colors that appear to have been chosen for their capacity to further repel. By comparison her female figures are let off fairly lightly: a suitably pretty pink used for the recent WOMAN WITH A DOG (2004) and a fairly predictable black for the nun-like ST. KATHARINA.

It is the discomforting, satirical nature of her male figures that makes them all the more memorable. Seen in combination with Fritsch's other recent two-dimensional productions, which isolate the clichés of domestic imagery (kitsch fridge magnets and postcards from Paris), her work can be seen to have arrived at a new level of contemporary observation. Perhaps Fritsch's work has lost something of its icy remove through the contextualization of two-dimensional images, but what it has gained is a capacity to register more evocatively in our daily lives: to surround us with pictures in both two dimensions and three, all of which are worthy of dissection.

1) Elizabeth A. Smith, "New Forms for Old Symbols" in *Katharina Fritsch* (Chicago: Museum of Contemporary Art, 2001), p. 7.
2) Lynne Cooke, "Parerga" in *Katharina Fritsch* (New York: Dia Center for the Arts, 1994), p. 6.
3) Katharina Fritsch interview with Susanne Bieber in *Katharina Fritsch* (London: Tate Modern, 2002), p. 98.
4) A Conversation with Ken Adam, Cristina Bechtler, Katharina Fritsch, and Hans Ulrich Obrist, moderated by Bice Curiger. Cristina Bechtler (ed.), *Style and Scale, or: Do You Have Anxiety?* (Vienna, New York: Springer-Verlag, 2009).

KATHARINA FRITSCH, GARDEN SCULPTURE 1
(TORSO), 2006, polyester, paint, 78 ³/₄ x 15 ³/₄ x 15 ³/₄";
POSTCARD 1 (ESSEN), 2006, silkscreen, plastic, paint,
110 ¹/₄ x 157", detail / 1. GARTENSKULPTUR (TORSO),
Polyester, Farbe, 200 x 40 x 40 cm; 1. POSTKARTE (ESSEN),
Siebdruck, Kunststoff, Farbe, 280 x 399 cm, Detail.

Von dort draussen hier herab

JESSICA MORGAN

Schlange und eines Tintenfisches wurden die in diesen Formen vermutlich angesprochenen uralten Mythen und Fabeln allgemein so aufgefasst, dass sie uns unwillkürlich dazu führten, deren – und unsere eigenen – psychologische Tiefenschichten zu ergründen. Die Technik Fritschs besteht in einer Verstärkung; ihre erwiesenermassen peinliche Sorgfalt im Umgang mit Details, Massstäblichkeit, Farben und Oberflächen gewährleistet nicht nur die unmittelbare Verständlichkeit ihrer Formen, sondern gibt einem das Gefühl, gleichsam an den Ort einer prägenden Erfahrung versetzt zu werden. Fritschs Werke sind daher als Madeleines im Proust'schen Sinn zu verstehen: Sie beschwören die verlorene Erinnerung und Vorstellungswelt der Kindheit wieder herauf.

Obwohl ich mit den Quellen durchaus vertraut bin, aus denen, wie man allgemein annimmt, viele von Fritschs Darstellungen herrühren sollen, hat mich die psychoanalytische Deutung ihrer Kunst nie wirklich zu überzeugen vermocht. Vielleicht ist es eine generationsbedingte oder sogar eine Art nationale Kluft, die mich von ihrem Werk trennt; unterschwellige Phobien, die mit Teufeln, Ratten und religiösen Legenden zusammenhängen, liegen mir gefühlsmässig ziemlich fern. Im städtischen London meiner Kindheit waren Einbrecher, Strassenräuber und die willkürliche Gewalt der Strasse die wahren Gefahren. Angesichts von Fritschs RATTENKÖNIG (1991–93), DOKTOR (1999) oder HÄNDLER (2001)

Über das Unbewusste im Werk von Katharina Fritsch wurde schon viel geschrieben. Es hiess, es sei «düster und unheimlich»[1] und befasse sich mit «der dunklen Seite der Seele».[2] Von ihren ersten Darstellungen von Ratten, eines Mönchs, eines Gespensts bis zu den neueren Skulpturen eines Riesen, einer

JESSICA MORGAN ist Kuratorin für zeitgenössische Kunst an der Tate Gallery of Modern Art in London.

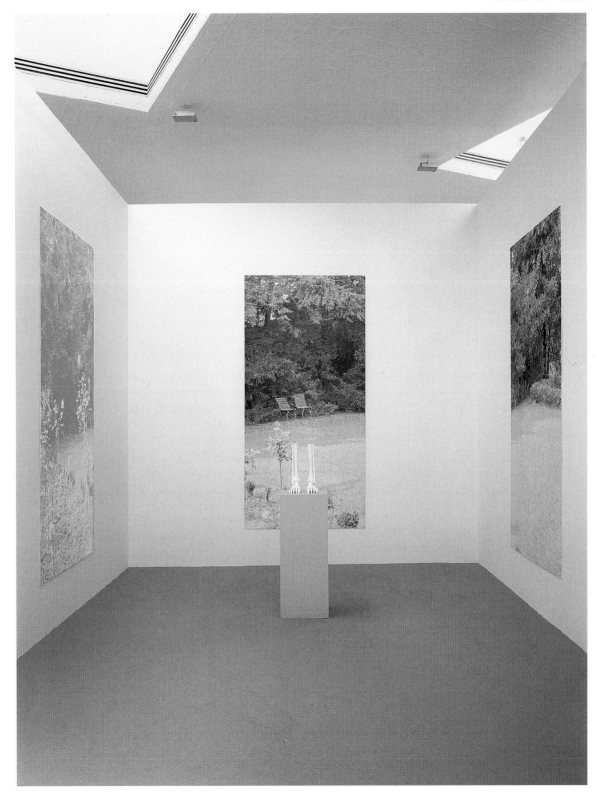

KATHARINA FRITSCH, PHOTOGRAPH 1 (ROSE GARDEN), 1977/2007, silkscreen, plastic, paint, 3 parts, 110 ¼ x 52 ³/₈" each; GARDEN SCULPTURE 3 (SKELETON FEET), 2006, polyester, paint, 55 ¹/₈ x 15 ³/₄ x 15 ³/₄", exhibition view, Matthew Marks Gallery, New York / 1. FOTO (ROSENGARTEN), Siebdruck, Kunststoff, Farbe, 3-teilig, je 280 x 133 cm; 3. GARTENSKULPTUR (SKELETTFÜSSE), Polyester, Farbe, 140 x 40 x 40 cm, Ausstellungsansicht.

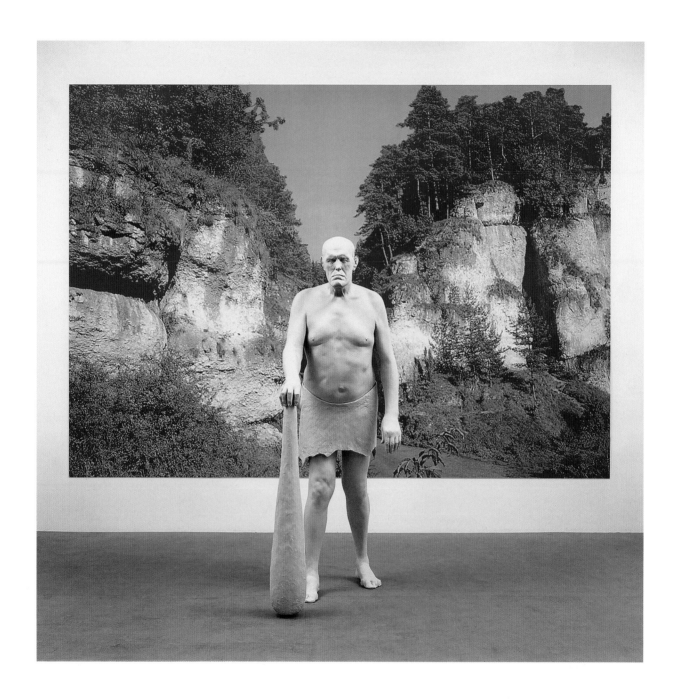

KATHARINA FRITSCH, GIANT, 2008, polyester, paint, 76 ³/₄ x 37 ⁴/₈ x 27 ¹/₂"; POSTCARD 4 (FRANCONIA),
2008, silkscreen, plastic, paint, 110 ¹/₄ x 159 ¹/₂" / RIESE, Polyester, Farbe, 195 x 95 x 70 cm;
4. POSTKARTE (FRANKEN), Siebdruck, Kunststoff, Farbe, 280 x 405 cm.

bin ich zunächst einmal von der überirdischen, ja geradezu halluzinatorischen Wirkung der makellos modellierten, matten Oberflächen überwältigt. Die aussergewöhnliche Autonomie dieser Werke im Verhältnis zur ihrer Umgebung halte ich für ultra-zeitgenössisch: Sie scheinen mir in Wahrheit eher in der verkommerzialisierten Volkskultur und den entwaffnenden Bildeffekten des Films beheimatet, als aus einem wiedererstandenen Totentanz oder einer Fabel des deutschen Mittelalters entsprungen zu sein. So wie Fritschs Werke der kontextuellen Einbettung in den Ausstellungsraum widerstehen, wirken sie sogar beinah wie eine Art digitale Projektion. Diese entwaffnende Qualität geht auch auf die dezidiert nicht spiegelnden Oberflächen zurück, die jede Absorption der Umgebung verunmöglichen, genau wie ihr makelloser Finish sie vom Betrachter und jedem nichtfritschschen Werk abhebt, das das Pech hat, in ihren Dunstkreis zu geraten. Dennoch liegt die verunsichernde, geisterhafte Qualität von Fritschs Arbeiten eindeutig in ihrer unerbittlichen räumlichen Existenz; sie bleiben für uns – anders als ein Film, in den wir eintauchen können – undurchdringlich. Diese Wesen erwecken nicht den Eindruck von Trugbildern aus einer Hollywoodwerkstatt, sondern es handelt sich ganz klar um einzigartige skulpturale Objekte, die sich offensichtlich nicht in ihre Umgebung einfügen wollen.

Es scheint, dass Fritsch diese «Isolation der Form» (oder des Bildes) am Anfang dadurch erreichte, dass sie spielzeugartige Objekte und Multiples auf Gestellen präsentierte (WARENGESTELL, 1979–84). Diese Glasregalgebilde legten zwar den Vergleich mit der Welt der Warenpräsentation nahe, in meinen Augen glichen sie jedoch eher Vitrinen aus dem privaten Bereich – solchen, in denen Familienschätze gehütet und präsentiert werden, egal ob Nippes oder halbwegs kostbare *objets d'art*. Diese Vermutung wird durch Fritschs Wahl der Artefakte bestätigt, die an die Launen und Eklektizismen einer individuell gestalteten Sammlung denken lassen – wie etwa eine Gruppe Spielzeugschäfchen, ein Spiegel, eine Glasperlenkette sowie ein echt verblüffender, lichtdurchlässiger, grosser, grüner Schmuckstein, der sich mysteriöserweise zuoberst auf dem höchsten Regal befindet. Nur jene Gestelle, die mit so vielen Repro-duktionen ein und desselben Objekts gefüllt sind – WARENGESTELL MIT MADONNEN (1987/1989) oder WARENGESTELL MIT GEHIRNEN (1989) –, dass man unweigerlich an Massenproduktion denkt, beschwören die typische Ästhetik der Konsumgüterpräsentation; in diesem Fall bedecken die Objekte das Gestell, das sie trägt. Tatsächlich ist es in erster Linie der Umriss des prallvollen Gestells (ein nicht schiefer Turm von Pisa und eine Sanduhrform), der unseren Eindruck bestimmt, und nicht eines der darin untergebrachten Objekte. Schliesslich hat sich Fritsch dazu entschlossen, die Vitrine durch einen gebräuchlicheren Sockel zu ersetzen, doch auch dieser wurde zu monumentaler Grösse aufgeblasen, um seinem riesigen skulpturalen «Aufsatz» genügend Platz zu bieten: ELEFANT (1987) erforderte wirklich eine gigantische Leistung. Es war eine fast unvorstellbar grandiose Geste für eine Künstlerin, die gerade mal ihre erste Einzelausstellung in Deutschland hatte, und sie etablierte sogleich Fritschs Meisterschaft im Umgang mit einer bestimmten Art von Verfremdung und fremdartigen Formen. Der Elefant – den man bereits mit der Museumswelt verband, wenn auch mit der des Naturhistorischen Museums – galt mit seinen Körpermerkmalen schon seit Langem als eines der spektakulärsten Naturschauspiele. Fritsch versah das vertraute Sujet mit einer atemberaubenden Oberfläche in mattem Dunkelgrün. Es war eine entwaffnende Bravourleistung, die sie im gleichen Jahr noch mit ihrer MADONNENFIGUR in fluoreszierendem Gelb überbot, die in Münster ohne Sockel an prominenter Stelle in der Fussgängerzone zwischen Warenhaus und Kirche stand. In diesen und ähnlichen Werken erreichte Fritsch jene fremdartige Entrücktheit, die nicht mehr mit der gängigen Interpretation ihrer Kunst als Projektion unterbewusster Ängste und Wünsche übereinstimmt. Während Träume und Albträume sich durch eine Verzerrung der Realität auszeichnen, sind Fritschs Figuren seltsam fremde Wesen jenseits jedes begründenden Kontexts.

Im Zusammenhang mit ihrem plastischen Werk hat Fritsch von ihrem Bedürfnis gesprochen, «sämtliche Gesetze der Bildhauerei zu befolgen», trotz ihres Wunsches, solche Gesetze zu ignorieren und stattdessen, wie sie sagt, «dreidimensionale Bilder» zu produzieren.[3] Aber was ist mit dreidimensiona-

len Bildern gemeint? Bezeichnet dieser Ausdruck ein perfekt aufgebautes, makelloses Bild, das nur im Geist existiert, und nicht in unserer immer mit Fehlern behafteten Wirklichkeit? Und was genau ist der Unterschied zwischen einem flachen Bild und einer Rundskulptur? Ist es nur eine Frage von Details? Fritsch hat davon gesprochen, in Bildern denken zu können und über eine Art persönlicher innerer Zeichensprache zu verfügen. Diese Auffassung von Sprache deutet an, warum ihre Kunst für all jene schwer ergründbar bleibt, die nicht über das sprachliche Werkzeug verfügen, um ihr Zeichensystem zu entschlüsseln. Dennoch hebt dieser «Distanzierungseffekt» ihre Werke von denen anderer Künstler ihrer Generation ab, welche sich ebenfalls mit der Appropriation von Alltagsobjekten befasst haben. Etwa Haim Steinbach, Sherrie Levine oder Robert Gober, allen voran aber Jeff Koons, dessen Werke der 80er- und 90er-Jahre insbesondere in Europa oft als zynisch «missverstanden» wurden. Mittlerweile hat sich herauskristallisiert, dass Koons' subversive Strategie eher darin besteht, die Massenkultur zu zelebrieren, als sie zu kritisieren. Ist Fritsch demselben Lager zuzuordnen wie Koons?

Meiner Ansicht nach besteht der wichtigste Unterschied zwischen den beiden Künstlern, darin, dass Koons – mit der Zugänglichkeit seiner glänzenden Oberflächen, seinen offen sexuellen Sujets und seinen Anspielungen auf Spielzeuge und Populärkultur – einen bewussten Integrationsversuch macht, wogegen Fritsch ihrer Herkunft enthobene skulpturale «Bilder» präsentiert, die wie momenthaft erstarrt und unerreichbar entrückt wirken.

Umso überraschender sind vor diesem Hintergrund Fritschs neuere Arbeiten. Jetzt haben die Skulpturen Hintergründe erhalten! Wir stehen nicht mehr Ausserirdischen gegenüber, die es aus dem Nichts in unsere reale Welt verschlagen hat. Jetzt gibt es Hinweise, dass sie eine eigene Heimat haben. Dieser Eindruck entsteht durch die grossformatigen monochromen Photographien (Bilder von Bildern). In KOCH (2008) streckt uns beispielsweise ein Koch in ekligem Tortengussgelb, vor dem Schwarzweissphoto eines nicht sehr einladend wirkenden Gasthauses, einen gefüllten Teller im selben unappetitlichen Gelb entgegen. In RIESE (2008) steht ein zementgrauer Höhlenmensch (der Abguss eines 1 Meter 95 grossen Taxifahrers aus Düsseldorf) mit einem Ausdruck resignierter Schicksalsergebenheit auf seine Fred-Feuerstein-artige Keule gestützt vor der dramatischen Ansicht eines felsigen Geländes. ST. KATHARINA (2007) zeigt die mattschwarze Replik einer Statue der heiligen Katharina vor dem Bild einer üppig mit Efeu überwucherten Mauer. Obwohl die Skulpturen das Doppelbödige der typisch Fritsch'schen Oberflächen und Farbpigmente beibehalten haben, hat diese neue Einbettung in einen Kontext eher filmische Qualität. Tatsächlich war es äusserst interessant, in einem Essay im Katalog zu ihrer jüngsten Ausstellung im Kunsthaus Zürich zu lesen, dass Fritsch ein ergiebiges und von gegenseitigem Verstehen geprägtes Gespräch mit dem legendären Filmset-Designer Ken Adam führte; dieser wurde durch seine Dekorationen und Bauten für die frühen James-Bond-Filme (*Dr. No* und *Goldfinger*) berühmt und zeichnet auch für die fantastisch anmutenden Szenerien in Stanley Kubricks *Dr. Strangelove* verantwortlich.[4] Die Wirkung, die Fritschs neue Hintergründe in Kombination mit den Skulpturen erzeugen, hat eigentlich nichts mit Set-Design zu tun, doch es erinnert von ferne an die «Blue screen»-Effekte etwas älterer Filme oder TV-Produktionen aus den 60er- und 70er-Jahren, in denen die Schauspieler nachträglich in virtuelle Szenerien eingeblendet wurden, was im Wesentlichen ein Kamera- und Montagetrick war. Das Licht in den photographierten Bildern ist gleichmässig verteilt, und in Grösse und Proportionen erinnern sie an die Filmleinwand. Die Gesamtwirkung beruht sehr viel stärker auf dem narrativen Zusammenhang als auf irgendeinem skulpturalen Einzelmoment.

Die neuen Werke sind auch äusserst witzig, obwohl ich mit der Auffassung, dass Fritschs Werk eher humoristisch ist als todernst, vermutlich in der Minderheit bin. Ich habe Arbeiten wie MANN UND MAUS (1991–92) und KIND MIT PUDELN (1995–96) immer witzig-amüsant gefunden, und die neueren Werke RIESE und KOCH sind noch bissiger, durch die Art, wie sie einen bestimmten Männertypus auf die Schippe nehmen. Es wurde darauf hingewiesen, dass Fritsch für ihre Männerskulpturen lebendige Modelle verwendet, während sie die weiblichen Formen

KATHARINA FRITSCH, FRENCH BED,
2009; POSTCARD 6 (IBIZA), 2007;
POSTCARD 9 (IBIZA), 2007, exhibition
view, Deichtorhallen, Hamburg /
FRANZÖSISCHES BETT, 6. POST-
KARTE (IBIZA); 9. POSTKARTE (IBIZA),
Ausstellungsansicht.

von bestehenden Statuen ableitet, etwa die MADON-NENFIGUR, ST. KATHARINA und GARTENSKULPTUR (TORSO 2005/06). Die Präzision und der Realismus, die Fritsch erreicht, indem sie vom lebenden Modell ausgeht, verweist auf einen ganz gewöhnlichen Menschen unserer Zeit, sodass uns, selbst wenn wir vor dem mit einer Tierhaut bekleideten Höhlenmenschen stehen, immer bewusst ist, dass das Ziel ihres Angriffs im zwanzigsten Jahrhundert geboren wurde. Dagegen bleiben Fritschs Frauenfiguren unnahbar erhaben, sie dürfen in den Formen uralter Archetypen ruhen und brauchen nicht auf die Ebene des Hier und Jetzt herabzusteigen. Ja, es scheint sogar zunehmend so, dass Fritschs besondere Oberflächenbehandlung – die matte Farbe, die ihre Skulpturen im Ausstellungsraum abhebt – ebenfalls einen geschlechtsspezifischen Aspekt hat, eine Finesse, die in den neueren Werken stärker zutage tritt. Während frühere männliche Figuren, wie DOKTOR (1999), HÄNDLER (2001) und MÖNCH (1999), eine dem Rollenklischee entsprechende Farbe erhielten (Weiss, Rot, Schwarz), sind die neuen Männerfiguren nicht nur weniger rasch und leicht als «Typen» identifizierbar (und wirken dadurch etwas weniger penetrant), sondern sind mit Farben gepaart, die aufgrund ihres starken Abstossungspotenzials gewählt zu sein scheinen. Im Vergleich dazu kommen ihre Frauenfiguren einigermassen glimpflich davon: ein angemessen hübsches Rosa für die FRAU MIT HUND (2004) und ein ziemlich vorhersehbares Schwarz für die nonnenartige ST. KATHARINA.

Die beunruhigende, satirische Qualität ihrer Männerfiguren macht diese jedoch nur umso unvergesslicher. Betrachtet man sie zusammen mit Fritschs anderen neueren zweidimensionalen Arbeiten, die Klischees aus dem häuslichen Bildvokabular aufgreifen (kitschige Kühlschrankmagnete und Paris-Postkarten), zeigt sich, dass ihre Arbeit eine neue Stufe zeitkritischer Beobachtung erreicht hat. Vielleicht hat Fritschs Werk durch den Kontext der zweidimensionalen Bilder etwas von seiner eisigen Distanziertheit verloren, dafür aber die Macht hinzugewonnen, stärker in unseren Alltag hineinzuwirken: uns mit zwei- und dreidimensionalen Bildern zu umstellen, die es allemal wert sind, analysiert zu werden.

(Übersetzung: Suzanne Schmidt)

1) Elizabeth A. Smith, «New Forms for Old Symbols», in *Katharina Fritsch*, Museum of Contemporary Art, Chicago 2001, S. 7.
2) Lynne Cooke, «Parerga», in *Katharina Fritsch*, Dia Center for the Arts, New York 1994, S. 6.
3) Katharina Fritsch im Interview mit Susanne Bieber, in *Katharina Fritsch*, Tate Modern, London 2002, S. 98.
4) *Style and Scale, or: Do You Have Anxiety?* – A Conversation with Ken Adam, Katharina Fritsch, and Hans Ulrich Obrist, moderiert von Bice Curiger, hg. v. Cristina Bechtler, engl./dt., Springer-Verlag, Berlin/New York 2008.

"THIS DREAM IS ABOUT YOU"

JEAN-PIERRE CRIQUI

"Orpheus, Homer and Hesiod were only able to make the Chimera; God made the octopus."[1] Thus writes Victor Hugo, at the start of Book IV, Part II, of his novel, *Les Travailleurs de la Mer* (Toilers of the Sea, 1866), the last installment of a trilogy on fate which began with *The Hunchback of Notre-Dame* (1831), followed by *Les Misérables* (1862). Attempting to catch a crab that has escaped under a great rock formation not far from the shore, Gilliatt, the protagonist, finds himself suddenly confronted by a huge octopus that seizes him, forcing him to struggle mightily against it. This battle between man and octopus provides Hugo with the pretext for a long exposition—half description, half digression—that probably stands as the most striking text devoted to this kind of animal in all of French literature. "It is disease embodied in monstrosity."[2]

Apparently it wasn't until the mid-nineteenth century that cephalopods began to take on this terrifying role in the popular imagination. In 1861, in a chapter of *The Sea* (1861) titled "The Plunderer of the Sea (octopus, etc.)," Jules Michelet, letting some dark phantom speak, already associates these animals with the realm of "war" and "murder." Through the episode just evoked, the *Toilers of the Sea*, which brought the world *pieuvre*—until then limited to the dialect of the Anglo-Norman islands—into French, established the creature's demonic legend:

Your muscles swell, your fibers writhe, your skin cracks under the foul weight, your blood spurts forth and mingles frightfully with the lymph of the mollusk. The creature superimposes itself upon you by a thousand mouths; the hydra itself incorporates with the man; the man amalgamates himself with the hydra. You form but one. This dream is upon you.[3]

Towards the end of her recent exhibition at the Kunsthaus Zurich (2009), Katharina Fritsch offered onlookers a work in perfect resonance with this Romantic myth of the octo-

JEAN-PIERRE CRIQUI is editor-in-chief of the *Cahiers du Musée national d'art moderne* (Centre Pompidou, Paris). He has just published a monograph study of Wim Delvoye (Idées & Calendes/SuperVision, Neuchâtel).

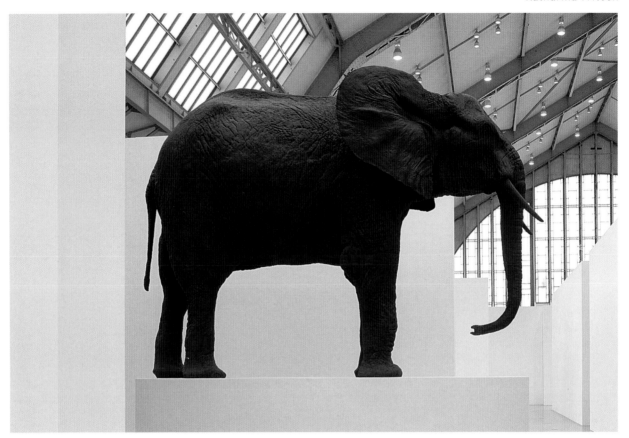

Katharina Fritsch and the Laws of Animal Attraction

pus. I am talking about OKTOPUS (2006/2009). On a slender white platform four feet by four feet, the figure of a bright orange octopus clutches, in one of its tentacles reaching up into the air, a deep-sea diver who is matte black in color, similar to the adjustable-height tripod supporting these elements. This distanced presentation makes the scene akin to a sort of laboratory specimen, an impression even further accentuated by the monochrome, non-mimetic character of the colors assigned to the diver as well as the animal. Living beings usually have a single hue in the sculptural world of Fritsch, who thereby follows what one might call the "Pink Panther principle": that is, her use of color serves an identifying, even symbolic

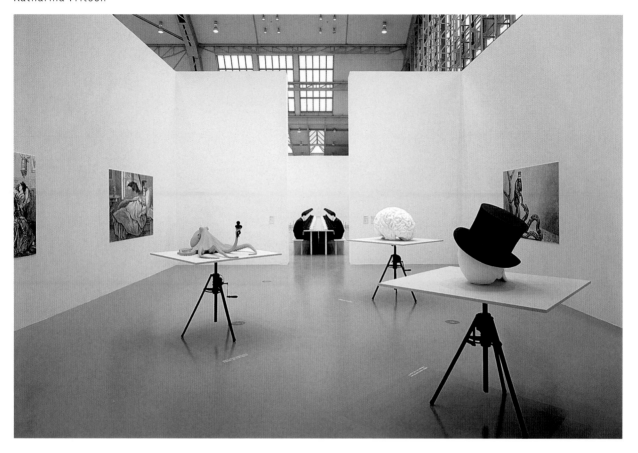

KATHARINA FRITSCH, OCTOPUS, 2006/2009; BRAIN, 1987/2009; SKULL WITH TOP HAT (MODEL), 2006/2008, exhibition view, Deichtorhallen, Hamburg / OKTOPUS, GEHIRN, TOTENKOPF MIT ZYLINDER (MODELL), Ausstellungsansicht.

purpose, without necessarily being related to the actual appearance of the representations.[4] At the core of this universe, animals hold a prominent place, first of all because of the relative frequency of their appearance, and secondly due to the specific task they are assigned. The manner in which the artist portrays them, but also the situations in which she puts them, makes them ambiguous forces at the intersection of multiple currents: primal human fears and superstitions such as those often described in children's stories, totemic thought and its images, Freudian *Unheimlichkeit* and dreamwork. In Zurich, works from the "Zeitungsillustration" (Newspaper Illustration) series, exhibited not far away from OKTOPUS, gave a precise sense of the latter's complex tonality through a system of echoes. These enlargements of essentially "late-nineteenth-century" engravings on plastic panels similarly showed a deep-sea diver carrying the corpse of a shipwrecked woman, a girl devoured by a crocodile, or even— in keeping with a more indirect, though no less crucial relationship between the octopus and its victim—a group of ladies from New York giving themselves over to the effects of opium.

Because they disturb us, Fritsch's animals hold us, attract us, and even sometimes astound us. When we stand before them, we are g r i p p e d , in the same way as the diver of OKTOPUS.

KATHARINA FRITSCH, NEWSPAPER ILLUSTRATION 4
("SCENE FROM THE LONDON ZOO: PULLING AN ALREADY
SWALLOWED BOA FROM THE MOUTH OF A PYTHON"),
2008, silkscreen, plastic, paint, 52 $^3/_4$ x 78 $^3/_4$," /
4. ZEITUNGSILLUSTRATION («SZENE IM SCHLANGEN-
KÄFIG DES ZOOLOGISCHEN GARTENS ZU LONDON:
HERAUSZIEHEN EINER BEREITS VERSCHLUNGENEN BOA
AUS DEM RACHEN EINER PYTHONSCHLANGE»), Sieb-
druck, Kunststoff, Farbe, 134 x 200 cm.

This is because the "silence of animals,"[5] which conveys, for those who pay close attention, a considerable weight of meaning, clearly has something in common with the modes of signification proper to imagery and to art, which themselves cultivate a form of (literal or metaphorical) silence. The poetry of Rainer Maria Rilke, particularly the *Neue Gedichte* (1907), is full of this sort of affinity: one need only read, among many others, the poems entitled "Der Hund," "Die Gazelle," and "Die Flamingos" (*In Spiegelbildern wie von Fragonard … / In Mirror Reflections like those of Fragonard …*) to enter a world where naked life mingles intimately with the image, and where the most infinitesimal element—as in the case of the ancient torso of Apollo to which Rilke devotes himself—returns our gaze (*denn da ist keine Stelle, die dich nicht sieht / For there's no place on it that does not see you.*)[6]

Animal presence is fundamentally polymorphous in the work of Fritsch, in which we have encountered, over the years, cats (KATZEN IM KÖRBCHEN/Cats in Punnet, 1980, derived from a bronze bibelot); toads (UNKEN, Croakers, 1982/1988, a disk inside a green slip-cover provided with a central label of the same color, which presents the listener with the amphibians' croakings during mating); dogs (the bulldog with which Herr Reimers walked about for an entire day in 1986, at the opening of the outdoor sculptural exhibition "Sonsbeek '86," which was documented by the photograph SPAZIERGÄNGER MIT HUND/Stroller with Dog, 1986, and is comparable to FRAU MIT HUND/Woman with Dog, made eighteen years later, in 2004, where the animal has the distinctive feature of being represented, like its mistress, through other animals, namely conches); birds (LEXIKONZEICHNUNGEN VON VÖGELN/Dictionary Drawings of Birds, 2006/2008, and TAPETE MIT DINOSAURIERN/Wallpaper with Dinosaurs, 2007, where they are presented against a background of prehistoric creatures); reptiles (SCHLANGE/Serpent, 2008, a shiny bronze that looks like a long ribbon of licorice); and insects (3. POSTKARTE [KÄFER]/3rd Post Card [Bug], 2009). And we must not forget one of her most imposing works, and no doubt the first to bring the artist international attention, the lifesize ELEFANT (1987), in green polyester, perched atop a tall, white, oval pedestal. But here I shall briefly dwell only on two animal works, which seem to me closely connected.

KATHARINA FRITSCH, POSTCARD 3 (BEETLE), 2009 / 3. POSTKARTE (KÄFER); FLORENTINE FRITSCH and KATHARINA FRITSCH, REFRIGERATOR, 2008 / EISSCHRANK.

FLORENTINE FRITSCH and KATHARINA FRITSCH, REFRIGERATOR MAGNET, 2008 / EISSCHRANKMAGNET.

MANN UND MAUS (Man and Mouse, 1991/1992) immediately strikes us for the maximum efficiency with which the sculpture highlights the contrast between black and white. It is a profoundly dualistic composition that associates its juxtaposition of man and animal with the duality of those two colors, and with the polarities of up/down, vertical/horizontal, waking/sleeping (the mouse, in any case, being portrayed in a position contrary to sleep). It is certainly hard to imagine that the man's situation is somehow a comfortable one, but such a consideration tries, no doubt, too hard to relate it to some sort of reality, which the size of the rodent contradicts outright. The most likely hypothesis is therefore that of the dream, with the mouse belonging to the brain activity of the sleeper, like the bones one often sees in the balloon over a sleeping dog's head in comic books. For this reason, the erudite reference that came to the minds of many observers and commentators of this work was Henry Fuseli's THE NIGHTMARE (1781), a painting exhibited for the first time at the Royal Academy of Arts, London, in 1782, whose success later led the artist to paint several other versions. It should, however, be pointed out that, unlike what is happening in the Fuseli painting (where the scowling incubus, sitting on the sleeping woman and facing the viewer, embodies a satanic combination of human and animal, with the latter also manifest in the form of a goggle-eyed horse's head), no explicit sign of struggle or suffering is presented in Fritsch's sculpture. It is therefore equally legitimate to see it as derived from any number of ancient religions, such as Egyptian, according to which what looms over the sleeper is his soul—or, according to other references, his totemic deity. Pondering this sort of conjunction between interiority and otherness, Georges Bataille, in his *Theory of Religion*, wrote: "The animal opens before me a depth that attracts me and is familiar to me. In a sense, I know this depth: it is my own."[7]

Thus it is a logical step, so to speak, from MANN UND MAUS to RATTENKÖNIG (Rat King, 1993). In the latter, the animal has proliferated, and man has disappeared. He will return not long thereafter, combined with an even larger group of animals, in KIND MIT PUDELN (Child

with Poodles, 1995/1996), a joyously absurd pairing of an asexual child with two-hundred and twenty-four poodles arranged in concentric circles around him, a work that has always made me think of the famous snapshot taken by Harold Edgerton in the 1930s which shows a drop falling into some milk—but that's another story. A kind of terror immediately emanates from RATTENKÖNIG (a direct experience of the sculpture here becomes more necessary than ever). The fear derives from the size of the rats, which each stand nearly 10 feet tall, but also from their being organically joined together, which gives one a foreboding of permanently conflicted movement, painful and utterly hellish. The anxiety is generated by the sense of *teeming* (*grouillement*), which Barthes, in analyzing the work of an artist quite unlike Fritsch, Bernard Réquichot, used to explain this particular zoological anomaly: "Now, it seems that the conglomeration of creatures provokes in us a paroxysm of repugnance: swarming worms, nests of serpents, hives of wasps."[8]

In parallel with this potential chaos, Fritsch's sixteen rats are immobilized for eternity, like sphinxes, and full of mineral majesty; they bring us back to the most archaic sort of religious art. I see them as sly gods of dream and the night—potential catastrophes, which it is up to us to ward off through various offerings and repeated visits to the temple that houses them, though with no guarantee of success. Victor Hugo had evoked a similar phenomenon concerning the evil octopus in the *Toilers of the Sea*, which I will cite to leave our fascination open-ended for now:

Possibility is a terrible matrix. Monsters are mysteries in their concrete form. Portions of shade issue from the mass, and something within detaches itself, rolls, floats, condenses, borrows elements from the ambient darkness, becomes subject to unknown polarizations, assumes a kind of life, furnishes itself with some unimagined form from the obscurity, and with some terrible spirit from the miasma, and wanders ghost-like among living things. It is as if night itself assumed the form of animals.[9]

(Translation: Stephen Sartarelli)

1) Victor Hugo, *The Toilers of the Sea*, trans. Isabel F. Hapgood (New York: Penguin Publishers, Signet Classics, 2000), p. 415.
2) Ibid, p. 417.
3) Ibid, p. 419. Both published three years after *Les Travailleurs de la Mer*, Comte de Lautréamont's *Les Chants de Maldoror* and Jules Verne's *Vingt mille Lieux sous les Mers* (1870) perpetuated this myth in very distinctive registers, though both are obviously indebted to Hugo's novel. Concerning the question of when legend rivals scientific observation, see Roger Caillois, *La Pieuvre. Essai sur la logique de l'imaginaire* (Paris, La Table Ronde, 1973).
4) In this way, the octopus in OKTOPUS is a color more suggestive of a fox. Whether this is coincidental or not, it is worth noting that Greek thought likened these two animals to one another, considering them both to be endowed with great shrewdness. See the excellent book by Marcel Detienne and Jean-Pierre Vernant, *Les Ruses de l'Intelligence. La Mètis des Grecs* (Paris: Flammarion, 1974), particularly chapter II, "Le renard et la poulpe." Marcel Detienne and Jean-Pierre Vernant, *Cunning Intelligence in Greek Culture and Society*, trans. Janet Lloyd (Hassocks, England and New Jersey: Harvester Press: Humanities Press, 1978).
5) A passing tribute to the monumental study by Elisabeth de Fontenay, *Le Silence des Bêtes. La philosophie à l'épreuve de l'animalité* (Paris: Fayard, 1998).
6) A world that is no more and no less than that of the "poem of nature," as invoked by Jean-Christophe Bailly in an essay distinguished by its sensitivity as well as its literary quality, *Le Versant animal* (Paris: Bayard, 2007), p. 118.
7) Georges Bataille, *Theory of Religion*, trans. Robert Hurley (New York: Zone Books, 1989), p. 22.
8) Roland Barthes, *The Responsibility of Forms: Critical Essays on Music, Art, and Representation*, trans. Richard Howard (Berkeley: University of California Press, 1985), p. 211. It is interesting to note that the cases Barthes cites in the continuation of this passage all involve Germany (Altenburg, Bonn, Schnepfenthal, Frankfurt, Erfurt, Lindenau).
9) Victor Hugo, *The Toilers of the Sea*, Volume 2 (Cambridge: Little Brown, 1888), p. 200.

«DIESER ALBDRUCK IST ÜBER EUCH GEKOMMEN.»

JEAN-PIERRE CRIQUI

«Orpheus, Homer und Hesiod haben nur die Chimäre erdenken können; Gott hat den Kraken erschaffen.»[1] So beginnt der 2. Abschnitt des Kapitels «Das Ungeheuer» des 4. Buches vom 2. Teil des Romans *Die Arbeiter des Meeres* von Victor Hugo, nach dem *Glöckner von Notre-Dame* und den *Elenden* der dritte Band seiner Roman-Trilogie über die Schicksalshaftigkeit.[2] Als der Romanheld Gilliatt versucht, nicht weit vom Ufer entfernt eine Krabbe zu fangen, die sich in ein grosses Felsloch geflüchtet hat, findet er sich plötzlich einem riesigen Kraken gegenüber, der sich seiner bemächtigt und gegen den er sich erbittert zur Wehr setzt. Dieser Kampf zwischen Mensch und Krake bietet Victor Hugo die Möglichkeit zu einer ausführlichen Abhandlung – halb Beschreibung, halb Abschweifung –, die von allen Texten der französischen Literatur, die sich mit dieser Tierart befasst haben, zweifellos die erstaunlichste ist: «Schreckliches Wesen, das in Wirklichkeit ein Weichtier ist. Seine Knoten knebeln; seine Berührung ist lähmend. Sein Anblick erinnert an Skorbut und Gangrän. Krankheit hat sich zu Monstrosität zusammengefügt.»[3]

Es scheint, als hätten die Riesentintenfische erst ab Mitte des 19. Jahrhunderts die Rolle des Untiers in der kollektiven Fantasie übernommen. Bereits 1861 hatte Jules Michelet in seinem Buch *La Mer*[4] im Kapitel «Der Freibeuter des Meeres (Krake usw.)», in dem düstere Phantasien zu Wort kommen, dieses Tier mit der «Welt des Krieges und des Mordes» in Zusammenhang gebracht. Durch die erwähnte Episode in Hugos Roman fand das Wort *pieuvre* für Krake, das bis dahin nur in den Dialekten der anglonormannischen Inseln vorkam, Eingang in die französische Sprache und erhielt seine dämonische Konnotation:

Was ist eine Kralle gegen diesen Schröpfkopf. Mit den Krallen dringt das Tier in euer Fleisch ein; beim Saugnapf aber dringt ihr selbst ins Tier ein. Eure Muskeln schwellen an, die Fasern krümmen sich,

JEAN-PIERRE CRIQUI ist Chefredaktor der *Cahiers du Musée national d'art moderne* des Centre Pompidou. Er ist Autor von *Wim Delvoye* (Ides & Calendes/SuperVision, Neuchâtel).

Katharina Fritsch
und die Gesetze
animalischer Anziehung

die Haut platzt unter dem widerlichen Druck, das Blut spritzt auf und mischt sich in abscheulicher Weise mit dem Körpersaft des Mollusken. Das Tier stülpt sich mit tausend gemeinen Mündern über euch; die Hydra verleibt sich dem Menschen ein; der Mensch vermischt sich mit der Hydra. Beide bilden ein einziges Wesen. Dieser Albdruck ist über euch gekommen.[5]

Gegen Ende ihrer Ausstellung im Kunsthaus Zürich (2009) konfrontierte Katharina Fritsch das Publikum mit einem Werk, das eine perfekte Reminiszenz an diesen romantischen Mythos des Kraken[6] ist: OKTOPUS (2006/2009), auf einer dünnen, weissen, quadratischen Platte von 1,20 Metern Seitenlänge liegt ein greller, orangener Oktopus und hält in einem

KATHARINA FRITSCH, MAN AND MOUSE, 1991/1992, polyester, paint, 88 $^5/_8$ x 51 $^1/_8$ x 94 $^1/_2$" / MANN UND MAUS, Polyester, Farbe, 225 x 130 x 240 cm.
(PHOTO: NIC TENWIGGENHORN)

seiner in die Luft ragenden Tentakel einen Taucher gefangen, dessen mattschwarze Farbe derjenigen des höhenverstellbaren Dreifusses ähnelt, auf dem der Oktopus liegt. Die distanzierte Präsentation lässt die Arbeit wie eine Art Musterexemplar in einem Labor erscheinen. Dieser Eindruck wird durch die monochromen, unnatürlichen Farben von Taucher und Tier noch verstärkt. Meistens sind die Geschöpfe im plastischen Universum der Katharina Fritsch einfarbig; damit folgt sie einem Grundsatz, den man das Rosaroter-Panther-Prinzip nennen könnte: Die Farbskala hat Signal-, ja Symbolcharakter, ohne dass sich ein Bezug mit dem tatsächlichen Aussehen des dargestellten Gegenstands aufdrängt.[7] Tiere nehmen in diesem Universum einen bedeutenden Platz ein, einerseits weil sie relativ häufig vorkommen, andererseits wegen ihrer Symbolträchtigkeit. Die Art und Weise, wie Fritsch sie darstellt, aber auch die Situationen, in die sie sie einbettet, verleihen ihnen vieldeutige Kräfte am Kreuzungspunkt verschiedenster Strömungen: seien es die uralten Ängste der Menschheit und ihr Aberglaube, wie sie beispielsweise in Märchen zum Ausdruck kommen, sei es die Eindringlichkeit totemistischen Denkens und seiner Bilder, das Unheimliche oder die Freudsche Traumarbeit. In Zürich machten Arbeiten aus der Serie «Zeitungsillustrationen» (2007/2008), die im gleichen Raum wie der OKTOPUS hingen, dessen vielschichtige Tonalität deutlich, als wären sie ein System von Echos. So zeigten die Vergrösserungen von Illustrationen im Stil der zweiten Hälfte des 19. Jahrhunderts einen Taucher, der den Leichnam einer ertrunkenen Frau trägt, ein junges Mädchen, das von einem Krokodil gefressen wird, oder auch – a priori ohne direkten Bezug zum Kraken oder seinem Opfer, aber nicht minder gravierend – eine Gruppe von Frauen in New York, die sich der Wirkung des Opiums hingeben.

Weil sie uns irgendwie beunruhigen, lassen uns die Tiere der Katharina Fritsch innehalten, ziehen uns an, ja bringen uns zuweilen aus der Fassung. Manchmal geschieht es, dass wir sie ansehen und gepackt werden wie der Taucher vom OKTOPUS. Das liegt zweifellos daran, dass im «Schweigen der Tiere» – für denjenigen, der darauf zu achten weiss – so viel Bedeutungsschwere mitschwingt – ganz ähnlich den Aussageweisen der Bilder und der Kunst, die ihrerseits eine bestimmte Form des Schweigens (im wörtlichen und im metaphorischen Sinne) kultiviert.[8] In Rainer Maria Rilkes Dichtung, insbesondere in den *Neuen Gedichten*, wimmelt es von Spuren einer solchen Affinität; man braucht unter den zahlreichen Gedichten nur «Der Hund», «Die Gazelle» oder «Die Flamingos» («In Spiegelbildern wie von Fragonard …») zu lesen, um einzutauchen in eine Welt, wo das nackte Leben mit dem Abbild aufs Engste verbunden ist und selbst die kleinste Stelle, wie beim archaischen Torso Apollos, zu dem auch Rilke Zuneigung fasst, unseren Blick erwidert: «denn da ist keine Stelle, / die dich nicht sieht».[9]

Die Präsenz des Animalischen ist ganz und gar polymorph im Werk der Katharina Fritsch, wo sich im Laufe der Jahre verschiedene Tiere begegnen: Katzen (KATZEN IM KÖRBCHEN, 1980; nach einer Nippfigur aus Bronze), Amphibien (UNKEN, 1982/88; Single-Schallplatte

in grüner Hülle mit ebenfalls grünem Etikett in der Mitte, das dem Hörer das Quaken der Unken zur Brunftzeit ankündigt), Hunde (die Bulldogge, mit der Herr Reimers im Jahr 1986 am Tag der Eröffnung der Skulpturenausstellung Sonsbeek '86 einen ganzen Tag lang spazieren ging, was auf der Photographie SPAZIERGÄNGER MIT HUND festgehalten wurde, zu dem wiederum die achtzehn Jahre später entstandene Skulptur FRAU MIT HUND (2004) passt, bei der das Besondere ist, dass Hund und Herrin aus anderen Tieren – Muscheln – komponiert wurden. Es folgen Vögel mit urzeitlichen Geschöpfen im Hintergrund (LEXIKONZEICHNUNGEN VON VÖGELN, 2006/07, und TAPETE MIT DINOSAURIER, 2008), Reptilien (SCHLANGE, 2008; ein glänzendes Bronzeobjekt, das wie eine ausgerollte Lakritzschnecke aussieht), Insekten (3. POSTKARTE [KÄFER], 2009), und nicht zu vergessen das imposanteste unter den Säugetieren und zweifellos die erste Arbeit, die Fritsch international bekannt machte, ihr lebensgrosser ELEFANT (1987) aus grünem Polyester, der auf einem hohen, weissen, ovalen Podest thront. Ich möchte mein Augenmerk auf zwei weitere Werke richten, die Tiere in Szene setzen und mir auf das Engste miteinander verbunden zu sein scheinen.

MANN UND MAUS (1991/92) besticht auf Anhieb durch den Schwarz-Weiss-Kontrast der Skulptur: Es ist eine ganz und gar dualistische Komposition, die den Gegensatz von Tier und Mensch mit dem zweier Farben verbindet, aber auch mit den Gegensatzpaaren hoch/tief, waagrecht/senkrecht, wachend/schlafend (zumindest ist die Maus in einer Haltung wiedergegeben, die der eines Schlafenden diametral entgegengesetzt ist). Man kann sich freilich nur schwer vorstellen, dass die Lage des Mannes irgendwie bequem ist, aber das würde bedeuten, dass man sie mit einer realen Situation verbindet, was allein die schiere Grösse des Nagers ausschliesst. Das Nächstliegende scheint also der Traum zu sein, wobei die Maus – wie der Knochen, der in Comics in einer Sprechblase über dem schlafenden Hund zu sehen ist – etwas mit der Hirntätigkeit des Schlafenden zu tun hat. Eine Assoziation, die sich unweigerlich aufdrängt, ist das Gemälde mit dem Titel der NACHTMAHR (1781) von Johann Heinrich Füssli, das 1782 erstmals in der Royal Academy in London gezeigt wurde und dessen Erfolg den Künstler dazu veranlasste, weitere Fassungen zu malen. Doch im Unterschied zu Füsslis Bild (es zeigt einen Alb, ein satanisches Mischwesen, auf einer Frau hockend, das sich mit verzerrtem Gesicht dem Betrachter zuwendet, und im Hintergrund einen glupschäugigen Pferdekopf) findet sich im Werk von Fritsch kein greifbares Zeichen für einen Kampf oder Schmerz. Daher ist es ebenso statthaft, darin eine Abwandlung jener unzähligen antiken religiösen Darstellungen zu sehen, ägyptischen beispielsweise, wo über dem Schlafenden seine Seele thront oder – nach anderer Lesart – sein Totemgott. In seinen Überlegungen über diese Art des Zusammentreffens von Innerlichkeit und Andersheit schrieb Georges Bataille in seiner *Theorie der Religion*: «Durch das Tier öffnet sich vor mir eine Tiefe, die mich anzieht und die mir vertraut ist. In gewissem Sinne ist diese Tiefe mir bekannt: Es ist die meine.»[10]

Es ist nur folgerichtig, nach MANN UND MAUS über den RATTENKÖNIG (1991/92) zu sprechen. Die Tiere haben sich stark vermehrt und der Mensch ist verschwunden. (Er wird später wieder auftauchen, inmitten einer noch viel grösseren Tierschar, nämlich in KIND MIT PUDELN [1995/96], einer vergnüglich-absurden Kombination aus einem geschlechtslosen Kind und 224 Pudeln, die in konzentrischen Kreisen um dieses angeordnet sind, was mich immer an das Photo mit dem in Milch herabfallenden Tropfen von Harold Edgerton aus den 30er-Jahren denken liess, aber das ist eine andere Geschichte.) Der RATTENKÖNIG hat etwas imminent Bedrohliches an sich – hier ist die unmittelbare Konfrontation mit der Skulptur notwendiger denn je. Dieses Gefühl der Bedrohung hat mit der Grösse der Ratten zu tun, die alle knapp drei Meter hoch sind, aber auch mit der unentwirrbaren Verknotung ihrer

Schwänze, die jede Bewegung als unmöglich, schmerzhaft, ja infernalisch erscheinen lässt. Es ist das beklemmende Gefühl, wie es durch ein «Gewimmel» ausgelöst wird, jenes Phänomen, welches Roland Barthes im Zusammenhang mit einem von Fritsch weit entfernten Künstler namens Bernard Réquichot untersuchte, indem er diese besondere Anomalie im Tierreich als Beispiel heranzog: «Nun scheint es, dass das Konglomerat von Tieren in uns den Gipfel des Abscheus auslöst: Ein Gewimmel von Würmern, Verknotungen von Schlangen, Nester von Wespen. Dieses märchenhafte Phänomen fasst den ganzen Horror der Tieragglomerate zusammen: der Rattenkönig.»[11] Parallel zu diesem potenziellen Chaos sind die für immer regungslosen sechzehn Ratten von Fritsch, gleich Sphinxen, von mineralischer Majestät erfüllt und verweisen uns aufs Neue auf die religiöse Kunst in ihrer archaischsten Form. Ich sehe in ihnen heimtückische Götter des Traumes und der Nacht – Mächte der Katastrophe, deren unmittelbares Bevorstehen wir bannen müssten (durch diverse Opfergaben, wiederholte Besuche im laizistischen Tempel, der sie beherbergt), allerdings ohne Garantie auf Erfolg. Im Kontext des unheilvollen Kraken in *Die Arbeiter des Meeres* kam Victor Hugo auf ein ähnliches Phänomen zu sprechen, mit dem wir hier enden möchten, indem unsere Faszination in der Schwebe gehalten wird:

Das Mögliche ist eine furchtbare Matrix. Das Mysterium konkretisiert sich in Monster. Schatten spalten sich aus diesem Block, der Immanenz, ab, zerreissen, lösen sich, rollen, wogen, verdichten sich, entleihen sich die Schwärze der Umgebung, durchwandeln unbekannte Polarisationen, nehmen Leben an, bilden mit der Finsternis wer weiss welche Gestalt und mit dem Miasmus wer weiss welche Seele und dringen als Larven mitten durch die Lebenskraft. Gleichsam tiergewordene Finsternis.[12]

(Übersetzung: Caroline Gutberlet)

1) Victor Hugo, *Die Arbeiter des Meeres*, übers. v. Rainer G. Schmidt, Hamburg, Achilla Press, 2003, S. 407.

2) *Notre-Dame de Paris* erschien 1831, *Les Misérables* 1862, *Les Travailleurs de la Mer* 1866.

3) Siehe Anm. 1, S. 409.

4) Jules Michelet, *Das Meer*, übers. v. Rolf Wintermeyer, Frankfurt/New York 1987; das erwähnte Kapitel beginnt auf Seite 146.

5) Siehe Anm. 1, S. 412.

6) Drei Jahre nach *Die Arbeiter des Meeres* erschienen das Prosagedicht *Les Chants de Maldoror* von Lautréamont (dt. *Die Gesänge des Maldoror*) und der Roman *Vingt mille Lieues sous les Mers* von Jules Verne (dt. *20.000 Meilen unter dem Meer*), die diesen Mythos auf sehr unterschiedliche Weise fortschrieben, wobei ganz offensichtlich Hugos Roman beiden als Inspirationsquelle diente. Zu der Frage, worin die Fiktion mit der wissenschaftlichen Beobachtung konkurriert, vgl. Roger Caillois, *La Pieuvre. Essai sur la logique de l'imaginaire*, Paris 1973 (dt. *Der Krake. Versuch über die Logik des Imaginativen*, übers. v. Brigitte Weidmann, München/Wien 1986).

7) So lässt die Farbe der Krakenfigur Oktopus eher an einen Fuchs denken. Ob nun Zufall oder nicht, in der Vorstellung der alten Griechen gehörten diese Tiere, die beide für äusserst schlau gehalten wurden, zusammen. Siehe das grossartige Buch *Les Ruses de l'Intelligence. La Mètis des Grecs* von Marcel Detienne und Jean-Pierre Vernant (Paris 1974), insbesondere das 2. Kapitel «Der Fuchs und der Krake».

8) Meine Hochachtung für das monumentale Werk von Elisabeth de Fontenay, *Le Silence des Bêtes. La philosophie à l'épreuve de l'animalité*, Paris 1998.

9) Rainer Maria Rilke, «Archaischer Torso Apollos», in *Ausgewählte Gedichte*, Frankfurt a. M., Suhrkamp-Verlag, 1982, S. 58.

10) Georges Bataille, *Theorie der Religion*, übers. v. Andreas Knop, München, Matthes & Seitz, 1997, S. 23 (franz. OA *Théorie de la Religion* [1948], Paris 1973).

11) Roland Barthes, «Réquichot und sein Körper», in *Der entgegenkommende und der stumpfe Sinn. Kritische Essays III*, übers. v. Dieter Hornig, Frankfurt a. M., Suhrkamp-Verlag, 1990, S. 219–246, hier S. 222 f. (franz. OA «Réquichot et son corps [1973]», in *L'Obvie et l'Obtus. Essais critiques III*, Paris 1982). Es ist interessant festzustellen, dass die im Anschluss an die zitierte Stelle genannten Fälle alle in Deutschland zu finden sind (Altenburg, Bonn, Schnepfenthal, Frankfurt, Erfurt, Lindenau bei Leipzig).

12) Siehe Anm. 1, S. 414.

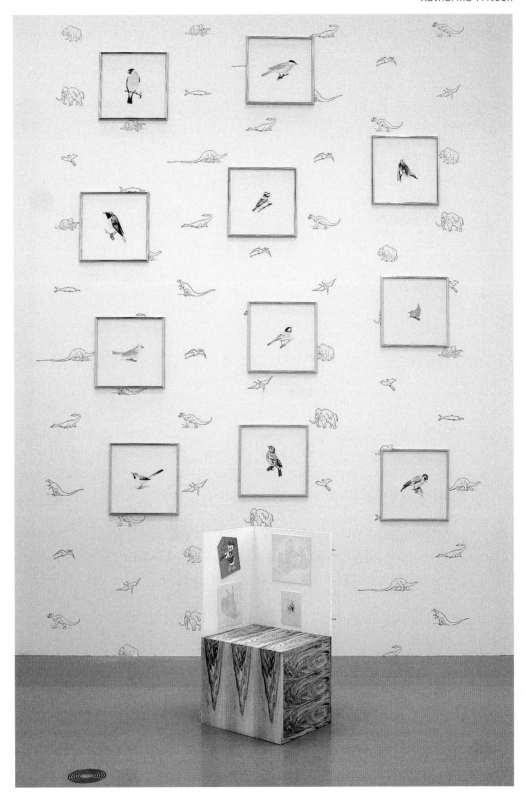

KATHARINA FRITSCH, BEDSIDE TABLE, 2009; WALLPAPER WITH DINOSAURS, 2007; LEXICON DRAWINGS OF BIRDS, 2006/2008, exhibition view, Deichtorhallen, Hamburg / NACHTTISCH, TAPETE MIT DINOSAURIERN, LEXIKONZEICHNUNGEN VON VÖGELN, Ausstellungsansicht.

EDITION FOR PARKETT 87

KATHARINA FRITSCH

APPLE, 2009/10
High speed resin cast, color, hand finished, diameter 5 $^1/_2$".
Edition of 48/XII, signed and numbered certificate.

APFEL, 2009/10
Schnellgiessharz, Farbe, handbearbeitet, Durchmesser 14 cm.
Auflage: 48/XII, signiertes und nummeriertes Zertifikat.

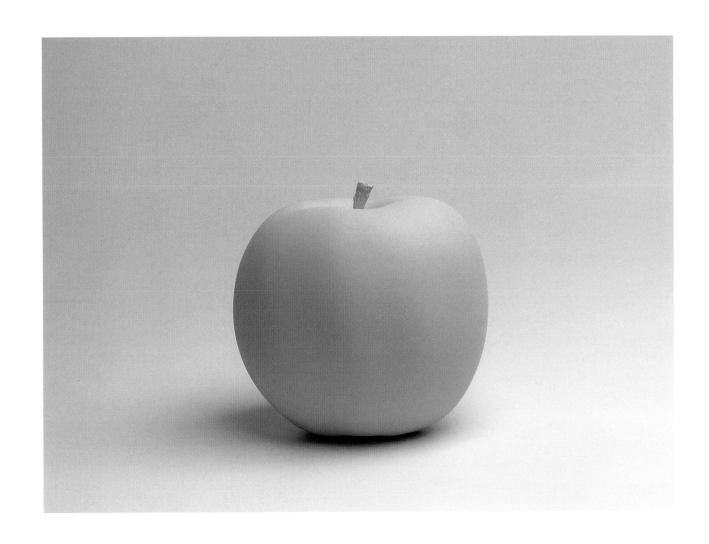

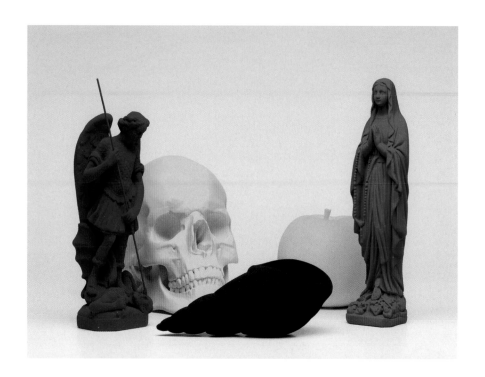

KATHARINA FRITSCH, 2ND STILL LIFE, 2009/2010, 5 hand-finished casts:
scull, madonna, angel (St.Michael), shell, apple; Zellan, high speed resin cast,
color, 16 ¹/₂ x 16 ¹/₂ x 11 ⁷/₈", special 25 years edition for Parkett /
2. STILLEBEN, 2009/2010, 5 handbearbeitete Gussobjekte und -figuren:
Totenkopf, Madonna, Engel (St. Michael), Muschel, Apfel; Zellan,
Schnellgiessharz, Farbe, 42cm x 42 cm x 30 cm, 25 Jahre Parkett Spezial-Edition.

Katharina Fritsch

born 1956 in Essen, lives and works in Düsseldorf.

geboren 1956 in Essen, lebt und arbeitet in Düsseldorf.

Kelley Walker

born 1969 in Columbus, Georgia, lives and works in New York.

geboren 1969 in Columbus, Georgia, lebt und arbeitet in New York.

Cerith Wyn Evans

born 1958 in Llanelli, Wales, lives and works in London.

geboren 1958 in Llanelli, Wales, lebt und arbeitet in London.

Annette Kelm

born 1975 in Stuttgart, lives and works in Berlin.

geboren 1975 in Stuttgart, lebt und arbeitet in Berlin.

Kelley Walker

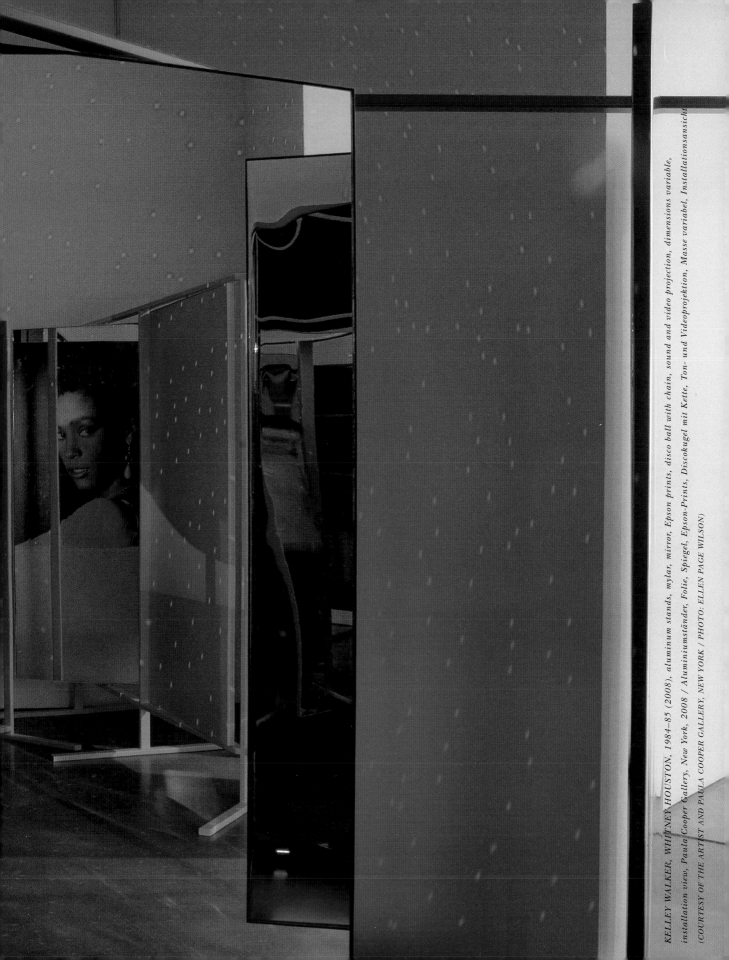

KELLEY WALKER, WHITNEY HOUSTON, 1984–85 (2008), aluminum stands, mylar, mirror, Epson prints, disco ball with chain, sound and video projection, dimensions variable, installation view, Paula Cooper Gallery, New York, 2008 / Aluminiumständer, Folie, Spiegel, Epson-Prints, Discokugel mit Kette, Ton- und Videoprojektion, Masse variabel, Installationsansicht (COURTESY OF THE ARTIST AND PAULA COOPER GALLERY, NEW YORK / PHOTO: ELLEN PAGE WILSON)

Bringing It Back Alive!

*A pioneer should have imagination, should be able to
enjoy the idea of things more than the things themselves.*
—Willa Cather, O Pioneers![1]

JOHANNA BURTON

I.

When I began writing this text, Kelley Walker had nearly finished a group of works shown in November and December, 2009, in Berlin. What he chose to present comprised his first solo exhibition at the recently opened Capitain Petzel, a gallery consolidating the power and resources of two dealers who otherwise head longstanding independent spaces (Gisela Capitain in Cologne; Friedrich Petzel in New York). Capitain Petzel opened its doors in October 2008, taking the opposite tack from most galleries during such a volatile economic moment; indeed, the enterprise's confident appearance amidst the turmoil lent its project some very unique historical contours.

The gallery space's footprint and past are in and of themselves notable enough to mention. Located in Mitte, Capitain Petzel sits on Karl-Marx-Allee, occupying a lightly renovated building originally designed in 1964 by the East German modernists Josef Kaiser and Walter Franek explicitly for the purpose of showcasing fine and applied art produced in the Eastern Bloc. Capitain Petzel makes much of this legacy, having devoted, for instance, its inaugural show (in which Walker participated) to a group meditation on the site: the gallery's stable of artists was, according to a press release, invited to "respond to the architecture, form, history, and surroundings of the pavilion." Naming its first show after the building's original functional designation, "Kunst im Heim" ("Art in Your Home"), the newly established gallery hoped to engage contexts both within and beyond the immediate one and, in so doing, asked that art shown on its walls operate on multiple registers.

During my recent visit to Walker's studio in New York, I saw that his interest in considering every angle of Capitain Petzel's space had not waned—little wonder, perhaps, given the understandable need to plot most of the work's detailed production and installation for his show well before shipping it to Germany. Still, the strange fussiness brought by the artist and his assistants to the otherwise laissez-faire assemblage of a more-or-less-to-scale model—to say

JOHANNA BURTON is an art historian and critic living in New York City.

KELLEY WALKER, UNTITLED, 2009,
detail, layered New York Times, wheatpaste, dimensions variable /
OHNE TITEL, geschichtete Zeitungsseiten (New York Times),
Kleister, Masse variabel.
(PHOTO: ROMAN MÄRZ)

nothing of its pride of place on a table in the middle of the studio—suggested (to me, at least) that more was at stake than the mere figuring of pragmatics. Indeed, if the ostensible reason for constructing such a model is to quickly and efficiently get a handle on real-world spatial dynamics and dimensions, something about Walker's approach felt, I realized, *twisted*—or, perhaps better put, askew.

This impression came partly from literal circumstances within the model itself: when deciding how to position two of the gallery's three moveable walls, Walker had quickly and rather arbitrarily drawn a kind of lopsided rectangle (slightly cocked with its uneven sides), which then served as a framework for the floor area between them. As significant, however, was that the irregular geometry of this ground was rendered in the artist's model using stiff strips of layered newspaper reminiscent of those employed as "mortar" in a number of his paintings—and so the space between the walls seemed as freighted with potential meaning as anything that might hang on them. Or, more precisely, Walker's consideration of the gallery's contours seemed to revolve less around how to fill or occupy the space than around problems of perspective and, moreover, of audiences' behavior as it would be inflected—or even shaped—by architecture. Indeed, his placement of the walls in the model created a situation where viewers trying to approach certain individual works would inevitably find themselves "framed" too. As Walker himself pointed out when I asked, audience members standing on the upper tier of the Capitain Petzel gallery space would be perfectly positioned to look down and into the proceedings.

What, then, was the purpose of this model? True, during our conversation the artist moved around a few tiny versions of his work, wondering where they would eventually settle: various "brick" paintings on various walls; a quiet scanner "painting" (here stamp-size, in reality to scale, offering only an image of the scanner's own empty bed); a couple of curved sculptural objects (eventually produced in hard, thick, heavy transparent Plexiglas, nearly human-size, but here lolling on the model's floor, nothing more than scraps of thick paper). But more central was Walker's continuous talk about vantage points, describing possible operations of display via various modes of luring and teasing the viewer's gaze. This space he was envisioning and contemplating, in other words, was a thoroughly encoded one, in which so many glimmers of possible meaning and connection could be made to appear and disappear, as if in a perpetual game of hide-and-seek.

Yet the import of Walker's stealthy visual perambulations of the space became clear to me only after he gestured offhandedly to a discarded third level of his model—a windowless downstairs basement that Walker in passing also referred to as the "dungeon"—and mentioned that he had initially planned to stage

KELLEY WALKER, *installation view, Capitain Petzel, Berlin, 2009 / Installationsansicht. (PHOTO: ROMAN MÄRZ)*

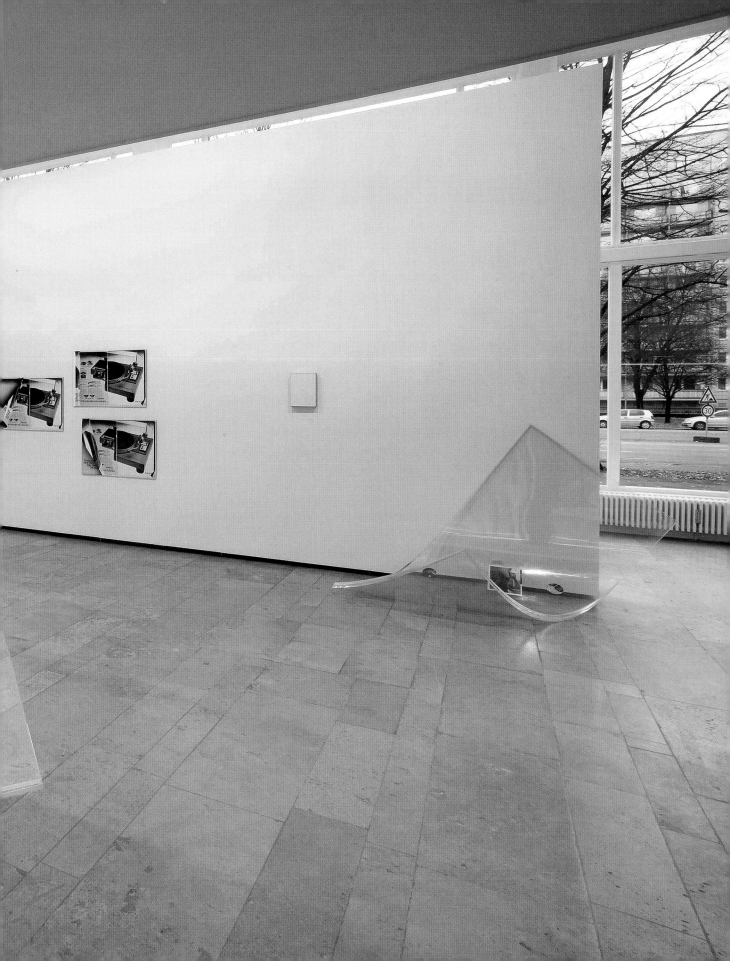

his entire show there. Something had just seemed obscene about how luxurious the largely glass-walled gallery proper was, making him nervous to occupy it (though he was hardly a newcomer to such a situation, having exhibited in his fair share of lush environments over the past several years). This impulse to bury himself—or, at least, to invert the expectations of the gallery—was dispelled, however, when he found that the history of Karl-Marx-Allee 45 was not quite so straightforward after all. Between its first iteration as an example of Socialist architecture and its current iteration as a respected space for showing art, the building had been taken up and used in other ways and to different ends—the most spectacular case being, for Walker, its transformation into a showroom for high-end BMWs sometime during the early 1990s.

In what could be called a flicker of productive crassness, this last discovery rendered his own task more complex. After all, one reasonably anticipates that art that engages a given site should gravitate toward its underbelly, moving into the basement, as it were, and summon up the repressed past or create some place for alterity. But in this instance such a move suddenly seemed beside the point, because the underbelly was already above ground, embedded there in the space's "low" history as a showroom for luxury goods. Indeed, this knowledge only forced in turn certain questions about art and, more specifically, our expectations for it: to what end does art bring up what lies below? To what degree and in what ways do artistic inversions render ostensibly "non-normative" histories, desires, and aesthetics central and visible? Perhaps art both allows for and expects what lies beneath. And, on this occasion, perhaps moving into the space above, with all its "sullied" commercial history, would better enable Walker to perform an inversion of another order, turning his critical eye on art itself and the ways in which its embrace of the "low," in fact, both buoys and gives it shape. Moving above ground, in other words, might provide insights into the basement of art itself, putting on display and deferring, if for a brief moment, its typically smooth passage of images, objects, and motifs from popular to high culture. Looking at the architecture of Capitain Petzel from a living perspective, Walker's model

created the chance for us to watch ourselves watching, never isolating art from the surrounding forces of commercial culture but rather pushing the two into an awkward embrace.

II.

Walker's exhibition had by the time of this half of my essay's writing been installed, the show opened, an accompanying press release issued. (The contents of the last consist of the following, without any commentary: a brief history of The Loft, an underground gay dance party that began in New York in 1970; and the basics of the CMYK Four-Color process, used by Walker in much of his production.)[2] In different configurations on the structural and mobile walls of Capitain Petzel hung a number of Walker's brick paintings, previous iterations of which have—it should be said in light of the artist's model for the gallery space—too often been described only in formal terms rather than in contextual ones. It's true, of course, that even the formal aspects of these works (the "body" of the bricks) are themselves indexes of a sort: the images come from scans of the objects and are used simultaneously to empty out and fill the canvases they occupy. In this way, they render the compositions ordered, seemingly minimal, though all the while gesturing toward weight, heft, *blockage*. But when it comes to the matter of context for such works—beyond the over-determined meaning of "brick," something all the more evocative in Berlin—there is always the accompanying "mortar," the textual and imagistic *stuff* harvested by Walker from various magazines and newspapers from particular times, which lace through his compositions. Spread over his canvases, these contents seem to peek out from behind the bricks even while their materials, in fact, are cutouts adhered on the surface of his canvases.

If not readable in a strictly linear sense—the bricks disrupt, distract, distance, do-away with so many words—these are nonetheless anchors of meaning. For instance, the brick paintings shown in Berlin (strangely ghost-like affairs due to the white bricks Walker opted to populate many of them with, some of these paintings are large and commanding,

others are long, tall strips only a foot or so wide) are at a glance embedded in the palette, fashion, and vernacular of 1970s America. We know the slightly strange hues, the "far out" vibe, the kind of drama of that era (which has been so fully appropriated by various culture-industry outlets for our own). This retro-atmosphere is subtle in some works. To describe one largely bricked-over canvas peeking out a mini-narrative: "And then the phone rang. He'd just landed. Dying to see her." It's less subtle in others. Case in point, a square, largely image-based painting with full pages of reportage and advertising: Vince Aletti writing on the Rolling Stones; Isaac Hayes's new "Chocolate Chip"; an article about "Disco Kids in Gay L.A."

Before thinking that this constellation of events and images might feel slightly tamed by the paintings to which they are made to bend, we should consider how Walker's exhibition also features two clumsy yet lyrical Plexiglas sculptures that loll anthropomorphically on the floor—each one with a scatter of images suspended like insects in wax. Within their Plexi frames, the pictures float as part-objects, estranged from their original contexts and also sometimes cut into shapes—mostly album-like circles—and, thus, doubly abstracted. As significantly, these strange, sculptural unfurlings of time and space offer their wares even while holding them tight, encasing collections of images that would seem to catalogue the artist's own impulses and desires. In fact, these images, as I saw them in the studio, were originally hoarded by Walker in a growing archive that felt very personal even as they traversed several genres: pictures of queer goings-on, from public sex to drag divas taken by a photographer I'd not heard of before named Toby Old; archival ephemera, including an invitation to The Loft (procured from Vince Aletti); various iterations of James Brown's 1971 album *Hot Pants* mostly encased in album covers on which black women's body parts (mostly asses) are featured; gay male porn (including such popular genres as "watersports"). At Capitain Petzel, however, the sculptures render these images wholly perverse in their backhanded availability; the ephemera here are ostensibly available to be seen from all sides, but are nonetheless *untouchable*. So many glints of distance

and proximity, content and context: it is tempting to look again at the voyeurism and hide-and-seek quality to this treatment of the space and wonder if Walker's exhibition—using the space to re-examine its own premises—maps the logic of *cruising* onto the platform of art. Or if, as we bear in mind the hide-and-seek of the studio model, we are watching art's operations—its critical unveilings, its aesthetic desires—stalled on the gallery floor.

Most prominent among these images are a handful of advertisements for a Pioneer turntable: model PL-518, in particular. Here it appears in an advertisement with Andy Warhol who seems coolly able to sell the Pioneer products (including the turntable) flanking him precisely because it's clear he could not care less. Elsewhere, in another advertisement taken from Walker's collection, the machine is posed on the page as if we were looking down onto it, seeing it from above. Finally, the model appears in a work that Walker created using a beautifully boring ad from the 1970s—an overly technical, manual-like thing that appeals to the egos of the tech-savvy—whose three-page spread shows the turntable sitting there, depicted in clinically serious fashion. The trick, however, is that this ad is a fold-out, with the true believer supposed to get satisfaction from the reveal: on the pages that lie beneath, the machine's innards are detailed lovingly, and compared to other, *lesser* models. In Walker's work, ten photographs create the impression that the fold-out—or the "skirt"—of the ad is

Invitation to David Mancuso's Loft,
ca. 1970, New York /
Einladungskarte zu Loft.

Loft invitation **Collection of Vince Aletti**

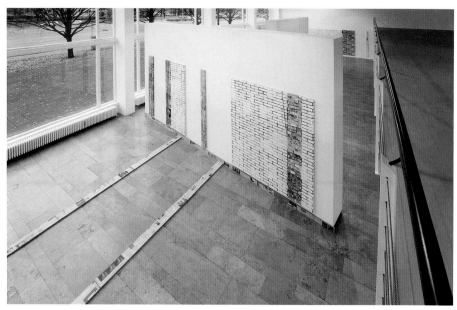

KELLEY WALKER,
installation view,
Capitain Petzel, Berlin, 2009 /
Installationsansicht.
(PHOTO: ROMAN MÄRZ)

KELLEY WALKER,
UNTITLED, 2009,
detail, layered New York Times,
wheatpaste, dimensions variable /
OHNE TITEL, geschichtete
Zeitungsseiten (New York Times),
Kleister, Masse variabel.
(PHOTO: ROMAN MÄRZ)

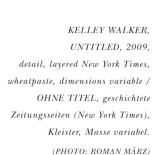

That we do not miss what is being withheld, and perhaps do not even see the immense labor of the withholding, is not the point—or perhaps it is. Pioneer's logo, and thus Walker's for a moment too, quietly printed in the corner, reads like a backwards threat: "We bring it back alive." This is a promise but also a quiet admission: all we look at, all we hear here is so much reanimation—a coaxing back into the here and now. A pioneer, etymologically, is defined both as avant-garde and as one who acts as foot-soldier, pawn to higher powers.

slowly being lifted. The slow unfolding recalls Roland Barthes' apt description of desire's deviant operations in his early essay "Striptease," the first sentence of which notes: "Woman is *desexualized* at the very moment when she is stripped naked."[3] Yet the longer one looks, the more one feels that something isn't adding up. Part of what should be found under the lifted page is quietly upended, erased. For while we are teased with bits and pieces of the detailed technical explication, the overall operation reveals itself to be a farce: the page turned back on itself shows not a verso image (something different) but a doubled, reverse-mirror version of itself—this accomplished for Walker via difficult, time-intensive programming by an architect using the model of a barrel-curve.

1) Willa Cather, *O Pioneers!* (New York: Houghton Mifflin Company; The Riverside Press, Cambridge, 1913), p. 48.
2) While it is not within the purview of this essay, the relationship between disco—its role in the burgeoning gay community of the 1970s, its revolutions in music, its conjunctions of race and sexuality—and Walker's work bears mention. He has turned time and again to such conventions as the disco-ball as an overburdened icon, for instance, but here bends more forcefully to the queer histories such imagery evokes. A recent issue of *Criticism: A Quarterly for Literature and the Arts 50*, no. 1 (winter 2008) comprises a number of valuable academic (and other) ruminations on the subject of disco. See especially Douglas Crimp's "Disss-co (A Fragment)," which appears there, pp. 1–18.
3) Roland Barthes, "Striptease" in *Mythologies* (New York: Hill and Wang, 1972), p. 84, author's emphasis.

Wieder zum Leben erweckt

JOHANNA BURTON

Ein Pionier sollte Phantasie haben, sollte sich an der Vorstellung von etwas mehr erfreuen können als an der Sache selbst.
—Willa Cather, O Pioneers![1)]

I.

Während ich mit der Niederschrift dieses Textes beginne, steht Kelley Walker kurz vor der Vollendung einer Gruppe von Werken, die im November (2009) in Berlin gezeigt werden sollen. Die Arbeiten sind das Material für seine erste Einzelausstellung in der kürzlich eröffneten Galerie Capitain Petzel, die die Macht und Mittel zweier bekannter unabhängiger Kunsthändler vereint (Gisela Capitain in Köln und Friedrich Petzel in New York). Sie öffnete ihre Tore im Oktober 2008 und setzte ein antizyklisches Signal in wirtschaftlich derart unsicheren Zeiten: Das selbstbewusste Auftreten des Unternehmens inmitten der allgemeinen Unruhe verlieh diesem Vorhaben ganz besondere Konturen.

Denn Grundfläche und Geschichte der Galerieräumlichkeiten sind schon für sich genommen bemerkenswert genug. Die Capitain Petzel Gallery befindet sich in der Karl-Marx-Allee in Berlin Mitte, in einem moderat renovierten Gebäude, das

1964 von Josef Kaiser und Walter Franek, Vertretern einer ostdeutschen Architekturmoderne, eigens zum Zweck der Präsentation von Kunst und Kunsthandwerk aus dem Ostblock entworfen wurde. Die Galerie arbeitet mit diesem Erbe, etwa indem sie ihre erste Ausstellung (an der Walker beteiligt war) einer Gruppenausstellung über den Standort widmete. Laut Presseinfo wurden die Künstler von der Galerie aufgefordert, «sich mit der Architektur, Form, Geschichte und Umgebung des Ausstellungsgebäudes auseinanderzusetzen». Betitelt «Kunst im Heim» nach der ursprünglichen funktionalen Bezeichnung des Gebäudes, sollten die gezeigten Arbeiten die nahe liegenden wie auch darüber hinausgehenden vielschichtigen kontextuellen Zusammenhänge erkunden.

Als ich vor Kurzem Walkers Atelier in New York besuchte, stellte ich fest, dass ihm nach wie vor sehr daran gelegen war, jeden Winkel der Räumlichkeiten von Capitain Petzel in Betracht zu ziehen – wohl kaum verwunderlich angesichts des verständlichen Bedürfnisses, die vielen Details der Produktion und

JOHANNA BURTON ist Kunsthistorikerin und -kritikerin und lebt in New York.

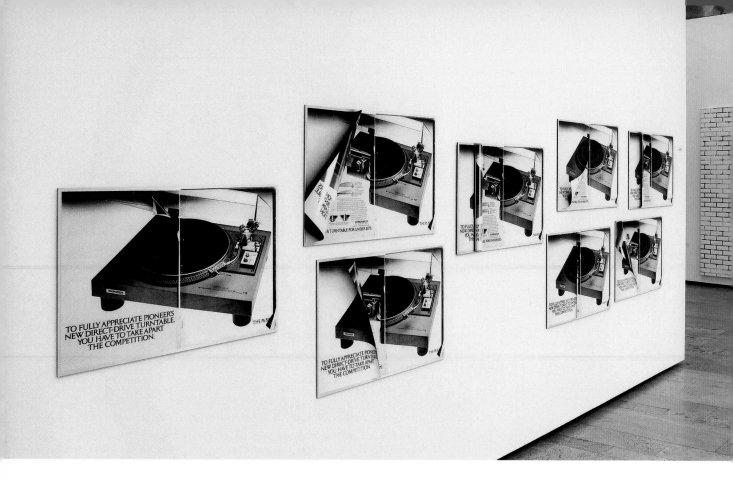

KELLEY WALKER, PIONEER PL-518 SERIES, 2009, detail, 4-color process silkscreen with acrylic ink on MDF, suite of 10 panels, 22 ³/₄ x 33 x ¹/₄" each, installation view Capitain Petzel, Berlin, 2009 / 4-farbiger Siebdruck mit Acryltinte auf MDF, Folge von 10 Tafeln, je 57,8 x 83,8 x 0,6 cm. (PHOTO: ROMAN MÄRZ)

Installation für seine Ausstellung (grösstenteils geraume Zeit vor dem Transport nach Deutschland) genau auszuarbeiten. Trotzdem: Die merkwürdige Aufgeregtheit, die der Künstler und seine Assistenten beim ansonsten gelassenen Zusammenbau eines mehr oder weniger massstabgetreuen Modells an den Tag legten – um von dessen Ehrenplatz auf einem Tisch in der Mitte des Ateliers ganz zu schweigen –, machte (auf mich jedenfalls) den Eindruck, dass mehr auf dem Spiel stand als das blosse Austüfteln pragmatischer Fragen. Wenn der Grund für den Bau eines solchen Modells vordergründig darin besteht, die Dynamik und Dimensionen eines Raumes schnell und effizient in den Griff zu bekommen, so hatte Walkers Herangehensweise etwas Verdrehtes – oder vielleicht besser gesagt: etwas Verqueres – an sich.

Dieser Eindruck rührte zum Teil von den konkreten Gegebenheiten innerhalb des Modells selbst her: Bei seiner Entscheidung bezüglich der Position von zwei der drei verschiebbaren Wände der Galerie hatte Walker auf die Schnelle und eher willkürlich eine Art von schiefem (und mit seinen ungleichen Seiten leicht aufgerichtetem) Rechteck gezeichnet, das daraufhin als Rahmen für die Bodenfläche dazwischen diente. Nicht minder erheblich war jedoch, dass zur Darstellung der unregelmässigen Geometrie dieser Grundfläche im Modell mehrschichtige steife Zeitungspapierstreifen verwendet wurden, ähnlich denen, die in einer Reihe seiner Bilder als «Mörtel» fungieren. Der Raum zwischen den Wänden schien daher genauso wichtig wie die an den Wänden hängenden Arbeiten. Oder genauer gesagt: Walkers Überlegungen zu den Umrissen der Galerie drehten sich offenbar weniger darum, wie der Raum zu füllen oder zu bespielen sei, als um Fragen der Perspektive und, darüber hinausgehend, des Betrachterverhaltens, sofern dieses durch die Architektur beeinflusst – oder gar geprägt – werden würde. Durch die Art

und Weise, wie er die Wände im Modell platzierte, ergab sich tatsächlich eine Situation, in der der Betrachter, beim Versuch, näher an bestimmte Einzelwerke heranzutreten, zwangsläufig würde erkennen müssen, dass er seinerseits «eingerahmt» sei. Wie Walker selbst auf meine Frage hin zu bedenken gab, würden Besucher der Ausstellung, die auf der Empore des Ausstellungsraums stünden, sich an idealer Stelle befinden, um auf die Vorgänge hinabzusehen und einen Einblick in sie zu gewinnen.

Worin also bestand der Zweck dieses Modells? Während unseres Gesprächs schob Walker einige wenige Miniaturversionen seiner Werke herum, um zu sehen, wo sie am Ende ihren Platz finden würden: diverse Backstein-Bilder an verschiedenen Wänden, ein stilles Scanner-Gemälde (hier im Briefmarkenformat, in Wirklichkeit ein massstabgetreues Bild, das lediglich die leere Auflagefläche des Scanners selbst zeigt), ein paar geschwungene skulpturale Objekte (die letztlich aus hartem, dickem, schwerem durchsichtigem Plexiglas nahezu in menschlicher Körpergrösse hergestellt werden sollen, hier aber blosse dickere Papierschnitzel, die sich auf dem Boden des Modells räkeln). Wesentlicher jedoch war Walkers ständiges Gerede von Blickwinkeln und seine Beschreibung von möglichen Mechanismen der Präsentation mittels unterschiedlicher Methoden, den Blick des Betrachters zu ködern und zu reizen. Der Raum, den er sich ausmalte und über den er sich Gedanken machte, war mit anderen Worten ein durch und durch kodierter Raum, der es erlaubte, die verschiedensten Schimmer möglicher Bedeutungen und Zusammenhänge wie in einem unendlichen Versteckspiel aufscheinen und verschwinden zu lassen.

Der Sinn von Walkers heimlichen optischen Raumbegehungen wurde mir allerdings erst klar, nachdem er in einer spontanen Geste auf eine verworfene dritte Ebene seines Modells hinwies – ein fensterloses Untergeschoss, das Walker beiläufig auch als das «Verlies» bezeichnete – und erwähnte, dass er ursprünglich vorgehabt habe, seine ganze Ausstellung dort zu inszenieren. Irgendetwas am Luxus des eigentlichen, überwiegend von Glaswänden eingerahmten Galerieraums sei ihm obszön vorgekommen, weshalb ihn die Aussicht, diesen Raum zu bespielen, nervös gemacht habe (auch wenn eine

solche Situation für ihn alles andere als neu war, hat er doch im Lauf der letzten Jahre zur Genüge in opulenten Kunsträumen ausgestellt). Dieser Impuls unterzutauchen – oder zumindest die Erwartungen der Galerie auf den Kopf zu stellen – verflog jedoch, als er herausfand, dass die Geschichte der Karl-Marx-Allee Nr. 45 am Ende nicht ganz so eindeutig war. Zwischen der ersten Inkarnation des Gebäudes als Schulbeispiel sozialistischer Architektur und seiner jetzigen Funktion als angesehener Kunstausstellungsstätte war das Gebäude in anderer Weise und zu anderen Zwecken bespielt und genutzt worden, wobei die Umwandlung in einen Showroom für BMW-Luxuslimousinen irgendwann während der ersten Hälfte der 90er-Jahre in Walkers Augen den spektakulärsten Fall darstellte.

Diese letzte Entdeckung machte, in einem Hauch von produktiver Absurdität, die Aufgabe für Walker nur noch komplizierter. Schliesslich darf man von Kunst, die sich mit einem bestimmten Standort auseinandersetzt, erwarten, dass sie zu dessen Unter- oder Schattenseite hinstrebt, gleichsam in den Keller hinabsteigt und die verdrängte Vergangenheit heraufbeschwört oder irgendwie Platz für Alterität schafft. In diesem Fall jedoch erschien ein derartiger Schritt plötzlich unerheblich, befand sich die Unterseite doch bereits an der Oberfläche, dort eingebettet in die «niedere», triviale Geschichte der Räumlichkeit als Showroom für Luxusgüter. Diese Erkenntnis drängte tatsächlich ihrerseits bestimmte Fragen über Kunst und, genauer, über unsere Erwartungen an sie auf: Zu welchem Zweck bringt Kunst Verschüttetes hoch? Inwiefern und auf welche Art und Weise rücken künstlerische Umkehrungen angeblich «nicht-normative» Geschichten, Triebe und Ästhetiken in den Mittelpunkt und machen sie sichtbar? Vielleicht so wie die Kunst mit dem Verschütteten rechnet – ihm aber auch gleichzeitig gerecht werden will. Wahrscheinlich war es genau diese Verlagerung in den Raum darüber, mit dessen «belasteter» kommerzieller Geschichte, die Walker in die Lage versetzen würde, eine Umkehrung anderer Art durchzuführen und seinen kritischen Blick auf die Kunst selbst zu richten, darauf, wie ihre Bejahung und Vereinnahmung des Niederen oder Trivialen ihr gerade Auftrieb und Form gibt. Eine Verlagerung

an die Oberfläche könnte mit anderen Worten Einblicke in die Unterseite der Kunst geben und, wenn auch nur für kurze Zeit, ihre typischerweise nahtlose Überführung von Bildern, Objekten und Motiven aus der Trivial- in die Hochkultur zur Schau stellen und hinauszögern. Bei der Betrachtung der Architektur von Capitain Petzel aus dieser vitalen Perspektive würde Walkers Modell uns sodann die Chance bieten, uns selbst beim Betrachten zuzusehen und dabei die Kunst nie von den sie umgebenden Kräften des Kommerzes zu isolieren, sondern die beiden vielmehr in eine gegenseitige Umarmung zu drängen.

II.

Zum Zeitpunkt der Niederschrift dieser Zeilen wurde Walkers Ausstellung bereits installiert und eröffnet und eine begleitende Presseinfo herausgegeben. (Letztere hat, ohne jeden Kommentar, Folgendes zum Inhalt: eine kurze Geschichte von The Loft, einer schwulen Untergrund-Tanzparty, die erstmals 1970 in New York stattfand, und die Grundlagen des Vierfarbendruckverfahrens CMYK, von dem Walker bei einem Grossteil seines Schaffens Gebrauch macht.)[2] An den tragenden und verschiebbaren Wänden von Capitain Petzel hängen jetzt in unterschiedlichen Anordnungen mehrere Backsteinbilder Walkers, die in früheren Varianten – so muss man angesichts des Modells des Künstlers für den Galerieraum sagen – nur allzu oft statt unter kontextuellen lediglich unter formalen Gesichtspunkten beschrieben worden sind. Es stimmt natürlich, dass sogar die formalen Aspekte dieser Arbeiten (der «Körper» der Backsteine) irgendwie Indexcharakter haben: Die Bilder sind Abtastbilder der betreffenden Objekte und dienen dazu, die Leinwände, die sie einnehmen, gleichzeitig zu leeren und zu füllen. Auf diese Weise geben sie den Kompositionen etwas Geordnetes, scheinbar Minimalistisches, auch wenn sie dabei die ganze Zeit auf Gewicht, Schwere, Blockierung verweisen. Wenn es jedoch um die Frage des Kontextes der Arbeiten geht – und zwar über die überdeterminierte Bedeutung des gerade in Berlin umso beziehungsreicheren «Backsteins» hinaus –, dann ist da immer der dazugehörige «Mörtel», das Füllsel aus Text- und Bildmaterial, das Walker verschiedenen Zeitschriften und Zeitungen aus einer bestimmten Periode entnimmt und mit dem seine Kompositionen durchsetzt sind. Verteilt über seine Leinwände, scheinen diese Inhalte hinter den Backsteinen hervorzuschauen, auch wenn es sich bei ihnen vom Material her in Wirklichkeit um auf die Leinwand geklebte Ausschnitte handelt.

Auch wenn sie sich nicht in einem streng linearen Sinn lesen lassen – die Backsteine unterbrechen, lenken ab, rücken in die Ferne, lassen zahlreiche Wörter verschwinden –, sind sie dennoch Bedeutungsanker. So lassen die Backsteinbilder in Berlin (sie wirken seltsam geisterhaft aufgrund der weissen Backsteinmuster, mit denen Walker viele von ihnen überzog, in manchen Fällen grosse, eindrucksvolle Formate, in anderen lange und in die Höhe ragende, lediglich etwa 30 cm breite Streifen) sofort erkennen, dass sie in die Farbpalette, Mode und Umgangssprache des Amerikas der 70er-Jahre eingebettet sind. Die leicht ausgefallenen Farbtöne, die «abgefahrene» Stimmung, die besondere Dramatik dieser Ära (die über die verschiedenen Absatzkanäle der Kulturindustrie so gründlich für unsere eigene Zeit verfügbar gemacht worden ist) sind uns vertraut. Diese Retro-Atmosphäre ist in manchen Arbeiten subtil. Um ein weitgehend mit Ziegeln angefülltes Bild zu beschreiben, das eine Mini-Erzählung hervorscheinen lässt: «Und dann klingelte das Telefon. Er sei gerade ge-

KELLEY WALKER, URINAL, 2009, detail, Plexiglas,
magazine pages, 2 parts, 51 ⁵/₈ x 55 ¹/₈ x 83 ¹/₂" each, installation
view Capitain Petzel, Berlin, 2009 / Plexiglas, Zeitschriften-Seiten,
2 Teile, je 131,1 x 140 x 212,1 cm, Installationsansicht.
(PHOTO: ROMAN MÄRZ)

KELLEY WALKER, UNTITLED, 2009, *vinyl record,*
45 rpm, James Brown record cover mounted on paper, framed,
30 ¹/₂ x 20 ¹/₂ x 1 ¹/₂" / OHNE TITEL, Vinyl-Schallplatte,
Plattencover auf Papier, gerahmt, 77,5 x 52,1 x 3,8 cm.
(PHOTO: ROMAN MÄRZ)

landet. Könne es nicht erwarten, sie zu sehen.» In anderen wiederum ist sie weniger nuanciert. Zum Beispiel ein grossformatiges, überwiegend bildgestütztes Gemälde mit ganzseitigen Reportagen und Anzeigen: ein Artikel von Vince Aletti über die Rolling Stones, das neue Album «Chocolate Chip» von Isaac Hayes, ein Beitrag über «Disco Kids in Gay L.A.»

Ehe wir mutmassen, dass diese Konstellation von Ereignissen und Bildmotiven etwas zahm wirken könnte, sollten wir die beiden klobigen und doch gefühlvollen Plexiglasskulpturen in Betracht ziehen, die sich anthropomorphisch auf dem Boden räkeln, beide mit verstreut in ihnen eingelagerten Bildern, gleich Insekten in Bernstein. Im Innern ihrer Plexiglaskörper schweben die Bilder wie Teilobjekte, ihrem ursprünglichen Kontext entfremdet, in manchen Fällen zudem in bestimmte Formen – meist

an Schallplatten gemahnende Kreise – geschnitten und folglich doppelt abstrahiert. Diese sonderbaren skulpturalen Entfaltungen von Zeit und Raum bieten gleichzeitig ihre Ware an und halten sie doch fest, Sammlungen von Bildern enthaltend, die, so scheint es, die Antriebe und Triebe des Künstlers zu katalogisieren scheinen. Tatsächlich wurden diese Bilder, so, wie ich sie im Atelier sah, von Walker in einem anwachsenden Archiv gesammelt, das sehr persönlich wirkte, auch wenn sie sich über die verschiedenen Gattungsgrenzen hinwegsetzten: Bilder von schwulem Treiben, von Sex an öffentlichen Orten bis hin zu Transvestiten-Divas, aufgenommen von einem Photographen namens Toby Old, von dem ich vorher nie gehört hatte; archivalische Ephemera, darunter eine (von Vince Aletti erhaltene) Einladung zu The Loft, verschiedene Ausgaben von James Browns Album *Hot Pants* aus dem Jahr 1971, die meisten davon in Plattenhüllen mit Abbildungen von Körperteilen schwarzer Frauen (überwiegend Ärsche) darauf, schwuler Männerporno (einschliesslich solch beliebter Genres wie «Wassersport»). Bei Capitain Petzel machen die Skulpturen aus diesen Bildern in ihrer indirekten Verfügbarkeit allerdings etwas ganz und gar

KELLEY WALKER, WAVE, 2009, details, Plexiglas, magazine pages, 2 parts, 23 ²/₉ x 59 ⁴/₅ x 97 ³/₅" each /
WELLE, Details, Plexiglas, Zeitschriften-Seiten, 2 Teile, je 59 x 151,9 x 247,9 cm. (PHOTO: ROMAN MÄRZ)

Verdrehtes: Die Ephemera stehen hier anscheinend zur Verfügung, um von allen Seiten her gesehen zu werden, sind aber gleichwohl unberührbar. All diese Schimmer von Ferne und Nähe, Inhalt und Zusammenhang. Es ist verlockend, sich den Voyeurismus und Versteckspielcharakter dieser Raumauffassung ein weiteres Mal anzusehen und sich zu fragen, ob Walkers Ausstellung in der Verwendung des Raums (zur Überprüfung ihrer eigenen Prämissen) die Logik des *Cruising* auf die Plattform der Kunst abbildet. Oder ob wir, eingedenk des Versteckspiels des Modells im Atelier, die Wirkungsmechanismen der Kunst – ihre kritischen Enthüllungen, ihre ästhetischen Triebe – auf dem Fussboden der Galerie abgewürgt sehen.

Unter den Bildern stechen einige Reklamen für einen Plattenspieler der Marke Pioneer hervor, um genau zu sein für das Modell PL-518. Auf einer Anzeige ist Andy Warhol zu sehen, der offenbar ganz gelassen die ihn flankierenden Pioneer-Produkte (den Plattenspieler eingeschlossen) an den Mann zu bringen vermag, gerade weil es ihm offensichtlich völlig egal ist. In einer weiteren aus Walkers Sammlung stammenden Werbeanzeige ist der Apparat auf dem Blatt so in Pose gesetzt, als würden wir von oben auf ihn hinabblicken. Schliesslich taucht das Modell in einer Arbeit auf, die Walker unter Verwendung einer wunderschön langweiligen dreiseitigen Werbeanzeige aus den 70er-Jahren schuf – einer sich offensichtlich an den Technikfreak wendenden Anzeige im Stil einer Gebrauchsanleitung –, in der der Plattenspieler in klinisch-seriöser Manier abgebildet ist. Der Kniff ist allerdings, dass es sich bei diesem Inserat um ein Ausfaltblatt handelt; der echte Liebhaber soll durch das beim Ausfalten sichtbar Werdende befriedigt werden, denn auf den verdeckten Seiten wird das Innenleben des Apparates mit viel Liebe zum Detail beschrieben und mit Modellen minderer Qualität verglichen. In der Ausstellung erzeugen zehn Photographien den Eindruck, als würde das Ausfaltblatt – wie der Saum eines Rocks – langsam hochgezogen. Das sachte Auseinanderfalten oder Enthüllen erinnert an Roland Barthes' treffende Beschreibung der Mechanismen der Lust in seinem frühen Aufsatz «Striptease», deren erster Satz besagt: «Die Frau ist *entsexualisiert* in dem Moment, da sie entblösst ist.»[3]

Je länger man jedoch hinsieht, umso mehr bekommt man den Eindruck, dass etwas nicht stimmt. Ein Teil dessen, was sich unter der hochgezogenen Seite finden sollte, ist still und leise umgestülpt, getilgt. Denn während uns die eine oder andere detaillierte technische Erklärung häppchenweise als Köder vorgeworfen wird, entpuppt sich der gesamte Vorgang selbst als eine Farce: Die umgedrehte Seite zeigt kein rückseitiges Bild (etwas Anderes), sondern eine verdoppelte, spiegelverkehrte Ausgabe von sich selbst – etwas, was mittels komplizierter, aufwändiger Programmierung durch einen Architekten unter Verwendung des Modells einer Trommelkurve für Walker realisiert wurde.

Dass wir das uns Vorenthaltene nicht vermissen und uns die immense Arbeit des Vorenthaltens entgehen könnte, ist nicht der Punkt – oder vielleicht doch. Das unaufdringlich in der Ecke abgedruckte Pioneer-Firmenzeichen, das für einen Moment eben auch Walkers Logo ist, liest sich wie eine umgekehrte Drohung: «We bring it back alive», wir lassen es von Neuem lebendig werden. Dies ist ein Versprechen, zugleich aber auch ein leises Eingeständis: so viel von all dem, was wir uns hier ansehen, was wir hier hören, ist Wiederbelebtes, ins Hier und Jetzt Zurückgeholtes. Ein Pionier ist, von der Etymologie des Wortes her, sowohl ein Vorreiter als auch einer, der als Fusssoldat, als Spielball für höhere Mächte, dient.

(Übersetzung: Bram Opstelten)

1) Willa Cather, *O Pioneers!* Houghton Mifflin Company, New York, The Riverside Press, Cambridge 1913, S. 48.
2) Obwohl es den Rahmen dieses Aufsatzes sprengt, ist die Beziehung von Walkers Werk zum Phänomen der Disco – zu deren Rolle in der aufkommenden homosexuellen Szene der 70er-Jahre, den Revolutionen, die sie in der Musik herbeiführte, der Art und Weise, wie sie Rasse und Sexualität verknüpfte – durchaus eine Erwähnung wert. So hat sich Walker immer wieder Konventionen wie der Discokugel als einem überstrapazierten Klischee zugewandt. Hier aber wendet er sich emphatischer den schwulen Geschichten zu, die solche Motive heraufbeschwören. Eine neuere Ausgabe der Zeitschrift *criticism: A Quarterly for Literature and the Arts*, Nr. 50/1 (Winter 2008) enthält eine Reihe von wertvollen akademischen (und sonstigen) Betrachtungen über das Thema Disco. Siehe insbesondere den Beitrag von Douglas Crimp, «Disss-co (A Fragment)», ebenda, S. 1–18.
3) Roland Barthes, «Striptease», in *Mythen des Alltags*, Suhrkamp-Verlag, Frankfurt am Main 1964, Hervorh. d. Verf.

KELLEY WALKER, UNTITLED, 2009, 4-color process silkscreen with acrylic ink on canvas, Playboy, December 1975, 96 x 72" / OHNE TITEL, 4-farbiger Siebdruck mit Acryl-Tinte auf Leinwand, 243,8 x 182,9 cm. (PHOTO: ROMAN MÄRZ)

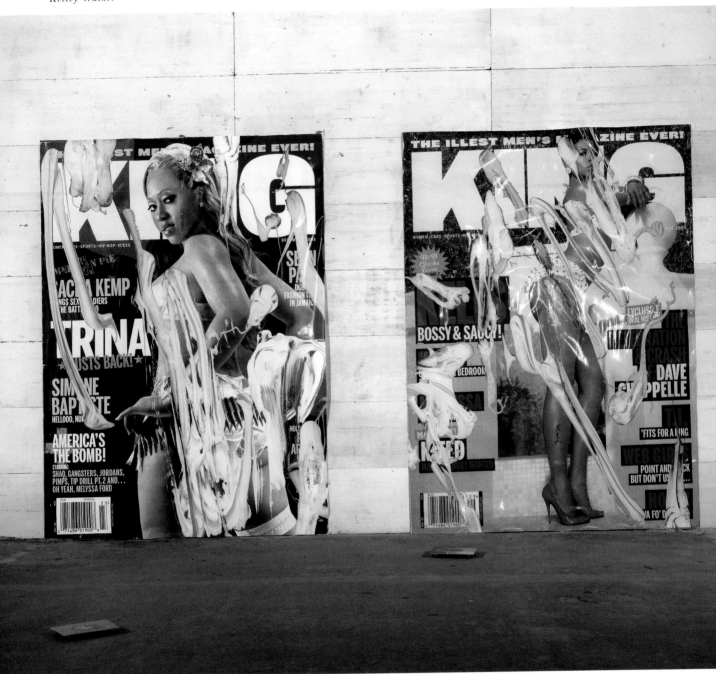

Left / Links: KELLEY WALKER, SCHEMA; AQUAFRESH PLUS CREST WITH WHITENING EXPRESSIONS (TRINA) 2006,
digital print on paper from CD-ROM, dimensions variable, installation view, "Fuori Uso Altered States: Are you experienced?", Pescara, 2006 /
Digitaler Print auf Papier von CD-ROM, Masse variabel, Installationsansicht.

Right / rechts: KELLEY WALKER, SCHEMA; AQUAFRESH PLUS CREST WITH WHITENING EXPRESSIONS (KELIS), 2006,
digital print on paper from CD-ROM, dimensions variable / Digitaldruck auf Papier von CD-ROM, Masse variabel.

Kelley Walker's Negro Problem

GLENN LIGON

"He's white?" This has been asked of me enough times with a double take or a sputter of disbelief that I know the question signifies something beyond mere curiosity about Kelley Walker's race. The incredulity with which the revelation is greeted owes in part to the "blackness" of some of Walker's most celebrated works—chocolate smeared images of civil rights protesters and covers of black gentlemen's magazines overlaid with digitally scanned toothpaste—coupled with uncertainty about his "right" to use those images. Walker's whiteness is thought to be a problem because these images are considered the natural purview of black artists, for whom there is imagined to be a distinct, already known, separate-but-equal entity called "black culture" which we use as our birthright and white artists use at their peril. But while there are certainly images with black people in them, is there really such a thing as "black images"? In what sense is a white photographer documenting the brutality of white southern policemen against civil rights workers creating "black images"? If a black person had made the same photographs, would they be even blacker images? Or are "black images" just images commandeered for use by black people, the way the word "nigger" has been transformed from a slur to a term of endearment (albeit one that white people speak at risk of bodily harm)?

If we agree for the moment that there is no such thing as "black images"—that there are only "images"—then what, exactly, is so troubling about Walker's use of images with black people in them? The answer may be that his work forces us to acknowledge that although race is a biological fiction, it remains an entrenched social and political fact. Even if we say "race doesn't matter," in reality it matters a great deal. This might explain the teeth-sucking sound or resigned sighs that knowledge of Walker's whiteness provokes in some quarters: "Just another example of white folks appropriating black culture." But if we can acknowledge the private whispers about this thorny issue, how do we explain the profound silence in the critical writing on Walker's work (and in the art world more generally) about how race operates? It is as if questions of race are deemed irrelevant, uninteresting, or just too complicated to deal with. In Europe, where Walker has received substantial curatorial and critical support, the issue of race in his work may be deemed "too American" to address, and in America it may be thought "too black." This silence is troubling, I would argue, because Walker is quite aware of the intractability of the "problem" of his racial identity in relationship to images of black people, and part of the impact of his work is that it calls attention to very difficult and still unsettled questions about the politics of representation.

One of the problems with discussions of race is that no one ever has to speak up on whiteness, while

GLENN LIGON is an artist living and working in New York City.

those who are not white get called upon to speak their difference again and again. In the art world, the discourse around black artists often focuses on race even when their work does not. Take, for example, the following quotation from a review of Steve McQueen's film *Deadpan* (1997), a complex restaging of a scene from the Buster Keaton movie *Steamboat Bill, Jr.* (1928) in which a house facade falls over a standing man:

> *Metaphors crowd in. Seen in an American context, the house suggests a sharecropper's cabin; its destruction evokes Abraham Lincoln's Civil War caveat, "a house divided against itself cannot stand," referring to a nation riven by the question of slavery. (Mr. McQueen is black.)*[1]

While the reviewer is clearly sympathetic to McQueen's artistic project, he equates the blackness of the artist's body with the "blackness" of his work, and once that occurs, metaphors do, indeed, crowd in. A racial reading that feels tangential to the film's primary concerns is privileged over an exploration of McQueen's relationship to, say, theorist Tom Gunning's notion of a "cinema of attractions" or to an experimental filmmaker like Michael Snow. This is not to suggest that the race of the protagonist of the film doesn't matter; it's just that in this case race seems to matter too much.

If the work of black artists provokes overdetermined readings, what do we make of the critical response to Walker's work, in which black bodies appear front and center but barely get a second glance? An argument could be made that Walker's digital and appropriative strategies, along with the leveling effect of collage, render his subject matter irrelevant. Yet if this were his goal, it is hard to imagine why he would repeatedly use subjects that, given our long, troubled history and current political reality, are so resistant to being made irrelevant. And if it were true that Walker's (black) subjects do not matter, why wouldn't the critical writing on his work simply say as much, rather than sidestepping the issue by quickly mentioning race only to move on to yet another discussion of Warhol and appropriation? Don't think this silence doesn't operate on an institutional level too. The cultural critic Hazel Carby once suggested that for many non-black individuals, black cultural products are a substitute for prolonged and

meaningful contact with black people, and given the dearth of exhibitions that include black artists (or their segregation into race- and identity-themed shows), it seems that many museums and Kunsthalles find it easier to deal with images of blacks rather than with the people themselves, images which Walker's work readily provides. While this is in no way Walker's responsibility—after all, hate the game, not the player—it is shocking that what was once the subject of academic conferences and anguished curatorial meetings is now considered too boring (or problematic) to discuss.

When is a race riot not a race riot? When it is a Warhol. But is a race riot not a race riot when it is a Kelley Walker? Walker has put some distance between himself and Warhol by using different source photos for his *Black Star Press* works, rotating the images, and overlaying them with chocolate or turning them Coca-Cola red. He has also put some distance between himself and his subject matter, and here time is on Walker's side. When Warhol used similar images they were current news. In Walker's paintings, the photographs are now almost a half-century distant from the events they depict and have lost some of their original frisson, rendering them in the minds of some commentators "just images" to be used without regard to their historical and political specificity.

Yet if Walker's interventions create a distance between the race riot photograph and us, they also brings us closer to the image, in part because of the nagging worry that the images are not his to use. Race riots are race riots—and not just Warhols—in Walker's work because our anxiety about his whiteness and his chocolaty transgressions reveals that we are not "beyond" race; we have just begun to address it. This ultimately points to our failure to realize the "post-racial" society that the men and women in those images were marching to achieve. If we had made it to that promised land, these images would belong to "culture" as opposed to "black culture," thereby detaching the racial identity of the maker or user of an image from its politics, whether correct or not. Perhaps in that promised land, knowledge of Walker's racial identity would be met with a shoulder shrug, and the power of the work would be less dependent on some (by then dated) notion of racial

transgression (which his toothpaste- and chocolate-smeared images of black people currently trade in) than on how he lays bare the complicated ways in which we (re)make images and on the instability of their meaning. In that future world, the ways race operates in his work would already have been thoroughly considered by others as integral to the work's meaning (and would not be seen as black people's obsession).

Speaking of obsessions, here's Walker on one of his: "There is something amazing and extremely tragic about Whitney Houston that is very American."[2] But really the most amazing and tragic and American thing about Whitney Houston, and about Michael Jackson, Sonny Liston, civil rights protestors, and *King* cover girl Regina Hall (all of whom populate Walker's art) is that they point to the fact that there is nothing more American than black Americans. America without black people would be like a day without sunshine. And I know that Walker is a good American boy because he, like many other white Americans, has a healthy, wholesome, complicated, troubling, and troubled obsession with black people, an obsession that I confess I happen to share. Until we get to the promised land let us think of Kelley Walker's "negro problem" as an American dilemma, a dilemma which gives enormous vitality to his work and one which we all ignore at our peril.

1) Holland Cotter, "Art in Review," *The New York Times*, 23 January 1998, section E, p. 35.
2) Christopher Bollen, "Kelley Walker," *Interview Magazine*, December/January 2009, p. 159.

KELLEY WALKER, UNTITLED, 2006, light box with duratrans, 60 ³/₄ x 120 x 4" /
OHNE TITEL, Lichtkasten mit Duratrans, 154,3 x 304,8 x 10,2 cm.

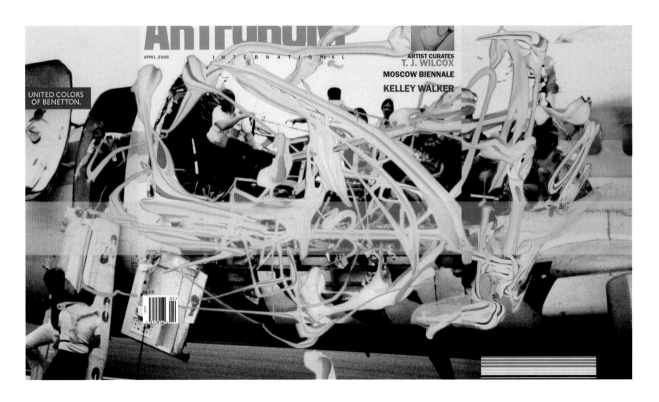

KELLEY WALKER, WHITNEY THE GREATEST HITS – HOW WILL I KNOW: ARISTA 2000, 2008, aluminum stands, mylar, mirror, Epson prints, disco ball with chain, wood, fluorescent tubes, dimensions variable, installation view, Wiels, Centre d'Art Contemporain, Brussels, 2008 /

Kelley Walkers Rassenproblem

GLENN LIGON

«Was, er ist weiss?» Ich habe diese perplexe Frage so oft gehört, dass mir klar wurde: Da steckt mehr dahinter als blosses Erstaunen über Kelley Walkers Hautfarbe. Das Kopfschütteln erklärt sich teils aus dem «schwarzen» Charakter vieler seiner bekanntesten Werke – mit Schokolade beschmierte Bilder von Bürgerrechtsprotesten oder Umschläge afroamerikanischer Herrenmagazine mit Schlieren gescannter Zahnpasta –, teils aus dem Zweifel, ob er überhaupt das «Recht» hat, solche Bilder zu verwenden. Der Stein des Anstosses ist Walkers Rassenzugehörigkeit, denn sein Bildmaterial gilt als angestammte Domäne schwarzer Künstler, denen von Geburt an ein eigener, bereits bekannter, getrennter, aber gleicher Bereich namens «schwarze Kultur» zusteht, den weisse Künstler nur auf eigene Gefahr betreten dürfen. Bilder, die schwarze Menschen zeigen, gibt es natürlich, aber gibt es wirklich so etwas wie «schwarze Bilder»? Erzeugt ein weisser Photograph, der das brutale Vorgehen weisser Polizisten gegen Bürgerrechtler in den US-Südstaaten dokumentiert, «schwarze Bilder»? Wären dieselben Bilder, aufgenommen von einem schwarzen Photographen, noch schwärzer? Oder ist der Gebrauch «schwarzer Bilder» einzig schwarzen Personen vorbehalten, wie der des Schimpfworts «nigger» als kumpelhafte Anrede (Weisse, die es in den Mund nehmen, setzen ja nach wie vor ihre Gesundheit aufs Spiel)?

Nehmen wir also an, dass es so etwas wie «schwarze Bilder» gar nicht gibt – sondern einfach nur «Bilder». Dann stellt sich die Frage, warum Walkers Bilder schwarzer Menschen solchen Anstoss erregen. Vielleicht weil sie uns zwingen einzugestehen, dass die Idee der Rasse trotz mangelnder biologischer Grundlage auf sozialer und politischer Ebene hartnäckig weiter besteht? Wir können noch so oft sagen, «Rasse spielt keine Rolle», die Wirklichkeit sieht anders aus. Kein Wunder also, dass Walkers weisse Hautfarbe bei gewissen Leuten ein resigniertes Kopfnicken hervorruft: «Wieder ein Weisser, der sich an der Kultur der Schwarzen bedient.» Wenn wir einräumen, dass dieses heisse Eisen hinter vorgehaltener Hand diskutiert wird, wie erklärt sich dann das völlige Schweigen der Walker-Literatur (und der Kunstwelt überhaupt) zum Rassenproblem? Als wäre es nicht relevant oder interessant genug oder einfach zu kompliziert, um sich mit ihm abzumühen. Womöglich gilt dieses Problem in Europa, wo Walker von zahlreichen Kritikern und Kuratoren unterstützt

GLENN LIGON ist Künstler. Er lebt und arbeitet in New York.

wird, als «zu amerikanisch» und in Amerika als «zu schwarz». Mich irritiert dieses Schweigen, da Walker sich sehr wohl der Komplikationen bewusst ist, die seine Rassenzugehörigkeit bei der Appropriation von Bildern dunkelhäutiger Menschen heraufbeschwört. Die Intensität seiner Kunst entspringt zum Teil ihrer Strategie, äusserst schwierige und bis dato ungelöste Fragen zur Politik der Repräsentation offen zur Diskussion zu stellen.

Die Rassendebatte verläuft auch deshalb so einseitig, weil Weisse sich nie für ihren Status verantworten müssen, während Farbige ständig aufgefordert sind, zu ihrem Anderssein Stellung zu nehmen. Der Diskurs über schwarze Künstler konzentriert sich sogar dann noch auf ihre Rasse, wenn ihre Werke ganz andere Themen behandeln. Man nehme zum Beispiel das folgende Zitat aus einer Rezension des Films *Deadpan* (1997), in dem Steve McQueen (ein schwarzer Künstler) die berühmte Szene aus Buster Keatons *Steamboat Bill, jr.* (1928) – eine Hausfassade fällt über einen stehenden Mann, ohne in zu verletzen – aufwändig nachstellt:

Zahlreiche Metaphern drängen sich auf. Im amerikanischen Kontext verweist das Haus auf die Hütte eines Pächters. Seine Zerstörung erinnert an das Wort Abraham Lincolns aus der Zeit des Sezessionskriegs, das vor einer Spaltung der Nation durch die Sklavenfrage warnt: «Ein in sich gespaltenes Haus kann keinen Bestand haben.[1]

Der Kritiker, der dem Werk McQueens offenbar positiv gegenübersteht, setzt die schwarze Hautfarbe des Künstlers mit der «Schwärze» seiner Arbeit gleich. Logisch, dass sich dann die Metaphern aufdrängen. Eine Rassenoptik, die an den Hauptanliegen des Films vorbeisieht, wird anderen Interpretationslinien vorgezogen, etwa McQueens Beziehung zum «Kino der Attraktionen» des Theoretikers Tom Gunning oder zu experimentellen Filmemachern wie Michael Snow. Damit sei nicht gesagt, dass die Rasse der Hauptfigur des Films keine Rolle spielt, nur scheint sie in diesem Fall eher nebensächlich.

Die übliche Überinterpretation schwarzer Kunst macht es umso unerklärlicher, dass kaum ein Kritiker von den schwarzen Körpern Notiz nimmt, die Walker so prominent in seinen Werken platziert. Man könnte argumentieren, dass seine Digital- und Aneignungsstrategien zusammen mit dem Nivellierungseffekt der Collage die Bildbedeutung entleeren. Wenn das die Absicht des Künstlers wäre, bleibt rätselhaft, warum er immer wieder auf eine Thematik zurückgreift, die sich angesichts unserer langen, schmerzvollen Geschichte und unserer aktuellen politischen Realität erfolgreich dagegen wehrt, in die Belanglosigkeit abzugleiten. Wenn es aber stimmt, dass Walkers (schwarze) Subjekte keine besondere Funktion erfüllen – könnte die Kritik dieser Tatsache nicht einfach Rechnung tragen, anstatt den Problempunkt Rasse kurz zu streifen und dann auf sattsam abgehandelte Themen wie Warhol oder Appropriation auszuweichen? Auf institutioneller Ebene herrscht dasselbe Schweigen. Der Kulturkritiker Hazel Carby mutmasste einmal, dass schwarze Kulturprodukte in nicht schwarzen Kreisen als Ersatz für einen anhaltenden, konstruktiven Kontakt mit schwarzen Menschen dienen. Wenn man bedenkt, wie selten schwarze Künstler an Ausstellungen beteiligt sind (oder wie oft sie unter einer Rassen- oder Identitätsschablone zusammengruppiert werden), kommt man tatsächlich zu dem Schluss, dass viele Museen und Kunsthallen lieber mit Bildern von Schwarzen umgehen als mit dunkelhäutigen Menschen in Fleisch und Blut. Und Walker liefert diese Bilder. Der beschriebene Missstand ist natürlich nicht seine Schuld, die liegt im System. Es ist erschütternd, dass eine Frage, die vormals auf wissenschaftlichen Konferenzen und in hitzigen Kuratorengesprächen ausdebattiert wurde, heute als zu langweilig (oder kontrovers) gilt, um noch viele Worte darüber zu verlieren.

Wann sind Rassenunruhen keine Rassenunruhen? Wenn es ein Warhol ist. Aber ist eine Rassenunruhe auch keine Rassenunruhe, wenn sie ein Walker ist? In der Serie *Black Star Press* distanziert sich Walker von Warhol, indem er andere Photovorlagen wählt und die gekippten Bilder mit Schokolade überzieht oder in Coca-Cola-Rot taucht. Zugleich distanziert er sich auch vom Inhalt der Bilder, und diesmal hat Walker die Zeit auf seiner Seite. Warhol verarbeitete aktuelle Nachrichtenphotos. Die Aufnahmen, die Walker für diese Serie heranzieht, dokumentieren Ereignisse, die schon fast ein halbes Jahrhundert zurückliegen. Sie haben ihre ursprüngliche Spannung verloren und sind in den Augen mancher Kritiker «nichts als Bilder» – herausgelöst aus dem histori-

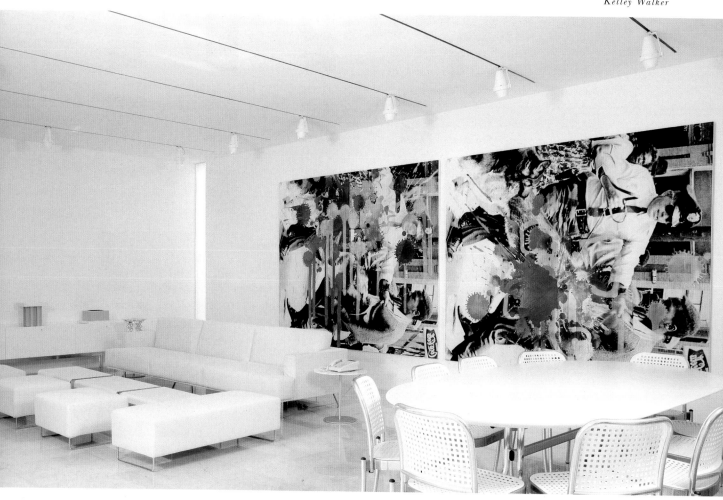

KELLEY WALKER, BLACK STAR PRESS (ROTATED 90 DEGREES), BLACK PRESS, BLACK STAR, 2006,
digital prints on canvas with silkscreened chocolate, installed by Carlos and Rosa de la Cruz, diptych, 83 x 104" each; 83 x 208" overall /
Digitale Prints auf Leinwand, mit siebgedruckter Schokolade, installiert von Carlos und Rosa de la Cruz, Diptychon,
je 211 x 264,2 cm, total 211 x 528,4 cm.

schen und politischen Zusammenhang und daher
beliebig verwendbar.

Walkers Interventionen erzeugen jedoch nicht
nur Distanz zwischen uns und der Photographie
eines Rassenkrawalls, sie bringen uns auch näher
an das Bild heran, zum Teil gerade wegen dem na-
genden Verdacht, dass er es eigentlich gar nicht ver-
wenden dürfte. Rassenunruhen sind Rassenunruhen
– und nicht nur Warhols – in Walkers Kunst, weil
die Verunsicherung, die seine weisse Hautfarbe und

seine schokoladigen Ausschweifungen verursachen,
beweist, dass das Thema Rasse noch lange nicht
hinter uns, sondern jetzt erst wirklich vor uns liegt.
Wir sind gezwungen zu erkennen: Die postrassisti-
sche Gesellschaft, für die die abgebildeten Männer
und Frauen auf die Strasse gegangen sind, die exis-
tiert vorerst noch nicht. Wären wir schon in dieses
Gelobte Land eingezogen, gehörten die fraglichen
Bilder einer «Kultur» an und nicht einer «schwarzen
Kultur» und ihre politische Aussage würde nicht von

*KELLEY WALKER, GRAMMY AWARD 1986, 2009,
2 offset press sheets, front and back, 40 x 28" each /
2 Offsetdrucke, Vorder- und Rückseite, je 101,6 x 71,1 cm.*

der Rassenzugehörigkeit ihres Urhebers oder Benutzers bestimmt. Kelley Walker ist weiss? Bewohner jenes Gelobten Landes würden bei dieser Neuigkeit nur mit der Schulter zucken. Die Wirkung seiner Werke wäre dann nicht mehr auf die Übertretung von (bis dahin ohnehin überholten) Rassentabus angewiesen (wie es bei seinen mit Zahnpasta und Schokolade beschmierten Bildern schwarzer Menschen gegenwärtig der Fall ist) und entspränge stattdessen ihrer Fähigkeit, den komplizierten Prozess

unserer Bild(re)produktion wie auch die Instabilität der Bildbedeutung blosszulegen. In dieser zukünftigen Welt hätten andere bereits gründlich über die Funktion der Rasse in der inneren Mechanik von Walkers Schaffen nachgedacht und erkannt, dass sie ein Grundelement seiner Aussage darstellt (anstatt solche Einsichten als Zwangsvorstellung Schwarzer abzutun).

Apropos Zwangsvorstellungen, hier ist eine von Walker: «Whitney Houston hat etwas Faszinierendes

und zugleich unglaublich Tragisches, das sehr, sehr amerikanisch ist.»[2] Das Faszinierendste, Tragischste und Amerikanischste an Whitney Houston wie auch an Michael Jackson, an Sonny Liston, an den Bürgerrechtskämpfern und am *King*-Covergirl Regina Hall (die alle auf Walkers Bilder erscheinen) ist, dass sie uns klarmachen: Nichts ist amerikanischer als die Afroamerikaner. Amerika ohne Schwarze ist wie ein Tag ohne Sonnenschein. Ich weiss, dass Walker ein guter *American Boy* ist, weil er wie viele andere weisse Amerikaner eine gesunde, widersprüchliche, bedenkliche und gestörte Schwäche für Schwarze

hat, eine Schwäche, zu der auch ich mich bekennen muss. Ehe wir ins Gelobte Land einziehen, tun wir gut daran, Kelley Walkers «Rassenproblem» als amerikanisches Dilemma zu begreifen. Dieses Dilemma, das seinem Werk enorme Vitalität verleiht, missachten wir alle auf eigene Gefahr.

(Übersetzung: Bernhard Geyer)

1) Holland Cotter, «Art in Review», *The New York Times*, 23. Januar 1998, Teil E, S. 35.
2) Christopher Bollen, «Kelley Walker», *Interview Magazine*, Dezember/Januar 2009, S. 159.

KELLEY WALKER, WHITNEY HOUSTON, 1984–85 (2008), aluminum stands, mylar, mirror, Epson prints, disco ball with chain, sound and video projection, dimensions variable, installation view, Paula Cooper Gallery, New York, 2008 / Aluminium-Ständer, Folie, Spiegel, Epson-Prints, Discokugel mit Kette, Klang- und Videoprojektion, Masse variabel.

(PHOTO: ELLEN PAGE WILSON)

ANTEK WALCZAK

New, Uncertain:

In a rather round-about way, many of the artists have provided a visible analog for the Second Law of Thermodynamics, which extrapolates the range of entropy by telling us energy is more easily lost than obtained, and that in the ultimate future the whole universe will burn out and be transformed into an all-encompassing sameness.
—Robert Smithson, Entropy and the New Monuments

What the myth of Götterdämmerung signified of old, the irreligious form of it, the theory of entropy, signifies today—world's end as completion of an inwardly necessary evolution.
—Oswald Spengler, The Decline of the West

If one were to take the twenty six letters of the alphabet, mix them up, and rearrange them in a chance sequence, the odds of returning to their proper order would be slight. Repeating this random assembly another hundred times would yield one hundred more unique and unpredictable arrangements that would nevertheless all have something in common. Viewed as a totality, their exclusive singularities would present a uniform contour of incomprehensibility. Each of these reconfigurations of the English alphabet represents a potentiality or openness that, in differing from the customary A-to-Z sequence, is perceivable as new to the extent that it is uncertain. The uncertainty is due to a lack of information, which, in this case, means a high state of entropy.[1]

A search on MySpace for bands playing within a twenty-mile radius of Manhattan over a one-week period would easily yield a thousand results. However, quantity alone is not a measure of information: though the data returned from our query appears rich, it is also abstracted, undefined, and entropic. To deal with these results we could use a hypothetical creature akin to Maxwell's demon—but instead of reversing thermodynamic entropy by rearranging molecules into hot and cold parts, it would have the power to determine a music

ANTEK WALCZAK is an artist and member of the Bernadette Corporation. He lives in New York.

Speculations Around the Work of Kelley Walker

KELLEY WALKER, BLACK SUEDE, 2005, Black Suede, signed certificate, 58 x ¹/₄",
dimensions variable / Black Suede, signiertes Zertifikat, 147,3 x 0,6 cm, Masse variabel.

KELLEY WALKER, SILVER, 2005, silver leather, signed certificate,
58 x ¹/₄", dimensions variable / Silber-Leder, signiertes Zertifikat,
147,3 x 0,6 cm, Masse variabel.

scene in New York by sorting data into relevant and irrelevant categories. Armed with an extensive archive of the history of music, this "creature" (as software) would go to each of these bands' home pages, listen to their sample tracks, and make decisions as to keeping or discarding the band in question. If it were to adhere to a definition of originality based on pure novelty and difference, it would quickly get bogged down in a multitude of possibilities, an ever-expanding range of novelty where every choice can be just as easily replaced by another. The only way for any single choice to gain significance—or at least survive in a large field of information tending towards entropy—is for it to have some redundancy with what has been already encountered and identified. It is, thus, this redundancy that acts as a constraint in limiting the patterns of possibilities and preventing any of the parts of a system (say, of bands playing in New York) from being wholly independent of one another.[2]

In 1970, the folded arrow logo—the universal symbol for recycling—was the winning design by a University of Southern California student in a contest sponsored by the Container Corporation of America. CCA's patronage of art and use of modernist aesthetics in advertising made it one of the pioneers of corporate sponsorship in the arts. It was this same "giant" of an industry that, beginning in the 1930s, "transformed the manufacture of containers (boxes, bags, tubes, bottles, cans, cartons, jars, caps, and corks) and made possible the inter-

national distribution of consumer goods that would otherwise have been too fragile, perish-able, bulky, or awkward to ship."[3] Eclipsing another prominent circular logo from recent history—the peace sign—the recycling logo was devised to raise awareness of a dilemma and to symbolize its solution, to present disaster and recovery as a single smooth process. The Möbius strip-inspired design, with its endlessly intertwining surface, is a fitting sign to alert people of the environmental destruction resulting from certain forms of production while ensuring the continuation of such production. As a symbol, its meaning is thus quite ambiva-lent. For those sorting garbage within the domestic environment, it might signify reassurance and empowerment—helping to ease the conscience. On the other hand, it is a sign of the relentless persistence of a Capitalist system set on turning its own waste into a commodity.

The same late-Vietnam War, post-'68 consciousness that gave birth to Environmentalism marked the beginning of the postmodern era, which, at the same time, indicated backlash to post-war radical politics. In the end, the state won the battle of "direct confrontation," prompting a back-to-the-land movement, a retreat to rural communal living, leaving only a few hardcore cells in urban communities, who were set on continuing to operate in a mode of underground terroristic spectacle. The leftist presses of the sixties such as the *Berke-ley Barb* and the *Chicago Seed* that arose from rootless, student communities defined by radical politics quickly gave way to the alternative publications of the seventies such as the *Berke-ley Monthly* and the *Chicago Reader*, which helped reshape tradi-tional urban geography by catering to new urban "communi-ties of interest," defined in a commercial context: cinema, art, music, bars, nightclubs, self-improvement centers, and physical therapy courses.[4] For Radicals, there was a great deal of frustra-tion as a result of this complete state of repression, which led

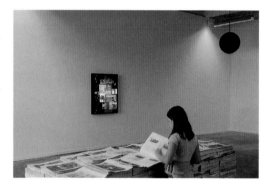

KELLEY WALKER, installation view,
Lyon Biennale, 2007 / Installationsansicht.

to the subsequent foundering of radical political groups and movements altogether. They would begin to seek out solutions as individuals and live out politics as "personal examples"—all with the hope that their political identities would be capable of eventually spreading to and transforming others. Radicalization would continue in areas outside of conventional political struggle, addressing terms of gender and confronting inherited positions of author-ity. But without long-term strategy and follow-up—without re-insertion back into a mode of conflict—identity politics would eventually settle into personal identity policies, decisions about what kinds of information one can consume, and with the spreading of more interac-tive forms of mass media, what kinds of messages one wishes to broadcast.

In contrast to political repression, counter-cultural sensibilities were left free to struggle in the markets of mass industrial society. They enabled, through consumerism, many options for the expansion and diversification of identity, with a democratization of sophistication and the erosion of taste—both of which were once the obvious borders of a mass culture. As with Baudelaire's witticism about the critical awakening of the bourgeois, abnegation of the mainstream is itself a mainstream sentiment today, whether from an elitist position behind a velvet rope and stanchion that could be placed anywhere, or from the refined decision, say, to shop alternatively at a Whole Foods or Hot Topic.[5] Conversely, the notion of a high cul-ture that can be critiqued or opposed by mass culture has become equally hollow, especially with the upgrading of commercial broadband and cable networks for high-speed data access. Being better informed, as we have now begun to see, doesn't necessarily require social activ-

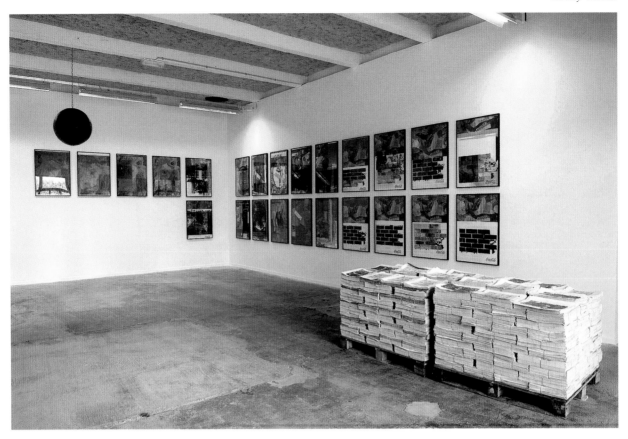

KELLEY WALKER, installation view, Lyon Biennale, 2007 / Installationsansicht.

ity, experience, or initiation. It has become a question of how, in a game of mass differentia-tion, one uses the data being archived. By using taste as a way to identifying with, against, and because of others, one merely decides whether to go with Sade or Lil' Wayne, or both. With information no longer being held or dispensed by hierarchies of the informed, the diffusion and leakage of data entails a loss of power, or aura. This statement comes from a one-time executive director of research at AT&T's Bell Laboratories who concludes, "Perhaps in the past the fact that information was more limited created an uncertainty which provided a kind of free space for human judgment."[6]

In 2001, Benjamin H.D. Buchloh's 1989 essay "Andy Warhol's One Dimensional Art: 1956–1966" was reprinted in a slim *October Files* book on Warhol. The timing of this reprint, com-ing on the heels of the eighties, felt like an incursion into one side of an entrenched debate regarding the "spectacle" of Pop Art. Furthermore, it felt as if the two sides of the debate were by then both outmoded. One of the effects of the policies that descended from iden-tity politics was the nineties notion of stretching and blurring one's identity as an artist by role playing. This was done on a small-scale as a form of personal resistance and denial of the artist as a singular role, but it was also done on a larger scale using big-budget celebrity aplomb rivaling anything the culture industry could muster. In the expansion of the sphere of art practice to include a full range of activities—fashion, running a nightclub, operating

KELLEY WALKER, ANDY WARHOL, JOSEPH BEUYS, LUCIO AMELIO, NAPOLI, APRILE 1980, PHOTO DI MIMMO JODICE, 2007,
detail, digital prints and drafting tape on paper, 5 parts: 78 x 46 ¹/₂", 69 x 46", 65 ³/₄ x 39 ¹/₂", 80 ¹/₂ x 49", 85 x 49 ¹/₂" / Ausschnitt,
Digitaldrucke und Abdeckband auf Papier, 5 Teile: 198,1 x 118,1 cm, 175,3 x 116,8 cm, 167 x 100,3 cm, 204,5 x 124,5 cm, 215,9 x 125,7 cm.

a design business, producing films destined for Cannes, collaborating with pop musicians—
there was yet another expression of the old, dying notion of subverting and scandalizing the
age-old presumptions of high culture. It seemed that the only alternative to participating
in a "pop festival"—in the market-driven, institutionalized white cube—was to critique the
entire situation. By focusing on Warhol's early work in comparison to the New York School,
Buchloh elaborated on the devices of the modernist canon—the monochrome, the ready-
made, seriality—all of which were strategically appropriated by Warhol in order to confront
"dominant art world expectations (and self-deceptions)" of pictorial substance, radical nega-
tion, and openness towards the viewer.[7] This same rationale can be applied to a hypothetical
art practice in 2001—albeit one less interested in Disney-level Pop Art and getting on CNN
than in creating confrontations again within the confines of a traditional gallery space and in
re-appropriating another post-Pop, post-minimal, post-conceptual moment, yet without the
irony-prone distancing mechanisms of institutional and relational critique practices.

The uneasy partnership between technological advances—those which spark all sorts of
implications for the arts prior to their canonization, penetration, and ultimate acceptance—
is a topic well covered by Margot Lovejoy in her book on digital technologies and visual cul-
ture, *Digital Currents: Art in the Electronic Age* (2004). Lovejoy asserts that while photography
may have been readily welcomed by Delacroix, as well as influencing Degas and Manet, it was

just as quickly met by a neutralizing effort to maintain the defense of painting. Allowances were thus eventually made for the christening of a new separate category known as Fine Art photography. It wasn't until Warhol's radical use of silkscreening techniques on canvas that the barriers separating these genres could no longer be sustained.[8]

The same pattern can be identified in the realm of digital technologies and their containment in categories such as new media, or Internet art. Ostensibly, new technologies eradicate more art than they create; YouTube has done more to make earlier, self-confessional, performative video art less interesting than to promote any type of hypermedia aesthetic possibilities in that genre. In spite of the general enthusiasm and publicity given to so-called "technological revolutions," it is only when the tool is buried in a hermetic practice within Fine Art that an actual shift in representation can be seen to occur. Take for example a digital scanner used for creating layers that can then be flattened onto the pixels of an appropriated image. The use here is more concerned with the status of appropriation than with proposing a new kind of photography or digital paint brush. Where appropriation once meant that an image could be taken and redirected somewhere else, the currency of images has been flooded to the point that there is no more value, nor interest, in appropriation as a form of thievery. With the status of the image increasingly reduced to that of randomness and background noise, the act of appropriating a single image is only one step in a more complex process of appropriating art history, manipulating it, picking and choosing parts—parts that may or may not work in a format where shock value is little more than an effect, but an effect that can, all the while, operate as a temporary barrier in the reception of an overall presentation. One of the accusations leveled at our unoriginal age, which can only pick and choose and recombine and recycle, is that it lacks the facility to handle its references. There's no way to reply to such an accusation, but it would be interesting to attempt to explain such objection as the residual impulses and desires of modernist consumers who, in their requirements for more numerous points of originality, are, in fact, stimulating the decomposing action of uncertainty and entropy.

1) Jeremy Campbell, *Grammatical Man: Information, Entropy, Language, and Life* (New York: Simon and Schuster, 1982), pp. 44–48.

2) Ibid., pp. 73–74.

3) For the recycling symbol design contest see Bruce N. Wright, "Earth first," I.D. (Mar./Apr. 1998), p. 32, and for the note on CCA and modern art see Neil Harris, "Designs on Demand: Art and the Modern Corporation," in exh. cat., *Art, Design, and the Modern Corporation* (Washington D.C.: Smithsonian Institution Press, 1985), p. 16, an issue coincidentally raised in Buchloh's text on Warhol (see note 7).

4) David Armstrong, *A Trumpet to Arms: Alternative Media in America* (Boston: South End Press, 1981), pp. 276–277.

5) "The 'bourgeois' ceased to exist the moment he himself adopted the word as a term of abuse—which only goes to prove his sincere desire to become artistic, in relation to the art critics." Charles Baudelaire, "The Salon of 1845 (A few words of introduction)" in *Art in Paris 1845–1862: Salons and Other Exhibitions Reviewed by Charles Baudelaire* (London: Phaidon Press, 1965), p. 1.

6) Robert W. Lucky, *Silicon Dreams: Information, Man, and Machine* (New York: St. Martin's Press, 1989), p. 12.

7) Buchloh writes, "like all other modernist strategies of reduction, the monochrome easily approached the very threshold where sacrality inadvertently turned into absolute triviality, whether as the result of incompetent execution of such a device of apparently supreme simplicity, or from the effect of exhausting a strategy by endless repetition, or as an effect of the artists' and viewers' growing doubts about a strategy whose promises and pretenses had become increasingly incompatible with its actual physical and material object status and functions." Benjamin H. D. Buchloh, "Andy Warhol's One-Dimensional Art: 1956–1966" (1989) in *October Files: Andy Warhol* (Cambridge, Mass.: The MIT Press, 2001), p. 8, 16.

8) Margot Lovejoy, *Digital Currents: Art in the Electronic Age* (New York: Routledge, 2004), pp. 22–24, 54.

ANTEK WALCZAK

Neu, unbestimmt:

So haben viele dieser Künstler eine Art visueller Analogie zum zweiten Hauptsatz der Thermodynamik erstellt, der das Ausmass der Entropie extrapoliert, insofern er besagt, dass Energie leichter verloren geht, als gewonnen wird, und dass in ferner Zukunft das gesamte Universum ausgebrannt sein wird und nur allumfassende Gleichheit bleibt.
– Robert Smithson, «Entropie und Neue Monumente»

Das Weltende als Vollendung einer innerlich notwendigen Entwicklung – das ist die Götterdämmerung; das bedeutet also, als letzte, als irreligiöse Fassung des Mythos, die Lehre von der Entropie.
– Oswald Spengler, *Der Untergang des Abendlandes*

Wer die sechsundzwanzig Buchstaben des Alphabets vermischt und wahllos wieder aufreiht, trifft mit grösster Wahrscheinlichkeit nicht die Reihenfolge A bis Z. Wird der Versuch hundert Mal wiederholt, entstehen hundert einzigartige und unvorhersehbare Buchstabenfolgen, die eines gemeinsam haben: Ihre Singularität zeichnet insgesamt eine scharfe Kontur des Unbegreiflichen. Jede Neuordnung des Alphabets verkörpert in der Abweichung vom üblichen A bis Z eine Möglichkeit oder Offenheit, die – insofern sie unbestimmbar bleibt – als neu empfunden wird. Die Unschärfe entsteht aus einem Informationsmangel, das heisst in diesem Fall aus einem hohen Grad der Entropie.[1]

Eine Suche auf MySpace nach Bands, die in einer Woche innerhalb eines Umkreises von dreissig Kilometern um Manhattan spielen, würde Tausende Resultate bringen. Doch Quantität allein ist kein ausreichendes Mass für den Informationsgehalt erfasster Daten: Was auf den ersten Blick imposant erscheint, entpuppt sich bei genauerem Hinsehen als abstrakt, vage, entropisch. Wir könnten zur Aufschlüsselung der Resultate eine Kreatur wie den maxwellschen Dämonen gebrauchen, der zur Umkehrung der thermodynamischen Entropie warme von kalten Molekülen trennt. Nur hätte er hier die Aufgabe, Informationen über die New Yorker Musikszene als relevant oder irrelevant einzustufen. Bewaffnet mit einem Riesen-

ANTEK WALCZAK ist Künstler und ein Mitglied der Bernadette Corporation. Er lebt in New York.

Spekulationen zum Werk von Kelley Walker

KELLEY WALKER,
BEOGRAM 4000, 2002,
digital print on adhesive vinyl
from CD-ROM, installed by
Debra and Dennis Scholl,
originally produced as a poster
with CD-ROM / Digitaldruck
auf selbstklebendem Vinyl,
installiert von Debra und
Dennis Scholl, ursprünglich
ein Poster mit CD-ROM.
(PHOTO COURTESY OF DEBRA
AND DENNIS SCHOLL,
MIAMI BEACH)

archiv der Musikgeschichte würde diese «Kreatur» (alias Software) auf den Homepages der Bands Hörproben nehmen und dann entscheiden, wer berücksichtigt oder ausgeschieden wird. Ginge er dabei von einem Kriterium aus, das Originalität als neu oder anders definiert, würde er schnell in einer immensen Möglichkeitsvielfalt versinken, in einem sich ständig erweiternden Spektrum neuer Lösungen, die untereinander austauschbar sind. Eine einzelne Möglichkeit kann nur dann Bedeutung erlangen – oder zumindest in dem weiten, entropisch determinierten Informationsfeld überleben –, wenn sie eine gewisse Redundanz mit früheren, bereits bewerteten Elementen aufweist. Diese Redundanz wirkt als Filter, der die Ausbreitung der Möglichkeiten einschränkt und sicherstellt, dass kein Teil des Systems (zum Beispiel alle Bands, die in New York spielen) sich völlig von den anderen ablöst.[2]

Das Recycling-Symbol mit der Endlosschleife aus drei Pfeilen war 1970 der preisgekrönte Beitrag eines Studenten zu einem Designwettbewerb der University of Southern California. Gesponsert wurde der Wettbewerb von der Container Corporation of America (CCA), die sich durch ihre modernistische Werbeästhetik und ihr Kunstprogramm früh als Pionier der privatwirtschaftlichen Kunstförderung hervorgetan hatte. Es war ebendieser Branchengigant, der ab den 30er-Jahren «die Herstellung von Verpackungsmaterial (Schachteln, Tüten, Tuben, Flaschen, Dosen, Behälter, Gläser, Verschlüsse und Korken) revolutionierte und damit den Weg frei machte für den internationalen Vertrieb von Konsumgütern, die andernfalls zu

KELLEY WALKER, installation view,
Paula Cooper Gallery, New York, 2008 /
Installationsansicht.

zerbrechlich, verderblich, sperrig oder ungeeignet für den Transport gewesen wären».[3] Das Recycling-Symbol, das noch populärer wurde als ein anderes Kreissymbol – das CND-Symbol –, sollte auf einen Missstand hinweisen und dessen Korrektur anpreisen: Problem und Lösung in einem einzigen nahtlosen Kreislauf. Der vom Möbiusband inspirierte Entwurf macht effektiv auf die Zerstörung der Umwelt durch bestimmte Produktionsmethoden aufmerksam und stellt zugleich sicher, dass die Produktion unverändert weitergehen kann. Die Bedeutung des Symbols ist zweideutig: Einerseits beruhigt es das Gewissen all jener, die im trauten Heim ihren Müll sortieren; andererseits verbildlicht es das unbeirrbare Fortschreiten des kapitalistischen Systems, das sogar noch den eigenen Abfall zur Ware macht.

Die Zeit nach 1968, als der Vietnamkrieg in seine Endphase ging, markiert nicht nur die Geburtsstunde des Umweltbewusstseins, sondern auch den Beginn der Postmoderne, die in gewisser Hinsicht eine Gegenreaktion auf die Protestbewegungen der Nachkriegszeit darstellte. Der durch direkte Konfrontation attackierte Staat behielt am Ende die Oberhand. Es folgte der Rückzug in Landkommunen. In den Stadtzentren hielten sich nur ein paar extremistische Zellen, die eine Art terroristisches Untergrundspektakel inszenierten. Die linken Blätter der 60er-Jahre wie *Berkeley Barb* oder *Chicago Seed*, eine Blüte des wurzellosen, radikalen Studentenmilieus, wichen rasch der Alternativpresse der 70er-Jahre wie *Berkeley Monthly* oder *Chicago Reader*, die auf die neuen urbanen «Interessengemeinschaften»

zugeschnitten waren (definiert nach kommerziellen Gesichtspunkten: Kino, Kunst, Musik, Bars, Nachtclubs, Selbsthilfegruppen, Physiotherapiekurse) und damit die Neuordnung der Stadtgeographie beschleunigten.[4] Radikale Gruppen und Strömungen litten unter der fast totalen Unterdrückung und verloren zunehmend an Bedeutung, bis sie begannen, nach individuellen Lösungen zu suchen. Man lebte Politik als «persönliches Beispiel» – in der Hoffnung, dass das eigene politische Bewusstsein irgendwann in der Lage sein würde, andere zu erreichen und zu verändern. Gesellschaftskritische Ideen florierten ausserhalb der konventionellen politischen Arena; überkommene Geschlechterrollen und Autoritätsstrukturen wurden demontiert. Doch ohne langfristige Strategien und anhaltende Konfliktbereitschaft degenerierte Identitätspolitik zur vereinzelten Identitätstaktik, die sich heutzutage die Frage stellt, welche Art von Information konsumiert und – mit dem Aufkommen interaktiver Massenmedien – weiterverbreitet werden soll.

Angesichts der politischen Repression mussten die Anhänger der Gegenkultur auf sich allein gestellt ums Überleben in den Märkten der Industriegesellschaft kämpfen. Ihr Konsumismus eröffnete der Identität neue Erweiterungs- und Diversifikationsmöglichkeiten. Parallel dazu kam es zu einer Demokratisierung und Nivellierung des «guten» Geschmacks, der sich vordem von der Trivialkultur abgegrenzt hatte. Wie in Baudelaires Bonmot über das Erwachen des kritischen Verstands beim Spiesser ist die Ablehnung des Mainstream selbst zum Mainstream geworden, egal ob man elitär hinter dem roten Absperrseil, das überall aufgestellt werden kann, Position bezieht oder ob man sich die knifflige Frage stellt, in welchem alternativen Delikatessen- oder Modeladen man sein Geld ausgeben soll.[5] Umgekehrt hat auch die Idee einer Hochkultur als Zielscheibe der Massenkultur an Substanz verloren, besonders seit dem Aufkommen kommerzieller Highspeed-Netze. Besser informiert zu sein, erfordert, wie sich herausstellt, nicht unbedingt soziale Aktivitäten, Erfahrungen oder Bindungen. Vielmehr geht es heute darum, wie man in einem Spiel der Massendifferenzierung die archivierten Daten nutzt. Der Geschmack als Identifikation mit, wegen oder gegen etwas läuft auf die Entscheidung hinaus, ob man es mit Sade, Lil Wayne oder beiden hält. Da die Information nicht mehr von Hierarchien Informierter kontrolliert und verbreitet wird, verursacht das Entweichen und Durchsickern der Daten einen Verlust der Macht und Aura. Ein ehemaliger Forschungsdirektor der Bell Laboratories von AT&T kommentiert: «Der Umstand, dass Informationen früher nur beschränkt verfügbar waren, liess eine Unsicherheit entstehen, die dem menschlichen Urteil einen gewissen Freiraum bot.»[6]

Benjamin H. D. Buchlohs Essay «Andy Warhol's One Dimensional Art: 1956–1966» (1989) erschien 2001 in einem schmalen Band von *October Files* über Warhol. Der Zeitpunkt der Neuauflage kurz nach Ende der 90er-Jahre wirkte wie ein Frontalangriff im Stellungskrieg, der zwischen Kritikern um das «Spektakel» der Pop-Art tobte. Die Opponenten wirkten damals schon recht angestaubt. Eine der Folgen, der zur Taktik verkommenen Identitätspolitik, war die Tendenz vieler Künstler der 90er-Jahre, die Identität durch Rollenspiele zu dehnen und zu verwischen. Dies geschah auf individueller Ebene als Widerstand gegen die elitäre Position des Künstlers, aber auch in gross angelegten Kampagnen, die den Vergleich mit den Mechanismen der Kulturindustrie nicht zu scheuen brauchen. Die Erweiterung der Kunstpraxis auf Aktivitäten aller Art – Mode, Leitung eines Nachtclubs oder eines Designbüros, Filmproduktionen auf Cannes-Niveau, Gemeinschaftsprojekte mit Popmusikern – war im Kern beseelt vom alten, sterbenden Impuls, die überkommenen Konventionen der Hochkultur zu sabotieren. Wer an den Popfestivals im kommerzialisierten, institutionalisierten *White Cube* nicht teilnehmen wollte, dem blieb kein anderer Ausweg, als die gesamte Situation anzupran-

gern. In seiner Beschränkung auf das Frühwerk Warhols im Kontrast zur New York School erhellte Buchloh das Instrumentarium der Moderne – Monochromie, Readymade, Serialität –, das Warhol strategisch genutzt hat, um die vorherrschenden Erwartungen und Selbsttäuschungen der Kunstwelt wie Materialität des Bildes, radikale Negation und Offenheit zum Betrachter zu düpieren.[7] Dasselbe Schema liesse sich auch im Jahr 2001 auf eine Kunstpraxis anwenden, die weniger an einer disneyartigen Pop-Art oder an CNN-Auftritten interessiert war, sondern an den wiederholten Auseinandersetzungen mit den Grenzen des Galerieraums und an erneuten Versuchen mit einem Post-Pop-, Post-Minimal-, Post-Konzept-Ansatz, diesmal allerdings frei von den ironisch besetzten Distanzierungsmechanismen institutioneller und relationaler Kritik.

Das gespaltene Verhältnis zu technologischen Neuerungen – die die Künste auf vielfältige Weise beeinflussen, ehe sie infiltriert, absorbiert und schliesslich akzeptiert werden – behandelt Margot Lovejoy in ihrem Buch über Digitaltechnologie und visuelle Kultur *Digital Currents: Art in the Electronic Age*. Die Photographie, schreibt Lovejoy, wurde von Delacroix enthusiastisch aufgenommen und auch Degas und Manet waren für ihre Anregungen empfänglich. Zugleich gab es aber auch Bemühungen, die Photographie zum Schutz der Malerei zu neutralisieren. So wurde eine völlig neue Disziplin aus der Taufe gehoben, die Kunstphotographie. Erst Warhol hat durch seine radikale Anwendung des Siebdrucks auf Leinwand die Grenzen zwischen den beiden Genres aufgebrochen.[8]

Dasselbe Schema wiederholt sich nun im Bereich der Digitaltechnologie und ihrer Eingrenzung in Kategorien wie Neue Medien oder Netzkunst. Vieles spricht dafür, dass die neuen Technologien mehr Kunst eliminieren als schaffen. YouTube lässt frühe bekenntnishafte Videoperformances langweiliger aussehen und hat aus ästhetischer Sicht nicht die erwartete hypermediale Innovation gebracht. Trotz der Euphorie und des Medienrummels um die sogenannte «technologische Revolution» kann eine echte Neuwertung der Repräsentation erst dann stattfinden, wenn die neuen Techniken in eine hermetische Praxis innerhalb der bildenden Kunst eingebettet sind. Man nehme zum Beispiel die Erzeugung visueller Schichten mittels eines Digitalscanners, die dann über die Pixel eines Medienbilds gelegt werden. Der Künstler will hier den Akt der Aneignung thematisieren und nicht irgendeiner neuen Art der Photographie oder digitalen Malerei zum Durchbruch verhelfen. Aneignung bedeutete früher, dass man ein Bild nimmt und in eine neue Richtung dirigiert. Inmitten der heutigen Bilderflut hat die Aneignung als Diebstahl jeden Wert und Anreiz verloren. Während das Bild zum beliebigen Hintergrundgeräusch verkommt, bildet seine Aneignung nur einen Schritt im komplexen Prozess der Aneignung der Kunstgeschichte. Man dreht und wendet sie und holt sich die Teile heraus, die man braucht – Teile, die nicht unbedingt funktionsfähig sind in einer Situation, in der Schockwirkung wenig mehr ist als ein Effekt, aber immerhin kann dieser Effekt die Rezeption eines Werks kurzzeitig blockieren. Unserer einfallslosen Zeit, die nichts kann als herauspicken und wiederverwerten, wird oft vorgeworfen, sie hätte die Kontrolle über ihre Informationsquellen verloren. Darauf lässt sich nichts sagen, doch wäre es interessant, diese Anschuldigung als rudimentären Trieb und Wunsch des modernistischen Konsumenten zu deuten, der mit seiner Forderung nach mehr Originalität ungewollt die Auflösungskräfte der Instabilität und Entropie in Bewegung setzt.

(Übersetzung: Bernhard Geyer)

1) Jeremy Campbell, *Grammatical Man: Information, Entropy, Language, and Life*, Simon and Schuster, New York 1982, S. 44–48.

2) Ebd. S. 73–74.

3) Für den Recycling-Symbol-Wettbewerb vgl. Bruce N. Wright, «Earth first», *I.D.* (März/April 1998), S. 32. Zur Rolle der CCA in der modernen Kunst vgl. Neil Harris, «Designs on Demand: Art and the Modern Corporation», in: *Art, Design, and the Modern Corporation*, Ausst.-Kat., Smithsonian Institution Press, Washington, D.C. 1985, S. 16.; zufälligerweise schneidet auch Buchloh in seinem Text über Warhol dieses Thema an (vgl. Anm. 7).

4) David Armstrong, *A Trumpet to Arms: Alternative Media in America, South End Press*, Boston 1981, S. 276–277.

5) «Es gibt den Bourgeois nicht mehr, seit der Bourgeois – was seinen guten Willen beweist, sich den Feuilletonschreibern gegenüber zum Artisten entwickeln – sich selber dieses Schimpfwortes bedient.» Charles Baudelaire in «Der Salon 1845», in *Sämtliche Werke*, Band 1, Juvenilia – Kunstkritik, 1832–1846, München, Carl-Hanser-Verlag 1977, S. 127.

6) Robert W. Lucky, *Silicon Dreams: Information, Man, and Machine*, St. Martin's Press, New York 1989, S. 13.

7) Buchloh schreibt, «Andererseits teile die Monochromie das Schicksal anderer Reduktionsverfahren der Moderne – sie endete im Trivialen. Und daran war entweder die unzulängliche Anwendung einer Methode von scheinbar grösster Einfachheit schuld, deren Erschöpfung durch unendliche Wiederholung, oder durch die wachsenden Zweifel bei Künstlern und Publikum an einer Strategie, deren Versprechungen immer weniger mit den realen Kunstobjekten und ihren Funktionen vereinbar waren.» Benjamin H. D. Buchloh, Andy Warhols eindimensionale Kunst: 1956–1966", in *Andy Warhol Retrospektive*, Ausst.-Kat., Museum Ludwig, Prestel-Verlag, München, 1989 S. 44.

8) Margot Lovejoy, *Digital Currents: Art in the Electronic Age*, Routledge, New York 2004, S. 22–24, 54.

KELLEY WALKER, BOSE, 2007, digital print and gold leaf on laser-cut steel, 58 x $^1/_8$",

installation view Le Magasin, Grenoble, 2007 / Digitaldruck und Blattgold auf lasergeschnittenem Stahl,

147,3 cm x 0,3 cm. (PHOTO: ILMARI KALKKINEN)

KELLEY WALKER, BOSE, 2007, digital print and gold leaf on laser-cut steel, 58 x $^1/_8$" /

Digitaldruck und Blattgold auf lasergeschnittenem Stahl, 147,3 x 0,3 cm.

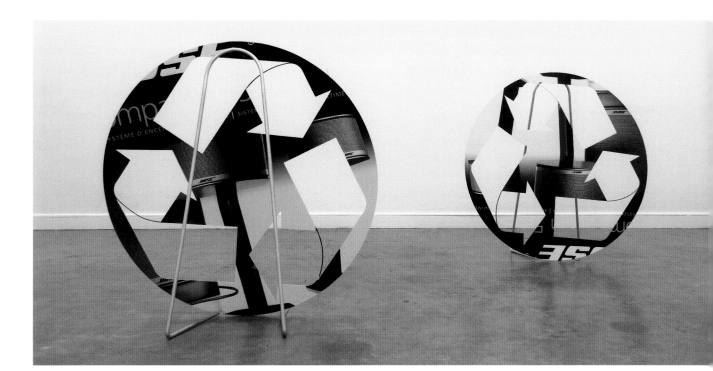

EDITION FOR PARKETT 87

KELLEY WALKER

UNTITLED, 2010

Cast in various media (e. g. chocolate, paper pulp, resin),
each unique, with cap worn by artist,
approx. 12 x 7 x 11", approx. 15.5 lbs.
Edition of 35/XX, signed and numbered certificate

Guss in diversen Materialien (Schokolade, Papiermaché, Harz, u. a.),
Unikate, mit vom Künstler getragener Kappe,
ca. 30 x 17,5 x 26 cm, ca. 7 kg.
Auflage 35/XX, signiertes und nummeriertes Zertifikat.

Moon Turned
a Fire Red

MICHAEL ARCHER

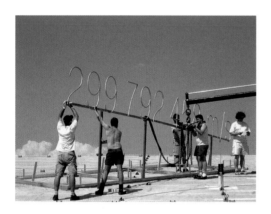

CERITH WYN EVANS, 299,792,458 M/S, 2004, installation view, Kunsthaus Bregenz / Installationsansicht. (PHOTO: DUSTY SPRENGNAGEL)

Walter Benjamin was only expressing a truth all of us had already grasped with our senses when he wrote in *One Way Street* (1928) about the way in which neon signs transmit their messages. It is not, strictly speaking, what they say that matters; it is, rather, their reflection in the surfaces of their surroundings that carries the content. Benjamin's image of the neon sign's text—"the fiery pool reflecting it in the asphalt"—is specific, revealing the extent to which our apprehension of contemporary culture's spectacular offerings is a haptic process.[1] If the world around us is a series of screens or surfaces onto which consumerism's messages are projected, then our intimate contact with the material grain of those surfaces offers the key to much of our understanding. And if, as Benjamin suggests, it is the spectacle that defeats criticism, it can only be through that contact, rather than by one's attempt to remove oneself from it, that a space for thought can be found. It is here, in the intimacy of this contact, in the specificity of the image and its material substrates, and in an examination of just what it is to transmit a message, that Cerith Wyn Evans focuses his attention.

Over the past dozen or so years Wyn Evans has made a number of neon works, many of which have been short texts. Even where they are an image (or an abstract form), it seems that words play a major part. One example of this is TAKASHIMAYA ROSE (2007) which was made as a direct response to the work of the Scottish poet and artist Ian Hamilton Finlay. Renowned for his major project, LITTLE SPARTA (1966–), the garden where he lived near Edinburgh before his death in 2006, Finlay's interest in the rose was multi-layered: it was not only the literal flower, but also an image encountered in its many historical, literary, mythical, and metaphorical guises. Wyn Evans' ROSE—the logo of the famous Japanese Takashimaya department store—refers to a similarly complex history: a barbed, protected symbol of

MICHAEL ARCHER is a writer on art, and Reader in Art at Goldsmiths College, London.

CERITH WYN EVANS, 299,792,458 M/S, 2004, installation view, Kunsthaus Bregenz /
Installationsansicht. (PHOTO: DUSTY SPRENGNAGEL)

courtly love, chaste purity, beauty, and sentiment. If the concerns of the two artists can be seen to intersect, the ground of their meeting is surely Gertrude Stein's effort to unpack the flower's symbolic complexity and to relieve it of its accreted layers of cloying sentimentality. Her "rose is a rose is a rose," admired by Finlay as exemplary in its insistence upon the need to allow words to tell their own story, brings us, in the company of Wyn Evans' work, up against Sigmund Freud's equally emphatic pronouncement urging us to believe the evidence of our own eyes and to accept that sometimes a cigar is just a cigar. What is essential is the acknowledgement that, despite the apparent abstract insubstantiality of the word, the potential for recognition and interpretation lies in an engagement with certain physical qualities: the spill of the light, its color, its pattern, font, gauge, the arc and fold of the neon's glass tubing, the wall upon which it is fixed, and so on. Insofar as these neons—texts or not—are readable then, they are so in part as diverse attempts to answer the question Wyn Evans himself poses: "How could a text be carried now?" The question recalls Richard Wollheim's discussion of "the way of borrowing" in his book *Painting as an Art* (1987). How is it possible, he asks, to work with a text, and the ideas it embodies, without the borrowing being no more than an

act of subservience, obeisance, inadequacy?[2] How can the delivery of those embodied ideas simultaneously figure the space for the viewer's interpretative experience? Wyn Evans' work is always a matter of this kind of spacing.

He lays similar weight on the "tactility" of visual experience, and its importance, primarily in the context of film, for the viewer's critical engagement. "There is an assumption," so he says, "that the image is what happens within the screen." So as to counter this easy assumption that content resides merely within the picture, Wyn Evans stresses his concern with the means by which any image becomes possible: "I was always more interested in the structural,

CERITH WYN EVANS, installation view, 2009, deSingel, Antwerp / Installationsansicht. (PHOTO: JAN KEMPENAERS)

material aspects—what the notion of projection means. I want to knock on the walls or look at the materiality of how this is translated into pixels or the grain of emulsion."[3] Many of the neon works, in fact, refer more or less directly to the language of film and the narrative structures associated with it. Take, for example, LATER THAT DAY (2001), MEANWHILE... ACROSS TOWN (2001), INTERIOR (DAY) (2001), and SLOW FADE TO BLACK... (2003). In each, our apprehension of time and location is precisely dislocated, while at the same time overlaid with

a strong sense of reality having become its own fiction. TIME HERE BECOMES SPACE (2004) says another neon, along with its companion, SPACE HERE BECOMES TIME (2004); and closely related, too, is 299,792,458 M/S (2004): this number, the speed of light itself, is that absolute constant which, as Naum Gabo and Antoine Pevsner pointed out in the "Realistic Manifesto," is at once the fastest and at the same time the stillest, quietest phenomenon.[4]

One of the earliest neons, from 1997, is a figure made up of several sweeping curves. Initially, it appears as a loosely drawn figure eight, but the way in which the lines overlap and interweave makes it spatially far more complex. What Wyn Evans has, in fact, sketched out is, as the title suggests, a MÖBIUS STRIP (1997)—that easily-produced, endlessly fascinating, twisted and looped band which, having neither inside nor outside, exists as a single, continuous surface. Much more recently, ...VISIBLEINVISIBLE (2007) reiterates MÖBIUS STRIP's interior/exterior continuity through its reference to Maurice Merleau-Ponty's last, unfinished book, *The Visible and the Invisible* (1968). This book, especially the chapter, "The Intertwining: The Chiasm," has been an element in several of Wyn Evans' recent works, such as the blinds he installed over the windows of the White Cube gallery in 2008, whose automated openings and shuttings spelled out passages from Merleau-Ponty's text in Morse code. "The visible of the world," writes Merleau-Ponty, "is... a connective tissue of exterior and interior horizons." Connectivity makes the relationship between the visible and he or she who sees, a reciprocal one: "He who sees cannot possess the visible unless he is possessed by it, unless he is of it."[5] Wyn Evans values this emphasis on transitivity for the way it allows Merleau-Ponty's thought to move from "a phenomenological real of a body in space" to recognition of the possibility of community and correspondence as achievable on a different level.[6]

The year prior to MÖBIUS STRIP, Evans had made INVERSE, REVERSE, PERVERSE (1996), an installation whose major element was a large, wall-mounted concave mirror. Those looking into it would find themselves reflected just as the title suggests. Turning to leave, they were then confronted with a pale green neon above the gallery's doorway which spells out "EXIT" in reverse: TIXƎ. The sign was hidden due to its position in the room, and it was only after having been flipped and somersaulted through the act of looking in the mirror that visitors found themselves to be, as it were, behind the looking glass into which they had just been staring. The way out of the gallery—also being the same way in—is revealed to be the exit through which they must already have passed, for the back-to-front nature of the text clues one in to the idea that they are positioned on the sign's, and thus the doorway's, far side.

CERITH WYN EVANS, THE PLEXIGLASS COVER OF AN EIGHTIES BANG & OLUFSEN RECORD PLAYER. RESTING ON TOP, THE REPLICA OF AN AZTEC SMILING FACE MADE FROM JADE. BELOW, A JAZZ RECORD THAT HAS REMAINED STILL FOR YEARS... , 2008, neon installation, deSingel, Antwerp / DER PLEXIGLAS-DECKEL EINES BANG & OLUFSEN PLATTENSPIELERS DER 80ER JAHRE. DARAUF, DIE KOPIE EINES LÄCHELNDEN AZTEKENGESICHTS AUS JADE. UNTEN, EINE JAZZ-PLATTE, DIE JAHRELANG NICHT GESPIELT WURDE, Neon-Installation. (PHOTO: JAN KEMPENAERS)

The three words of the title—inverse, reverse, and perverse—are familiar from their multiple appearances in the lyrics to the Velvet Underground song "The Murder Mystery." (And here we might think, again, of Freud, for whom the task of investigating the subconscious processes that present themselves as slips of the tongue was akin to the work of "a detective engaged in tracing a murder.")[7] Though "The Murder Mystery" was recorded and released in 1968–69, after John Cale had left the band, it is nonetheless Cale's association with the group that adds a further layer to the work since his boyhood home, Garnant in South Wales, is also the place where Wyn Evans' paternal grandparents lived. What we are to do with such information and, indeed, how we are to come by it in the first place is a key issue. Wyn Evans talks of it as a problem of "encryption," that is, the presence within the work of a frame (of reference) or alternatively a cipher whose function may be understood as essentially communicative rather than as a barrier to comprehension.[8] How might one frame a work, label it, or otherwise invite access to an interpretative resource within it that might allow the viewer to engage with its different layers rather than feel alienated by lack of knowledge? One often-encountered way is to consider Wyn Evans' working method as a kind of collage, as the term relates to Cubism. It is here that one finds a mix and juxtaposition of elements and modes of representation—text as words, text as image, drawn and painted representations, trompe l'œil sleight of hand, printed matter bearing imagery and text, paper carrying color, and so on. All of these are multivalent with regard to the structure, form, subject matter, and content of the collage. Wyn Evans' practice is certainly rich in this kind of gathering and placing of things in relation to one another, but I would suggest that neither collage nor even the more constructive overtones of montage are quite adequate to categorize what his work ultimately achieves. The neons impress upon us the far more integral co-existence of the multiple realms to be found within his work, whether those realms are literal, fabulous, hallucinatory, or otherwise.

"Voodoo Chile (Slight Return)" is the final track on Jimi Hendrix's 1968 double album *Electric Ladyland.* In literal terms, it is what the title states: a shorter, higher tempo and more aggressive reappearance or resumption of the long, slow blues track "Voodoo Chile," on the first side of the album. In a more oblique sense, those four words (and the parentheses that loosely hold two of them) invoke the insurgent recurrence of the mystical, the magical, and the inexplicable within the rationality of civilized existence. They offer, in other words, a prime instance of the Freudian notion of the return of the repressed. I am aware that introducing the song in this way, locating it on the fourth side of a double LP, is to speak of the outmoded and the technologically superseded. For who, nowadays, would look to a pair of twelve-inch diameter plastic discs, grooved on both sides, as the optimum method for delivering an eighty-minute collection of songs to the prospective listener? But such recourse to the obsolete is a feature of Wyn Evans' work. It is so, not because of a wish on his part to champion the old-fashioned for its own sake, but because, again as Freud assured us, that which is past is not irretrievably gone. It remains endlessly available for recuperation into the processes of meaning-production.

CERITH WYN EVANS, SPACE HERE BECOMES TIME – TIME HERE BECOMES SPACE, 2004, neon installation, deSingel, Antwerp /

In 2006, Wyn Evans used part of the final verse in "Voodoo Chile (Slight Return)" as the text for a neon sign. Though the color of the light used was white, the front of the tubes were darkened, so that the words read as black letters on the white glow that bounced off the wall from the rear of the tube:

And if I don't meet you no more in this world
Then I'll, I'll meet you in the next one
And don't be late, don't be late

The many repetitions and slippages within this short passage imply a kind of blurring that might come from the overlapping and super-position of images—this world and the next, meet meet, don't don't don't, be be, late late. It is as hesitant as it is authoritative. It stutters in a way reminiscent of the thought patterns of Gilles Deleuze and Félix Guattari's conceptual persona, the Stammerer. Just as the Stammerer prompts the question, "what is this thought that can only stammer?" we wonder what world(s) are revealing themselves to us in the text's repetitions and differences.[9] The central repetition of AND IF I DON'T MEET YOU ... (2006) is I'll, I'll. Mirroring each other across the separating linkage of the comma, the twinned identities of the doubled "I" can be seen to exist simultaneously in both this world and the next. Such doubling is of the same nature as that which Rosalind Krauss discusses in her study of "The Photographic Conditions of Surrealism." Generally reluctant to employ montage as a means to juxtapose competing and conflicting realities, the Surrealists "infiltrated the body" of the photographic print with a "spacing" produced through techniques such as the positive/negative image of the Rayograph. What is seen in the Surrealist photograph, therefore, is not "reality," but "the world infested by interpretation or signification."[10] Wyn Evans' neon signs demonstrate to us that our own world is equally infested and that we should, for sure, embrace the symptoms.

1) Walter Benjamin, "This Space for Rent" in "One Way Street," *Selected Writings, Volume 1: 1913–1926* (Cambridge, Mass: Belknap Press, 1996), p. 476.

2) Richard Wollheim, *Painting as an Art* (London: Thames & Hudson, 1987). See Chapter IV, "Painting, Textuality, and Borrowing," p. 187.

3) Cerith Wyn Evans interviewed by Manfred Hermes in *Cerith Wyn Evans* (Frankfurt and New York: Frankfurter Kunstverein in association with Lukas & Sternberg, 2004), p. 131.

4) "Look at a ray of sun... the stillest of the still forces, it speeds more than 300 kilometres in a second... behold our starry firmament... who hears it... and yet what are our depots to those depots of the Universe?"—Naum Gabo & Antoine Pevsner, "The Realistic Manifesto," 1920. Reprinted in Herschel B. Chipp, *Theories of Modern Art: A Sourcebook by Artists and Critics* (Berkeley and London: University of California Press, 1968), p. 327.

5) Maurice Merleau-Ponty, *The Visible and the Invisible* (Evanston, Illinois: Northwestern University Press, 1968), footnote p. 131, author's emphasis.

6) See note 3, p. 135.

7) Sigmund Freud, *Introductory Lectures on Psychoanalysis* (Harmondsworth: Penguin, 1974), p. 52. This is, in fact, itself a nice parapraxis since, in the course of his interview with Hermes, Wyn Evans says that "inverse, reverse, perverse" is a quote from "The Gift." "The Gift" appears on the Velvet Underground's second album, *White Light/White Heat*, and, like "The Murder Mystery," makes use of a radical separation of sound between the two stereo channels. Cale voices the narrative of "The Gift."

8) See note 3, p. 130.

9) Gilles Deleuze and Félix Guattari, *What is Philosophy* (London: Verso, 1994), p. 69.

10) Rosalind E. Krauss, "The Photographic Conditions of Surrealism," originally published in *October*, no. 19 (Winter 1981), reprinted in *The Originality of the Avant-Garde and Other Modernist Myths* (Cambridge, Mass: MIT Press, 1985), p. 107.

CERITH WYN EVANS, VISIBLE INVISIBLE, 2007, installation view (exterior), White Cube Gallery, London /

Der Mond färbte ein Feuer rot

MICHAEL ARCHER

Als Walter Benjamin in *Einbahnstrasse* (1928) beschrieb, wie die Neonreklame ihre Botschaft überbringt, brachte er lediglich eine bereits allgemein vertraute Sinneserfahrung auf den Punkt: Es kommt gar nicht so sehr darauf an, was die Reklame sagt, sondern ihre Spiegelung auf den Flächen rundum – «die Feuerlache, die auf dem Asphalt sie spiegelt» – vermittelt uns ihren Sinn. Benjamins Metapher für die Neonreklame ist insofern bezeichnend, als sie enthüllt, wie weitgehend unsere Wahrnehmung des spektakulär auftretenden modernen Kulturangebots eine haptische Angelegenheit ist.[1] Wenn die Welt um uns herum aus lauter Bildschirmen oder Projektionsflächen der Botschaften unserer Konsumgesellschaft besteht, dann liegt der Schlüssel zu unserem Verständnis weitgehend in unserer unablässigen hautnahen Berührung mit der materiellen Realität dieser Flächen. Und wenn Benjamins Ansicht zutrifft, dass das Spektakel das Ende der Kritik bedeutet, so allein aufgrund dieser Reibung und nicht durch die Bemühungen eines Einzelnen, Distanz beziehungsweise Raum zum Denken zu gewinnen. Cerith Wyn Evans richtet seine ganze Aufmerksamkeit auf diesen engen Kontakt, auf die spezifische Beschaffenheit von Bild und Trägermaterial und untersucht dabei, was das eigentlich i s t : eine Botschaft übermitteln.

Im Lauf der vergangenen zwölf Jahre schuf Wyn Evans eine Reihe von Neonarbeiten, darunter viele mit kurzen Texten; selbst wo es sich um ein Bild (oder eine abstrakte Form) handelt, scheinen Worte eine wichtige Rolle zu spielen. TAKASHIMAYA ROSE (2007) ist ein solches Beispiel, die Arbeit entstand in direkter Auseinandersetzung mit dem Werk des

MICHAEL ARCHER ist Kunstpublizist und Dozent für bildende Kunst am Goldsmiths College in London.

CERITH WYN EVANS, VISIBLEINVISIBLE, 2007, installation view (interior), White Cube Gallery, London /
SICHTBARUNSICHTBAR, Installationsansicht (innen). (PHOTO: STEPHEN WHITE)

schottischen Dichters und Künstlers Ian Hamilton Finlay, der vor allem durch sein gros-
ses Gartenprojekt LITTLE SPARTA (Klein-Sparta, 1966–) berühmt wurde. Finlays Interesse
an der Rose war vielschichtig und galt durchaus nicht nur der Blume selbst, sondern auch
dem Bild der Rose in all seinen historischen, literarischen, mythischen und metaphorischen
Ausprägungen. Wyn Evans' ROSE – das Logo des bekannten japanischen Warenhauses Ta-
kashima – verweist auf einen ähnlich komplexen historischen Hintergrund: ein mit Dor-
nen bewehrtes Symbol der höfischen Liebe, keuschen Reinheit, der Schönheit und feinen
Empfindung. Wenn die Interessen der beiden Künstler sich hier überschneiden, so ist die
Basis dieser Gemeinsamkeit zweifellos in Gertrude Steins Versuch zu sehen, die symbolische
Komplexität der Blume aufzubrechen und sie von den angelagerten Sentimentalitätsschich-
ten zu befreien. Ihr «Rose ist eine Rose ist eine Rose» – für Finlay
ein bewundernswertes Beispiel für das Beharren auf der Notwen-
digkeit, Wörtern zu erlauben, ihre eigene Geschichte zu erzählen
– bringt uns in Kombination mit Wyn Evans' Arbeiten auf Sigmund
Freuds nicht minder emphatische Aufforderung, unseren eigenen
Augen zu trauen und zu akzeptieren, dass eine Zigarre manchmal
nur eine Zigarre ist. Entscheidend ist die Anerkennung der Tatsa-
che, dass die Erkenntnis und Deutung eines Wortes, trotz seiner
scheinbar abstrakten Immaterialität, auf dessen Verknüpfung mit
gewissen physischen Qualitäten beruht: Lichtfluss, Farbe, Muster,
Schrifttyp und -grad, Biegungen und Knicke der Neonröhren, der
Wand, an dem das Ganze befestigt ist, und so fort. Wenn sich diese
Neonarbeiten – ob Text oder nicht – entziffern lassen, so zumindest

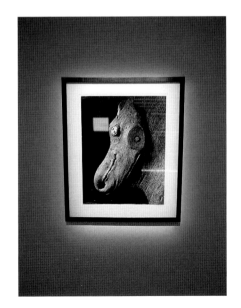

SULWYN EVANS, UNTITLED, ANTHROPOMORPHIC PHOTOGRAPH, 2003,
installation view, White Cube Gallery, London / OHNE TITEL,
ANTHROPOMORPHE PHOTOGRAPHIE. (PHOTO: STEPHEN WHITE)

als mögliche Antwort, auf die von Wyn Evans gestellte Frage: «Wie lässt sich heute ein Text übermitteln?» Die Frage erinnert an Richard Wollheims Erörterung über die «Art der Anlehnung» in seinem Buch *Painting as an Art* (1987). Wie ist es möglich, mit einem Text und der Idee, die er verkörpert, zu arbeiten, ohne dass die Anlehnung nichts weiter ist als ein Akt der Unterwerfung, Huldigung und der eigenen Unzulänglichkeit?[2] Wie kann die Übermittlung der verkörperten Ideen zugleich den Raum für die interpretative Erfahrung des Betrachters mitliefern? In Wyn Evans' Arbeit geht es immer um solche Zwischenräume.

Ähnliches Gewicht legt er auf das «Taktile» der visuellen Erfahrung und auf dessen Bedeutung für das kritische Verhältnis des Betrachters, vorab im Zusammenhang mit dem Medium Film. «Man nimmt allgemein an», sagt er, «dass das Bild das ist, was sich auf der Leinwand abspielt.» Und um der bequemen Annahme entgegenzutreten, der Inhalt stecke einfach im Bild, betont Wyn Evans sein Interesse für die Mittel, die jedes Bild möglich machen: «Ich war aber immer eher an den strukturellen Aspekten, etwa der Projektion, interessiert. Ich

möchte an die Wände klopfen, auf die Materialität eingehen und sehen, wie sich ein Bild in Pixel oder in das Korn der Emulsion übersetzt ...»[3] Viele der Neonarbeiten nehmen tatsächlich mehr oder weniger direkt Bezug auf die Filmsprache und deren narrative Strukturen. Nehmen wir beispielsweise LATER THAT DAY (Etwas später am Tag, 2001), MEANWHILE... ACROSS TOWN (Inzwischen, am anderen Ende der Stadt, 2001), INTERIOR (DAY) – Innenraum (bei Tag), 2001 – und SLOW FADE TO BLACK... (Allmähliches Sich-Verlieren im Schwarz, 2003). In jedem dieser Werke wird unser Orts- und Zeitempfinden gezielt gestört und zugleich vom Eindruck überlagert, dass die Wirklichkeit zu ihrer eigenen Fiktion geworden ist. TIME HERE BECOMES SPACE (Zeit wird hier Raum, 2004) sagt ein weiterer Neonschriftzug in Begleitung von SPACE HERE BECOMES TIME (Raum wird hier Zeit, 2004); nah verwandt ist auch 299,792,458 M/S (2004); diese Grösse, die Lichtgeschwindigkeit, ist jene absolute Konstante, die, wie Naum Gabo und Antoine Pevsner in ihrem «Realistischen Manifest» hervorhoben, zugleich das schnellste und stillste aller stillen Phänomene ist.[4]

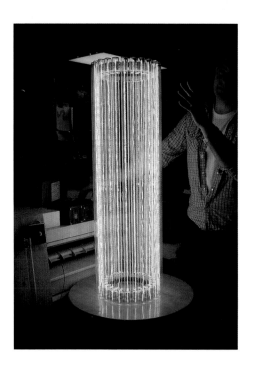

Eine der ersten Neonarbeiten, aus dem Jahr 1997, ist eine Figur aus mehreren grosszügig geschwungenen Kurven. Auf den ersten Blick wirkt sie wie eine flüchtig hingeworfene Acht, doch die Art, wie die Linien sich überschneiden und ineinandergreifen, sorgt für eine räumlich wesentlich komplexere Wirkung. Wie der Titel MÖBIUS STRIP (1997) verrät, hat Wyn Evans eine Möbiusschleife skizziert, dieses leicht herzustellende, unendlich faszinierende, verdrehte und wieder zusammengefügte Band, das weder eine Innen- noch eine Aussenseite hat, sondern aus einer

Filament columns, prototype / Leuchtdraht-Säulen, Prototyp.
(PHOTOS: CERITH WYN EVANS)

einzigen fortlaufenden Fläche besteht. Die wesentlich neuere Arbeit, ... VISIBLEINVISIBLE (2007), wiederholt das Innen-Aussen-Kontinuum der Möbiusschleife durch den Verweis auf Maurice Merleau-Pontys letztes, unvollendet gebliebenes Werk, *Das Sichtbare und das Unsichtbare* (1968). Dieses Buch, insbesondere das Kapitel «Die Verflechtung – der Chiasmus», spielt in einigen neueren Arbeiten von Wyn Evans eine Rolle, etwa bei den Lamellenstoren, die er 2008 vor den Fenstern der White Cube Gallery anbrachte, deren automatisches Öffnen und Schliessen Passagen aus Merleau-Pontys Text im Morse-Alphabet zitierte. «Das Sichtbare der Welt», so Merleau-Ponty, «ist Bindegewebe der äusseren und inneren Horizonte ...» Dieses Verbundensein macht das Verhältnis zwischen dem Sichtbaren und dem Sehenden zu einem reziproken: «der Blick ist nämlich selbst Einkörperung des Sehenden in das Sichtbare, Suche nach sich selbst im Sichtbaren, dem es z u g e h ö r t ...»[5] Wyn Evans gefällt diese Betonung des Transitiven, weil es Merleau-Pontys Denken erlaubt, vom «phänomenologischen Realen des Körpers im Raum» zur Möglichkeit einer – auf einer anderen Ebene sich vollziehenden – Gemeinschaft und Entsprechung zu gelangen.[6]

Im Jahr vor MÖBIUS STRIP hatte Evans INVERSE, REVERSE, PERVERSE (Verkehrt, andersrum, pervers, 1996) geschaffen, eine Installation, die zur Hauptsache aus einem grossen, an der Wand befestigten konkaven Zerrspiegel bestand. Wer hineinschaute, sah sich genau so gespiegelt, wie im Titel angekündigt. Und wer sich zum Verlassen der Galerie anschickte, sah sich einem blassgrünen Neonschriftzug über dem Eingang zur Galerie gegenüber, der EXIT (Ausgang) von hinten betrachtet buchstabierte: TIXƎ. Das Zeichen blieb aufgrund seiner Position im Raum zunächst verborgen und die Besucher fanden sich erst nach dem Blick in den Spiegel und dem Erlebnis des Verkehrt- und Auf-den-Kopf-gestellt-Werdens in der Situation wieder, jetzt quasi hinter dem Spiegel zu stehen, in den sie eben noch gestarrt hatten. Der Weg aus der Galerie hinaus – identisch mit dem Weg hinein – entpuppt sich als Ausgang, den sie bereits beim Betreten der Galerie passiert haben müssen, denn die «rückwärtige» Ansicht des Textes legt den Schluss nahe, dass es sich um die Rückseite des eigentlichen Zeichens auf der andern Seite der Tür handelt.

Die drei Worte des Titels – *inverse*, *reverse* und *perverse* – sind uns aus dem Velvet Underground-Song «The Murder Mystery» vertraut, wo sie mehrmals vorkommen. (Auch hier könnte man sich an Freud erinnert fühlen, für den die Analyse unterbewusster Prozesse, die in Versprechern oder anderen Fehlleistungen zum Ausdruck kommen, der Arbeit desjenigen ähnelt, der «als Kriminalbeamter an der Untersuchung einer Mordtat beteiligt» ist.)[7] Auch wenn «The Murder Mystery» (1968) aufgenommen und herausgebracht wurde, nachdem John Cale die Band verlassen hatte, kann es wichtig sein zu wissen, dass Cale als Kind in Garnant Sould Wales zu Hause war, am selben Ort, wo auch Evans' Grosseltern lebten. Was wir mit solchen Informationen anfangen und wie wir überhaupt an sie herankommen, ist eine Schlüsselfrage. Wyn Evans redet in diesem Zusammenhang vom Problem der «Verschlüsselung», das heisst von der Präsenz in einem Werk mit einem bestimmten (Bezugs-)Rahmen oder von einer Chiffre, deren Funktion ihrem Wesen nach eher verständnisfördernd als hemmend ist.[8] Wie kann man einem Werk einen Rahmen geben? Wie es entsprechend kennzeichnen oder dem Betrachter Zugang zu einer Interpretationsquelle verschaffen, die es ihm vielleicht ermöglicht, sich auf die verschiedenen Schichten des Werks einzulassen, statt sich durch fehlendes Wissen vor den Kopf gestossen zu fühlen? Eine Möglichkeit, der man häufig begegnet, ist, Wyn Evans' Arbeitsweise als eine Art Collage im kubistischen Sinne dieses Begriffs zu betrachten: Man sieht sich mit einer Mischung und einem Nebeneinander von Elementen und Darstellungsweisen konfrontiert – Text als Worte, Text als Bild, gezeichnete

und gemalte Darstellungen, Trompe-l'œil-Kabinettstückchen, Gedrucktes mit Bildern und Text, Papier als Farbträger und so weiter. Das alles ist polyvalent hinsichtlich Struktur, Form, Sujet, Materie und Inhalt der Collage. Natürlich ist Wyn Evans' Kunst reich an derartigen Kombinationen, Konstellationen und Verbindungen von Elementen, aber ich würde sagen, dass weder die Collage noch die eher konstruktiv konnotierte Montage wirklich zur Kategorisierung dessen geeignet sind, was seine Arbeit letztlich leistet. Die Neonarbeiten machen uns das sehr viel ganzheitlichere Nebeneinander der vielfältigen Facetten seines Werks deutlich, seien diese nun realistisch, märchenhaft, halluzinatorisch oder sonst was.

«Voodoo Chile (Slight Return)» ist der letzte Titel auf Jimi Hendrix' Doppelalbum *Electric Ladyland* von 1968. Und wörtlich genommen ist es genau, was der Titel sagt: eine kürzere, tempointensivere und aggressivere Wiederaufnahme des langen, langsamen Bluesstücks auf der ersten Seite des Albums. In einem etwas hintergründigeren Sinn beschwören die vier Worte (und die beiden Klammern, die zwei davon lose zusammenhalten) das rebellische Wiederaufleben des Mystischen, Magischen und Unerklärlichen inmitten der Rationalität unserer zivilisierten Existenz. Mit anderen Worten liefern sie ein wunderbares Beispiel für den Freud'schen Begriff der Rückkehr des Verdrängten. Es ist mir durchaus bewusst, dass die Verortung des Songs auf der vierten Seite einer Doppel-LP bedeutet, über etwas Altmodisches, technisch Überholtes zu sprechen. Denn wer würde heutzutage noch zwei beidseitig gerillte 33-Zentimeter-Kunststoffscheiben als geeignetes Mittel betrachten, um eine achtzigminütige Liedersammlung an die potenziellen Zuhörerinnen und Zuhörer zu bringen? Solche Rückgriffe auf Obsoletes sind jedoch bezeichnend für Wyn Evans' Werk. Und zwar nicht, weil es sein Wunsch wäre, für das Altmodische als solches eine Lanze zu brechen, sondern wiederum weil, wie Freud uns versichert, das Vergangene nicht unwiederbringlich verloren ist. Es bleibt auf immer verfügbar, um erneut aufgenommen und in den Prozess der Bedeutungsbildung eingebracht zu werden.

2006 hat Wyn Evans einen Teil des letzten Verses von «Voodoo Chile (Slight Return)» als Neonschriftzug verwendet. Obwohl er weisses Licht benutzte, war die Vorderseite der Lichtröhren geschwärzt, sodass die Worte sich in schwarzen Buchstaben vor der – durch die Rückseite der Röhren – hell erleuchteten Wand abhoben:

And if I don't meet you no more in this world
Then I'll, I'll meet you in the next one
And don't be late, don't be late

Die vielen Wiederholungen und Verzögerungen innerhalb der kurzen Passage erzeugen eine Art Unschärfe, wie sie bei Überschneidungen oder Überlagerungen von Bildern entstehen könnte – *this world* und *the next one, meet, meet, don't don't don't, be be, late late*. Es ist ebenso zögernd wie gebieterisch.

Dieses Stottern erinnert an das Denkmodell der Begriffsperson des Stotterers bei Gilles Deleuze und Félix Guattari. Genau wie der Stotterer diese Autoren zur Frage veranlasst, «Was ist jenes Denken, das nur stottern kann?», fragen wir uns, welche Welt (Welten) sich uns in diesen Wiederholungen und Abwandlungen des Textes enthüllt (enthüllen).[9] Die zentrale Wiederholung in Evans' AND IF I DON'T MEET YOU … (2006) ist *I'll, I'll*.

Die Zwillingsidentitäten des doppelten I spiegeln sich über die trennende Verbindung des Kommas hinweg und man kann sie als gleichzeitig in dieser und der nächsten Welt existierende betrachten. Die Verdoppelung hat denselben Charakter wie jene, die Rosalind Krauss

in ihrer Studie «Die fotografischen Bedingungen des Surrealismus» behandelt. Die Surrealisten waren im Allgemeinen zurückhaltend, wenn es darum ging, die Montage als Werkzeug zur Gegenüberstellung widersprüchlicher und miteinander konkurrierender Wirklichkeiten einzusetzen; stattdessen infiltrierten sie den Körper des Photoabzugs mit «Zwischenräumen», die mittels Techniken wie dem Positiv-/Negativbild der Rayographie (Man Rays Photogrammtechnik) erzeugt wurden. Bei einer surrealistischen Photographie schauen wir demnach «nicht auf die Realität (…), sondern auf eine von Interpretation oder Signifikation überwucherte Welt».[10] Wyn Evans' Neonzeichen halten uns vor Augen, dass unsere eigene Welt genauso überwuchert ist und dass wir diese Erscheinungen unbedingt freudig begrüssen sollten.

1) Walter Benjamin, «Diese Flächen sind zu vermieten», in ders., *Einbahnstrasse*, Suhrkamp-Verlag, Frankfurt 1955, S. 96. [1. Aufl. Rowohlt 1928]

2) Richard Wollheim, *Painting as an Art*, Kapitel IV, «Painting, Textuality, and Borrowing», Thames & Hudson, London 1987, S. 187ff. (Zitat aus dem Engl. übers.)

3) Cerith Wyn Evans im Gespräch mit Manfred Hermes, in *Cerith Wyn Evans*, Frankfurter Kunstverein und Lukas & Sternberg, Berlin/New York 2004), S. 154.

4) «Schau' einen Sonnenstrahl an … die stillste aller stillen Kräfte, er legt 300 000 Kilometer in der Sekunde zurück … Betrachte den Sternenhimmel … wer hört ihn … und doch, was sind unsere Bahnhöfe gegenüber den Bahnhöfen des Universums?» Naum Gabo und Antoine Pevsner, «Das Realistische Manifest» (1920), abgedruckt in *Naum Gabo: Sechzig Jahre Konstruktivismus*, hg. v. Steven A. Nash und Jörn Merkert, Prestel, München 1986, S. 203.

5) Maurice Merleau-Ponty, *Das Sichtbare und das Unsichtbare*, Wilhelm-Fink-Verlag, München 1986, S. 173.

6) Vgl. Anm. 3, S. 152.

7) Sigmund Freud, *Vorlesungen zur Einführung in die Psychoanalyse*, Fischer-Taschenbuch-Verlag, Frankfurt am Main 1991, S. 25. Hier stossen wir übrigens auf eine amüsante Fehlleistung des Künstlers selbst, denn im Lauf seines Interviews mit Hermes sagt Wyn Evans, «inverse, reverse, perverse» sei ein Zitat aus «The Gift» (Das Geschenk). Dieser Song aus dem zweiten Album von Velvet Underground, *White Light, White Heat*, arbeitet – wie «The Murder Mystery» – mit einer radikalen Trennung der beiden Stereokanäle. John Cale trägt die Handlung des Songs vor.

8) Vgl. Anm. 3, S. 130.

9) Gilles Deleuze und Félix Guattari, *Was ist Philosophie*, Suhrkamp-Verlag, Frankfurt 1996, S. 79.

10) Rosalind E. Krauss, «Die fotografischen Bedingungen des Surrealismus», in *Die Originalität der Avantgarde und andere Mythen der Moderne*, hg. v. Herta Wolf, Verlag der Kunst, Amsterdam/Dresden 2000, S. 130–162, Zitat: S. 153.

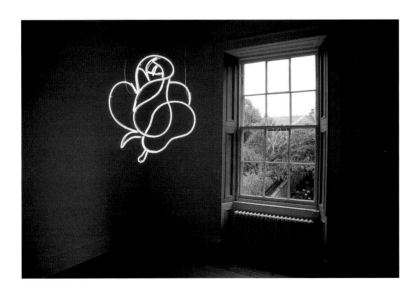

CERITH WYN EVANS, UNTITLED (WHITE ROSE), 2007, neon, 36 ¹/₂ x 32 ³/₄" / OHNE TITEL (WEISSE ROSE), Neon, 93 x 83 cm.

Im Zeichen und Geist einer Stoa

JAN VERWOERT

Wo können wir uns treffen? Nicht nur zum Reden. Oder um etwas zu sehen und geboten zu bekommen. Sondern um uns darüber klar zu werden, was geschehen ist und wie es mit uns weitergehen soll. Das geht aber weder in der Öffentlichkeit noch bei dir oder mir. Auf dem Markt hat es ebenso wenig Sinn wie zuhause. *Agora* und *Oikos* sind gleich ungeeignet. Dort klingen die Stimmen zu laut, hier zu leise. So oder so werden wir uns an diesen Orten nichts mitzuteilen haben. Denn in *Agora* und *Oikos* hat alles seine feste Bedeutung. Es gelten geregelte Absprachen. Auf dem Markt und im Haushalt steht der Sinn und Wert aller Dinge schon im Voraus fest. Aber genau darüber wollen wir uns doch klar werden. Also erübrigt sich unser Gespräch an diesen Orten. Wir müssten schon einen Ort aufsuchen, an dem unser Treffen anders ablaufen würde. Die griechische Philosophie kennt so einen Ort. Es ist die Stoa.[1] Sie liegt zwischen *Agora* und *Oikos*. Die Stoa ist der Park oder Wandelgang vor dem Haus (oder Hain vor der Stadt), eine Zone, die weder zum Innenraum des Hauses noch zum Aussenraum der Stadt gehört. Sie ist weder privat wie der Haushalt noch öffentlich wie der Markt. Sie ist keins von beiden und beides zugleich. Deshalb ist die Handhabung von Sinn und Wert in ihr nicht gesetzlich geregelt. Man kann frei über sie denken und

sprechen. Die Richtung, die ein Gespräch nimmt, ist nicht vorausbestimmt. Wer sich hier trifft, wandert, sprechend oder schweigend, in offenen Kreisen, *peripatetisch*, in der Stoa umher. Das ist die Bewegung eines freien Denkens und Empfindens. Es verdankt seine Möglichkeit den topologischen Ungesetzlichkeiten einer Stoa.

Cerith Wyn Evans schafft in seinen Arbeiten die Möglichkeit einer Stoa. Er sorgt für Situationen, in denen die Gesetze geregelter Kommunikation keine Gültigkeit mehr besitzen und die klare Trennung von Diskursräumen aufgehoben ist. Von «Arbeiten» zu sprechen, ist deshalb in bezug auf Wyn Evans auf eine Art bereits verkehrt. Natürlich gibt es konkrete Installationen. Und sie sind präzise komponiert. Aber sie haben weniger den Charakter von *Aussagen* (so wie man von Arbeiten sagen kann, dass sie Aussagen machen). Spürbar geht es bei Wyn Evans eher um die Formulierung von *Zuständen*. Von Zuständen, in denen wir uns befinden, wenn wir nach Art der Stoa denken oder fühlen: wenn sich Ideen nicht zu Aussagen verfestigen, sondern im freien Spiel der Kräfte bewegen. Auf Installationen von Wyn Evans zu treffen, hat immer etwas von einer Rückkehr zu einer Wahrnehmungshaltung, einem Gefühlszustand, einer Welt. Eine vergleichbare Erfahrung ist das Wiederaufnehmen einer Lektüre, in die Welt eines Romans zurückkehren, sich erneut von dessen Figuren umgeben zu sehen und weiter mitzuverfolgen, wie sich deren Konstellation entwickelt.

Das Mittel zur Komposition dieser Zustände ist bei Wyn Evans die konzeptuelle Form. Konzeptuell heisst hier, dass seine Kunst, um nicht notwendig nur Kunst sein zu müssen, zum Beispiel auch die Nähe zum Kino sucht, ohne je zu Kino zu werden, weil das Kino, von der sie dann handelt, selbst mehr mit Literatur zu tun hat, ohne doch eigentlich literarisch zu sein. Wyn Evans vollzieht eine peripatetische Bewegung im Zwischenraum von Kunst, Kino und Literatur, ohne sich je den Gesetzen eines Feldes ganz zu unterwerfen. Im Gegensatz zu Künstlern, die Konzeptkunst heute bloss noch als historisch etabliertes Genre behandeln und als Zitatenschatz ausschlachten, realisiert er damit durch seine Perepatetik das Potenzial und die Provokation der ursprünglichen Idee konzeptueller Praxis: einen freien Raum zu

JAN VERWOERT ist Contributing Editor der Zeitschrift *frieze* und Autor von *Bas Jan Ader: In Search of the Miraculous* (The MIT Press, 2006). Er unterrichtet am Piet Zwart Institute in Rotterdam und dem Royal College in London.

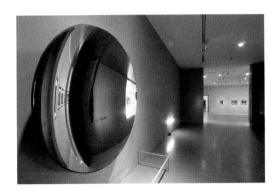

CERITH WYN EVANS, INVERSE, REVERSE, PERVERSE,
1996, installation view, Museum of Fine Arts Boston /
VERKEHRT, ANDERSRUM, PERVERS, Installationsansicht.
(PHOTO: MFA BOSTON)

schaffen, eine Stoa also, die zwischen allen Medien, Genres und Disziplinen liegt, zu allen hin offen bleibt, ohne von deren Regeln beherrscht zu werden.

TIXƎ (1992) ist hier exemplarisch. Es ist ein Neonzeichen. Es buchstabiert das Wort «Exit» spiegelverkehrt, TIXƎ. Dieses Zeichen würde mir den Weg zum Ausgang weisen. Wäre es nicht umgedreht. Denn so habe ich den Ausgang schon im Rücken. Vor mir sehe ich nun die Spiegelung des Wegweisers zu dem Ort, wo ich bin. Es ist wie in Cocteaus *Orphée*

(1949): Ich schaue aus dem Spiegel zurück in den Raum, den ich wohl beim Schritt durch den Spiegel eben verlassen haben muss. TIXƎ ist der Einausgang eines Ausseninnenraums. In einem Text über Wyn Evans beschreibt Mark Cousins die topologische Ungesetzlichkeit dieses Einausgangsausseninnenraums in einer wunderbar agrammatikalischen Wendung als «Raum, in den man gerne heraustreten möchte, hätte man ihn nicht gerade betreten».[2] Was ist dieser Einausgangsausseninnenraum? Er ist der Raum der Spiegelung, der Reflektion, wortwörtlich also der des Denkens. Ich trete nicht einfach so in ihn ein. Ich verliere mich eher in ihm, wenn ich in Gedankenverlorenheit verfalle. In diesem Zustand Gedanken zu betrachten, heisst, sie in ihrer Äusserlichkeit (ihrer reinen Materialität) zu erfahren, wie sie sich, Buchstabe für Buchstabe, zu immer neuen Konstellationen verketten, verkehren und verdrehen. Das ist der philosophische Zustand. So fühlt sich die Stoa in ihrer topologischen Ungesetzlichkeit an: als Eingang zum Ausgang aus den geregelten Diskursen und Übergang in einen Bereich, wo sich die Grammatiken der Diskurse wie seismische Platten übereinanderschieben und in den Hohlräumen Luft zum Denken bleibt.

Von einem solchen Zwischenraum handelt auch die Geschichte, die Wyn Evans über die Entstehung des Neonzeichens erzählt.[3] Er war mit Lee Bowery in

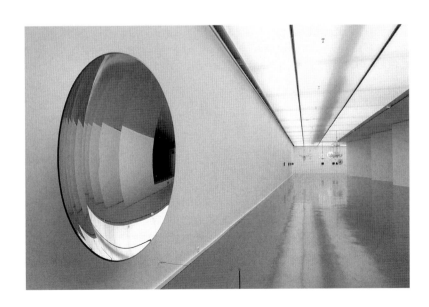

CERITH WYN EVANS, INVERSE,
REVERSE, PERVERSE, 1996, installation
view, Musée d'art moderne, ARC, Paris /
VERKEHRT, ANDERSRUM, PERVERS,
Installationsansicht.
(PHOTO: Musée d'art moderne, PARIS)

die Matineevorstellung eines grossen Kinos am Leicester Square in London gegangen, um irgendeinen Blockbuster zu sehen. Beim Versuch, den Kinosaal während der Vorstellung zu verlassen, war er in einen abgesperrten Notausgang geraten, der, nachdem die Tür hinter ihm ins Schloss gefallen war, weder in den Saal noch auf den Platz Ausgang gewährte. Im Glas der Tür spiegelte sich das Exit-Zeichen. Der Ton des Films von drinnen wird dabei genauso zu hören gewesen sein wie die Geräusche draussen vom Platz. Das ist eine phantastische Parabel auf das, was konzeptuelle Praxis als Möglichkeit einer Stoa sein kann: die Erfahrung eines Zustands, in dem die Töne aus dem Haus der Kultur mit den Geräuschen des Marktplatzes (des materiellen Lebens und der Politik) auf besondere Weise zum Zusammenklingen zu bringen sind, weil der Ort, an dem sie sich mischen, ausserhalb beider Bereiche liegt. Dieses Aussen ist jedoch nicht das, von dem die romantische Ideologie der Überschreitung handelt. Es liegt nicht am Rand der Gesellschaft, sondern mitten in ihr, in den Einausgangsausseninnenräumen, die sich auf der Schwelle zwischen den gesellschaftlichen Feldern befinden.

Zu welcher Art von Handlung führt die perepatetische Bewegung zwischen den Feldern? Die Situationisten sprachen von *détournement*. «Aneignung» ist dafür die Übersetzung. Aber sie trifft es nicht ganz. Im *détournement* steckt *dé-tour*, das vom Weg Abkommen, das auf Abwege Bringen, das Abwegige vielleicht überhaupt. Das Ab-Wegige entspricht dem Geist der Peripatetik. Sie folgt keinen bestehenden Wegen. Die Aneignung des Kinos hat bei Wyn Evans diesen Charakter von *détournement*: von Akten, die das Kino auf Abwege bringen. Er sieht die Faszination des Kinos nicht, wie man erwarten würde, in den bewegten Bildern, sondern im Phänomen der Projektion, des «Lichtspiels», selbst. Als Spiel mit dem Licht durchläuft das Kino auf Abwegen dann bei Wyn Evans eine Reihe von *détournements* oder Gestaltwandlungen. In HAS THE FILM ALREADY STARTED? (Hat der Film bereits begonnen?, 2000) lässt er auf einen weissen Helium-Ballon, der, an einen Pflasterstein gebunden, zwischen Zimmerpalmen schwebt, einen Film projizieren. Dieser ist dem eigentlich bildlosen Film *L'Anticoncept* (1952) von Gil J. Wolman nachempfunden. Der zeigt nur einen dun-

kel umrahmten hellen Kreis. Er wirkt wie der Licht-Punkt eines Scheinwerfers. Von Zeit zu Zeit erlischt er kurz, um direkt wieder aufzuleuchten. Der Punkt ist leicht grösser als der Ballon. So ergibt sich auf der Wand hinter dem Ballon ein Lichtkranz wie bei einer Sonnenfinsternis. Wolmans Film war kein Kino des Bildes, aber eins der Sprache. In seinem Voice-Over verlas er einen agrammatikalisch montierten Text über den Zustand des poetischen Erlebens. In Wyn Evans' Version ist auf der Tonspur nur Knistern und Knacken zu hören. Objekte anstelle (oder vor) einer Leinwand als Projektionsfläche zu nutzen, tat auch Maurice Lemaître, der wie Wolman zum Kreis der Lettristen gehörte und probierte, das Kino in räumlichen Gesamtinszenierungen aufzulösen. Eine davon trug den Titel *Le film est déjà commencé?* (1951), den Wyn Evans hier weiterverwendet.

Diese Bezüge sind keine Zitate. Die genannten Lettristen sind Figuren in einer Welt, die Wyn Evans skizzenhaft anlegt. Diese Welt ist in einem gewissen Grundzustand. In ihr herrscht das Grundgefühl der lettristischen Haltung vor. Aus ihr spricht der Geist des Lettrismus: die elegant anarchische Geste der Demontage und Vermischung von Kino und Literatur. Die Form von Wyn Evans' Bezugnahme ist dabei weniger die der *Referenz* als die der *Reverenz*. Statt Wissen vorzuführen, investiert er Leidenschaft in die Beschwörung eines Geistes. Er vermittelt die Faszination für den Stil einer gewissen Form des freien Umgangs mit Kino und Literatur. Nicht zuletzt dadurch, dass er ebenso frei mit den Quellen verfährt, die er erschliesst. In den Kreis der Geister, die er ruft, wird so auch Marcel Broodthaers eingeladen. Die Zimmerpalmen signalisieren seine Präsenz. Ob er nun offiziell zu den Lettristen gehörte oder nicht, spielt keine grosse Rolle. Was zählt, ist seine geistige Nähe zu ihnen. Wyn Evans stellt so durch eine Geste der Reverenz eine Nähe zwischen Figuren her und beruft den Geist ihrer kollektiven Subjektivität ein. Entscheidend ist, dass in der Geste der Reverenz eine Art von *Irreverenz* mitschwingt. Die Sorgfalt bei der Komposition der Figuren geht bei Wyn Evans einher mit einer gewissen Sorgenfreiheit im Umgang mit den Requisiten, die er zur Konstruktion ihrer Welt benutzt. Pflasterstein, Ballon, Zimmerpalmen und fast bildloser Film: Zusammen ergeben sie eine

knappe, keine ehrfürchtige Geste, die eine Stoa, keinen Tempel, schafft. Ein Tempel entspräche dem Geist der Lettristen nicht. Nur eine ihrerseits irreverente Geste tut das.

Diese Spur von Irreverenz macht bei der Einberufung der Figuren aus der Vergangenheit einen grossen Unterschied. Und zwar in Bezug auf eine Grundhaltung zu Macht und Gesetz. In disziplinären Diskursen ist die Bezugnahme auf historische Grössen in der Regel nicht zu trennen von einem Kalkül der Legitimation. Man führt sie als Autoritäten an, um der eigenen Aussage Geltung zu verschaffen. So will es das Gesetz der Wissenschaft. Psychoanalytisch gesehen, ist eine solche Aufführung von Vaterfiguren zutiefst ödipal. Als Ausdruck einer freien Bewegung der Peripatetik stehen Wyn Evans' Gesten des liebevoll irreverenten *détournements* im grundsätzlichen Widerspruch zu dieser ödipalen Haltung. Sie zollen der Macht des Gesetzes keinen Respekt. Stattdessen stellen sie aus Passion die Nähe zu einem Geist her. Dieser Geist verschafft niemandem Recht und Geltung. Er verspricht Genuss. Den Genuss antiödipalen Denkens jenseits von Gesetzen.

LOOK AT THAT PICTURE ... HOW DOES IT APPEAR TO YOU NOW? DOES IT SEEM TO BE PERSISTING? (Sieh dir das Bild an ... Wie erscheint es dir? Hat es Bestand?, 2003) ist eine weitere, dem Geist dieses Denkens gewidmete Situation der Einberufung. Fünf Kristallleuchter verschiedener Herkunft sind in einem Raum installiert. Jeder von ihnen ist mit je einem Computer verbunden, der in Realzeit je einen ausgewählten Text in Morsecode übersetzt und die codierten Signale an den Leuchter sendet. Im Rhythmus der Signale erleuchten und verlöschen dessen Lichter dann. Auf fünf einfachen Bildschirmen an den Wänden erscheinen die Textzeilen und Signalketten, die im Augenblick codiert und projiziert werden. Es gibt Auszüge aus John Cages Tagebuch, Erinnerungen von Brion Gysin und Terry Wilson an ein spiritistisches Medium (das später für den CIA arbeitete), eine giftige Kritik am modernen Spiritismus von Adorno, ein Plädoyer von Eve Kosofsky Sedgewick gegen eine paranoide, für eine passionierte Kultur des Lesens und ein vom Salon der Madame Lafayette kollektiv verfasster Liebesroman. Formal betrachtet, führt das *détournement* des Kinos hier zu einer wieder anderen Auslegung der Konzepte von Projektion und Lichtspiel. In HAS THE FILM ALREADY STARTED? (2000) wurde die Filmprojektion zu einem blinkenden Scheinwerferlicht. Das blinkende Licht der Leuchter ist die nächste Gestaltverwandlung. Die Literatur kommt auf denselben Abweg. Text wird Code wird Signal. Der Morsecode fungiert dabei als Sprache zwischen allen Medien. Er kann visuell, textuell oder auditiv, also Licht, Chiffre oder Ton sein. Eine Sprache, die viele Sprachen zugleich ist. Welch ein Mittel, um auf der Schwelle zwischen den Medien eine andere Form der Kommunikation zu versuchen!

Zugleich ist der Morsecode aber auch eine Unsprache. Er ist nicht mehr wirklich in Verwendung. Und die Anzahl derjenigen, die ihn fliessend lesen könnten, wird beschränkt sein. Das gibt der Form der Einberufung in diesem Fall einen besonderen Charakter. Einerseits richtet sie sich an alle. An alle, die den Raum betreten und das Leuchten sehen. Andererseits richtet sie sich an einen Unbekannten, an jemanden, der die Signale zu decodieren imstande wäre, angesichts der geringen Wahrscheinlichkeit, dass sich so jemand als Besucher einfindet, also vielleicht auch an niemanden. Die Signale adressieren also potenziell alle und keinen zugleich. Der Modus der Adressierung ist in sich gespalten. Das spiegelt die Form der von ihnen einberufenen Gemeinschaft wider (wenn man die Menge aller, die die Leuchter je sehen, als eine Gruppe betrachtet, die eine Gemeinschaft sein könnte). Potenziell besteht sie aus jedem, jemand Besonderem oder vielleicht überhaupt niemandem. Diese Gemeinschaft verbindet kein gemeinsamer Name, mit dem sie hier angesprochen würden. Es gibt auch kein Programm, keine Heilige Schrift, auf das sie einzuschwören wäre, denn es werden viele, sich zum Teil widersprechende Texte gemorst. Diese Gemeinschaft bleibt ungeeint.

Ähnliches gilt für den Geist der Gemeinschaft von Figuren, die die Signale einberuft. Die Form ihrer Einberufung sagt bereits Entscheidendes darüber aus, *in* welchem Geist sie sich versammeln. Gewöhnlich ist unmittelbar klar, in welchem Zeichen sich eine Gemeinschaft einfindet. Hier nicht. Denn Wyn Evans' Zeremonie der Einberufung wirkt klandestin und offen zugleich. Einerseits hat das Prozedere etwas von einer Séance, denn die blinkenden Leuch-

ter wirken durchaus gespenstig. Ihr rhythmisches Aufglühen und Verlöschen gleicht einer Atembewegung. Es erweckt sie zum Leben. Das Zusammentreffen der gerufenen Geister erscheint absolut möglich. Zugleich andererseits aber auch fraglich. Kann es in diesem Raum spuken? Seine Atmosphäre ist alles andere als schummerig. Das Licht ist an. Man sieht die Rechner arbeiten. Wie alles funktioniert, ist kein Geheimnis. Wyn Evans' konzeptuelle Geste eröffnet also einen Raum, der zwischen den Feldern aufklärerischer und okkulter Praxis liegt. Zum einen schafft er Transparenz: Alles ist hell erleuchtet. Texte kritischer AutorInnen werden verlesen. Langsam verlesen. Buchstabe für Buchstabe. Das ist wie ein Seminar in *close reading*: eine Praxis der *Hermeneutik*. Nur ist das Verlesen zum anderen auch ein Akt der Codierung, der die Texte ihrer direkten Lesbarkeit entzieht, aber ihren Geist beschwört: eine Praxis der *Hermetik*. In was für einem Geist wird diese Seminarséance gehalten? Im Geist eines Denkens, das sich auf der Schwelle zwischen zwei Schulen des Verstehens bewegt, aber keiner zugehört. Im Geist einer Stoa.

Mit Geistern weiss man ausserdem nie. Es ist nicht gesagt, dass sie kommen, wenn man sie ruft. Sie erscheinen, wann *sie* wollen. Das macht die Séance im Umgang mit Figuren aus der Vergangenheit zu einer besonderen Technik. Im Zitat ergreift der Zitierende unmittelbar *Besitz* von dem Zitierten. Die Séance verläuft anders. Man muss mit Geistern erst verhandeln. Wer dabei die Oberhand verliert, ist am Ende selbst der *Besessene*. Machtverhältnisse sind hier nicht vorausgesetzt, sondern Verhandlungsgegenstand. Im Vergleich zum Zitat ist die Zeremonie der Einberufung deshalb auf riskante Weise performativ und im Ausgang offen. Sie kann eine Gemeinschaft der Geister (unter und mit den Geistern) nicht erzwingen. Dieses Fehlen von Zwang charakterisiert Wyn Evans' Geste. Sie wirkt ungezwungen. Und sie zwingt weder uns Gäste noch die Geister dazu, unserer möglichen Gemeinschaft die Gestalt einer Gruppe mit fester Identität geben zu müssen. Nicht mal das Bestehen der Gemeinschaft ist gesichert. Es gibt keine bindenden Verträge. Sondern nur eine Geste der Einladung. Diese Einladung jedoch bleibt bestehen. Die Rechner und Leuchter wiederholen sie pausenlos.

Obwohl ihre Existenz nicht zu beweisen ist, existiert diese Gemeinschaft im Zustand der andauernden, riskanten Beschwörung ihrer Möglichkeit.

Entscheidend aber bleibt, dass Wyn Evans den Geist nie vom Zeichen trennt, in dem Gemeinschaft einzuberufen ist. Zeichen behandelt er dabei einerseits wortwörtlich als montierte Buchstaben, codierte Signale, projizierte Lichtzeichen. Kommunizieren heisst hier buchstäblich Zeichen geben, senden und empfangen. Das Zeichengeben ist andererseits aber wiederum auch nie losgelöst von dem Geist zu betrachten, in dem Wyn Evans es praktiziert, einer gewissen Irreverenz: einer Ungezwungenheit und Verweigerung falscher Ehrfurcht. Wyn Evans' Zusammenarbeit mit Florian Hecker an der abstrakten Oper NO NIGHT NO DAY (Keine Nacht kein Tag, 2009) hat diesen Charakter. Aus ihr ergab sich (zunächst, die Kollaboration ist damit nicht abgeschlossen) ein beinahe bildloser Film mit einer fast tonlosen Musik. Das projizierte Material zeigt Flecken und Schatten. Manche erscheinen nur kurz. Andere bewegen sich, wachsen, schrumpfen und wandern. Das sieht man erst schwarz auf weiss und dann auch in Farbe. Dazu hört man Dinge, die Geräusche oder Töne oder sequenzierte Signale oder unsequenziertes Klangmaterial sein könnten. Aus dem simultanen Detournement von Kino und Musik spricht zum einen der Geist einer Verweigerung: Dem Kino, das glaubt, bewegtes Bild, und der Musik, die glaubt, sequenzierter Klang sein zu müssen, wird kein Respekt gezollt. Zum anderen ist dies aber auch ein Liebesbeweis gegenüber einer avantgardistischen Form des Umgangs mit Kino und Musik, lettristischer oder anderer Provinienz. Irreverent bleibt diese Geste der Reverenz dennoch, weil sie ohne Manifest auskommt und avantgardistische Form in etwas verwandelt, was Universal-, Geheim- oder gar keine Sprache sein könnte: die Transmission von Licht- und Tonsignalen. NO NIGHT NO DAY bewegt sich so peripatetisch entlang einer historischen Schwelle zur Avantgarde, bringt ihre Sprache auf Abwege und zieht sie gerade dadurch in die stets gegenwärtige Bewegung im Feld einer Stoa hinein.

Zeichen gibt man in der Hoffnung, dass sie erwidert werden könnten. Auf das Senden des Signals folgt das Warten auf Antwort. Die Frage ist also: Wie

CERITH WYN EVANS, IN GIRUM IMUS NOCTE ET CONSUMIMUR IGNI, 2009, firework installation, deSingel, Antwerp /
Feuerwerk-Installation. (PHOTO: JAN KEMPENAERS)

wäre auf die Transmission zu antworten? Mit welchen Gesten und Signalen, im Zeichen welcher möglicherweise durch die Antwort zu stiftenden Gemeinschaft wäre das zu tun? Von ihrem Geist her wäre das eine Sprache, die einerseits hermeneutisch die Signale zurückverfolgt zu ihren Herkunftsorten und aus der (Ir)reverenz die Referenz herausliest und verdeutlicht, auf welche Geschichte wir uns beziehen. Andererseits wäre es im Sinn dieser Geschichte, ihren Geist nicht zu verraten, und also hermetisch zu antworten, mit Worten, die wie Signale sind: ein Schwenken von Flaggen, Zwinkern von Augen oder Eintippen von Rhythmen in ein Transmissions-Gerät.

In diesem Austausch kann es kein Ende geben, nur immer wieder, auf peripatetisch agrammatikalischen Abwegen die Rückkehr zum Eingangsausgangsort des Innenaussenraums einer Stoa, einem Raum, in dem Du trittst, indem Du aus ihn hineingehst.

1) Die folgende Deutung der Stoa übernehme ich mit Dank aus einem unveröffentlichten Konferenzbeitrag von Nikos Papastergiadis, dessen Inhalt mir Cuauhtemoc Medina im Gespräch vermittelte.
2) Mark Cousins, «Moderato Cantabile», *Afterall* 4, 2001, S. 100–101.
3) Cerith Wyn Evans, «Innocence and Experience», in *frieze* 71, 2002, S. 76–81, S.79.

CERITH WYN EVANS, ARR./DEP. (IMAGINARY LANDSCAPE...FOR THE BIRDS), 2007, installation view, Lufthansa Aviation Center, Frankfurt / ANK./ ABF. (IMAGINÄRE LANDSCHAFT ... FÜR DIE VÖGEL), Installationsansicht. (PHOTO: NORBERT MIGULETZ)

Under the Sign and in the Spirit of a Stoa

Where can we meet? Not just to talk. Or to look at something and be entertained. But rather, to find out what happened and what life is going to be like. But we can't do that in public, or at your place, or at mine. It makes as little sense at the market as it does at home. *Agora* and *oikos* are both equally unsuitable. In the former the voices are too loud, in the latter too soft. We won't be able to say very much to each other anyway, because in either place conventions control what things mean. At the market and in

the household what constitutes meaning and value is understood. But the constitution of meaning and value is exactly what we want to understand—and contest. So there's no point in having a conversation there. We would have to find someplace else so that our meeting can take a different turn. There's a place like that in Greek philosophy. It's the stoa.[1] It lies between *agora* and *oikos*. It's a park or a portico in front of a house (or a grove before the city), a zone that is neither inside a house nor directly in the city. It is neither private like a household nor public like a market. It is neither the one nor the other and yet, it is both at once. And as such, it's a place where there is no legal protocol for dealing with meanings and values, so that you are free to think and speak about them at will. The direction our conversations may take is not predetermined. Those who meet here stroll about in the stoa, in open circles, peripatetically, in conversation or in silence. This is the movement of free thinking and feeling. It owes its potential to the topological unlawfulness of a stoa.

Cerith Wyn Evans creates the potential of a stoa in his works. He establishes situations in which the laws of regulated communication no longer apply and the clear distinction between spaces of discourse has been suspended. It would therefore even be somewhat misleading to refer to "works" when talking about the art of Wyn Evans. Obviously there are con-

JAN VERWOERT is contributing editor at *frieze* and the author of *Bas Jan Ader: In Search of the Miraculous* (The MIT Press, 2006). He teaches at the Piet Zwart Institute in Rotterdam, and the Royal College of Art, London.

CERITH WYN EVANS, ASTRO-PHOTOGRAPHY BY
SIEGFRIED MARX (1987), 2006, installation view,
Stedelijk Museum, Amsterdam / ASTRO-PHOTOGRAPHIE
VON SIEGFRIED MARX, Installationsansicht. (PHOTO:
STEDELIJK MUSEUM)

crete installations. And they are composed with precision. But they do not primarily have the character of *statements* (of the kind we are referring to when we say a work makes a statement). Instead, they tangibly formulate *states*, the states which we are in when we think or feel in the manner of a stoa, when ideas do not coalesce into statements because they are held in motion through the free interplay of forces. Encountering an installation by Wyn Evans is like returning to a particular perceptual attitude, an emotional state, a world. The experience is comparable to coming back to a book we have started reading and, on reentering the world of the novel, being surrounded by its characters and following the further development of their relationships.

Wyn Evans' approach to the composition of these states is conceptual in form. In this case, conceptual means that, in order to prevent his art from necessarily being art and art alone, it seeks the company of cinema, for instance, without ever becoming cinema, because the cinema it deals with has more to do with literature, without actually being literary. Wyn Evans thus engages in a peripatetic motion between art, cinema, and literature without ever submitting entirely to the laws of one particular domain. In contrast to artists, who now simply treat Conceptual Art as a historically established genre and a source of exploitable quotations, his peripatetic motion actualizes the original idea of conceptual practice: to create a free space, namely, a stoa, which lies between all media, genres, and disciplines, remaining open to all of them without submitting to the dominion of their rules and regulations.

TIXƎ (1992) is exemplary in this respect. It is a neon sign, a mirror image of the word "EXIT." This sign would show me the way out—if it weren't backwards. So the exit must already lie behind me. What I see in front of me is the mirror image of the sign that indicates where I am. It's like in Cocteau's *Orphée* (1949): I look out of the mirror back into the room that I must have just left by stepping through the mirror. TIXƎ is the way in to the way out of an outside-inside space. Writing about Wyn Evans, Mark Cousins describes the topological unlawfulness of this way-in-way-out-outside-inside space in a wonderfully agram-

CERITH WYN EVANS, CHANGING LIGHT AT
SANDOVER, computer screen, detail /
WECHSELNDES LICHT BEI SANDOVER, Computerbild-
schirm, Ausschnitt. (PHOTO: STEPHEN WHITE)

CERITH WYN EVANS, "…visibleinvisible," 2008, exhibition view, Musac, Leon / Ausstellungsansicht. (PHOTO: MUSAC)

CERITH WYN EVANS, exhibition view, 2004, Museum of Fine Arts Boston / Ausstellungsansicht. (PHOTO: MFA)

matical turn of phrase as a "room into which one would like to exit had one not already just entered from it."[2] What is this way-in-way-out-outside-inside space? It is the space of mirroring, of reflection; it is literally the space of thinking. I cannot simply enter it at will. Instead I tend to stray into it by getting lost in thought or slipping into reverie. To contemplate thoughts in this state means to experience them in their externality (their sheer materiality), in terms of the way in which they literally—letter by letter—interlock, invert, and twist around to form ever new constellations. This is the philosophical state. This is what the topological unlawfulness of the stoa feels like: like the way in to the way out of regulated discourse, and a passage into a region where the grammars of discourses shift and overlap like tectonic plates creating air pockets for thinking in between them.

The story that Wyn Evans tells about how the neon sign came about involves such an in-between space.[3] He and Lee Bowery had gone to a matinee in a big movie theater on Leicester Square in London to see some blockbuster movie. Wyn Evans walked out in the middle of the movie and accidentally chose an emergency exit that was blocked off so that after the door closed behind him, he could neither go back into the theater nor get out of the building. The exit sign was mirrored in the outer glass door. Both the sounds of the film inside the theater and the noises from the square outside must have been audible there. That is a fantastic parable for what conceptual practice can be when it renders the potential of a stoa: the experience of a state in which the sounds from a house of culture meld with the noises of the marketplace (material life and politics), resonating in a special way because they mix in a place that lies outside both realms. This "outside," however, is not of the kind invoked by the romantic ideology of transgression. It is not on the fringes of society but right in the middle of it, in the way-in-way-out-outside-inside spaces located on the threshold between different social spheres.

What kind of activity is generated by peripatetic movement between different spheres? The Situationists spoke about *détournement.* This concept is often used as a synonym for "appropriation." Yet there is more to the term. It comprises the word "détour," so it also contains the notion of deviating from a given path or being led astray. The notion of de-viation in turn corresponds to the dynamic of a peripatetic straying away from existing paths. Wyn Evans' appropriation of the cinema actualizes this dimension of

détournement in the form of acts that lead the cinema astray. The object of his fascination with cinema is not, as one would expect, the moving image, but rather the phenomenon of projection—the play of light. Led astray, as a play of light, the cinema then undergoes a series of *détournements* or transmutations in his installations. In HAS THE FILM ALREADY STARTED? (2000), a film is projected on a white helium balloon, tied to a cobblestone and suspended among indoor palm trees. Like Gil J. Wolman's movie *L'Anticoncept* (1952), the film is practically imageless. It only shows a bright circle in a dark outline that looks like a spotlight. From time to time, the light vanishes but instantly reappears. As the circle of light is a little bit bigger than the balloon, it produces a halo on the wall behind the balloon, like that of a solar eclipse. Wolman created a cinema, not of images but of words. In the voiceover to *L'Anticoncept* he is heard reciting an agrammatically (de)composed text on the state of poetic experience. In Wyn Evans' version, the soundtrack consists only of static. Maurice Lemaître similarly used objects as surfaces of projection instead of, or in front of, a screen. Like Wolman, he was associated with the Lettrists and sought to dissolve the cinema into an event in space. One of these para-cinematic works went by the title *Le film est déjà commencé?* (1951), which Wyn Evans re-invokes here.

These references are not quotations. The above-named Lettrists are characters in a world fleshed out by Wyn Evans. This world is in a particular state, in which the basic sentiment of the Lettrist attitude prevails. It articulates the spirit of Lettrism: the elegant anarchistic gesture of dismantling and amalgamating cinema and literature. The mode in which Wyn Evans relates to the Lettrist principle is thus not so much a form of *reference* but of *reverence*. Instead of displaying knowledge, he invests passion in the invocation of a spirit. He communicates the fascination inherent to a certain manner of freely dealing with cinema and literature. And he does so by dealing with his sources just as freely. Hence, Marcel Broodthaers is invited to join the circle of spirits that he invokes. The indoor palm trees indicate his presence. Whether or not he was officially a Lettrist doesn't matter. What counts is the spiritual affinity. It is through a gesture of rever-

ence, therefore, that Wyn Evans creates proximity between characters and evokes the spirit of their collective subjectivity. Crucially, though, a certain quality of *irreverence* is present in this gesture of reverence. The care with which Wyn Evans summons the spirits goes hand-in-hand with a certain carefree manner of picking material props for the ceremony of their invocation. Cobblestone, balloon, indoor palm trees, and an almost imageless film: together they form a simple, concise gesture that does not seem overly reverent; nor does it erect a temple. It creates a stoa. A temple would not suit the spirit of the Lettrists. Only a suitable irreverent gesture does.

This element of irreverence makes all the difference in terms of the attitude towards power and the law manifest in the way characters from the past are being invoked. As a rule, in disciplinary discourses, reference to respected historical figures is inseparable from a strategic interest in gaining legitimation. They are cited as authorities to validate one's assumptions. It is what the law of academia demands. Psychoanalytically speaking, summoning such father figures is profoundly Oedipal. As manifestations of free peripatetic motion, Wyn Evans' gestures of lovingly irreverent *détournement* fundamentally reject this Oedipal logic. They show no respect for the authority of a law. Instead, they thrive on a passion to create an affinity to a spirit. This spirit does not legitimize anyone's claim to power. It promises pleasure: the pleasure of anti-Oedipal thinking beyond the law.

LOOK AT THAT PICTURE ... HOW DOES IT APPEAR TO YOU NOW? DOES IT SEEM TO BE PERSISTING? (2003) is another site of invocation dedicated to the spirit of this form of thinking. Five chandeliers of varying provenance are installed in one room. They are each linked to a computer that converts a selected text into Morse code in real time. The lights of the chandeliers brighten and fade to the rhythm of the coded signals relayed by the computer. Five simple monitors mounted on the walls display the sentences and signals as they are being processed. The texts include passages from John Cage's diary, Brion Gysin and Terry Wilson's memories of a spirit medium who later worked for the CIA, a scathing critique of modern spiritism by Adorno, an essay by Eve Kosofsky Sedgwick against a paranoid culture of

reading and for a passionate one, and a love story collectively written by the salon of Madame Lafayette. In terms of the implications of its form, the *détournement* of the cinema here leads to yet another interpretation of projection as a play of light. In HAS THE FILM ALREADY STARTED? (2000), the film projection became a twinkling spotlight. The blinking light of the chandeliers continues this series of transmutations. Literature is likewise led astray. Text becomes code becomes signal. Morse code emerges as a language between all media. It can be visual, textual, or aural: light, cipher, or sound. A language that is many languages at once; what an exceptional means for attempting another form of communication on the threshold between media!

But at the same time, Morse code is a non-language. It is not really in use anymore. And the number of those who can read it fluently is probably limited. The mode of invocation therefore has a special character in this case. On one hand, it addresses anyone. Anyone who walks into the room and sees the chandeliers. On the other hand, it only speaks to an unknown someone, capable of decoding the signals. Which may possibly be no one, given the unlikely chance of such a visitor appearing. So the signals potentially address anyone and no one at the same time. Their mode of address is split from within. This has immediate implications for the form of the community summoned by the signals (if we consider all those, who will ever see the chandeliers, as a group, which could be a community). Potentially it consists of someone, someone special or possibly no one at all. This community does not share a common name by which it could here be addressed. Nor is there one doctrine or sacred script by which its members could swear, because a multiplicity of at times contradictory texts are being projected. This community remains ununited.

Moreover, the very manner in which they are convoked already says a great deal about the spirit in which they gather. Ordinarily, the sign under which a community comes together is immediately evident. Not in this case. Wyn Evans' ceremony of convocation seems to be both clandestine and open at once. On one hand, its procedure resembles a séance, not least due to the spectral aura of the blinking chandeliers. They come to life as they brighten and fade, as if they were breathing. The congregation of summoned spirits seems perfectly plausible. And yet questionable as well. Can this room be haunted? Its atmosphere is anything but spooky. It is well lit. You can see the computers at work. There is no secret about the way anything functions. Wyn Evans' conceptual gesture therefore marks a threshold between enlightened and occult practice. On the other hand, he creates transparence: everything is illuminated. Texts by critical writers are being spelled out. Slowly. Letter by letter. It is like a seminar on the *hermeneutic* technique of close reading. Except that the reading here is also an act of encrypting, which obliterates the direct legibility of the texts but invokes their spirit, cryptically, through coded signs: a *hermetic* practice. In what spirit is this seminar-séance then being conducted? In the spirit of a way of thinking that exists on the threshold between two schools of interpretation and belongs to neither. In the spirit of a stoa.

Besides, you never know with spirits. There is no guarantee that they'll come when called. They appear when *they* want to. So séances are a tricky technique for dealing with creatures from the past. In the case of citations, the one who cites seeks to take *possession* of what is cited. Things work differently in a séance. With spirits you must negotiate. And if you lose the upper hand in this process you might end up being the one *possessed*. Power relations are not predetermined; they are subject to negotiation. In contrast to the act of citation, the ceremony of convocation remains perilously performative and open ended. It cannot coerce a community (among and with spirits) to come into being. This lack of coercion characterizes Wyn Evans' gesture. It does not feel forced. And it forces neither guests nor spirits to give our potential community the shape of a group with a fixed identity. Not even the persistence of the community is ensured. There are no binding contracts. Only a gesture of invitation. That, however, persists. The computers and chandeliers repeat the invitation incessantly. Although its existence cannot be confirmed, this community exists in the perilous state of a continued invocation of its potential.

Most importantly, however, Wyn Evans never separates the spirit from the sign under which the com-

CERITH WYN EVANS and THROBBING GRISTLE,
A=P=P=A=R=I=T=I=O=N, 2008, installation view,
Yokohama Triennale / ERSCHEINUNG, Installationsansicht.
(PHOTO: YOKOHAMA TRIENNALE)

munity is invoked. On one hand, he treats signs literally as mounted letters, encoded ciphers, projected light signals. In which case communicating literally means giving signs. On the other hand, the literalist dimension of this act of giving signs can never be viewed apart from the spirit in which Wyn Evans practices it, namely, a certain irreverence, a lack of coercion, and a rejection of false awe. Wyn Evans' collaboration with Florian Hecker on the abstract opera NO NIGHT NO DAY (2009) has this quality. So far (as the collaboration is not yet finished) it has led to an almost imageless film with nearly toneless music. The projected material shows spots and shadows. Some appear only briefly. Others move, grow, shrink, and wander. First in black on white, and then in color. Accompanied by sounds that could be noises or tones, sequenced signals or unsequenced acoustic material. One thing that this simultaneous *détournement* of cinema and music articulates is a spirit of dissent: it owes nothing to a cinema that clings to the moving image, and a music that assumes it would have to be an orderly concatenation of notes. Yet at the same time, the *détournement* testifies to a love of avant-gardistic form: to a mode of dealing freely with cinema and music, of Lettrist or other provenance. A gesture of

reverence, yes, but performed irreverently, nonetheless, because it shuns the manifestos and translates avant-gardistic form into an audiovisual cipher that could be a universal or secret language, or no language at all—only a transmission of sounds and play of light. NO NIGHT NO DAY walks a peripatetic path along a historical threshold to the avant-garde, leading its language astray and thus pulling it back into the steady motion of thinking a stoa.

We give signs hoping for a response. When the signal is sent we wait for a reply. So the crux is: how to answer the transmission. Which language of gestures and signals would be suitable? In the name, sign, and spirit of which potential community are we to answer, given that this community is what our answer will establish? It could be a language developed in the spirit of someone who, on one hand, would hermeneutically trace the signals back to where they were sent from and, through reading the reference in the (ir)reverence, testify to the particular moment in history we are referring to. On the other hand, not to betray the spirit of this moment would mean not to expose but rather share its secret through responding hermetically with words that are like signals: like waving flags, batting your eyelids, winking, or tapping out rhythms on the keys of transmission devices. This exchange cannot end, it can only be continued through ongoing peripatetic detours and agrammatical deviations that make you stray through the way-in-way-out back into the inside-outside space of a stoa that you enter as you exit.

(Translation: Catherine Schelbert)

1) The following interpretation of the stoa is indebted to an unpublished paper by Nikos Papastergiadis, the contents of which were communicated to me by Cuauhtemoc Medina.
2) Mark Cousins, "Moderato Cantabile," *Afterall*, no. 4 (Autumn/Winter 2001), pp. 100–101.
3) Cerith Wyn Evan, "Innocence and Experience," *Frieze*, no. 71 (November–December 2002), pp. 76–81, here p. 79.

PABLO LAFUENTE

FOLLOW THIS,
YOU BITCHES

1.

"The poor can't be happy in Paris."[1] At least not in the Paris of the 1780s, the one that Louis-Sébastien Mercier portrayed in *Le Tableau de Paris* (1781–88). According to Mercier, they couldn't be happy in the city because there they were unrelentingly exposed to what they couldn't have. "We have in the capital passions that don't exist anywhere else. The sight of enjoyment invites you to enjoy yourself. All the actors who play a role on this great mobile theatre force you to become an actor yourself." Unhappiness, if shared by enough people at the same time and in the same place, can have very direct effects—as shown by the Revolution that immediately followed. But this unhappiness wouldn't have been enough were it not for the mimetic impulse that Mercier also identifies: the sight of enjoyment calls for further enjoyment, performance incites new performances… and the public display of sadness or anger commands compassion, active support, or shared rage. A city of Paris without poor inhabitants is unlikely to have been the stage for a revolution: the unhappiness or dissatisfaction created by the fact that the poor didn't follow Mercier's advice and leave the city resulted in radical social and political change that still shapes many of today's key political ideals. Whether this ability to share, or to aspire to share in what we see, is the result of neurological mechanisms, of social structures, or of a mere belief in equality is not the issue here. What is important for the moment is that the impulse seems

to exist and seems to have effects—and can easily (sometimes too easily) be used to explain people's individual and collective behavior.

Cerith Wyn Evans's exhibition "take my eyes and through them see you," which took place in autumn 2006 at the Institute of Contemporary Arts (ICA) in London, was introduced by the institution in terms of mimetic impulses.[2] A leaflet published on the occasion of the exhibition, which doubled as a press release and exhibition guide, pointed out that Wyn Evans first visited the ICA as a teenager in 1975, where he saw Broodthaers's exhibition "Décor: A Conquest by Marcel Broodthaers." The exhibition included LA BATAILLE DE WATERLOO (The Battle of Waterloo, 1975), a work that "had a tremendous effect on the young Wyn Evans"[3]—which Wyn Evans himself confirms, saying that the piece "was of enormous excitement to me."[4] He describes his first professional involvement with the ICA, four years after that first visit: Derek Jarman, whom he met at Patisserie Valerie at Old Compton Street, right behind St. Martins School of Art where he was studying, invited him and his fellow student John Maybury to show their films at the newly inaugurated ICA Cinémathèque. It was Wyn Evans's first showing of a work in public.

Broodthaers and Jarman, Patisserie Valerie and the ICA, St. Martins and Old Compton… for a young man from Wales, or so the story goes, the city of London in the 1970s must have felt like Paris in the 1780s—a city of passions and enjoyments, maybe also an unhappy city that, as the story goes, worked like a magnetic field on the young artist. This collection of influences, in the form of names, images, and sym-

PABLO LAFUENTE is managing editor of Afterall Books, co-editor of *Afterall* journal, and associate curator at the Office for Contemporary Art Norway.

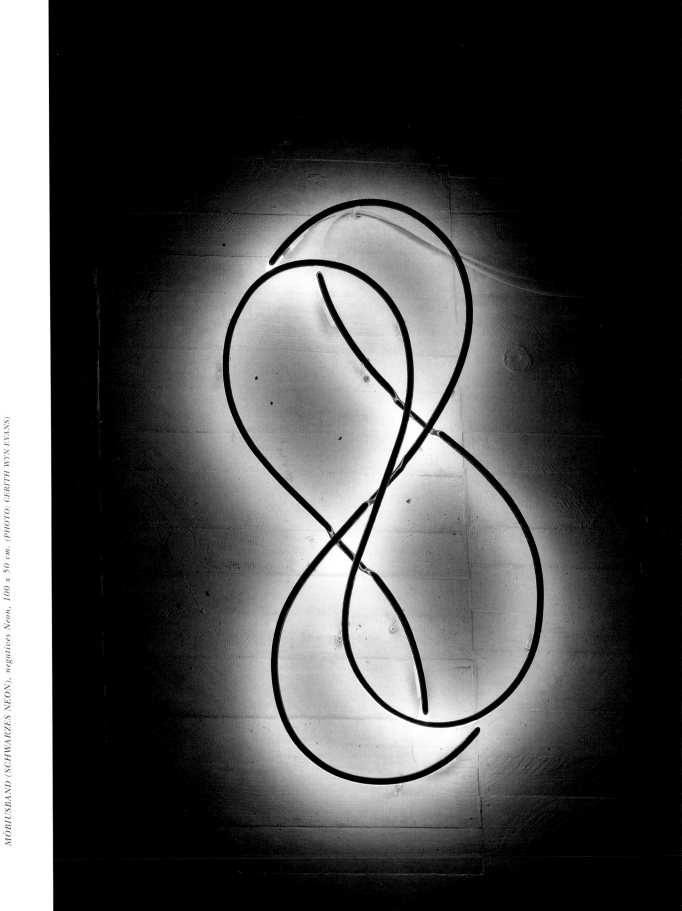

Hotel rooftop, Kitakyushu, Japan / Hoteldach. (PHOTO: CERITH WYN EVANS)

bols, provides a narrative of Wyn Evans's beginnings, and it allowed for "take my eyes and through them see you" to be presented as the closure of the cycle, a homecoming of sorts.[5] And in this narrative, the subject Cerith Wyn Evans is the key.

2.

To approach a specific work or exhibition through the subject who authors it is not uncommon—rather, it is probably the unwritten rule in writing about art, especially when the task is to write about an author in general. Whether this is the most productive approach is up for grabs. But in the case of Wyn Evans, some of the tropes at play in his practice seem to demand it. There are the autobiographical references, for example, in CONFIGURATION I (UNTITLED) (1996) and CONFIGURATION II (UNTITLED) (1996), two groups of portraits of Wyn Evans as a child taken by his father Sulwyn Evans, framed upside down. There are the photographs he prints in some of his books, snapshots that appear as the work of a delicate and curious eye and that construct the image of an individual sensibility at work—an image his own words reinforce, when he admits to be "some-

how bound up in this idea of selection, of sensibility, of the things that I feel speak to me."[6] There is also the collection of kindred sensibilities such as Broodthaers, Brion Gysin, Guy Debord, Pier Paolo Pasolini, and the many others whose texts he has translated into Morse code for lamps, chandeliers, and even searchlights. In summary, if a constant is to be identified, what immediately comes to mind is the suggestion of a unifying sensibility, one that, wherever it/he is, gathers objects, references, and materials.

So, there is a single creative subject—one that is shaped by attraction to other subjects (and images and things) and who exerts, in turn, an intense attraction for anyone who comes close (to him or to the work; as a spectator or as a writer). The compulsory task of the engaged viewer or commentator seems to be then to earnestly follow that sensibility and to reconstruct those choices, as a trajectory or as a unity on the basis of that individual subject. This is possibly why most of the discussion around Wyn Evans's work adopts, if not the biographical model, a phenomenological one: what is at stake is perception—a discussion of how images and things appear or reappear to a subject (the subject Wyn Evans in the first place

and the viewing subject later), of how they can be felt or sensed by means of a certain degree of abstraction, an economy of means, and a more or less identifiable style that is neither below nor above, but just different from knowledge.

But the moves of that sensibility prove not so easy to follow. Consider INVERSE REVERSE PERVERSE (1996), a concave mirror Wyn Evans made for his first gallery show at White Cube in 1996. Standing in front of it, one's self and the room are seen upside down—which immediately aligns the work with a tradition of institutional critique: the concave mirror both exposes and subverts the system of perception imposed by the art institution, literally turning the white cube upside down with a very simple gesture. Here, the artist Wyn Evans would be a critical subject alerting the viewer to how his or her subject position is constructed by the art institution. But this gets complicated when that viewing subject, looking at him- or herself in the mirror at a certain distance, finds their crotch in front of their face. What type of critical artist makes the viewer look into their crotch? In what kind of place do people do that? And what if you actually enjoy it?

Something similar happens with "take your eyes…" For DÉCOR (2006), and in reference to Broodthaers's 1975 exhibition, the wall separating the lower ICA gallery from the Mall was removed so that the street could be seen through the windows, and the gallery could be seen from the street. As a result, the key sites of Britain's legislative and executive power (Downing Street, the Houses of Parliament, and Buckingham Palace) were made symbolically present inside the now open gallery space. If this, again, sounds like straightforward institutional critique, the upstairs room facing the Mall complicated things: an empty space, the windows covered with Venetian blinds that, opening and closing, sent out a text in Morse code, the room was both a big head with eyes looking out onto the Mall and a stage where viewers were being looked at by two big flickering eyes on the wall. So the institution that is the object of institutional critique becomes a perceiving subject, and the viewing subject becomes an object to be seen—like the viewers looking through the peepholes in ÉTANT DONNÉS (1946–66). The parallels with Marcel Du-

champ's last work don't stop there, for the lower gallery windows opening onto the Mall, like the basement windows of Pedro Almodóvar's *Tacones lejanos* (High Heels, 1991), offered the visitors the chance to become voyeurs, to check out from below who was coming to the gallery and perhaps even enjoy the view.[7]

These contradictions, inconsistencies, disagreements, variances, or mismatches in the position of the subject and of the modes of subjection are as much of a constant in Wyn Evans's work as the individual, selective sensibility that was identified earlier. But they are so to the extent that it is impossible for this sensibility to aspire to be unifying. That is, unless anything fits within it—but then it would be almost impossible to follow it, even though that is exactly what the convention demands.

3.
I could tell you that the grass is really greener
on the other side of the hill.
But I can't communicate with you
and I guess I never will.
– Sandy Denny, "Solo" (1973)

In "Solo," Sandy Denny offers a subjective position to immediately withdraw it or, rather, make it clear that it is inaccessible. Arguably, it is in this absence of referent where the emotional charge of the song lies—and, this is a subjective statement, it is a very emotional song. Our ability to engage with it emotionally doesn't lie in its power to make us perceive, nor in its ability to invoke specific ideas or things, but in the way that it articulates a series of images behind which there is no ground or truth—neither a unifying subject nor an experience. Despite the fact that Wyn Evans's work has been discussed in terms of perception, as mentioned above, and of its ability to invoke other subjects or zones of experience, it is possibly better understood instead through its lack of grounding.[8] In fact, its ability to move the viewer (and, again a subjective statement, it can really move) is the effect of this lack.

If that is the case, the question that was left aside at the beginning of this text needs to be addressed. How do images move? How is it possible to participate

affectively in something that is obviously feigned? For example, as feigned and constructed as Sandy Denny's "Solo" or Wyn Evans's CLEAVE 03 (TRANSMISSION: VISIONS OF THE SLEEPING POET) (2003), for which a World War II searchlight projected a Morse translation of a text by Welsh clergyman and writer Ellis Wynne into the Venetian sky? The answer might be, as Rafael Sánchez Ferlosio says in his short essay "El llanto y la ficción" (Crying and Fiction, 1969–70), that what makes us feel is not the actual thing, but a mediated, secondary representation of the event.[9] He argues this with the help of a haiku:

In the sun the kimonos are drying:
Oh, the short sleeves
of the dead child!

The day after a child's death, the father looks through the window and sees the kimonos, still hanging from the previous day, composing a family portrait. But he suddenly becomes aware that one of the kimonos belongs to the child who just died. The last two verses can't be said aloud, drowned by a cry that is not caused by the body of the dead child, but by his kimono. As Sánchez Ferlosio concludes, every affect has its origin in a representation, and every representation, within art or outside of it, is composed of semantic and expressive elements. If that is the case, then we can understand how the image of the passions and enjoyments of Paris in the 1780s could cause unhappiness in others or how Marcel Broodthaers and Derek Jarman could have had a mimetic pull for a young Wyn Evans. We can also understand how CLEAVE 03, DÉCOR, and INVERSE REVERSE PERVERSE use images, names, and texts in a way that hopefully effects a pull and perhaps also makes you aware of it.

1) Louis-Sébastien Mercier, *Le Tableau de Paris* (Paris: La Découverte, 1998), pp. 145–7.
2) 20 September–29 October, 2006.
3) Jens Hoffmann, "Croeso Adref" in "take my eyes and through them see you," exhibition leaflet (London: Institute of Contemporary Art, 2006), n.p.
4) Cerith Wyn Evans, "Bringing the Wounded Back to the Battlefield" in "take my eyes and through them see you." See Note 3.

5) "Croeso Adref," the title of the short text in the exhibition leaflet, means "Welcome Home" in Welsh. Cerith Wyn Evans is Welsh; I don't know if he speaks the language.
6) Manfred Hermes, "This Double Ground of Space: Text, Translation, and Breathing—Interview with Cerith Wyn Evans" in Daniel Buchholz, Christopher Müller, and Nicolaus Schafhausen (eds.), *Cerith Wyn Evans* (New York: Lukas & Sternberg, 2004), p. 125.
7) And further, in page 108 of the MUSAC catalogue, there is a photograph of a partial nude, crotch exposed, holding a tree instead of a lamp, in what looks like a Japanese garden (with no waterfall).
8) See Daniel Birnbaum, "Late" in Octavio Zaya (ed.), *Cerith Wyn Evans: …visibleinvisible* (Ostfildern: Hatje Cantz; León: MUSAC, 2008), p. 25.
9) Rafael Sánchez Ferlosio, "El llanto y la ficción," (1969–70), *Ensayos y artículos*, Vol. II (Barcelona: Destino, 1992), pp. 138–41. Haiku translated from Spanish by the author.

CERITH WYN EVANS, CLEAVE 05, 2007, searchlight installation,
Kunstverein München /
Scheinwerfer, Installationsansicht. (PHOTO: KUNSTVEREIN MÜNCHEN)

PABLO LAFUENTE

HÖRT ZU,
IHR SCHLAMPEN

1.

«Die Armen können in Paris nicht glücklich sein.»[1] Jedenfalls nicht im Paris der 1780er-Jahre, jenem Paris, das Louis-Sébastien Mercier in *Le Tableau de Paris* (1781–88) schildert. Nach Merciers Darstellung konnten sie in der Stadt nicht glücklich sein, weil sie unerbittlich mit dem konfrontiert waren, was ihnen verwehrt blieb. «Es gibt in der Hauptstadt Leidenschaften, die nirgendwo sonst existieren. Beim Anblick von Vergnügen regt sich in einem der Drang, sich selbst zu amüsieren. All die Schauspieler, die auf dieser grossen fahrbaren Bühne eine Rolle spielen, zwingen einen, selbst Akteur zu werden.» Elend kann, wenn genügend Leute zur gleichen Zeit am gleichen Ort darin leben, ganz direkte Konsequenzen haben – wie die unmittelbar nachfolgende Revolution gezeigt hat. Diese Misere allein hätte allerdings nicht ausgereicht, wenn da nicht noch der ebenfalls von Mercier konstatierte Nachahmungsdrang gewesen wäre: Der Anblick von Vergnügen ruft zu weiterem Vergnügen auf, Schauspiel verlangt nach mehr Schauspiel … und die öffentliche Zurschaustellung von Traurigkeit oder Wut reizt zu Mitgefühl, tätiger Hilfe oder geteiltem Zorn. Ein Paris ohne Armut wäre wohl kaum zum Schauplatz einer Revolution geworden: Das Elend und die Unzufriedenheit, die daraus erwuchsen, dass die Armen Merciers Rat nicht folgten und die Stadt nicht verliessen, führten zu einem radikalen gesellschaftlichen und politischen Wandel, der bis in unsere Zeit hinein zahlreiche massgebliche

politische Ideale prägte. Ob diese Fähigkeit, an Erblicktem Anteil zu nehmen, oder dies anzustreben, die Folge neurologischer Mechanismen, gesellschaftlicher Strukturen oder eines blossen Glaubens an die Gleichheit aller ist, das ist hier nicht die Frage. Wichtig ist an diesem Punkt, dass es besagten Drang offenbar gibt und dass er Konsequenzen hat – und leicht (bisweilen allzu leicht?) dazu dient, das Einzel- und Kollektivverhalten von Menschen zu erklären.

In den einführenden Bemerkungen zu Cerith Wyn Evans' Ausstellung «take my eyes and through them see you», die im Herbst 2006 im Institute of Contemporary Arts in London stattfand, beschrieb das Institut die Ausstellung im Sinne eines Drangs zur Nachahmung.[2] In einer anlässlich der Ausstellung publizierten Broschüre, die gleichzeitig als Presseinfo und als Ausstellungsführer diente, wurde darauf hingewiesen, dass Wyn Evans im Jahr 1975 als Teenager zum ersten Mal das ICA besucht und bei dieser Gelegenheit Marcel Broodthaers' Ausstellung «Décor. A Conquest by Marcel Broodthaers» gesehen hat. Zu den Arbeiten in der Broodthaers-Ausstellung gehörte auch LA BATAILLE DE WATERLOO (Die Schlacht bei Waterloo, 1975), ein Werk, das «auf den jungen Wyn Evans einen enormen Eindruck machte»[3], wie Wyn Evans selbst bestätigt, wenn er erklärt, die Arbeit «hatte für mich etwas unheimlich Aufregendes»[4]. Er schildert, wie er zum ersten Mal als Künstler mit dem ICA zu tun hatte, vier Jahre nach jenem ersten Besuch: Derek Jarman, den er in der Patisserie Valerie an der Old Compton Street kennengelernt hatte, die direkt hinter der St. Martins School of Art gelegen war, an der Wyn Evans

PABLO LAFUENTE ist leitender Redakteur bei Afterall Books, Mitherausgeber der Zeitschrift *Afterall* und als Kurator für das Office for Contemporary Art Norway tätig.

damals studierte, bot ihm und seinem Kommilitonen John Maybury an, ihre Filme in der neu eingerichteten ICA Cinémathèque zu zeigen – das erste Mal, dass ein Werk von Wyn Evans öffentlich vorgeführt wurde.

Broodthaers und Jarman, die Patisserie Valerie und das ICA, St. Martins und Old Compton ... einem jungen Mann aus Wales muss London in den 70er-Jahren wie das Paris gegen Ende des 18. Jahrhunderts erschienen sein: eine Stadt der Leidenschaften und Vergnügungen, vielleicht auch eine unglückliche Stadt, die auf den jungen Künstler angeblich wie ein Magnetfeld wirkte. Diese Palette von Einflüssen in Form von Namen, Bildern und Symbolen ergibt eine Ursprungserzählung für die künstlerische Arbeit von Wyn Evans und machte es möglich, «take my eyes and through them see you» als das sich Schliessen eines Kreises, als eine Art Heimkehr darzustellen.[5] Und innerhalb dieser Erzählung ist das Subjekt Cerith Wyn Evans der Schlüssel.

2.

Sich einem bestimmten Werk oder einer Ausstellung über das Subjekt des Urhebers anzunähern, ist nicht ungewöhnlich. In der kunstkritischen Literatur dürfte dies die ungeschriebene Regel sein, besonders wenn die Aufgabe darin besteht, über einen Urheber i m A l l g e m e i n e n zu schreiben. Ob dies die fruchtbarste Herangehensweise ist, sei dahingestellt. In Wyn Evans' Fall aber scheinen manche der Tropen, die in seiner künstlerischen Praxis zum Tragen kommen, dieses Vorgehen zwingend nahezulegen. Da sind zum Beispiel die autobiographischen Bezüge in CONFIGURATION I (UNTITLED) (1996) und CONFIGURATION II (UNTITLED) (1996), zwei Gruppen von gerahmten, auf dem Kopf stehenden Porträtaufnahmen von Wyn Evans als Kind, die von seinem Vater Sulwyn Evans aufgenommen wurden. Dann sind da die Photos, die er in einigen seiner Bücher veröffentlicht hat, Schnappschüsse, die wie das Werk eines empfindlichen und neugierigen Blicks anmuten und die das Bild von einem Einzelbewusstsein bei der Arbeit entwerfen – ein Bild, das durch Wyn Evans' eigenes Eingeständnis bestätigt wird, wonach «mich diese Vorstellung des Auswählens, des empfindenden Bewusstseins, der Dinge, die nach meinem

Empfinden zu mir ‹sprechen›, irgendwie nicht loslässt»[6]. Und es gibt das Aufgebot von Sinnesverwandten wie Broodthaers, Brion Gysin, Guy Debord, Pier Paolo Pasolini und den zahlreichen anderen, deren Texte er für Lampen, Leuchter und gar für Scheinwerfer in Morsecode übertragen hat. Kurzum, wenn es darum geht, eine Konstante zu bestimmen, so kommt einem sofort die Andeutung eines verbindenden Bewusstseins in den Sinn, eines Bewusstseins, das überall dort, wo es (beziehungsweise er) sich aufhält, Objekte, Bezüge und Materialien sammelt.

Es gibt also ein einzelnes kreatives Subjekt, eines, das durch die Anziehung zu anderen Subjekten (und Bildern und Sachen) geprägt ist und das seinerseits eine starke Anziehungskraft auf jeden ausübt, der sich ihm nähert, sei es ihm selbst oder dem Werk, als Betrachter oder Kritiker. Die zwingende Aufgabe für den engagierten Betrachter oder Kommentator besteht also offenbar darin, diesem empfindenden Bewusstsein ernsthaft zu folgen und die Entscheidungen zu rekonstruieren, und zwar als eine Bahn oder eine Einheit auf der Grundlage des besagten Einzelsubjektes. Dies mag der Grund sein, weshalb der Grossteil der Diskussion um Wyn Evans' Werk sich, sofern nicht das biographische, dann ein phänomenologisches Modell zu eigen macht, denn das, worum es geht, ist die Empfindung: eine Erörterung der Frage, wie Bilder und Sachen einem Subjekt (wieder) erscheinen (in erster Linie dem Subjekt Wyn Evans und dann dem betrachtenden Subjekt), wie sie empfunden oder wahrgenommen werden kraft eines gewissen Masses an Abstraktion, einer Sparsamkeit der Mittel und eines mehr oder weniger erkennbaren Stils, der der Erkenntis weder über- noch untergeordnet, sondern einfach von dieser verschieden ist.

Es zeigt sich jedoch, dass es gar nicht so einfach ist, den Schritten dieses empfindenden Bewusstseins zu folgen. Nehmen wir INVERSE REVERSE PERVERSE (Verkehrt, andersrum, pervers, 1996), einen Hohlspiegel, den Wyn Evans für seine erste Galerieausstellung 1996 bei White Cube machte. Wenn man davorsteht, sieht man sich selbst und den Raum auf dem Kopf – womit sich das Werk sogleich in eine Tradition der institutionellen Kritik einreiht: Der Hohlspiegel entlarvt und untergräbt zugleich das auferlegte Sys-

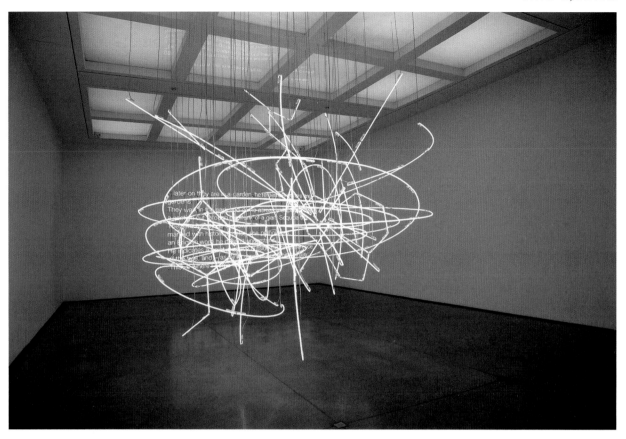

*CERITH WYN EVANS, TALVINDER, YOU'LL NEVER GUESS,
IT'S THE PACIFIC OCEAN AGAIN..., 2007, installation White
Cube Gallery, London / TALVINDER, DU WIRST ES NICHT
GLAUBEN, SCHON WIEDER DER PAZIFIK, Installationsansicht.*
(PHOTO: STEPHEN WHITE)

tem der Wahrnehmung, indem er mit einer denkbar einfachen Geste den weissen Kubus buchstäblich auf den Kopf stellt. In diesem Fall wäre der Künstler Wyn Evans ein kritisches Subjekt, das den Betrachter darauf aufmerksam macht, wie sein Subjektstandpunkt durch die Kunstinstitution konstruiert wird. Das Ganze wird allerdings vertrackt, wenn das betrachtende Subjekt, vor dem Spiegel stehend, feststellt, dass es seine Leistengegend unmittelbar vor Augen hat. Was für eine Art von kritischem Künstler zwingt den Betrachter, seine Leistengegend anzusehen? An was für einem Ort machen Leute das? Und was, wenn man tatsächlich Gefallen daran findet?

Etwas Ähnliches geschieht bei «take your eyes ...»: Für die Arbeit DÉCOR (2006), und als Anspielung auf die Broodthaers-Ausstellung von 1975, wurde die Wand, die den unteren Ausstellungsraum des ICA von der Mall trennt, entfernt, sodass die Strasse durch das Fenster zu sehen und der Ausstellungsraum wie-

derum von der Strasse her einsehbar war. Dadurch erhielten die zentralen Stätten der gesetzgebenden und exekutiven Macht in Grossbritannien (Downing Street, der Westminster-Palast und der Buckingham-Palast) eine symbolische Gegenwart innerhalb des nunmehr offenen Ausstellungsraums. Wenn sich dies wie direkte institutionelle Kritik anhört, so machte der obere, der Mall zugewandte Raum die Dinge komplizierter: leer und mit Jalousien vor den Fenstern, die durch Öffnen und Schliessen einen Text in Morsecode aussandten, war dieser Raum gleichzeitig ein grosser Kopf mit Augen, die auf die Mall hinausblickten, und eine Bühne, wo Besucher von zwei grossen flackernden Augen an der Wand beäugt wurden. Die Institution, die das Objekt institutioneller Kritik ist, wird somit zu einem wahrnehmenden Subjekt und das betrachtende Subjekt wird zu einem Objekt der Betrachtung – wie die Betrachter, die durch die Gucklöcher von ÉTANT DONNÉS (1946–66) spähen. Die Parallelen zu Marcel Duchamps letztem Werk sind damit noch nicht erschöpft, denn ähnlich wie die Kellerfenster in Pedro Almodóvars *Tacones lejanos* (High Heels, 1991) boten die Fenster im unteren Ausstellungsraum, die sich zur Mall hin öffneten, den Besuchern Gelegenheit, zu Voyeuren zu werden und von unten zu verfolgen, wer die Ausstellungsstätte aufsuchte, und diese Aussicht vielleicht sogar zu geniessen.[7]

Diese Widersprüche, Unstimmigkeiten, Ungereimtheiten, Abweichungen oder Diskrepanzen in der Stellung des Subjektes und den Formen der Subjektion sind ebenso eine Konstante in Cerith Wyn Evans' Werk wie das auswählende Einzelbewusstsein. Sie sind dies allerdings in einem Masse, dass besagtem Bewusstsein jede Möglichkeit versagt wird, verbindend sein zu wollen. Es sei denn, etwas passt ganz hinein – nur dass es in dem Fall nahezu unmöglich wäre, ihm zu folgen, obwohl genau das die Konvention verlangt.

3.
Ich könnte Dir sagen, dass jenseits des Hügels
das Gras tatsächlich grüner ist.
Nur, ich kann mich mit Dir nicht verständigen
und werde das wohl auch niemals können.
– Sandy Denny, «Solo» (1973)

In ihrem Song «Solo» bietet Sandy Denny einen subjektiven Standpunkt an, macht jedoch sofort wieder einen Rückzieher oder, genauer gesagt, macht deutlich, dass ein derartiger Standpunkt verwehrt ist. Die emotionale Spannung des Songs liegt wohl in der Abwesenheit eines Referenten. Und dies ist eine subjektive Aussage: Es ist ein sehr emotionales Lied. Dass wir imstande sind, uns emotional auf den Song einzulassen, hat seinen Grund nicht darin, dass der Song uns etwas erkennen lässt oder dass er bestimmte Vorstellungen oder Dinge zu beschwören vermag, sondern in der Art und Weise, wie er eine Folge von Bildern artikuliert, denen kein Boden, keine Wahrheit zugrunde liegt, das heisst weder ein verbindendes Subjekt noch eine Erfahrung. Auch wenn sich die kritische Auseinandersetzung zu Wyn Evans' Werk auf die Wahrnehmung konzentriert sowie auf dessen Fähigkeit, andere Subjekte oder Bereiche der Erfahrung zu beschwören, ist es für ein besseres Verständnis des Werkes hilfreich zu bedenken, dass es einer Fundierung entbehrt.[8] Seine Fähigkeit, den Betrachter zu bewegen (und das Werk kann, dies ist erneut eine subjektive Aussage, wirklich bewegen), ergibt sich eben aus diesem Fehlen.

CERITH WYN EVANS, "Bubble Peddler,"
exhibition view, 2007, Kunsthaus Graz / Ausstellungsansicht.
(PHOTO: CERITH WYN EVANS)

Metropolitan Museum, Tokyo. (PHOTO: CERITH WYN EVANS)

Wenn dies so stimmt, müssen wir uns der Frage zu-wenden, die wir eingangs dieses Beitrages beiseite geschoben hatten. Wie bewegen Bilder? Wie ist es möglich, affektiv an etwas einen Anteil zu haben, das offensichtlich fingiert ist? So fingiert und konstruiert etwa wie Sandy Dennys Song «Solo» oder Cerith Wyn Evans' Arbeit CLEAVE 03 (TRANSMISSION: VISIONS OF THE SLEEPING POET) (Übertragung: Visionen eines schlafenden Poeten, 2003), im Rahmen derer ein Scheinwerfer aus dem Zweiten Weltkrieg einen in Morsecode übertragenen Text des walisischen Geistlichen und Schriftstellers Ellis Wyne in den Himmel über Venedig projizierte? Eine mögliche Antwort könnte sein, wie Rafael Sánchez Ferlosio in seinem kurzen Essay «El llanto y la ficción» (Das Weinen und die Fiktion, 1969/70) erklärt, dass es nicht die Sache selbst ist, die unser Gefühl anspricht, son-dern vielmehr die vermittelte, sekundäre Darstellung des Geschehens.[9] Er führt dies anhand eines Haiku näher aus:

In der Sonne trocknen die Kimonos:
Ach, die kurzen Ärmel
des toten Kindes!

Am Tag nach dem Tod eines Kindes blickt der Vater durchs Fenster und sieht die Kimonos, die noch vom Vortag draussen hängen und die zusammen ein Fa-milienbildnis ergeben. Plötzlich wird ihm jedoch bewusst, dass einer der Kimonos dem Kind gehört, das gerade verstorben ist. Die beiden letzten Zeilen lassen sich nicht laut aussprechen, werden sie doch übertönt von einem Schrei, der nicht durch den

Anblick des Körpers des toten Kindes hervorgeru-fen wird, sondern durch den Anblick des Kimonos. Sánchez Ferlosio folgert, dass jeder Affekt seinen Ur-sprung in einer Darstellung hat und dass sich jede Darstellung, sei es in der Kunst oder ausserhalb, aus semantischen und expressiven Elementen zu-sammensetzt. Wenn das zutrifft, dann wird für uns nachvollziehbar, wie der Anblick der Leidenschaften und Vergnügungen im Paris der 1780er-Jahre andere unglücklich machen oder wie Marcel Broodthaers und Derek Jarman einen mimetischen Sog für den jungen Wyn besitzen konnten. Und es wird für uns ebenso nachvollziehbar, wie Arbeiten wie CLEAVE 03, DÉCOR oder INVERSE REVERSE PERVERSE Bilder, Namen und Texte dergestalt einsetzen, dass sich hof-fentlich ein Sog ergibt und uns ebendies womöglich auch bewusst gemacht wird.

(Übersetzung: Bram Opstelten)

1) Louis-Sébastien Mercier, *Le Tableau de Paris*, La Découverte, Paris 1998, S. 145–147.
2) 20. September – 29. Oktober 2006.
3) Jens Hoffmann, «Croeso Adref», in: «take my eyes and through them see you», Ausstellungsbroschüre, Institute of Con-temporary Art, London 2006, o.S.
4) Cerith Wyn Evans, «Bringing the Wounded Back to the Batt-lefield», in: «take my eyes and through them see you», ebenda.
5) Der Titel des kurzen Textbeitrages in der Ausstellungsbro-schüre lautet «Croeso Adref», walisisch für «Willkommen zu Hause»: Cerith Wyn Evans stammt aus Wales; ob er die Sprache spricht, weiss ich nicht.
6) Manfred Hermes, «This Double Ground of Space: Text, Translation, and Breathing – Interview with Cerith Wyn Evans», in: Daniel Buchholz, Christopher Müller und Nicolaus Schaf-hausen (Hrsg.), *Cerith Wyn Evans*, Lukas & Sternberg, New York 2004, S. 125.
7) Auf S. 108 des MUSAC-Katalogs findet sich zudem ein Photo einer teilweise entkleideten Person mit entblösster Leistenge-gend, die in einem japanisch anmutenden Garten (ohne Wasser-fall) statt einer Lampe einen Baum in den Händen hält.
8) Siehe Daniel Birnbaum, «Late», in Octavio Zaya (Hg.), *Ce-rith Wyn Evans: …visibleinvisible*, Hatje Cantz, Ostfildern, und MUSAC, León 2008, S. 25.
9) Rafael Sánchez Ferlosio, «El llanto y la ficción» (1969/70), in *Ensayos y artículos*, Vol. II, Destino, Barcelona 1992, S. 138–141.

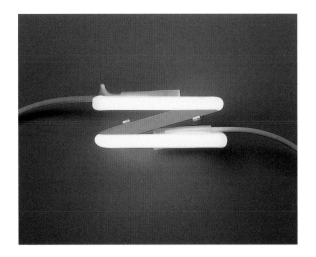

EDITION FOR PARKETT 87

CERITH WYN EVANS

E=Q=U=A=L=S, 2010
Neon light, 5 x 2 x $^3/_8$", electrical power cable,
transformer 6 x $^7/_8$ x $^7/_8$", with installation guide,
production by NEON Line, Vienna.
Edition of 35/XX, signed and numbered certificate.

Neonlicht, 12 x 5 x 1 cm, elektrisches Kabel,
Transformer 15 x 2 x 2 cm, mit Installationsanleitung.
Produktion: NEON Line, Wien.
Auflage: 35/XX, signiertes und nummeriertes Zertifikat.

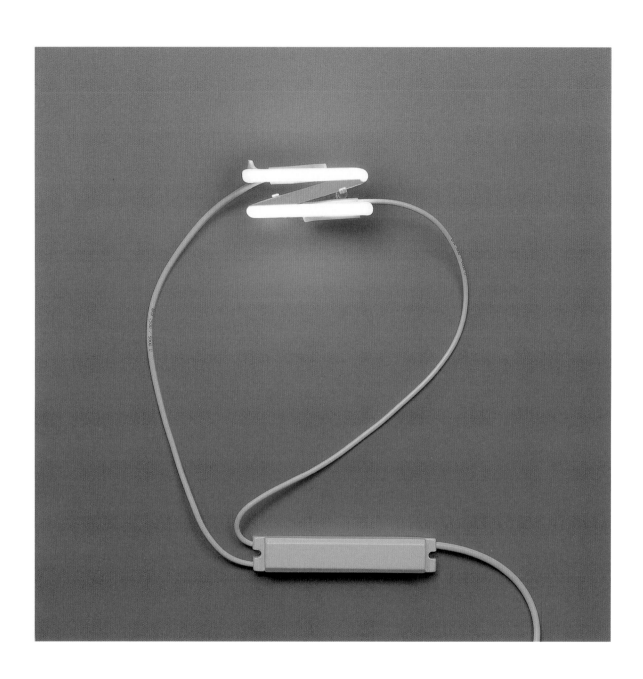

ANNETTE KELM

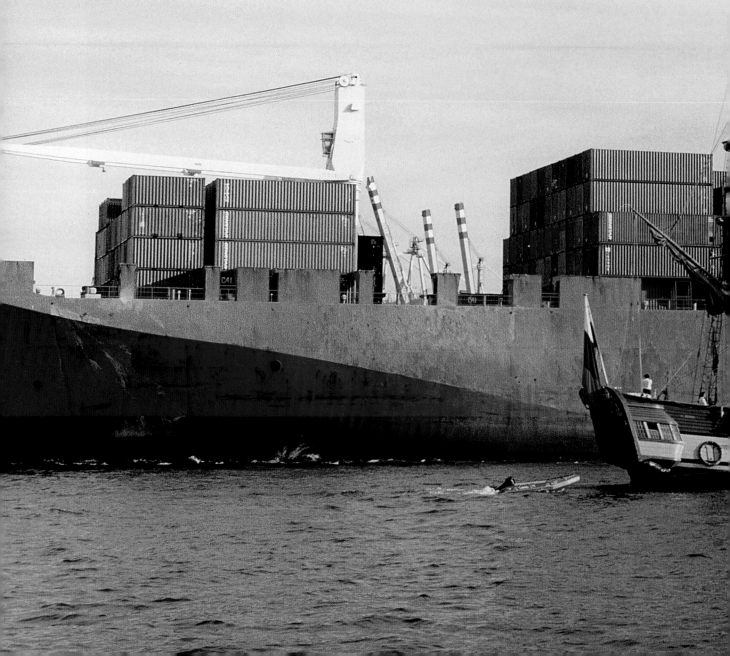

ANNETTE KELM, *UNTITLED, 2009, c-print mounted on alu-dibond, 24 x 36¹/₄" / OHNE TITEL, C-Print auf Alu-Dibond, 61 x 91,8 cm.*

BEATRIX RUF

Allerlei Wendungen

Eines der wohl am häufigsten reproduzierten Werke von Annette Kelm ist die Photographie UNTITLED (Ohne Titel, 2005). Ein Reiter, so gekleidet, dass er auch für einen Alltag im urbanen Umfeld tauglich wäre, lässt, auf einem unspektakulären Braunen sitzend, moderat die Tradition des Western anklingen. Der Reiter hält vollkommen unpassend einen weit geöffneten Fächer mit ausgestrecktem Arm Richtung Hinterhand des Pferdes, dessen Schweif bewegt ist, ansonsten fehlen jegliche Andeutungen von Bewegung oder sonstigen Störungen der Szenerie und der statischen Haltung des Tiers. Pferd und Reiter stehen in einem moderat gepflegten Park – der Rasen ist gestutzt, die Vegetation im Hintergrund ist eine Mischung von natürlichem Wuchs und kultiviert bearbeiteter Flora. Eine wie es scheint eher deplatziert gepflanzte Fächerpalme steht solitär im rechten mittleren Bereich der Szene. Diese wird von Pferd und Reiter halb verdeckt, sodass die Ähnlichkeit zwischen dem Fächer in der Hand des Reiters und den Blättern der Palme gerade noch bildwirksam werden kann. Die inhaltlichen Interpretationen und Lesarten des Bildes, von Rollenklischees, über Kultur- versus Naturdiskurse, Zivilisationskritik, Genderproblematik oder was einem sonst noch durch den Kopf gehen kann, kollabieren.

Das Bild UNTITLED (2007) zeigt eine mechanische Orgel, die den Übergang von der akustischen zur elektronischen Musikerzeugung repräsentiert. Annette Kelm hat das Instrument, einen sogenannten Wurlitzer, in einem Museum für Musikinstrumente photographiert. Die Szenerie insgesamt wirkt unwirtlich und wenig gestaltet, ein neutraler Betonraum, in dem isoliert weitere Instrumente stehen, die man im Hintergrund erkennen kann. Nicht gerade eine poetische oder an historischen Erzählungen reich zu nennende Atmosphäre. An einem

BEATRIX RUF ist Direktorin der Kunsthalle Zürich.

ANNETTE KELM, UNTITLED, 2005, c-print, 31 1/2 x 39 1/4" / OHNE TITEL, C-Print, 80 x 100 cm.
(ALL IMAGES COURTESY OF ANNETTE KELM AND GALERIE JOHANN KÖNIG, BERLIN)

Betonpfeiler rechts neben dem Wurlitzer hängt mit Klebestreifen provisorisch fixiert eine Miró-Graphik, die nur so gut zu sehen ist, dass man die Farben erkennt und eine auf lose verteilten Strichelungen mit den Primärfarben basierende Komposition; ein Halbkreis und eine Linie schliessen den Raum des Bildes nach oben und unten ab. Die Miró-Graphik wiederholt, wie der Fächer in der Hand des Cowboys die Wedel der Palme, zentrale Formelemente des Wurlitzers: das Halbrund des Instruments, die Lineatur seiner Tastenanordnung und die Unterscheidung der Tasten durch die gleichen Farben, die wir auf der Graphik erkennen können. Wie bei der Komposition Mirós befinden sich diese Elemente auf einem weissen Untergrund.

Die Betrachtung von ARCHEOLOGY AND PHOTOGRAPHY (Archäologie und Photographie, 2008) führt zunächst in eine andere Richtung, aber schliesslich zu einem ähnlichen formalen wie inhaltlichen Kollaps. Mit den klassischen Arrangements der Objektphotographie

ANNETTE KELM, UNTITLED, 2007, c-print, 39 1/2 x 32 3/4" / OHNE TITEL, C-Print, 100,5 x 83 cm.

– Hintergrundprospekt, leicht von oben nach unten gerichtete Perspektive, frei gestellte Gegenstände – wird gleichzeitig eine scheinbar medienanalytische, selbstreflexive Thematik angeführt: zwei Bücher, deren Titel um Photographie kreisen (*Archäologie und Photographie* das eine, *Photography and Literature* das andere), sind zusammen mit zwei Zucchini auf einem Blümchenstoff platziert. Die Raumlosigkeit, die durch die sonst üblichen monochromen Hintergründe, mit der Abrundung räumlicher «Horizontlinien» wie Ecken oder Berührungslinien von Wand und Boden, entsteht, wird durch das Blumenmuster des Hintergrundstoffes wieder aufgehoben. Die organischen Formen der Zucchini beginnen einen witzig-absurden Diskurs mit der wissenschaftlichen Anmutung der Bücher; die Blümchen des Stoffes verbinden sich auf perfide Weise mit Farbe und Form der Fruchtstengelansätze des Gemüses, die sich täuschend ähnlich sind. Wie in vielen anderen Arbeiten der Künstlerin klingen Fragen des Musters, des Vorder- und Hintergrunds und der Repräsentation an.

Die sechsteilige Porträtserie UNTITLED (2007) etwa zeigt eine mit Mantel und Schildkappe gut verpackte junge Frau, die vor einem neutralen blauen Hintergrund, der weder Ort noch Tageszeit erkennen lässt, von Bild zu Bild stetig Blick und Kopf von links nach rechts wendet. Frontal und immer in der gleichen Position aufgenommen, erfahren wir eigentlich gar nichts, nichts über die Porträtierte oder deren Emotionen, es ist auch keine Konfrontation mit dem Blick der Frau möglich, da deren Augen, verdeckt durch den Schild der Kappe, nur vage zu erkennen sind. Wie auch in anderen Serien der Künstlerin schauen wir uns die Bilder immer genauer an, so lange, bis das Schauen selbst zum Inhalt wird.

Die Antworten auf konkretes Nachfragen bei Annette Kelm – welche Interessen, Geschichten, Darstellungen sie verfolgt, behandelt, beabsichtigt – irritieren den Fragenden eigentlich noch mehr. Die Erzählungen zu den Bildern beginnen immer mit dem Interesse an einem spezifischen historischen Moment, einer persönlichen Geschichte, einem Interesse an ästhetischen Details oder historischen Fakten, die vergessen gingen oder aus dem Blickfeld geraten sind. Sie ist interessiert an kulturellen Prozessen des Übergangs von Produktionsmodellen und Objekten von der Hoch- zur Massenkultur, an historisch relevanten Entwicklungen in Design, Architektur und Technologie, den mannigfaltigen Veränderungen von Objekten und Bildern durch den Transport von Stilen und Produkten im globalisierten Konsum, an Fragen nach dem Artifiziellen und der Mehrdeutigkeit, die kulturelle Erscheinungen erfahren haben.

Immer aber münden ihre Beschreibungen zielstrebig in Informationen zur technischen Realisierung der Bilder. Sie lenkt damit nicht ab von den Fragen nach Inhalten, Erzählungen, Bedeutungen und lässt sich auch nicht auf das klischierte künstlerische Bonmot reduzieren, dass man ja Bilder mache und keine Texte. Sie legt ganz im Gegenteil offen, dass es viele Texte gibt, zahlreiche Stränge der diskursiven Annäherung an die Sujets des Bildes, das am Ende entstehen soll, also ein präzises Instrumentarium der Bildproduktion, das im Zusammenspiel von inhaltlichen, formalen und technischen Elementen einen Freiraum öffnen soll.

Die technischen Details der Arbeitsweise von Annette Kelm sind schnell aufgezählt, sie arbeitet klassisch, ihre Photographien entstehen mit analogen Grossbild-, Mittelformat- und Kleinbildkameras und sind Handabzüge. Diese scheinbar banalen Details aber sind präzise Entscheidungen im Dialog mit der Geschichte des Mediums selbst, sei es hinsichtlich der Positionierung von Photographie in die Reihe der als «Kunst» kanonisierten Medien wie auch hinsichtlich einer medieninhärenten Debatte der Veränderung unserer Bilder durch den technischen Fortschritt und die Variationen des Bildes durch medial definierte Qualitäten.

ANNETTE KELM, ARCHAEOLOGY AND PHOTOGRAPHY, 2008, c-print, 27 ¹/₂ x 33 ³/₄" / ARCHÄOLOGIE UND PHOTOGRAPHIE, C-Print, 69,60 x 85,60 cm.

Kelm macht sowohl Einzelphotos als auch Serien über einzelne Motive. Bei den Serien spielen zwar serienspezifische Erkennungszeichen, wie die Variation oder das Verhalten des Sujets in einer zeitlichen oder kompositorischen Entwicklung, eine Rolle, diese führen aber meist nicht zu mehr Information, einer Erzählung oder wie es etwa in den Serienbildern von Christopher Williams vorkommen kann, zu einer Diskussion über den Apparat und die Bedingungen der Abbildung selbst.

Die Formate der Arbeiten sind unspektakulär und von den Bildsujets entscheidend definiert: Wenn es sich um Reproduktionen handelt, zum Beispiel bei den 2007 entstandenen Arbeiten der BIG PRINTS, die auf Stoffmustern der Designerin Dorothy Draper beruhen, dann entspricht die Grösse des Bildes dem Format des verwendeten Stoffmusters. Bei Architekturaufnahmen, wie etwa in der 2008 entstandenen Serie über Muster- und Fertighäuser, die ausgehend von der Wolgaster Holzindustrie und den Deutschen Werkstätten am Anfang des letzten Jahrhunderts zur weltweiten Verbreitung dieses Modulbaues im Folklorestil führte, begegnen wir vertrauten Formaten der Architekturphotographie. Diese Bilder ermöglichen uns zugleich einen Blick auf das Objekt wie auch einen Bezug zu unserem eigenen Standpunkt und unserer eigenen realen Körpererfahrung mit diesen Architekturen. Auch die Porträts, Stillleben und Objektphotographien der Künstlerin sind an konventio-

ANNETTE KELM, FRYING PAN, 2007, c-print, 39 ¹/₂ x 31 ¹/₂" / BRATPFANNE, C-Print, 100,5 x 80 cm.

nelle Photographieformate angelehnt, die die Theorien der konzeptuellen und ästhetischen Strategien zur Positionierung der Photographie als Medium der visuellen Kunst ebenso präzise reflektieren wie leichtfüssig negieren.

Unsere Rezeption von Annette Kelms Werk wird also von Assoziationen und vor allem von Orientierungswünschen befeuert, die Arbeiten von Bernd & Hilla Becher genauso einschliessen wie die grossformatigen Bilder von Andreas Gursky, Thomas Struth, Thomas Ruff oder Candida Höfer. Wir suchen und fordern Interpretationsanker, die an künstlerische Ansätze und die veränderten Bedeutungen, die das Medium Photographie innerhalb der bildenden Kunst erlangt hat, andocken können. Wir folgen allen erdenklichen Spuren, die zu den weit verbreiteten Verwendungen der Photographie in den 90er-Jahren im internationalen Kontext führen. Wir hoffen Appropriation, inszenierte Photographie, narrative, konzeptuelle und gesellschaftskritische Ansätze zu finden oder medienkritische Ansätze der Repräsentation. Und ja, Kelms Verwendung der Photographie steht in einer Beziehung zu all den genannten Ansätzen, aber die uns bekannten Elemente und Lesarten werden mit leichthändiger, aber definitiv präziser Geste ausgehebelt; eine Einordnung mittels der ästhetischen wie konzeptuell definierten Erkennungszeichen kollabiert ebenso wie die eingangs erwähnte Suche nach Inhalten und Erzählungen.

ANNETTE KELM, UNTITLED, 2007, c-prints, 6 parts, 17 x 14 ¹/₂" each / OHNE TITEL, C-Prints, 6 Teile, je 43 x 37 cm.

Die Photographie scheint in den Arbeiten von Annette Kelm frei zu sein von diesen «Neben-schauplätzen». In ihrer Verwendung von Photographie spielt der Prozess der subjektiven Bild-findung und der technischen Bildentstehung eine zentrale Rolle. Die Arbeiten entstehen im Wechselspiel von intensiven Recherchen und intuitiven Vorgehensweisen als Ergebnis eines Hin und Her von Sehen und Komponieren, Verwerfen und Weiterkomponieren. Sie ent-stammten einem prozessualen Vorgehen, das eher der Malerei ähnlich ist. Kelm benutzt be-wusst die auf die einfachsten Grundlagen der Photographie reduzierten technischen Regel-werke und leiht sich von der Malerei den Anspruch, mit einfachen Mitteln individuelle Bilder und Porträts einer subjektiven Wirklichkeitswahrnehmung zu machen. Es entstehen enthie-rarchisierte Wahrnehmungs- und Wirklichkeitsprodukte, weil sie von Rezeptionsansprüchen wie Inhaltlichkeit, Faktizität oder homogenisierten Aussagen befreit sind.

Dies gilt auch für die installativen Präsentationen, die Annette Kelm mit ihren Arbeiten in Galerien und Institutionen «komponiert». Die Ausstellungen enthalten immer ihr gesamtes Motivrepertoire und Arbeiten aus unterschiedlichen Entstehungszeiten sowie das gesamte Repertoire der klassischen Repräsentationsformen der Photographie wie Stillleben, Porträts, Objektphotographie, Architektur- und Landschaftsphotographie. Das Bild der Hinterhufe eines Pferdes im Schnee (UNTITLED, 2001) kann auf eine von der Künstlerin mit einem eige-nen Photo gelabelte Schallplatte treffen (TARGET RECORD [Ziel-Schallplatte], 2005), die auf einem farbenfrohen Streifenstoff photographiert wurde; ein Papagei (TURNING INTO A PAR-ROT [Papagei werden], 2003) wird von einer behandschuhten, an die Falkenjagd erinnern-den Hand vor einen nicht ganz adäquaten Pflanzenhintergrund gehalten; photographierte Spiegeleier sind neben Händen zu sehen, die, Bettelgesten umkehrend, dem Publikum Geldmünzen entgegenhalten (UNTITLED, 2004); die Künstlerin, verkleidet mit Bart, steht im Fensterrahmen eines schiefen Hauses (YOUR HOUSE IS MY CASTLE [Dein Haus ist mein

Schloss], 2005), das im Garten der Monster von Bormarzo steht, den Vicino Orsini im 16. Jahrhundert in der Nähe von Rom anlegte. Oder sie bringt unterschiedliche Serien zusammen, wie die nächtlich aufgenommenen Palmen (I LOVE THE BABY GIANT PANDA, I'D WELCOME ONE TO MY VERANDA [Ich mag das Riesenpanda-Baby, ich hätte gerne eins auf der Veranda], 2003) oder die Äste eines Orangenbäumchens (UNTITLED, 2007) oder die von hinten photographierten durchlöcherten Schiessscheiben (UNTITLED, 2006). Die grossformatigen Reproduktionen von Stoffmustern könnten zu einem Bindeglied werden zum Bild der ersten elektrischen Gitarre vor einem afrikanisch anmutenden Stoff (FRYING PAN [Bratpfanne], 2007), der in den Niederlanden hergestellt und in Paris gekauft wurde. Ein Wasserglas mit Eukalyptuszweig, das auf einem Hawaii-Inselwelten-Stoffmuster steht, das mit dem abgebildeten Gegenstand visuell nahezu verschmilzt, wird durch den Titel AFTER LUNCH, TRYING TO BUILD RAILWAY TIES (Nach dem Mittagessen, Versuch Eisenbahnschwellen zu bauen, 2005) mit Assoziationen aufgeladen. Das Bild ist gespeist von Recherchen über die gescheiterten Versuche, die ersten Eisenbahnschwellen in den USA aus Eukalyptusholz herzustellen, und verwebt Stoff, Pflanze und historisches Wissen zu einer weiteren Geschichte der Sehnsucht.

Die individuellen Bilder begeben sich für jede aktualisierte Installation in neue Zusammenhänge, sie werden zu einem weiter gefassten Gesamtbild, das wiederum keine eindeutige Erzählung, keine identifizierbare Strategie zulässt. Die bereits aus den Einzelbildern bekannten Irritationen werden fortgesetzt: Reales und Fiktionales, Objektivität und Emotionalität, Gezeigtes und Abwesendes, collagierte Fakten, Geschichten und Geschichte tragen bei zu einer Ahnung von dem, was Bilder vielleicht sein können, und lassen eine Realität anwesend sein, in der die Gleichzeitigkeit vieler Wirklichkeiten, das Widersprüchliche, Brüchige und Mehrdeutig-Lesbare Alltag ist.

Twisting and Turning

BEATRIX RUF

The photograph UNTITLED (2005) is probably one of Annette Kelm's most frequently reproduced works. A rider dressed in clothing that could easily be encountered in an urban context is mounted on an unspectacular steed in a scene that is vaguely reminiscent of a Western. In an utterly inappropriate gesture, he is holding an open fan with his arm stretched back over the horse's hindquarters. The animal's tail is the only indication of movement in the static, immobile scene of horse and rider. They are pictured in a moderately well-kept park: the grass has been cut; the vegetation in the background is a mixture of natural growth and cultivated flora. A fan palm, looking slightly out of place, stands alone center right, half hidden behind horse and rider but still visible enough to underscore the resemblance between the rider's fan and the leaves of the tree. All the interpretations and readings of the picture's

BEATRIX RUF is the director of the Kunsthalle Zürich.

subject matter fall apart: clichéd roles, the discourse on culture versus nature, a critique of civilization, gender issues, or whatever else might come to mind.

UNTITLED (2007) shows a mechanical organ, representing the transition from acoustic to electronic music. Kelm photographed the Wurlitzer in a museum of musical instruments. The setting looks uninviting and slapdash; a few other isolated instruments can be made out in the background of this neutral, concrete space. The atmosphere is not exactly poetic or redolent of historic narrative. A Miró print has been scotch-taped to the concrete column beside the Wurlitzer. One can see that the composition is based on an arrangement of loosely scattered lines in primary colors, closed off top and bottom with a semicircle and a line. Just as the fan in the cowboy's hand echoes the palm leaves, the Miró print echoes the salient formal element of the Wurlitzer: the semicircle in the center with the linear arrangement of the keys, featuring the same colors as those in the print. In addition, both the Miró composition and the keys of the Wurlitzer are set off against a white ground.

ARCHEOLOGY AND PHOTOGRAPHY (2008) seems to take a different direction but ultimately leads to a similar collapse in form and content. The classical arrangement of object photography—a picture of single items shot slightly from above against a specific background—simultaneously implies a kind of media analysis and self-reflection: two books on photography (*Archäologie und Photographie* and *Photography and Literature*) have been placed with two zucchinis against a flowered fabric. The convention of using monochromatic backgrounds with rounded horizon lines to eliminate corners and the distinction between wall and floor ordinarily undermines any sense of space, but here it has been restored by the patterned fabric. The organically shaped zucchinis enter into absurd and witty discourse with the academically suggestive books, while the little flowers on the fabric establish an insidious alliance with the stem ends of the vegetables, so deceptively similar in color and shape. As so often in Kelm's work, the photograph alludes to questions of pattern, of foreground and background, and of representation.

The six-part series of portraits UNTITLED (2007) shows a young woman against a neutral blue background that reveals neither place nor time of day. She is wearing a baseball cap and is wrapped up in a coat. As the series progresses she turns her head from left to right. She is always photographed head on in the same position; we learn nothing about her or her emotions; nor can we look at her directly since her eyes are barely visible under the visor of the cap. As in other series, we look at the pictures so long and so intently until the act of looking itself becomes the content.

Kelm's answers to concrete inquiries—the interests that motivate her, the stories and representations that she pursues—leave the questioner even more baffled. The narratives behind the pictures always begin with curiosity about a specific historical moment, a personal story, interest in aesthetic details, or historical facts that have been forgotten or no longer attract attention. The artist is interested in cultural processes of transition; in models of production and objects as they shift from high art to mass culture; in historically relevant developments in design, architecture, and technology; in the diverse ways in which objects and images change through the transport of styles and products in an age of global consumption; and, finally, in questions of the artificiality and ambiguity that govern cultural artifacts.

Whatever the case, her descriptions always end up supplying information on the technical execution of her pictures, which does not, however, mean that she shuns questions of content, narrative, and meaning. Neither can her work be reduced to the hackneyed artistic *bon mot* that these are, after all, pictures and not texts. On the contrary, she demonstrates that

ANNETTE KELM, UNTITLED, 2001,
c-print, 27 1/2 x 39 1/4 " /
OHNE TITEL, C-Print, 70 x 100 cm.

ANNETTE KELM,
TARGET RECORD, 2005,
c-print, 13 ³/₄ x 17 ³/₄" /
ZIEL-SCHALLPLATTE,
C-Print, 35 x 45 cm.

there are a number of texts and many different strands of discursive approach to the subject matter of the emerging work. In other words, a precise set of tools for visual production allows for the interaction of substantial, formal, and technical elements, literally generating room for thought.

The tools of Kelm's trade are straightforward: her pictures are taken with large-, medium-, and small-format analogue cameras and individually printed by hand. These seemingly trivial details testify to deliberate decisions made in conversation with the history of her medium as regards its position among the rank and file of the media canonized as "art" and the nature of photography as a medium that filters our images, an inherent trait that is given additional impetus by technological advances.

Kelm makes single works as well as series on a single motif, the latter sharing recognizable features such as variations in composition or subject matter that change over time. Significantly, this does not necessarily lead to more information, to a narrative, or, as in the series that Christopher Williams makes, to debate on the mechanics or conditions of the image itself. The formats are unspectacular and defined by the subject matter. For instance, the size of the BIG PRINTS (2007), based on textiles designed by Dorothy Draper, echoes the format of the fabric pattern, and in the 2008 series of model homes and prefab housing, we encounter the familiar format of architectural photography. Beginning with the Wolgaster wood industry and the German workshops in the early twentieth century, this modular architecture in folkloric style spread across the globe. The photographs show us the object and, at the same time, they make us aware of our own vantage point by underscoring the way we physically experience the buildings. The artist's portraits, still lifes, and objects also adhere to conventional formats, not only exploring but also blithely negating the theories underlying

the conceptual and aesthetic strategies often enlisted to justify the medium of photography as a fine art.

The reception of Kelm's oeuvre sparks associations, most especially the impetus to seek orientation among such practitioners as Bernd & Hilla Becher and the large-format photography of, say, Andreas Gursky, Thomas Struth, Thomas Ruff, and Candida Höfer. We draw on anchors of interpretation secured in artistic approaches and the changing significance of the medium of photography within the fine arts. We follow every conceivable trail that leads to the widespread and manifold use of photography in the international context of the 1990s. We hope to find appropriation, staged photography, self-referentially critical representations, and a diversity of narrative, conceptual, and socially critical approaches. Kelm's use of photography is, of course, related to all of the above, while familiar elements and readings are subverted with a seemingly effortless *ménage* of definitive, precise gestures. Classification by means of aesthetic and conceptually defined recognition factors collapses just as much as the above-mentioned quest for content and narrative.

Kelm's photography seems to have been divested of these secondary considerations to make room for her main concerns: subjective imagery and technical production. Her works

ANNETTE KELM,
TURNING INTO
A PARROT, 2003,
c-print, 19 ³/₄ x 15 ³/₄" /
PAPAGEI WERDEN,
C-Print, 50 x 40 cm.

emerge on the cusp between intense research and intuitive action; they are the result of a constant back and forth between seeing and composing, followed by rejection and further composition. It is a process that is similar to painting. Kelm deliberately works with techniques reduced to the basics of photography; she borrows from painting the ambition of using simple means to produce individual images and portraits derived from the subjective perception of reality. The resulting products of perception and reality do not obey a hierarchy because they have been liberated from such critical expectations as content, facticity, or homogenized statements.

This also applies to the presentations that Kelm "composes" for galleries and institutions. Her exhibitions show a combination of works made at different times; they consistently include her entire repertoire of motifs and cover a wide variety of classical forms of representation in photography: still life, portraiture, object photography, architectural and landscape photography. The picture of a horse's back hoof in the snow (UNTITLED, 2001) may be juxtaposed with a record (TARGET RECORD, 2005) pictured against a background of colorfully striped fabric, its label showing a photograph by the artist; a parrot (TURNING INTO A PARROT, 2003) perched on a gloved hand, reminiscent of falconry, is pictured against a not-quite-adequate background of vegetation; fried eggs are seen next to hands holding coins out to the public in a reverse gesture of begging (UNTITLED, 2004); the artist, decked out in a false beard, is framed in the window of a slanted house (YOUR HOUSE IS MY CASTLE, 2005), located in the Bormarzo Garden of Monsters, which Vicino Orsini had installed near Rome in the sixteenth century. Or she combines different series like the palm trees photographed at night (I LOVE THE BABY GIANT PANDA, I'D WELCOME ONE TO MY VERANDA, 2003), the branches of an orange bush (UNTITLED, 2007), and a target full of bullet holes, photographed from the back (UNTITLED, 2006). The large-format reproductions of textile patterns could become a link to the picture of the first electric guitar photographed against a fabric that looks as if it might be African (FRYING PAN, 2007). The guitar was made in Holland and sold in Paris. A glass of water with a branch of eucalyptus dipped into it is placed on a fabric with a Hawaiian pattern and blends into it so well that it almost becomes indistinguishable. The title charges this work with myriad associations: AFTER LUNCH, TRYING TO BUILD RAILWAY TIES (2005). Taking its cue from research on failed attempts to use eucalyptus wood for the first railroad tracks built in the United States, the picture weaves fabric, vegetation, and historical knowledge into an additional tale of longing.

The pictures are given new contexts and, hence, new meanings in every new installation; they become part of a larger overall picture, which, once again, does not reveal or, indeed, permit any clear-cut narrative or identifiable strategy. The disturbing effects of the individual pictures prevail: real and fictional, objective and emotional, present and absent, a collage of facts, stories, and history offering hints of what the pictures might possibly be and presenting a reality in which the simultaneity of many realities, contradictions, breaks, and ambiguities are the stuff of everyday life.

(Translation: Catherine Schelbert)

ANNETTE KELM, YOUR HOUSE IS MY CASTLE, 2005, c-print, 10 ³/₄ x 13 ¹/₄ " / DEIN HAUS IST MEIN SCHLOSS, C-Print, 27,5 x 33,5 cm.

TOWARD A MINOR PHOTOGRAPHY:

Annette Kelm's Discrete Cosmologies

WALEAD BESHTY

Each act of depiction is the taming of an unruly past, a condensation of conventions, histories, and processes into a singular surface that is subsequently apprehended in a flash. And herein lies the double bind of the depictive in art, for depiction is the most conservative of gestures—naturalized, instrumental, idiomatic—and simultaneously the most contentious artistic act. Its sheer ubiquity and legibility place it squarely at the intersection of art and daily life, the very terrain that, since it was identified by the avant-gardes, has represented art's greatest revolutionary potential. Since the turn of the twentieth century, no medium has embodied the conflict over the depictive like photography: as the most widely disseminated popular medium and the most conventionalized representational form, it has been the subject of both ritualized scrutiny and nostalgic re-entrenchment.

WALEAD BESHTY is an artist, writer, and Associate Professor in Art Center College of Design's Graduate Fine Art Department. He lives and works in Los Angeles.

Yet it would be a mistake to claim that photography has been restrained by convention rather, it has no identity outside of convention and no history that is not equally a history of convention. The identity of photography is situated within the inverse relationship between materiality and convention, and as its material solidity has receded, dispersed technologically (a process initiated soon after its invention), convention has come to define it fully. This condition is not unique among objects of theoretical discourse; it is a state shared by all media that are identified and isolated as a tradition. Yet the photographic has undergone an even more extreme alchemical transformation that encompasses both art and the public sphere, not simply becoming a discursive collection of conventions, for this is what it always was, but of its conventions becoming subsumed within those of depiction, becoming inextricable from and unidentifiable outside the language of the depictive. The best evidence of this is the commonplace understanding that reproductions of photographs on billboards, in

books, in magazines, on computer screens, and on gelatin silver paper are equally a part of the photographic episteme despite their vastly differentiated materiality and mode of distribution. In short, they are equivalent because they serve as nothing more than the depictive.

By the late seventies, this peculiar circumstance made photography a wholly polarized artistic field. The practitioners and critics who noticed the tide changing diligently lined up on one side or the other of the ideological divide, arguing either for the redeployment of the instrumental force of the photographic to counter-institutional ends—a belief that the dominant language of the depictive might be redeemed—or for a deconstruction of its naturalized conventions, as though negation was not simply a

perverse form of preservation. Anachronistic as they may seem today, these polarities continued well into the following decade, and by now, the urgency once ascribed to photography in the discussion of the politics of art has waned, swept under the rug with other unfinished business. In the wake of this stalemate, the production of photographs in art appears to have suffered from a curious bout of self-inflicted amnesia: rather than being instrumental, it parodies the instrumental, abandoning any aspiration to a revolutionary project for the pictorialism of a premodern Beaux Arts, retroactively inserting itself into the tradition of the autonomous art object, or the taxonomies of the archival document, and blindly into its thoroughly disassembled instrumentality. Its contingent conventions, its elasticity of distribution

ANNETTE KELM, MIL ARRUGAS, 2005, c-print, 20 x 23 ¹/₂" / TAUSEND FURCHEN, C-Print, 50,8 x 60 cm.

ANNETTE KELM, UNTITLED, 2006, c-print, 27 ¹/₂ x 27 ¹/₂" / OHNE TITEL, C-Print, 70 x 70 cm.

and reception, have become concretized, inert, and stagnant, accepting the mute museum wall as its foregone conclusion, or, as George Baker surmised in his 2003 essay "Photography's Expanded Field," "Critical consensus would have it that the problem today is not that just about anything image-based can now be called photographic, but rather that photography itself has been foreclosed, cashiered, abandoned—outmoded technologically and displaced aesthetically."[1]

Thus we have a photographic discourse, theoretical or otherwise, that has become a moody precipitate of its headier days—a hermetic, over-crowded, over-theorized, and stifling field comprised of tired idioms, and a discourse-driven example of what Theodor Adorno termed "late style," which he likened to an aged piece of fruit whose surface is "furrowed, even ravaged," showing "more traces of history than of growth."[2] As Adorno wrote, late style "leaves only

fragments behind, and communicates itself, like a cipher, only through the blank spaces from which it has disengaged itself... its tears and fissures, witnesses to... finite powerlessness."[3] It is where "conventions find expression as the naked representation of themselves," producing "expressionless, distanced works" that turn "emptiness outward."[4]

Emerging in the early 2000s, Annette Kelm came to photography within its late moment, yet her work neither fit neatly into any of its entrenched modalities, nor did it propose a radical break with tradition. Instead, her unassuming images seem to curl up in the heart of the conflict, adapting photography's dominant tongue—its propensity for symbolism and historiography, its pictorial and taxonomic proclivities—to provisional ends. Her deadpan, frontal image of a fallen sequoia, MIL ARRUGAS (a thousand wrinkles, 2005), with its undulating root system

splayed out like an open wound and compressed against the picture's surface, offers an iconographic key to Kelm's oeuvre. MIL ARRUGAS was made on a trip to the same forest where Alfred Hitchcock, in his film *Vertigo* (1958), represented the conflation of time and space through a dismembered section of redwood. It was here that Hitchcock's protagonist, the hard-nosed former detective-turned-private eye, Scottie (James Stewart), fell victim to schizophrenic time, with his muse, Judy (Kim Novak)—masquerading as the psychically tortured "Madeleine"—pointing to one of the tree's annual rings and declaring it the moment of her death. For Scottie, his grip on reality loosened by his love for the imposter, this was the moment when the fragile barrier between past and present evaporated, and the beginning of his phantasmagoric descent into madness.

Reflecting on this scene some twenty years later in *Sans Soleil* (1983), Chris Marker mused on Hitchcock's anti-hero as a portrait of the archetypical filmmaker, an archeologist of images intoxicated by the fragments of the past and unable to resist falling victim to temporal aphasia. We follow Marker following Scottie's trail, just as Scottie followed his elusive object of desire, and along with Marker, we see time and space, present and past, reality and fantasy conflated in the synthetic temporality of cinematic time, Scottie's delirium representing Marker's filmic journey *en abyme*. The dizzying spiral encompassing Vertigo's opening credits served as Marker's ideogrammatic key, his narrator commenting: "Time cover[ed] a field ever wider as it moved away, a cyclone whose present moment contains motionless, *the eye*," or the "I," the seeing subject, ensnared within its vortex.

In MIL ARRUGAS Kelm stalks the eye and time to the mythical grounds of their conflation—the roots of the sequoia becoming the striations of an iris, giving us time again rendered as a static field. Yet, unlike the tidy geometry of Hitchcock's spiral, or the smooth cylindrical section that Scottie and Madeleine/Judy are seen standing before, Kelm's image is unruly: the dark center of the upended tree ensnared in the interlocking tendrils of its root system. Kelm delivers us an invaginated arrow of time (akin to Georges Bataille's pineal eye, whose conical form

echoes the tip of an arrow, and the piercing vision of the phallocentric camera) that is here split and inverted into an undulating pucker, an upended phallus revealing a darkened void enveloped in folds that retreat from its center like the rays of a sunburst in negative. Time is no longer depicted as the orderly sedimentations of the past, but as an interwoven knotted field that defies neat dissection and has literally been uprooted, arrested in a state of decay. Most telling, we are given a monocular double of the camera lens in the arrested spiral of the wounded tree as an eye that stares back like a clenched fist.

Like Marker's narrator, Kelm scavenges the historical and material world for totems, repeatedly revisiting the image of the eye and of time, symbols for which the technological image has always had almost religious deference. In her untitled series of targets, we are presented with a sequence of ocular forms marred by the literal piercing of arrows that inject pulsations of color through its blank surface. Again a flat field—an orderly terrain—is shot through with incidences that appear like an unnamed constellation: In her sequence of images that comprise the piece UNTITLED (2007)—a depiction of a woman flattened against a blue background with her eyes in deep shadow seemingly glancing back and forth—the camera's eye is transformed into a lurking, unseen stalker, yet the photographs are clearly staged, the forebodingly distanced precision of the lens performed rather than enacted. Another series, BACKSTAGE (2004), which shows an eye cropped tight, bracketed by false eyelashes, darting about as though trapped inside the frame, evokes the infamous scene in *Un chien andalou* (1929) where the empirical gaze of the camera literally dissects its object with the single slash of a razorblade, an instance of the symbolic and the depictive, the metaphoric and metonymic, consummated in one horrific gesture.

Yet, the violent taxonomies of the anonymous camera are never fully exploited by Kelm. The eye is never cut, the examination is left incomplete, and the sequence never resolves. The typological and serial turn from a monotonous drum roll into a circumstantial cadence. It is this quality of provisionality, what Gilles Deleuze and Félix Guattari called the "minor"—"that which a minority constructs within a

major language"—that Kelm here deploys.[5] No series lasts more than a few iterations, and their subjects—from a seated women, to a man at a thinly orchestrated Italian restaurant, to a palm tree blowing in the wind—could not be confused for the subject matter of the taxonomer, or the allegorical detritus of a social realist, yet the tools of their trades persist. As Deleuze and Guattari argue, "Minor languages are characterized not by overload and poverty in relation to a standard or major language, but by a sobriety and variation that are like a minor treatment of a major language… deterritorializing the major language."[6] The minor language is comprised of sliding meanings and innuendo that operates within the "cramped space" of the mother tongue, it never attempts to assert an oppositional language, it does not seek to "acquire the majority,"[7] but rather it insinuates itself within totalizing structures, turning them to the service of the transitory and contingent.

Channeling Walter Benjamin, Eduardo Cadava wrote, "The history of photography can be said to begin with an interpretation of the stars."[8] In Kelm's hands, photographs, like stars, are polysemic figures; they slyly shift meanings, slipping easily into a multitude of provisional patterns, allowing both symbolic inference and empiricist speculation to coexist. Her photographs embrace loose formal associations, tenuous historical linkages, and personal remembrances. The photograph AFTER LUNCH, TRYING TO BUILD RAILWAY TIES (2005) is exemplary in this respect. The vaguely Hawaiian motif of the fabric backdrop seen in the image evokes the anthropological uses of photography as much as it does the trope of botanical specimen documentation. Yet the mass-produced fabric never achieves the appearance of anthropological authenticity, instead it is a perversion that parallels the absurd prevalence of the Eucalyptus tree in Southern California, which is seen here demurely displayed in a common drinking glass. Native to Australia and imported in the early nineteenth century to the West Coast of the United States, it wasn't until the late 1860s that the Eucalyptus was planted on a grand scale to support the massive need for wood in the railroad and ship building industries. The fast-growing trees came to dominate the landscape, forcing out the native oaks, yet the Eu-

calyptus was a poor building material, wet and sappy, with a spiraling grain, and it had a natural tendency to curl as it dried, slowly tearing apart any structure it was used to build. In Kelm's image, these historical connections assume the character of the incidental: the plant clipping and cheap fabric infuse the larger narrative with a sense of whimsy while the lunch encounter is imbued with poetic significance.

Mythic conflations between the grand and the mundane are not uncommon in Kelm's vision. The same sensitivities draw her to the Los Angelino cowboy who enacts his personal fantasy in a neighborhood park, regally trotting amongst power lines and playing children, as they did to Albert Frey's sci-fi inflected restaurant-cum-spaceship, which sits in disrepair, peppered with graffiti as a rotting Futurism moored on the edge of an equally dead, man-made sea. But the elliptical conflation of past and present, history and image, is perhaps nowhere better on display than in Kelm's HOUSE ON HAUNTED HILL (I AND II) (2005). Both images depict Frank Lloyd Wright's Ennis-Brown house, whose structure has been slowly disintegrating into the hill on which it is perched. The culmination of Wright's pre-Columbian "textile block" houses, the Ennis-Brown, unlike its antecedents, went so far as to emulate pre-Columbian engineering, employing a high sand content concrete drawn directly from its grounds. While this decision literalized a very modern materialist interdependence of architecture and site, it also made the house particularly susceptible to erosion. The resulting piece of modern architecture, which was inspired by the timeless aura of ruins, has quickly become a ruin itself. A favorite of the Hollywood picture industry, the Ennis-Brown has served as the backdrop for several films (including the B-movie Kelm's titles her photographs after), but its most famous role was in Ridley Scott's *Blade Runner* (1982), a noir-ish imagination of a future populated by discursive fragments, simulations, and false figures: in short, the future presented as a ruin of the past, a material reality crushed under the weight of its images, that ironically foretold the fate of Wright's structure.

It would be a mistake to assume that Kelm's is a photography that proposes to remember for us: neither does it simulate or prescribe a historical narra-

tive, nor does it linger in the hermetic realm of the personal. Instead, it resides in the precarious position between worlds, between the personal and the public, the fleeting and the eternal, holding within each picture the potential for memory without prescription. It is this photography—not constructed to undermine totalizing or divisive potentials, but a provisional photography, grafted onto history's interior, a photography of minor proportions—that grows like a parasite within the dormant body of its host and, as such, outlives its confines, drawing new life from its dead flesh.

1) George Baker, "Photography's Expanded Field," *October*, vol. 114, Fall 2005, p. 122.
2) Theodor W. Adorno, "Late Style in Beethoven" in *Essays on Music*, ed. Richard Leppert, trans. Susan H. Gillespie (Berkeley and Los Angeles: University of California Press, 2002), p. 564.
3) Ibid, p. 566.
4) Ibid, pp. 566–67.
5) Gilles Deleuze and Félix Guattari, *Kafka: Toward a Minor Literature*, trans. Dana Polan (Minneapolis: University of Minnesota Press, 1986), p. 16.
6) Gilles Deleuze and Félix Guattari, *A Thousand Plateaus: Capitalism and Schizophrenia*, trans. Bernard Massumi (Minneapolis: University of Minnesota Press, 1987), p. 104.
7) Ibid. p. 106.
8) Eduardo Cadava, *Words of Light: Theses on the Photography of History* (Princeton: Princeton University Press, 1997), p. 26.

ANNETTE KELM, AFTER LUNCH TRYING TO BUILD RAILWAY TIES, 2005, c-print, 20 x 24" /
NACH DEM MITTAGESSEN, VERSUCH EISENBAHNSCHWELLEN ZU BAUEN, C-Print, 50,8 x 61 cm.

FÜR EINE MINORITÄRE PHOTOGRAPHIE:

Annette Kelms diskrete Kosmologien

WALEAD BESHTY

Etwas Abbilden heisst immer, eine widerspenstige Vergangenheit zu zähmen, Konventionen, zeitliche Abläufe und Prozesse zu einer einzigen Oberfläche zu verdichten, die dann blitzartig erfassbar wird. Darin besteht der Doublebind-Charakter der bildlichen Darstellung in der Kunst, denn das Abbilden ist die konservativste aller Gesten – im Sinn von eingebürgert, hilfreich, gebräuchlich – und zugleich der umstrittenste künstlerische Akt überhaupt. Seine schiere Allgegenwart und leichte Lesbarkeit versetzen ihn direkt in den Schnittpunkt von Kunst und Alltagsleben, also just auf jenes Terrain, das seit seiner Entdeckung durch die Avantgarde das grösste revolutionäre künstlerische Potenzial birgt. Seit der Jahrtausendwende hat kein Medium den Konflikt um die bildliche Repräsentation so sehr verkörpert wie die Photographie: als populäres Medium mit der

grössten Verbreitung und als am stärksten stilisierte Darstellungsform hat man sie regelmässigen rituellen Überprüfungen unterzogen, aber auch nostalgische Schutzwälle um sie herum errichtet.

Dennoch wäre es falsch, zu behaupten, dass die Photographie durch die Konvention behindert worden sei, denn es ist vielmehr so, dass sie ausserhalb der Konvention weder eine Identität hat noch eine Geschichte, die nicht zugleich eine Geschichte der Konvention selbst wäre. Die Identität der Photographie liegt in der reziproken Beziehung zwischen ihrer Materialität und ihrer Konvention, und da ihre materielle Solidität abgenommen beziehungsweise einen technologischen Auflösungsprozess durchlaufen hat (der kurz nach ihrer Erfindung einsetzte), wird sie mittlerweile ganz von der Konvention bestimmt. Dieser Umstand ist an sich nicht aussergewöhnlich für Objekte des theoretischen Diskurses, dieselbe Situation trifft auf alle Medien zu, die als Tradition betrachtet und isoliert werden. Das Photographische war jedoch sowohl im künstlerischen wie

WALEAD BESHTY ist Künstler, Autor und Associate Professor an der Abteilung für bildende Kunst des Art Center College of Design in Los Angeles. Er lebt und arbeitet in Los Angeles.

im öffentlichen Bereich einer besonders extremen alchemistischen Umwandlung unterworfen, indem sie nicht nur zu einer umfassenden Sammlung von Konventionen wurde, was sie schon immer gewesen war, sondern zu einer Sammlung von Abbildungskonventionen, wodurch sie sich untrennbar mit der Sprache der bildlichen Darstellung verflocht und ausserhalb derselben nicht mehr zu identifizieren war. Der beste Beweis dafür ist die verbreitete Auffassung, dass Reproduktionen von Photographien auf Plakatwänden, in Büchern, in Zeitschriften, auf Computerbildschirmen und auf Silbergelatineabzügen erkenntnistheoretisch durchwegs der Photographie zuzuordnen seien, trotz der extremen Unterschiede ihrer materiellen Beschaffenheit und Verbreitungsformen. Kurz, sie sind alle gleichwertig, weil sie nur noch als reine Abbilder fungieren.

Durch diesen seltsamen Umstand war die Photographie in den späten 70er-Jahren zu einer vollkommen polarisierten Domäne der Kunst geworden. Die

ANNETTE KELM, BACKSTAGE, 2004, c-print, 4 parts, 16 $^1/_2$ x 59 $^1/_4$ x 1 $^1/_4$"/
C-Prints, 4 Teile, 42,2 x 150,4 x 3,3 cm.

Kunstschaffenden und Kritiker, die den sich vollziehenden Wandel bemerkten, formierten sich geflissentlich auf der einen oder anderen Seite des ideologischen Grabens und machten sich entweder für den erneuten Einsatz der Macht der Photographie für anti-institutionelle Ziele stark – im Glauben, dass die herrschende Sprache des Abbilds eingedämmt werden könne – oder aber für die Dekonstruktion ihrer zur Regel gewordenen Konventionen, als ob die Ablehnung nicht bloss eine pervertierte Form der Bewahrung des Bestehenden wäre. So anachronistisch sie uns heute erscheinen mögen, diese Gegensätze hielten sich bis weit ins nächste Jahrzehnt hinein; mittlerweile hat sich die der Photographie einst zugeschriebene vordringliche Bedeutung für die politische Diskussion erledigt und wurde zusammen mit anderen unerledigten Angelegenheiten unter den Teppich gekehrt. Infolge dieser Pattsituation scheint die photographische Produktion in der Kunst unter einer seltsamen Attacke selbstverschuldeter Amnesie zu leiden: Statt einem Zweck zu dienen, parodiert sie das Zweckdienliche, lässt jede revolutionäre Ambition zugunsten des Piktorialismus einer vormodernen Auffassung der Schönen Künste fahren und reiht sich selbst in die Tradition des autonomen Kunstobjekts oder in das taxonomische System des Archivdokuments ein, womit sie sich blind der vollkommenen Demontage ihrer Zweckdienlichkeit fügt. Die Kontingenz ihrer Konventionen und die Elastizität ihrer Verbreitung und Rezeption haben sich verfestigt, sind träge geworden, stagnieren und akzeptieren die stumme Wand des Museums als ausgemachte Sache, oder, wie George Baker 2003 in seinem Essay «Photography's Expanded Field» mutmasst: «Laut allgemeiner Übereinkunft der Kritik besteht das Problem heute nicht nur darin, dass alles, was auf einem Bild beruht, photographisch genannt werden kann, sondern vielmehr darin, dass unter die Photographie selbst ein Schlussstrich gezogen wurde; man hat Bilanz gezogen und sie – als technisch überholt und ästhetisch verfehlt – aufgegeben.»[1]

Deshalb haben wir heute einen photographischen Diskurs (theoretischer oder sonstwelcher Art), der zu einem missmutigen Bodensatz aus wilderen Zeiten verkommen ist – eine hermetische, überbevölkerte, zu stark theoretisierte und erstickende Flut überstrapazierter Redewendungen –, ein diskursgesteuertes Beispiel dessen, was Theodor W. Adorno als «Spätstil» bezeichnete: Die Spätwerke bedeutender Künstler sind laut Adorno, anders als reife Früchte, «nicht rund, sondern durchfurcht, gar zerrissen» und «von Geschichte zeigen sie mehr die Spur als von Wachstum».[2] Die Subjektivität in den Spätwerken «lässt [von den Werken] Trümmer zurück und teilt sich, wie mit Chiffren, nur vermöge der Hohlstellen mit, aus welchen sie ausbricht. (…) die Risse und Sprünge (…) Zeugnis der endlichen Ohnmacht».[3] «So werden (…) die Konventionen Ausdruck in der nackten Darstellung ihrer selbst. (…) das Werk schweigt, wenn es verlassen wird, und kehrt seine Höhlung nach aussen.»[4]

Annette Kelm betrat die Szene in den ersten Jahren des neuen Jahrtausends, stiess also erst zu einem historisch späten Zeitpunkt zur Photographie, dennoch fügen sich ihre Arbeiten weder in eine der fest verankerten Formen, noch vollziehen sie einen radikalen Bruch mit der Tradition. Vielmehr scheinen sich ihre unprätentiösen Bilder im Zentrum des Konflikts einzurichten und zur Erreichung eines vorläufigen Ziels die vorherrschende Sprache der Photographie zu übernehmen – ihren Hang zum Symbolischen und Historisierenden, ihre piktorialen und taxonomischen Vorlieben. Kelms stoische Frontalansicht eines umgestürzten Mammutbaums, MIL ARRUGAS (Tausend Furchen, 2005), mit seinem wie eine offene Wunde dargebotenen, wellenartig verzweigten Wurzelsystem, das sich gegen die Bildfläche zu drängen scheint, ist ein ikonographischer Schlüssel zu Kelms Werk. MIL ARRUGAS entstand bei einem Ausflug in denselben Wald, wo Alfred Hitchcock in seinem Film *Vertigo* (1958) einst das Zusammenfallen von Raum und Zeit anhand eines geborstenen Mammutbaums darstellte. An diesem Ort geriet Hitchcocks Hauptdarsteller, der hartgesottene, zum Privatdetektiv mutierte ehemalige Kriminalbeamte Scottie (James Stewart) in den Bann der schizophrenen Zeit, als seine Muse Judy (Kim Novak) – in der Maske der psychisch angeschlagenen «Madeleine» – auf einen der Jahrringe des Baums deutete und ihn zum Zeitpunkt ihres Todes erklärte. Aus Liebe zu der schönen Betrügerin verliert Scottie das Gefühl für die Realität, im gleichen Moment löst sich die fragile

Schranke zwischen Vergangenheit und Zukunft auf und sein albtraumhaftes Eintauchen in den Irrsinn beginnt.

Als Chris Marker diese Szene zwanzig Jahre später in *Sans Soleil* (Ohne Sonne, 1983) reflektiert, sinniert er über Hitchcocks Antihelden als Porträt des archetypischen Filmemachers nach: ein archäologischer Ausgräber von Bildern, die durch Fragmente aus der Vergangenheit vergiftet sind, unfähig, sich gegen die temporale Aphasie zu wehren. Wir folgen Marker auf der Spur von Scottie, während Scottie seinerseits seinem flüchtigen Objekt der Begierde folgt, und zusammen mit Marker sehen wir, wie Zeit und Raum, Gegenwart und Vergangenheit, Realität und Phantasie in der synthetischen Zeit des Films verschmelzen, wobei Scotties Delirium für Markers filmische Reisen in den Abgrund steht. Die Schwindel erregende Spirale im Vorspann von Vertigo dient Marker als ideogrammatischer Schlüssel, während sein Erzähler folgenden Kommentar spricht: «die Zeit deckte ein Feld ab, das immer grösser wurde, je weiter es sich entfernte, ein Wirbelsturm, dessen gegenwärtiger Moment das bewegungslose Auge birgt» – das sehende Subjekt, das im Innern seines Wirbels gefangen ist. (Eye/I – Auge/Ich)

In MIL ARRUGAS verfolgt Kelm Auge und Zeit bis in die mythischen Urgründe ihrer Verschmelzung – wo die Wurzeln des Sequoia-Baumes zu Schlieren einer Iris werden und die Zeit erneut als statisches Feld wiedergeben. Doch im Gegensatz zur sauberen Geometrie von Hitchcocks Spirale und dem glatten Kegelschnitt, vor dem man Scottie und Madeleine/Judy stehen sieht, ist Kelms Bild widerspenstig: das dunkle Zentrum des entwurzelten Baumes umstrickt von den dichten Ranken seines Wurzelsystems. Kelm legt einen eingestülpten Zeitvektor frei (verwandt mit Georges Batailles Zirbel-Auge, dessen konische Form an eine Pfeilspitze und den penetranten Blick der phallozentrischen Kamera erinnert) – hier ist er gespalten – und verkehrt ihn zu einer sich kräuselnden Falte, einem umgestülpten Phallus, der in den wie Strahlen einer schwarzen Sonne sich von seinem Zentrum her ausbreitenden Falten eine verdunkelte Leere enthüllt. Die Zeit wird hier nicht mehr als geordnetes Sediment der Vergangenheit dargestellt, sondern als verknotetes Geflecht, das sich jeder sauberen Aufgliederung widersetzt, das buchstäblich entwurzelt und im Zustand der Zersetzung festgehalten ist. Dass uns aus der angehaltenen Spiralbewegung des verletzten Baumes ein einäugiges Double der Kameralinse entgegenstarrt – ein Auge wie eine geballte Faust –, sagt einiges aus.

Wie Markers Erzähler durchforstet Kelm die geschichtliche und materielle Welt nach Totems und greift dabei wiederholt das Bild des Auges und der Zeit auf, Symbole, die für das technisch erzeugte Bild schon immer fast religiöse Bedeutung hatten. In Kelms unbenannter Serie von Zielscheiben sehen wir uns einer Reihe von augenähnlichen Formen gegenüber, die buchstäblich durch das Eindringen von Pfeilen entstanden sind, welche wie Farbwellen über die leere Oberfläche jagen. Erneut wird ein flaches Feld – ein geordnetes Terrain – von Ereignissen durchbrochen, die wie ein namenloses Sternbild anmuten: In der Bildsequenz, zu der auch die Arbeit UNTITLED (Ohne Titel, 2007) gehört – das Bild einer Frau, ganz nah vor einem blauen Hintergrund, während ihre dunkel umschatteten Augen scheinbar umherschweifen –, wird das Auge der Kamera zum unsichtbar lauernden Voyeur; dennoch sind die Photos eindeutig inszeniert und die unheilschwangere distanzierte Präzision der Linse ist eher Demonstration als ehernes Gesetz. Eine weitere Serie, BACKSTAGE (Hinter der Bühne, 2004), die das eng beschnittene Bild eines Auges zeigt, umrahmt von falschen Wimpern, die heftig zucken, als wären sie innerhalb des Rahmens gefangen, erinnert an die berüchtigte Szene aus Luis Buñuels *Un chien andalou* (1929), in welcher der empirische Blick der Kamera sein Objekt buchstäblich in einem Schnitt mit der Rasierklinge zerteilt; ein Beispiel für Symbol und Abbild, Metapher und Metonymie, vollzogen in einer einzigen grauenvollen Gebärde.

Doch die systematische Gewalt der anonymen Kamera wird bei Kelm nie voll ausagiert. Das Auge wird nie zerschnitten, die Untersuchung bleibt unvollständig und die Sequenz löst sich niemals auf. Das Typologische und Serielle mutiert vom monotonen Trommelwirbel zum situationsangemessenen Rhythmus. Diese behelfsmässige Qualität bezeichneten Gilles Deleuze und Félix Guattari (im Kontext der Literatur) als «klein» oder «minder»: «Eine kleine

oder mindere Literatur ist nicht die Literatur einer kleinen Sprache, sondern die einer Minderheit, die sich einer grossen Sprache bedient.»[5] Keine Serie reicht weiter als ein paar Schritte, und ihre Sujets – von der sitzenden Frau über den Mann im sparsam angedeuteten italienischen Restaurant bis zu der sich im Wind wiegenden Palme – könnten nie mit dem Stoff des Systematikers verwechselt werden oder mit dem allegorischen Schrott eines Sozialrealisten,

ANNETTE KELM, HOUSE ON HAUNTED HILL II (DAY), 2005,
c-print, 31 1/4 x 38 1/2" / HAUS AUF DEM SPUKHÜGEL II (TAG),
C-Print, 79,5 x 98 cm.

ANNETTE KELM, HOUSE ON HAUNTED HILL I (NIGHT), 2005,
c-print, 20 x 25" / HAUS AUF DEM SPUKHÜGEL I (NACHT),
C-Print, 50,8 x 63,8 cm.

obwohl die Werkzeuge dieser Berufe noch existieren. Wie Deleuze und Guattari sagen: «Es gibt keine Verkürzung und keine Überfrachtung, die die minoritären Sprachen im Verhältnis zu einer Hoch- oder Standardsprache charakterisieren würde; es gibt eine Nüchternheit und Variation, die so etwas wie ein eingeschränkter Umgang mit der Standardsprache sind [...].» Es geht darum, «die Hochsprache zu deterritorialisieren.»[6] Die mindere Sprache setzt sich aus gleitenden Bedeutungen und Andeutungen zusammen, die im engen Raum der Muttersprache ihre Wirkung entfalten. «Es geht niemals darum, die Majorität zu erringen.»[7] Die minoritäre Sprache bringt sich in majoritäre Systeme ein und stellt diese in den Dienst des Transitorischen und Kontingenten.

In Anlehnung an Walter Benjamin schrieb Eduardo Cadava: «Man könnte sagen, dass die Geschichte der Photographie mit einer Sterndeutung begonnen hat.»[8] In Kelms Händen werden Photographien, wie Sterne, zu vieldeutigen Figuren; sie wechseln scheu ihre Bedeutungen und schlüpfen leicht in eine Vielzahl provisorischer Muster, die symbolische Bezüge und empirische Spekulation nebeneinander koexistieren lassen. Kelms Photographien begünstigen lose formale Assoziationen, heikle historische Verknüpfungen und persönliche Erinnerungen. Das Bild AFTER LUNCH, TRYING TO BUILD RAILWAY TIES (Nach dem Essen, beim Versuch Bahnschwellen zu verlegen, 2005) ist in dieser Hinsicht exemplarisch: Das vage hawaiianisch anmutende Motiv des Stoffs im Hintergrund erinnert ebenso an die Verwendung der Photographie in der Anthropologie wie an das Genre der Dokumentation botanischer Gattungen. Doch der industriell hergestellte Stoff verfügt nicht über die nötige anthropologische Authentizität, sondern bleibt eine Perversion, die dem absurden Überhandnehmen des Eukalyptusbaumes in Südkalifornien gleichkommt, dessen Zweig hier ganz gesittet in einem gewöhnlichen Wasserglas präsentiert wird. Ursprünglich in Australien beheimatet und im frühen 19. Jahrhundert an die Westküste der Vereinigten Staaten importiert, wurde der Eukalyptus erst in den späten 60er-Jahren des 19. Jahrhunderts im grossen Stil angepflanzt, um den enormen Bedarf an Holz für den Eisenbahn- und Schiffbau zu befriedigen. Die rasch wachsenden Bäume sollten die Landschaft

bald dominieren und die einheimischen Eichen verdrängen, dabei war Eukalyptus ein problematisches Baummaterial, nass und saftig, mit spiralförmiger Körnung, hatte es von Natur aus die Tendenz, sich beim Trocknen zu verwerfen und jedes Bauwerk langsam zu zerstören, zu dessen Bau es verwendet wurde. In Kelms Bild wirken diese historischen Anspielungen zufällig: Der abgeschnittene Zweig und der billige Stoff geben dem Ganzen etwas Kapriziöses, während das Zusammentreffen am Mittagstisch geradezu mit poetischer Bedeutung aufgeladen ist.

Die mythische Vereinigung von Grossartigem und Profanem ist bei Kelm nichts Ungewöhnliches. Es ist dieselbe Sensibilität, die sie zum Los-Angeles-Cowboy hinzieht, der seinen persönlichen Traum im Park seines Stadtbezirks auslebt, indem er majestätisch zwischen Stromleitungen und spielenden Kindern dahintrabt, oder zu Albert Freys sciencefictionmässig geschwungenem Restaurant-mit-Raumschiff, das baufällig und von Graffiti übersät als verrottetes Futurismusdenkmal am Rande eines nicht minder toten, von Menschen geschaffenen Meeres vor Anker liegt. Das elliptische Zusammenfallen von Vergangenheit und Gegenwart, Geschichte und Bild kommt aber wohl nirgends besser zum Ausdruck als in Kelms HOUSE ON HAUNTED HILL (I AND II) – Haus auf dem Spukhügel (I und II), 2005. Beide Bilder zeigen Frank Lloyd Wrights Ennis-Brown-Haus, dessen Baumasse langsam in den Hügel hineingesunken ist, auf dem es steht. Beim Ennis-Brown-Haus, das den Höhepunkt von Wrights präkolumbianischen Gewebe-Block-Konstruktionen darstellt, ging Wright, anders als bei dessen Vorläufermodellen, so weit, die präkolumbianische Bautechnik nachzuahmen, indem er einen stark sandhaltigen Beton verwendete, den er direkt aus dem Material des Baugrundes mischte. Diese Entscheidung war zwar die buchstäbliche Umsetzung einer äusserst modernen Wechselbeziehung zwischen Architektur und Gelände, machte das Haus jedoch auch besonders erosionsanfällig. Das entstandene Stück moderner Architektur, inspiriert durch die zeitlose Aura von Ruinen, wurde sehr rasch selbst zur Ruine. Als Liebling von Hollywood diente das Ennis-Brown-Haus in mehreren Filmen (einschliesslich des B-Movies, nach dem Kelm ihre Bilder getauft hat) als Kulisse, doch seine berühmteste Rolle war die in

Ridley Scotts *Blade Runner* (1982), einer schwarzen Zukunftsphantasie voller philosophischer Versatzstücke, Simulationen und falscher Figuren, kurz: die Zukunft als Ruine der Vergangenheit, eine materielle Realität, die vom Gewicht ihrer Bilder erdrückt wird und ironischerweise das Schicksal von Wrights Bau vorwegnimmt.

Es wäre ein Fehler, anzunehmen, dass Kelms Photographie sich anbieten würde, an unserer Stelle eine Erinnerungsfunktion zu übernehmen: Weder simuliert sie etwas, noch gibt sie einen historischen Zusammenhang vor, noch verweilt sie im hermetischen Bereich des Privaten. Sie ist vielmehr in der prekären Position zwischen den Welten angesiedelt, zwischen dem Privaten und dem Öffentlichen, dem Flüchtigen und dem Ewigen, wobei in jedem Bild das Potenzial zur Erinnerung steckt, ohne dass sie es uns aufzwingen würde.

Doch gerade diese Photographie – nicht gemacht, um ein Verallgemeinerungs- oder Sprengungspotenzial zu unterlaufen, sondern eine provisorische Photographie, die auf das Innere der Geschichte gepfropft ist, eine Photographie im kleinen Massstab – wächst wie ein Parasit im schlummernden Körper ihres Wirtes und überdauert so dessen Grenzen, indem sie neues Leben aus seiner toten Materie zieht.

(Übersetzung: Suzanne Schmidt)

1) George Baker, «Photography's Expanded Field», *October*, vol. 114, Herbst 2005, S. 122 (Zitat aus dem Engl. übers.).
2) Theodor W. Adorno, «Spätstil Beethovens», in Gesammelte Schriften Bd. 17: *Moments musicaux – Impromptus*, Suhrkamp-Verlag, Frankfurt am Main 1982, S. 13.
3) Ebenda, S. 15.
4) Ebenda, S. 16–17.
5) Gilles Deleuze und Félix Guattari, *Kafka: Für eine kleine Literatur*, übers. v. Burkhart Kroeber, Edition Suhrkamp, Frankfurt am Main 1976, S. 24.
6) Gilles Deleuze und Félix Guattari, *Tausend Plateaus*, übers. v. G. Ricke und R. Vuillié, hg. v. Günther Rösch, Merve-Verlag, Berlin 1997, S. 146.
7) Ebenda, S. 147.
8) Eduardo Cadava, *Words of Light: Theses on the Photography of History*, Princeton University Press, Princeton 1997, S. 26 (Zitat aus dem Engl. übers.).

STEFANIE KLEEFELD

Open Source

Das gestalterische Zutun sei da nicht gerade gross. Zwei Lampen indirekt auf den Hintergrund, eine aufs Objekt und abphotographieren. Das ist fast der geringste Aufwand, den man da betreiben kann, so Annette Kelm in einem Gespräch mit Jens Asthoff.[1] Kelm spricht hier von ihrer Arbeit ANONYMOUS, LILAC CLOCK BAG BUFFALO EXCHANGE (2007) – einer vierteiligen Photoserie, deren einzelne Aufnahmen dieselbe lilafarbene runde Handtasche zeigen, in deren Vorderseite eine Uhr mit Ziffernblatt eingenäht ist. Frontal aus gleicher Perspektive und vor weissem Hintergrund aufgenommen, unterscheiden sich die einzelnen Aufnahmen nur durch die jeweils um eine Minute variierende Zeigerstellung der Uhr.

Ein Grossteil der Photographien Kelms weist diese Art von Distanziertheit gegenüber dem zu photographierenden Gegenstand auf. Im Stil der neutralisierenden Studiophotographie werden die Sujets meist ohne Schattenwurf in einer Art «Nicht-Raum» festgehalten oder so aus nächster Nähe eingefangen, dass jeder räumliche Kontext negiert scheint. Als sei Kelms Projekt das einer Archäologie von Dingen, Architekturen und Landschaften, verweisen die Bildgegenstände so vor allem auf sich selbst: Da gibt es nichts, was enthüllt beziehungsweise über die Sujets hinaus erzählt wird. Dieses Nichts-Dazutun oder isolierte Präsentieren der Motive zeugt von einem Vertrauen in die Bildgegenstände. Es scheint zu genügen, sie ins rechte Licht zu setzen. «Die Begeisterung

des Photographen für ein Sujet ... ist vor allem eine Bestätigung des Da-Seins dieses Sujets, seiner Richtigkeit»[2], sagt Susan Sontag.

Kelm zeigt ihre Bildgegenstände entweder in einzelnen Aufnahmen oder in Serien, bei denen das Motiv mit einer Engelsgeduld und ohne jegliche Angst den Betrachter oder sich selbst zu langweilen, von verschiedenen Seiten beziehungsweise in unterschiedlichen Ausschnitten oder in einem geringen zeitlichen Abstand aus ein und derselben Perspektive eingefangen wird. Der Betrachter wird so Teil eines Unternehmens, bei dem Kelm die von ihr ausgewählten Sujets genauestens betrachtet und untersucht, und den Entdeckungen, die Kelm dabei macht, folgt (zumindest potenziell) auch der Betrachter.

Photographieren bedeutet immer auch, sich etwas anzueignen. Wie Merleau-Ponty jedoch gezeigt hat, schliesst jede Perspektive eine andere aus. Darin liegt die Unmöglichkeit, einem Phänomen in seiner Gänze wirklich habhaft werden zu können. So ist jeder Photographie das Scheitern dieses sich Aneignen-Wollens bereits eingeschrieben. Mit ihren Serien treibt Kelm dieses Aneignen-Wollen einerseits auf die Spitze (denn eine Aufnahme scheint nicht zu genügen), andererseits wird das Scheitern dieses Unterfangens in ihren Arbeiten thematisiert. «In der Wiederholung erliegen die Motive ihrem Streben nach Ähnlichkeit, sie lösen sich (wie selbstverständlich) vom Original wie von einer allmächtigen Vaterfigur»[3], so Dirk von Lowtzow. So eröffnet sich nicht in den Photographien selbst, sondern in den Leerstellen, in den Verschiebungen und feinen Un-

STEFANIE KLEEFELD ist Kunsthistorikerin und -kritikerin und lebt in Berlin. Sie ist Redakteurin von *Texte zur Kunst.*

170

ANNETTE KELM, FIRST PICTURE FOR A SHOW, 2007, c-print, 6 ¹/₄ x 7 ³/₄" /
ERSTES BILD FÜR EINE AUSSTELLUNG, C-Print, 16 x 20 cm.

terschieden zwischen den einzelnen Aufnahmen die Bedeutung, eröffnen sich Assoziationsräume, die über das Abgebildete hinausweisen.

Was aber sind das für Objekte, die Eingang in das Werk Kelms finden? In ihren Photographien richtet sie ihre Aufmerksamkeit oftmals auf das Unspektakuläre, das Alltägliche (etwa auf eine Eichel in FIRST PICTURE FOR A SHOW [Erstes Bild für eine Ausstellung, 2007]). Neben solch eher gewöhnlichen Bildgegenständen lassen sich in ihren Arbeiten aber auch eine Reihe kulturell aufgeladener Motive finden (beispielsweise die in Serie gegangenen ersten Fertighäuser, die Anfang des 20. Jahrhunderts aufka-

men). Alles andere als unbeschriebene Blätter tragen diese Sujets ihre Bedeutung bereits mit sich und weisen damit über sich hinaus auf einen Kontext, der mittels der Bildgegenstände aufgerufen wird. Demnach gibt es in Kelms Werk zwei Arten von Motiven: solche, die im kulturhistorischen Kanon bereits als bedeutend gesetzt sind, und solche, die Kelm aufgrund ihrer Wahl erst als bedeutend setzt.

Die Auswahl gewöhnlicher Motive geht auf das aus dem Surrealismus stammende Postulat zurück, dem Abseitigen Aufmerksamkeit zu widmen, dem – zumindest noch im Surrealismus – die moralische Prämisse eingeschrieben war, die Hierarchien zwi-

schen «schön» und «hässlich», «bedeutsam» und «trivial» aufzuheben. Diese Idee der Gleichwertigkeit aller Sujets beschränkt sich jedoch nicht nur auf die Auswahl der Bildgegenstände, sondern erstreckt sich auch auf deren Inszenierung innerhalb der Photographien. Da wird beispielsweise ein Julian Göthe für JULIAN, ITALIAN RESTAURANT (2008) in derselben Weise photographiert wie jedes andere Motiv ihrer seriellen Arbeiten auch. So weisen alle drei Photographien dieser Serie dasselbe Format auf während sich das Motiv der einzelnen Aufnahmen nur minimal unterscheidet: und zwar nicht in der Perspektive, nicht im Ausschnitt und nicht in der Komposition, sondern lediglich in den kleinen Bewegungen der Hände und Augen, die Göthe zwischen den einzelnen Aufnahmen vollzieht. Kelms Porträtphotographien sind daher immer auch als Objektphotographien zu lesen, wie auch umgekehrt ihre Objektphotographien, da sie den eingefangenen Gegenstand zu porträtieren scheinen, als Porträtphotographien verstanden werden können.

Diese Strategie der Gleichwertigkeit der Bildgegenstände (in der Auswahl und Inszenierung), kennzeichnet auch diejenigen Photographien Kelms, bei denen mehrere Objekte miteinander kombiniert und vor speziell ausgewählten Hintergründen arrangiert und drapiert werden. Diese Arbeiten un-

terscheiden sich von den zuvor genannten, jedoch nicht aufgrund ihres bis ins Detail durchdachten Komponiert-Seins. Denn wie Kelm selbst angemerkt hat, gibt es keinen neutralen Bildraum[4], sodass auch ihre scheinbar nicht komponierten Photographien (wie etwa die der Fertighäuser) als Setzungen und nicht als reine Dokumentationen verstanden werden müssen. Der Unterschied zwischen den beiden Arten ihrer Photographien liegt vielmehr in dem Kombiniert- beziehungsweise in dem in Beziehung-Gesetzt-Sein der Bildgegenstände untereinander, dem die Arbeiten bei aller Strenge ihre Manieriertheit verdanken (wobei die ebenfalls Bedeutung suggerierenden Hintergründe, für die Kelm oftmals ornamentale Stoffe verwendet, ebenfalls als Bildgenstände begriffen werden müssen). So stellt sich angesichts der kombinierten Photographien weniger die Frage nach dem Warum der Motive (eine Frage, die die Photographien mit nur einem Bildgegenstand aufwerfen) als vielmehr die nach dem Warum der Arrangements.

Kelms Arrangements sind zum Teil grotesk und verwirren zunächst. Dies ist auf das Nebeneinander scheinbar nicht zusammengehörender Dinge zurückzuführen. Die Bildgegenstände verweisen zwar auch hier auf sich selbst und ihre Geschichte, mittels ihrer Kombination wird diese Selbstreferentialität jedoch

auch konterkariert. Und in diesem Bruch eröffnet sich wie auch in der Repetition ein und desselben Gegenstandes «ein feinsinniges (...) Spiel der visuellen und verbalen Assoziationen»[5], wie Jessica Morgan es formuliert, bei dem unvertraut gemacht wird, was vertraut ist, und bei dem sich die Gedanken des Betrachters mit der den Gegenständen eingeschriebenen Bedeutung überlagern.

So auch bei ARCHEOLOGY AND PHOTOGRAPHY (2008) – einer Arbeit, auf der zwei stehende Bücher mit zwei weissen Zucchinis vor einem Stoffhintergrund mit grünem Blumenmuster zu sehen sind. Die Zusammenstellung der Bildgegenstände erscheint bizarr. Weder erschliesst sich die Kombination von Buch und Gemüse noch die von Hintergrund und Objekten; (abgesehen davon, dass, wie Beatrix Ruf treffend angemerkt hat, die Fruchtstängelansätze der Zucchinis eine formale und farbliche Korrespondenz zu den Blüten der auf dem Stoff abgebildeten Blumen aufweisen[6]). Was jedoch auffällt ist, dass Kelm hier gleichzeitig sowohl Objekte aus der Kategorie «abwegig» (die Zucchinis) als auch aus der Kategorie «bedeutend/beschrieben/aufgeladen» (die Photographiebücher) ausgewählt und miteinander arrangiert hat. Die Auswahl dieser Gegenstände wie auch die Kombination des Buches *Archäologie und Photographie* mit einer Zucchini legen nahe, die

Photographien als Kommentar zur eigenen Arbeit zu lesen.

Mit solchen Deutungsversuchen wähnt man sich jedoch immer auf unsicherem Terrain, denn im selben Moment, in dem man eine Lesart ausspricht, weiss man, dass die vorgeschlagene nur eine unter vielen möglichen ist. Und diese Offenheit der Arbeiten ist intendiert.

Deutlich wird dieses Intendiert-Sein bei ihrer vierteiligen Serie *Untitled* (Ohne Titel, 2007), die einen Orangenbaum zeigt, der in verschiedenen Ausschnitten und von unterschiedlichen Perspektiven aus aufgenommen wurde. Da weder der Titel der Photographie noch der grüne Hintergrund etwas über den Kontext des Baumes verraten, sieht der Betrachter das, was er sieht: vier Photographien, die in unterschiedlichen Ausschnitten ein und dasselbe Motiv zeigen. Bei weitergehender Beschäftigung mit der Arbeit erfährt man jedoch ein zusätzliches Detail, das wohl durch Kelm selbst in Umlauf gebracht wurde.

ANNETTE KELM, ANONYMOUS,
LILAC CLOCK BAG BUFFALO EXCHANGE, 2007,
c-prints, 4 parts, 19 1/4 x 23 1/2" each /
ANONYM, LILA UHRENTASCHE BUFFALO EXCHANGE,
C-Prints, 4 Teile, je 49 x 60 cm.

ANNETTE KELM, ERSTES MUSTERHAUS, HELLERAU,
DEUTSCHE WERKSTÄTTEN HELLERAU,
ARCHITEKT ADELBERT NIEMEYER, 1920, 2008,
c-print, 29 ³/₄ x 22 ³/₄" / C-Print, 75,5 x 58 cm.

So gehört der Orangenbaum ihren Eltern, den diese 1975 – dem Jahr, in dem Kelm geboren wurde – geschenkt bekommen haben.[7] Diese Information ist nicht elementar, um einen Zugang zu der Arbeit zu gewinnen. Den gewinnt man auch so, denn die Blätter und Früchte des Baumes verschmelzen aufgrund der fehlenden Schatten mit dem flächigen grünen Hintergrund zu einer Ebene, sodass der Gegenstand ins Ornamentale umgedeutet wird. Mit dieser Verflechtung von Vorder- und Hintergrund findet eine Verwischung der verschiedenen Bildebenen statt, die Kelm mit ihren Photographien der Stoffentwürfe Dorothy Drapers im selben Jahr aufs Äusserste getrieben hat. Denn da der Hintergrund bei den Aufnahmen der Stoffentwürfe zugleich photographiertes Objekt ist,

fallen hier Vorder- und Hintergrund in eins; wobei Kelm durch den Verzicht der materiellen Darstellung des Bildgegenstandes (zum Beispiel durch die Falten des Stoffes) den photographischen Bildraum in der dekorativen Oberfläche auflöst, während sie gleichzeitig das zu photographierende Objekt zeigt. Man kann die Photographien des Orangenbaumes aber auch unter dem Aspekt der Serie betrachten: der Aufnahme des Baumes also aus verschiedenen Perspektiven und in unterschiedlichen Ausschnitten und der damit einhergehenden Annäherung des Mediums Photographie an die Medien Film und Skulptur. Der biographische Aspekt gibt demnach lediglich eine weitere Bedeutungsebene hinzu.

Aufgrund der kalkulierten Freiräume in Kelms Arbeiten kommt man also nie an den Punkt, an dem alles gesagt wäre, sodass der abstruse Wunsch nach der Lesart, nach der Bedeutung in ihren Arbeiten ad absurdum geführt wird. Und diese Offenheit muss als künstlerische Strategie begriffen werden. Wie Beatrix Ruf treffend angemerkt hat, wechselt «Annette Kelm permanent die Ebenen der Assoziationen und damit die Wege, die man im Bild nehmen kann, und man selbst wechselt permanent die Zugangsweise: Mal dominiert das Verbale, mal das Konzeptuelle, mal das rein Retinale, mal geht es um Geschmack oder ästhetische Verführung.»[8] Alles ist da, doch es gibt keine Auflösung für das, was man sieht.

Diese Offenheit ihrer Arbeiten forciert Kelm nicht nur mittels ihrer Strategien der Bildgestaltung, sondern auch durch die von ihr gewählten Titel, die das Motiv nicht benennen, sondern andere Konnotationen anklingen lassen und somit mehr verschleiern als aufklären. Die Titel können dabei sowohl poetisch sein (etwa YOUR HOUSE IS MY CASTLE, [Dein Haus ist mein Schloss, 2005]) als sich auch auf das legendäre «Ohne Titel» zurückziehen. Ähnlich dem Herauslösen der Objekte aus ihrer originären Umgebung sowie ihrer Kombination mit anderen Gegenständen, besteht Kelm auch hier nicht auf den ursprünglichen Kontext des photographierten Gegenstandes. Bei anderen Arbeiten schlägt Kelm jedoch den genau entgegengesetzten Weg ein und benennt die gezeigten Gegenstände aufs Genaueste. So beispielsweise bei ihren Aufnahmen der ersten in Serie gegangenen Fertighäuser (ERSTES MUS-

TERHAUS, HELLERAU, DEUTSCHE WERKSTÄTTEN HELLERAU, ARCHITEKT ADELBERT NIEMEYER, 1920 [2008]). Ohne die Titel wären diese Motive nicht einzuordnen und, da Kelm in den Bildern selbst keine Brüche zu erzeugen sucht, nichts weiter als Aufnahmen schöner Häuser, so jedoch werden sie als Serie miteinander in Beziehung gesetzt. Und in dieser Bezugnahme zeigen sich nicht nur ihre Gemeinsamkeiten, sondern vor allem ihre Unterschiede, sodass, wie bei allen Serien Kelms, die Bedeutung zwischen den einzelnen Photographien liegt.

Diese De-Kontextualisierung beziehungsweise Kontextualisierung der Arbeiten mittels ihrer Titel weist auf eines der grundlegenden Merkmale des photographischen Bildes hin. Ist doch das, was eine Photographie zeigt, immer seiner ursprünglichen Umgebung entrissen, sodass jeder Aufnahme eine Vielfalt von Bedeutungen eingelagert ist. Die Aussage einer Photographie hängt demnach massgeblich davon ab, in welche Umgebung (Titel, andere Arbeiten und so weiter) sie gestellt wird. Denn, wie Susan Sontag sagt, «liegt die Realität ... nicht in ihren Abbildern, sondern in ihren Funktionen. Funktionen sind zeitliche Abläufe und müssen im zeitlichen Kontext erklärt werden. Nur was fortlaufend geschildert wird, kann von uns verstanden werden.»[9]

Das Beharren darauf, dass eine Photographie genauso viel zeigt, wie sie verbirgt, ist eines der medienreflexiven Momente der Arbeiten Kelms. Zeugt dieses Verbergen doch davon, dass Photographien immer nur Bruchstücke sind und somit nicht nur weit davon entfernt, etwas in seiner Komplexität einfangen zu können, sondern auch davon, ein objektives Abbild der Realität zu liefern. Denn die Photographie ist immer das Ergebnis eines Zusammentreffens von Bildgegenstand und Photographen oder Photographin. So legt die Photographie zwar Zeugnis ab von dem, was da ist, aber diesem Zeugnis ist immer auch die Sichtweise dessen eingeschrieben, der die Photographie macht. Demnach müssen auch Kategorien wie Intuition und Geschmack als konstituierende Elemente des photographischen Bildes betrachtet werden. Und auch dieses grundlegende Merkmal der Photographie thematisiert Kelm mit ihren Arbeiten, das heisst mit der offenkundigen Inszenierung und Ästhetisierung der Bildgegenstände.

Diese medienreflexive Komponente der Arbeiten zeigt sich aber nicht nur in der Methode, die grundlegenden Merkmale des Mediums mittels ihrer Betonung offenzulegen. Auch bei ihrem Versuch, die Photographie anderen Medien anzunähern (etwa dem Film oder der Skulptur), den Dirk von Lowtzow als «Trotz gegenüber dem eigenen Medium»[10] beschreibt, wird diese letztlich (da eine Photographie nun mal eine Photographie ist) auf ihre grundlegenden Parameter zurückgeworfen.

So stellt Kelms Werk ein komplexes System von Verweisen dar, wobei sich die Bezugspunkte permanent widersprechen. Oder anders formuliert: Annette Kelms Arbeiten lassen sich nicht auf eine Art von Motiv, ein Genre, ein Format oder eine Art der Titelgebung festlegen, sondern pendeln zwischen unterschiedlichen Polen hin und her. So scheinen das eigene Medium, die Faszination für das Archivieren und Inszenieren sowie die Attraktion, die für Kelm von Objekten, Architekturen und Personen auszugehen scheint, lediglich Ausgangspunkt zu sein, von dem aus sie ihre sehr eigenen und eigenständigen photographischen Bilder schafft. Wie die Schwierigkeit, ihr komplexes Werk fassen, ihm gedanklich und sprachlich Herr werden zu können, zeigt, ist ihre künstlerische Strategie dabei ebenso konzeptuell wie intuitiv. Annette Kelm wäre aber nicht Annette Kelm, wenn sie diese scheinbaren Gegensätzlichkeiten nicht miteinander zu vereinbaren wüsste.

1) Annette Kelm im Gespräch mit Jens Asthoff am 22.2.2008 in Kelms Berliner Atelier, «Annette Kelm», in *Camera Austria*, 12/208, S. 13.
2) Susan Sontag, *Über Fotografie*, Frankfurt am Main, Fischer-Taschenbuch-Verlag, 1980, S. 79.
3) Dirk von Lotwzow, «This is Not a Photograph», in *Annette Kelm*, Ausstellungskatalog Kunsthalle Zürich, KW Institute for Contemporary Art, Berlin, Witte de With Center for Contemporary Art, Rotterdam, London 2009, S. 81.
4) Siehe Anm. 1, S. 13.
5) Jessica Morgan, «Bilder und Objekte – Fotografie und Skulpturen», in *Annette Kelm. Errors in English*, London 2006, S. 30.
6) Beatrix Ruf, «Susanne Pfeffer, Beatrix Ruf und Nicolaus Schaffhausen im Gespräch», in *Annette Kelm*, siehe Anm. 3, S. 78.
7) Jens Hoffmann, «Annette Kelm», in *artforum*, January 2008, S. 269.
8) Siehe Anm. 6, S. 78.
9) Siehe Anm. 2, S. 29.
10) Siehe Anm. 3, S. 81.

STEFANIE KLEEFELD

Open Source

There's not much to it, really: a background indirectly lit by two lamps, and a third used to illuminate the object. Then press the release and that's it. As Annette Kelm notes in her conversation with Jens Asthoff, that's about as simple as it gets.[1] Kelm is talking about her work ANONYMOUS, LILAC CLOCK BAG BUFFALO EXCHANGE (2007)—a four-part photo series in which each image shows a round, lilac handbag with a clock face sewn into it. Photographed head on against a white background, the only discernible difference between the images is the fact that, in each, the hands of the clock have moved forward another minute.

Much of Kelm's photography displays the same sense of detachment. In the neutral style of studio photography, the subject matter is generally captured without shadows in a kind of non-space, or in such extreme close-up that the context is negated. It is as though Kelm's project is an archaeology of things, architectures, and landscapes in which the objects in her pictures refer primarily to themselves: nothing is revealed and nothing inferred beyond the subject matter itself. This approach of adding nothing or of presenting motifs in isolation bears witness to Kelm's confidence in her subject matter's ability to speak for itself. She merely has to present it in the right light. As Susan Sontag once put it, "The photographer's ardor for a subject… is, above all, an affirmation of the subject's thereness, its rightness."[2]

With the patience of a saint and no fear of boring herself or the viewer, Kelm presents her subject matter either in individual photographs or in series, varying the framing of the motif or capturing it at slightly different times, but never altering the camera angle. In this way, the viewer becomes part of Kelm's undertaking—her precise observations from behind the camera, her painstaking explorations—and is (potentially) able to grasp her discoveries.

Taking pictures is a form of appropriation. As Merleau-Ponty points out, however, every viewpoint excludes another one. Herein lies the impossibility of grasping any phenomenon in its entirety. Thus, the failure of that desire to appropriate something is inscribed in each and every photograph. Kelm's series take this desire to appropriate to new extremes (one photograph does not seem to suffice) and simultaneously address the failure of that undertaking. As Dirk von Lowtzow puts it, "Through repetition motifs succumb to their yearning for similarity, effortlessly detaching themselves from the original as from an all-powerful father figure."[3] So it is not in the photographs themselves, but in the empty spaces—the shifts and the subtle discrepancies between indivi-

STEFANIE KLEEFELD is an art historian and critic living in Berlin. She is editor of Texte zur Kunst.

ANNETTE KELM, JULIAN, ITALIAN RESTAURANT, 2008, c-print, 3 parts, 17 ¼ x 14 ½" each / C-Prints, 3 Teile, je 44 x 37 cm.

dual shots—that we find meaning and make associations that go beyond what is depicted.

But of what nature are the objects that appear in Kelm's work? In her photographs, she often focuses on the unspectacular and the everyday, such as an acorn in FIRST PICTURE FOR A SHOW (2007). Yet in addition to these relatively banal items, a number of culturally significant motifs can also be found, like the early-twentieth century prefabricated housing. These can hardly be described as blank pages, for they harbor compelling associations that emerge from the context. In other words, there are two types of motif in Kelm's work: those that are already regarded as significant within the canon of cultural history, and those that Kelm renders significant by dint of selecting them.

Selecting everyday motifs is rooted in the Surrealist maxim of paying attention to the peripheral, which, in Surrealism at least, was motivated by the moral premise of breaking down the hierarchical distinction between, say, beautiful and ugly or significant and trivial. Such parity is not, however, restricted to the artist's choice of motifs; it also applies to the way they are presented in photographs. For instance, Julian Göthe in JULIAN, ITALIAN RESTAURANT (2008) is photographed in the same way as any other motif in Kelm's serial works. All three photographs in the series are in the same format, while the motif in each photograph differs only minimally from the others—not in terms of angle, framing, or composition, but only as regards the subtle changes in Göthe's hands and eyes. In this respect, Kelm's portrait photographs are always to be read as object photographs, just as, conversely, her object photographs can be read as portraiture.

The strategy of according equal value to the subject matter of the pictures (in both choice and presentation) is also a hallmark of those photographs by Kelm in which several objects are juxtaposed and arranged against specially selected backgrounds. These works differ from those mentioned earlier, though not because of their painstakingly detailed composition. For, as Kelm herself has noted, there is no such thing as a neutral pictorial space.[4] Even those photographs that do not look orchestrated, like the images of prefabricated buildings, are to be taken as arrangements rather than as pure documentation. The difference between the two forms of photography lies in the fact that in these photographs the objects are combined or placed in relation to one another, which lend her works a mannerist air despite their stringency. (However, the ornamental fabrics in Kelm's evocative backgrounds are also to be regarded as part of the subject matter.) Given the combination of several objects combined in one photograph, the question that arises is not so much

why she uses a certain motif—especially in pictures featuring just one object—but why she has created a certain arrangement.

Faced with a juxtaposition of things that do not ordinarily belong together, some of Kelm's compositions are initially bewildering and grotesque. The objects in the pictures refer to themselves and their own history but, simultaneously, this self-referential aspect is undermined by the fact that they appear in combination. It is in both this discrepancy as well as the repetition that a subtle interaction—what Jessica Morgan terms "a subtle and yet acutely devised game of visual and verbal associations"[5]—comes into play, where the familiar becomes unfamiliar, and where the viewer's thoughts merge with the meaning inscribed in the objects.

This is true of ARCHEOLOGY AND PHOTOGRAPHY (2007), a work in which two upright books and two white zucchinis are presented against a backdrop of green floral fabric. The combination is bizarre: neither books and vegetables, nor background and objects, go together. But, of course, as Beatrix Ruf astutely notes, the stems of the zucchinis do corre-

late to some extent with the forms and colors of the plants on the fabric.[6] What is striking is the fact that Kelm has taken objects at once random (the zucchinis) and at the same time significant, descriptive, and charged (the photo books), and has put these two categories together. Both the choice of these objects and the fact that the book, *Archäologie und Photographie*, is combined with a zucchini suggest that the photographs are to be read as a commentary on her own work. Such attempts at interpretation, however, invariably venture onto thin ice—for as soon as a possible interpretation has been proposed, it becomes clear that it is only one of many. That open-ended aspect of her work is entirely intentional.

This intentionality is evident in *Untitled* (2007), a series that shows four pictures of the same orange tree. Since neither the title of the photograph nor the green background tell us anything about the context, the viewer sees only what is to be seen: one motif that has been photographed from four different angles. Further study reveals that the orange tree belongs to Kelm's parents, who received it as a gift in 1975—the year the artist was born.[7] This piece of information is

in itself not crucial to an understanding of the work. One can, for instance, access the work in terms of its ornamental appearance generated by the lack of shadow that makes the leaves and the fruit of the tree merge with the flat green background. Kelm has pushed this convergence of foreground and background, the blurring of boundaries between various pictorial levels, to new extremes in her photographs of Dorothy Draper's textile designs (2007). Since the background in these shots of the fabrics is, in itself, the photographed object, foreground and background become one: by eschewing the material portrayal of the object (e.g. the folds of the fabric), Kelm renders the photographic picture space as decorative surface while, at the same time, showing the object to be photographed. The photographs of the orange tree could also be regarded as examples of the serial nature of her work: the portrayal of the tree from different angles and differently cropped, and the resulting approximation of the photographic medium

to the media of film and sculpture. The biographical aspect is merely an added layer of meaning.

Given the deliberate openness of Kelm's work, there is never any one point at which everything has been said definitively, which means that the oddly insistent desire to find a way of reading it and to pinpoint the meaning of her work, is taken to absurdity. This openness has to be seen as an artistic strategy. As Beatrix Ruf noted, "Annette Kelm is permanently switching levels of association and hence the paths one can take in a picture, and, as a viewer, one constantly switches one's entry point: now the verbal predominates, now the conceptual, now the purely retinal; sometimes taste is involved, or aesthetic seduction..."[8] It's all there. But there is no resolution for what we see.

Kelm reinforces this openness in her work not only by means of compositional strategies, but also by choosing titles that do not actually name the motif, but trigger other connotations and, with that, con-

ANNETTE KELM, UNTITLED, 2007, c-prints, 4 parts, 24 1/2 x 19 3/4" each / OHNE TITEL, C-Prints, 4 Teile, je 62,3 x 50,3 cm.

ceal more than they reveal. The titles may be lyrical, as in YOUR HOUSE IS MY CASTLE (2005), or they may resort to the time-honored "Untitled." Just as she removes objects from their original setting and combines them with other objects, Kelm does not insist on the object's original context. At other times, however, she takes the opposite tack by precisely naming the objects on display. Take, for instance, her photographs of the first prefabricated houses: ERSTES MUSTERHAUS, HELLERAU, DEUTSCHE WERKSTÄTTEN HELLERAU, ARCHITEKT ADELBERT NIEMEYER, 1920 (2008). Without the title, these motifs would be impossible to categorize and since Kelm does not seek to create a hiatus of any kind in the pictures themselves, they might seem to be nothing but shots of beautiful houses. However, by using titles to define a series, she relates them to one another. It is within the context of this relationship that their similarities and, above all, their differences become evident. And so, as in all of Kelm's series, the meaning lies between the individual photographs.

Using the titles of the works to decontextualize or contextualize them is indicative of one of the fundamental characteristics of the photographic image. After all, what a photograph shows is invariably dislodged from its original setting, so that every photograph harbors multiple meanings. Accordingly, the statement a photograph makes depends essentially on the context (titles, other works, etc.) in which it is placed. As Susan Sontag points out, the "reality" of the world is not in its images, but in its functions. "Functioning takes place in time, and must be explained in time. Only that which narrates can make us understand."[9]

By insisting that a photograph reveals just as much as it conceals, Kelm's work reflects on the medium itself. This concealment betrays that photographs are merely fragments that cannot even come close to capturing something in all its complexity, let alone providing an objective image of reality. For photography is necessarily the product of a meeting between object and photographer. In this respect, a photograph may bear witness to what is there, but at the same time, the viewpoint of the person taking the photograph is always inscribed upon the image. Accordingly, such categories as intuition and taste must

be regarded as constituent elements of photography. This fundamental characteristic of photography is addressed by Kelm in the obvious staging and aestheticizing of her subject matter.

These "media-reflective" aspects of Kelm's work, however, are evident not only in her emphasis on exposing the fundamental characteristics of the medium. The artist's attempt to bring photography closer to other media, such as film or sculpture, which Lowtzow has described as "defiance" of her own medium,[10] ultimately casts photography back to its own basic parameters (a photograph, after all, is just a photograph).

In short, Kelm's work is a complex system of references in which the points of reference constantly contradict one another. Or, to put it another way: Annette Kelm's works cannot be pinned down to any one particular motif, genre, format, or title. They oscillate between extremes. The medium itself, the fascination for archiving and staging, and the attraction exerted by objects, architectures, and individuals seem to be no more than a starting point from which she can create her own distinctive photographic images. It is difficult to find words that might sum up this complex oeuvre, which in itself shows how conceptual and intuitive it really is. But Annette Kelm would not be Annette Kelm were it not for her remarkable ability to bring such seeming opposites together.

1) Annette Kelm in conversation with Jens Asthoff on 22 February 2008 in Kelm's Berlin studio. "Annette Kelm" in *Camera Austria*, no. 102, 2008, p. 13.
2) Susan Sontag, *On Photography* (London/New York: Farrar, Straus and Giroux, 1977), p. 77.
3) Dirk von Lowtzow, "This is Not a Photograph" in *Annette Kelm* exh. cat. (London: Koenig Books/Zurich: Kunsthalle Zürich/Berlin: KW Institute for Contemporary Art/Rotterdam: Witte de With Center for Contemporary Art, 2009), p. 67.
4) See note 1, p. 13.
5) Jessica Morgan, "Images and Objects—Photography and Sculptures" in *Annette Kelm. Errors in English* (London: Koenig Books, 2006), p. 32.
6) Beatrix Ruf, "Susanne Pfeffer, Beatrix Ruf and Nicolaus Schaffhausen in Conversation" in *Annette Kelm*, see note 3, p. 64.
7) Jens Hoffmann, "Annette Kelm" in *Artforum*, Vol. XLVI, No. 5, January 2008, p. 269.
8) See note 6, p. 64.
9) See note 2, p. 23.
10) See note 3, p. 67.

ANNETTE KELM, ATELIER HOFMANN, BEUREN 1892, 2009,
c-print, 30 ¹/₄ x 24" / C-Print, 77 x 61 cm.

ANNETTE KELM, ATELIER BÖCKLIN, ZÜRICH 1885, 2009,
c-print, 30 ¹/₄ x 24" / C-Print, 77 x 61 cm.

ANNETTE KELM, ATELIER BALMER, BASEL 1893, 2009,
c-print, 30 ¹/₄ x 24" / C-Print, 77 x 61 cm.

EDITION FOR PARKETT 87

ANNETTE KELM

UNTITLED, 2010

C-print from 4 x 5" negative, on Fuji Crystal Archive DPII matt,
paper size 16 x 20 $^5/_8$", image: 14 $^1/_2$ x 19 $^1/_8$",
printed by Golab, Berlin.
Edition of 38/XX, signed and numbered certificate.

C-Print von 4 x 5" Negativ, auf Fuji Crystal Archive DPII matt,
Papierformat 40,5 cm x 52,4 cm, Bild 36,7 cm x 48,6 cm,
gedruckt bei Golab, Berlin.
Auflage 38/XX, signiertes und nummeriertes Zertifikat.

ALLEN RUPPERSBERG

INSERT FOR

PARKETT

JACK GOLDSTEIN, 57; HE
LPED TO EXPLORE POST-
MODERNIST ART
JACK GOLDSTEIN, AN ART
IST WHOSE PERFORMANC
ES, SHORT FILMS, PAINTI
NGS AND SOUND PIECES
OF THE LATE 1970'S AND
EARLY 80'S HELPED DEF
INE THE EARLY STAGES
OF POST-MODERNIST AR
T, DIED ON FRIDAY AT HI
S HOME IN SAN BERNARD
INO, CALIF.
MR. GOLDSTEIN, WHO HAD
STRUGGLED FOR MANY Y
EARS TO OVERCOME DRU
G DEPENDENCY AND CH
RONIC DEPRESSION, COM
MITTED SUICIDE, SAID B
RIAN BUTLER, A LOS ANG

ELES ART DEALER WHO
REPRESENTED HIM. HE
WAS 57.
FOR A WHILE, MR. GOLDST
EIN, WHO WAS BORN IN M
ONTREAL IN 1945 AND MO
VED WITH HIS FAMILY T
O LOS ANGELES WHEN H
E WAS A TEENAGER, WAS
A LEADING MEMBER OF
A GENERATION INTRIGU
ED BY THE POWER AND M
ECHANISMS OF REPRESE
NTATION IN MASS CULTU
RE.
HE EARNED A BACHELO
R OF FINE ARTS DEGREE
FROM THE CHOUINARD A
RT INSTITUTE IN 1970 AN
D A MASTER'S DEGREE AT
THE CALIFORNIA INSTIT

UTE OF THE ARTS IN VALENCIA, CALIF., IN 1972. THERE, AS A TEACHING ASSISTANT TO THE CONCEPTUAL ARTIST JOHN BALDESSARI, HE MET A GROUP OF SLIGHTLY YOUNGER ARTISTS, INCLUDING MATT MULLICAN, DAVID SALLE, JAMES WELLING AND TROY BRAUNTUCH, WHO WERE GRAVITATING TOWARD APPROPRIATED IMAGES. ALONG WITH ARTISTS LIKE CINDY SHERMAN, LAURIE SIMMONS, SHERRIE LEVINE, SARAH CHARLESWORTH AND ROBERT LONGO, WHO WERE EXPLORING SIMILAR IDEAS IN NEW YOR

K, THEY WERE OFTEN G
ATHERED UNDER THE RU
BRIC PICTURES ART.
INSPIRED BY ANDY WAR
HOL AND ED RUSCHA, MR
GOLDSTEIN WAS ONE OF
THE FIRST ARTISTS TO E
XPLORE THE PHANTASM
AGORIC BEAUTY AND EM
PTY SPECTACLE OF THE
MOVIES BY ISOLATING T
HEIR TICS AND CONVEN
TIONS.
ON FILM, HE SHOWED THE
METRO-GOLDWYN-MAYER
LION GROWLING INTO IN
FINITY; IN PERFORMANC
E, HE HAD TWO WHITE-C
LAD FENCERS CROSS SW
ORDS IN A RED-TINGED L
IGHT. HIS 45-R.P.M. RECOR

DS, CULLED FROM MOVIE SOUNDTRACKS HAD TITLES LIKE "TWO WRESTLING CATS," THE "SIX-MINUTE DROWN," OR THE "LOST OCEAN LINER."

HIS PAINTINGS, WHICH FINE-TUNED PHOTO REALISM TO A CELLULOID-THIN ELEGANCE, FEATURED PANORAMIC DISPLAYS OF MIGHT AND LIGHT, THE ESSENCE OF FILM. THESE DARK, GLOWING IMAGES DEPICTED STREAKING FIGHTER JETS, LIGHTNING STORMS, EXPLODING NEBULAE AND CITY SKYLINES ILLUMINATED BY FIREWORKS OR BOMBING RAIDS.

MR. GOLDSTEIN MOVED TO NEW YORK IN 1974 AND HAD HIS FIRST SOLO SHOW THERE IN 1980 AT METRO PICTURES GALLERY. HE RETURNED TO LOS ANGELES IN THE LATE 1980'S AND SPENT MOST OF THE 1990'S OUT OF SIGHT. BUT OVER THE LAST FEW YEARS HE ENJOYED A NEW VISIBILITY. LAST YEAR HIS FILMS, WHICH WERE RECENTLY TRANSFERRED TO VIDEO, WERE SHOWN AT THE WHITNEY MUSEUM OF AMERICAN ART. A RETROSPECTIVE OF HIS WORK WAS HELD AT THE NATIONAL CENTER OF CONTEMPORARY ART IN

GRENOBLE, FRANCE, AND OTHER EUROPEAN EXHIBITIONS WERE PLANNED. HE WAS WORKING ON SOME NEW FILMS AND PLANNING A SHOW OF PAINTINGS AT MR. BUTLER'S GALLERY. AND "JACK GOLDSTEIN AND THE CALARTS MAFIA," AN ORAL HISTORY EDITED BY MR. GOLDSTEIN AND RICHARD HERTZ, WHO WILL PUBLISH IT. MR. GOLDSTEIN IS SURVIVED BY HIS PARENTS, MEYER AND ELLEN GOLDSTEIN, AND HIS SISTER, LINDA GOLDSTEIN, ALL OF SAN BERNARDINO.

FELIX PARTZ, 49, CONC
EPTUAL ARTIST
FELIX PARTZ, A MEMBE
R OF THE THREE-MAN
CANADIAN ART COLLA
BORATIVE GENERAL
IDEA, DIED ON JUNE 5
AT HIS HOME IN TORON
TO. HE WAS 49.
THE CAUSE WAS AIDS,
SAID A.A. BRONSON, THE
GROUP'S SURVIVING MEM
BER. JORGE ZONTAL, THE
GROUP'S THIRD MEMBER,
DIED OF AIDS IN FEBRU
ARY.
GENERAL IDEA, WHICH
WAS FORMED IN TORONT
O IN 1968, EXHIBITED WI
DELY IN NORTH AMERICA
AND EUROPE AND WAS T

TO BE

HE SUBJECT OF SEVERA
L RETROSPECTIVES. TH
E GROUP DEVELOPED A
WITTY, SLICK-LOOKING
FORM OF CONCEPTUAL
ART THAT BORROWED
LIBERALLY FROM ADVE
RTISING AND OTHER ART.
IT DEVOTED THE LAST
DECADE ALMOST ENTIRE
LY TO ART ABOUT AIDS
AND WAS ESPECIALLY W
ELL KNOWN FOR ITS AP
PROPRIATION OF ROBER
T INDIANA'S COLORFUL
"LOVE" EMBLEM, WHICH
IT CHANGED TO READ
AIDS.
MR. PARTZ, WHOSE ORIGI
NAL NAME WAS RON GA
BE, TENDED TOWARD TH

A MO·MENT

E ICONOCLASTIC. WHIL
E STILL AT THE UNIVE
RSITY OF MANITOBA SCH
OOL OF FINE ARTS IN WI
NNIPEG, HIS HOME TOW
N, HE **WHEN** OCOPI
ES OF **WHEN** TWOR
KS FOR HIS PRINT-MAKI
NG CLASS.
HE IS SURVIVED BY HIS
PARENTS, PERRY AND O
LIVE GABE, AND A BROT
HER, ROY, ALL OF WINN
IPEG.

Pictures Generation – wiederbelebt

PHILIPP KAISER

«Die Ansicht, Douglas Crimp habe 1977 mit einer Ausstellung die Karriere einiger Künstler gemacht, ist gänzlich und historisch falsch»[1], stellte nahezu zwanzig Jahre später der renommierte Kritiker Crimp selber fest. Dass jedoch dieses kleine feine Projekt in einem alternativen Ausstellungsraum in New York gut dreissig Jahre später nicht nur namengebend für eine viel diskutierte Ausstellung im Metropolitan Museum of Art wird[2], sondern für eine ganze Generation, die «Pictures Generation», hätte wohl zuletzt Douglas Crimp gedacht. Während das Wissen um die mit der Pictures Generation assoziierte Appropriation in Europa noch bis vor Kurzem ins Umfeld kritischer Kunstgeschichte gehörte, hat in den USA die postmoderne Theorie bereits in den 70er- und frühen 80er-Jahren, verbreitet von *October*, *Artforum* und *Art in America* (mit Crimp, Craig Owens, Hal Foster, Benjamin Buchloh und anderen),

PHILIPP KAISER ist Kurator am Museum of Contemporary Art, Los Angeles, und arbeitet zurzeit unter anderem an der ersten US-amerikanischen Jack-Goldstein-Retrospektive.

Jack Goldstein, MGM, 1975, 16-mm-film, color, sound, 2' / 16mm Film, Farbe, Klang. (PHOTO: COURTESY GALERIE DANIEL BUCHHOLZ, KÖLN/BERLIN)

die Lehrräume des Whitney Independent Study Program verlassen und Eingang in den universitären Alltag gefunden.

Aus diesen Gründen mag einiges an der wunderbaren und verdienstvollen Ausstellung im Metropolitan Museum erstaunen. Zunächst einmal fällt Crimps Name erst auf Seite 28 des umfassenden und akribisch recherchierten Katalogs, der ausschliesslich von Douglas Eklund, dem Kurator der Photographie-Abteilung, verfasst wurde. Für hitzige, mitunter feindselige Debatten sorgten neben dem gesetzten Zeitrahmen (1974–1984), und dem «Verschwinden» des in der historischen «Pictures»-Ausstellung präsenten Künstlers Philip Smith, vor allem auch die margi-

nalisierte Rolle von Theorie und Feminismus. Es wurde deutlich, dass der Prozess der Historisierung alles andere als abgeschlossen ist. Doch erst einmal der Reihe nach.

Als lose formierte Gruppe um den New Yorker Artists Space ist die Pictures Generation vermutlich die letzte avantgardistische Bewegung des 20. Jahrhunderts, die sich in kritischer Weise mit dem Erbe der Konzeptkunst, dem Minimalismus und der Pop-Art auseinandersetzte und Repräsentation und Appropriation zu den Stichwörtern der Stunde werden liess.[3] Wie Michael Lobel schreibt, verfällt die Kunstgeschichte hier erneut dem Muster, ein Ereignis zu einem historischen Wendepunkt zu stilisieren und die Geburt einer Bewegung

lediglich in einem punktuellen respektive einem linearen Zeitmodell zu beschreiben.[4] Da einige der Werke, die in der historischen «Pictures»-Ausstellung zu sehen waren – und jetzt im Metropolitan Museum ausgestellt sind –, vor 1977 entstanden waren, wird die Bedeutung der «Pictures»-Ausstellung unterminiert und unversehens die Frage gestellt: Was war denn 1974 und ist es folgerichtig, den Kurator der «Pictures»-Ausstellung, deren Künstlerinnen und Künstler sich nachhaltig mit Fragen von Originalität und Autorschaft auseinandergesetzt haben, mit fast gewollter Nachlässigkeit nicht in der Einleitung des Kataloges zu erwähnen?

Helene Winer, die damalige Direktorin des Artist Space, hatte Crimp eingeladen, eine Ausstellung (inklusive Publikation) zu organisieren. Es war auch Winer, die ihm eine Liste vielversprechender Künstler übergab, die es ihrer Ansicht nach verdienten, ernsthaft betrachtet zu werden.[5] Bekanntlich sind nur fünf Künstler ausgestellt worden: Troy Brauntuch, Jack Goldstein, Sherrie Levine, Robert Longo und Philip Smith. Es lohnt sich, auf den von Douglas Crimp verfassten Beitrag im Begleitheft, der weit weniger rezipiert wurde als die zwei Jahre später auf Rosalind Krauss' Anfrage für *October* entstandene revidierte Version, einen Blick zu werfen, um das Terrain abzustecken, dem sich eine ganze Generation zugehörig zu fühlen scheint.[6] War der erste Beitrag eine analytische und scharfsinnige Beschreibung nahe an den Werken, wurde in der zweiten Fassung – in Abgrenzung zu Michael Frieds modernistischen Reflexionen zur Minimal Art – eine postmoderne Photographie aus der Taufe gehoben, die sich mit den unterschiedlichen künstlerischen Verfahren «Zitieren», «Exzerpieren», «Rahmen» und «Inszenieren» auseinandersetzt. Wurden zuerst in konziser Weise die Eigenschaften der *Pictures* untersucht und festgehalten, dass sich die neue Künstlergeneration mit erinnerten, imaginierten und psychologisierten Bildern, mit Signifikationsprozessen und einer neuen Narrativität beschäftigt, so scheint es, als ob in der zweiten Fassung das Bild als stereotypisierte Formel aufgefasst wurde, die dazu dient, verschiedene Schichten der Repräsentation aufzudecken. Nach Crimp befindet sich hinter jedem Bild ein weiteres Bild.[7] In die «Lücke» zwischen den beiden Aufsätzen ist nicht alleine der Künstler Philip Smith gefallen, dessen Name in der zweiten Fassung zur Anmerkung degradiert wurde, auch die nicht-photographischen Praktiken wie Malerei oder Zeichnung bleiben nun unerwähnt, dies vermutlich, um das Profil dieser neuen Generation nicht mit der am Whitney Museum stattgefundenen «New Image Painting»-Ausstellung (1978) zu verwässern, einer Ausstellung neuer figurativer Positionen.

Mit diesen Ausführungen soll, um Missverständnissen vorzubeugen, nicht suggeriert werden, dass einzig Douglas Crimps Ausstellung und seine berühmten zwei Aufsätze das *Pictures*-Phänomen hinlänglich erklären, im Gegenteil, sie sind nur die Spitze des Eisbergs. Seine Beiträge sowie die darauffolgen-

"The Pictures Generation, 1974–1984,"
exhibition view, Metropolitan Museum,
New York / Ausstellungsansicht.
(PHOTO: METROPOLITAN MUSEUM, NEW YORK)

den Essays zur postmodernen Photographie haben in aller Klarheit poststrukturalistische Theorie und aktuelles Kunstschaffen gepaart und sich an einem damals jungen, zeitgenössischen Gegenstand erprobt. Die Ausstellung, glaubt man Matt Mullican, ist kaum zu überschätzen: «[Sie] wurde zu einem Wendepunkt ... wir wussten, sie war wichtig. Nicht die Ausstellung selbst, aber was sie repräsentierte, wir waren Teil davon.»[8] Die Ausweitung eines Ereignisses zu einem Phänomen wirft die Frage der Zugehörigkeit auf, es ist erstaunlich, dass, soweit mir bekannt ist, von keinem Kritiker oder Kunsthistoriker jemals der erweiterte Gruppenkontext der «Pictures Generation» in Frage gestellt wurde.

Doch weshalb soll sich die neue Generation bereits 1974 formiert haben? In diesem Jahr war Helene Winer, die seit 1980 gemeinsam mit Janelle Reiring die Galerie Metro Pictures führte, Direktorin an der Pomona College Art Gallery etwas ausserhalb von Los Angeles, wo sie eine ungemein aktive und einflussreiche Rolle einnahm, die erst im Laufe der Zeit in ihrer Wichtigkeit erkannt wurde. Aufgrund von Richard Hertz's Publikation *Jack Goldstein and the CalArts Mafia*[9] sind zahlreiche Indiskretionen über die künstlerische Studentenschaft am 1970 neu eröffneten und mittlerweile legendären California Institute of the Arts in Valencia Allgemeingut geworden. Nicht nur wissen wir, dass Winer und Jack Goldstein liiert waren, wir wissen auch, dass sie 1974 gemeinsam nach New York gezogen sind. Die CalArts Mafia, neben dem eigentlichen Anführer Goldstein – James Welling, David Salle, Matt Mullican und Troy Brauntuch –, ist ihnen gefolgt, wenngleich einige ihre Ateliers in Los Angeles behielten; sie wurden gewissermassen zum Kern der sogenannten «Pictures Generation». Als Schüler von John Baldessari hatten sie im Unterschied zu ihren New Yorker Freunden und den Buffalo-Künstlern Robert Longo, Cindy Sherman, Charles Clough, Nancy Dwyer und anderen von Anfang an grosse Vertrautheit im Umgang mit der Verwendung mediatisierter Bilder, dem grossen Thema dieser ersten mit dem Fernseher aufgewachsenen und von Watergate und dem Vietnam-Krieg desillusionierten Generation. Es war gerade diese kolportierte und verkürzte Geschichte, die das *Cal-Arts-Mafia*-Buch nicht zuletzt zementierte und die bei manchen Kritikern Missmut ausgelöst hat. Zugegebenermassen kommt John Baldessari bei der Formation dieser Gruppe eine kaum zu überschätzende Rolle zu, doch gleichzeitig darf nicht unerwähnt bleiben, dass es die Errungenschaften des Feminismus waren, die zur kritischen Auseinandersetzung mit Repräsentation geführt haben. Feminismus war Anfang der 70er-Jahre der Kern aller Veränderungen, der über die Jahre schliesslich in ein neues Stadium getreten ist. Hervorzuheben ist deshalb nicht nur die Tatsache, dass am CalArts die früheste und wohl bedeutendste Feminismusklasse gegründet wurde und dass beispielsweise David Salle sein Atelier mit Suzanne Lacy teilte, sondern auch, dass es die feministische Kunst war, die die Kategorien bereitstellte und Theorie als solche institutionalisiert hat.[10] Unbehagen generiert sicherlich auch die Vorstellung, dass die letzte Avantgarde New Yorks zum gros-

SHERRIE LEVINE, UNTITLED (AFTER WALKER EVANS) 2, 1981,
silver gelatin print, 4 x 5" / OHNE TITEL (NACH WALKER
EVANS) 2, Silbergelatine-Abzug, 10,2 x 12,7 cm.
(PHOTO: THE METROPOLITAN MUSEUM OF ART, © WALKER EVANS ARCHIVE)

sen Teil aus Los Angeles importiert wurde. Interessanterweise, und dies ist kaum bekannt, wurde die «Pictures»-Ausstellung nach Los Angeles re-importiert, ohne dort jedoch viel Aufsehen zu erregen.[11]

Die wohl gravierendste Kritik an der Ausstellung im Metropolitan Museum kam von Howard Singerman, er warf Eklund Theorieamnesie vor.[12] Er häufe Rezensionen und historisches Wissen an, ohne sich der Diskursivität vieler Werke zu stellen. Das Unvergleichliche an der Pictures Generation ist es ja gerade, dass die Kritik nicht Gegenpart, sondern Teil der künstlerischen Praxis ist. Hierin liegt auch eines der Hauptprobleme: Wie kann eine Kunst historisiert werden, die so sehr mit ihrer Theorie einhergeht? Wie sieht eine revisionistische Sichtung dieser Kunst aus? Der Versuch, die Geschichte neu zu schreiben, ohne die den Werken zugehörigen Texte und Reflexionen der Zeit zu berücksichtigen, muss misstrauisch machen. Das Verlangen, eine kontextreflexive Kunst autonomisieren zu wollen, ist mehr als problematisch. So schreibt Shepherd Steiner anlässlich Jack Goldsteins Frankfurter Retrospektive mit einer programmatischen Vehemenz, die Eklund glücklicherweise fehlt, dass es eines radikalen Korrektivs bedarf, da die Fetischisierung von Theorie seitens der Postmoderne das Werk verunkläre und im Wesentlichen falsch darstellen würde. Die Kritik sei blind für ihren Gegenstand gewesen, wirft er Douglas Crimp vor.[13] Das Verlangen einer neuen Generation, die Geschichte anders zu schreiben, ist nachvollziehbar, doch scheint es, als ob hier vergleichsweise der Russische Kon-

struktivismus von seinen radikal-utopischen Gesellschaftsentwürfen entkleidet und in bunt abstrakte Kompositionsklänge überführt werden soll. Falls dies die Revision einer ganzen Generation ist, so sollte diese lautstark aufschreien.

1) Claudia Gould, Valerie Smith, *5000 Artists Return to Artists Space: 25 Years*, New York 1998, S. 89.
2) Metropolitan Museum of Art, New York, «The Pictures Generation, 1974–1984», 21. April bis 2. August 2009.
3) Ann Goldstein, «In the Company of Others», in Helen Molesworth (Hg.), *Louise Lawler, Twice Untitled and Other Pictures*, Wexner Center for the Arts, Cambridge, MA, 2007, S. 133.
4) Michael Lobel, «Outside the Frame», in *Artforum*, September 2009, S. 253.
5) Siehe Anm. 1, S. 60 und 89.
6) *Pictures*, Ausstellungskatalog Artists Space New York, 1977, sowie «Pictures», in *October*, Nr. 8, Frühling 1979, S. 75–88. Deutsche Fassung des zweiten Essays in Tamara Horakova, Ewald Maurer et. al. (Hg.), *Image: /images, Positionen zur zeitgenössischen Fotografie*, Wien 2001, S. 120–138.
7) Ebenda, S. 137.
8) Siehe Anm., S. 61.
9) Richard Hertz (Hg.): *Jack Goldstein and the CalArts Mafia*, Minneola Press, Ojai, 2003.
10) Vgl. Craig Owens, The Discourse of Others: Feminists and Postmodernism, in Scott Bryson, Barbara Kruger (Hg.), *Craig Owens. Beyond Recognition. Representation, Power, and Culture*, New York 1992, S. 166–190.
11) Nach New York (24.9.–29.10.1977) war die Ausstellung am Allen Memorial Art Museum, Oberlin, Ohio (28.2.–25.3.1978), am Los Angeles Institute of Contemporary Art (15.4.–15.5.1978) und an der University of Colorado Art Gallery, Boulder (8.9.–6.10.1978), zu sehen.
12) Howard Singerman, «Language Games», in *Artforum*, September 2009, S. 257ff.
13) Shepherd Steiner, «Korrektur-Massnahmen, Zwischen dem eigenständigen Werk und dem Korpus von Jack Goldstein», in Ausst.-Kat. *Jack Goldstein*, Verlag Walther König, Museum für Moderne Kunst, Frankfurt am Main, 2009, S. 13.

Pictures Generation Redux

PHILIPP KAISER

"The idea that Douglas Crimp did an exhibition in 1977 and, thereby, made the careers of a bunch of artists, is completely and historically wrong,"[1] noted the renowned art critic Crimp himself some twenty years later. Yet Crimp would have been the last to imagine that, thirty years after the fact, this distinctive little project in an independent New York gallery space would not only be the title of a controversial exhibition at the Metropolitan Museum of Art,[2] but that it would even come to define an entire generation: the Pictures Generation. In Europe, awareness of the appropriation art generally associated with the Pictures Generation was, until relatively recently, the preserve of art critics and theorists, while in the USA postmodernist theories had been touted since the 70s and early 80s in such publications as *October*, *Artforum*, and *Art in America* (by the likes of Crimp,

 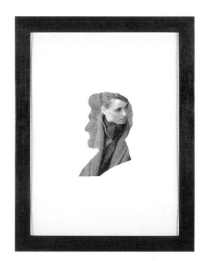

SHERRIE LEVINE, UNTITLED (PRESIDENT, 2), 1979, collage / OHNE TITEL (PRÄSIDENT, 2), Collage. (PHOTO: METROPOLITAN MUSEUM, NEW YORK)

SHERRIE LEVINE, UNTITLED (PRESIDENT, 5), 1979, collage / OHNE TITEL (PRÄSIDENT, 5), Collage. (PHOTO: METROPOLITAN MUSEUM, NEW YORK)

Craig Owens, Hal Foster and Benjamin Buchloh) and had been carried forth from the seminar rooms of the Whitney Independent Study Program into mainstream university life.

For these reasons, the otherwise excellent and commendable exhibition at the Metropolitan Museum harbors some surprises. For one

thing, Crimp's name is not even mentioned until page twenty eight of the comprehensive and painstakingly researched catalogue written entirely by Douglas Eklund, associate curator of the Department of Photographs. Moreover, the timeframe selected for the show—the decade 1974–1984—the omission of Philip Smith, an artist who

PHILIPP KAISER is Curator at the Museum of Contemporary Art, Los Angeles. His current projects include preparing the first US retrospective exhibition of the work of Jack Goldstein.

had been included in the original "Pictures" exhibition, and the marginalized role of theory and feminism were all factors that triggered heated and at times vitriolic debate, clearly indicating that the writing of history is far from finished. But—first things first.

Loosely grouped around the New York Artists Space, the Pictures Generation was probably the last avant-garde movement of the twentieth century.[3] It took a critically analytical approach to the legacy of Conceptual Art, Minimal Art and Pop Art, and made representation and appropriation the buzzwords of the day. I do agree

undermines the historical significance of the Pictures exhibition. At the same time, one wonders what was really going on in 1974, and whether there is any logical justification—given that the artists in the "Pictures" exhibition took such an abiding interest in issues of originality and authenticity—for what seems to be an almost willful failure to mention the name of the original exhibition's curator in the introduction?

Crimp had been invited by Helene Winer, the director of Artists Space at the time, to organize a show and produce the catalogue. And it was Winer who provided

that Crimp wrote for the accompanying publication, which received far less attention than the revised version produced two years later for *October* at the request of Rosalind Krauss.[6] Whereas the first version was a keenly analytical and astute close-reading of the works, the second version—in contrast to Michael Fried's modernist reflections on Minimal Art—extolled a post-modernist photography with a focus on citing, excerpting, framing, and staging. Concise analysis of the *Pictures* in the initial text noted how the new generation of artists explored psychologically charged, imagined, and remem-

SHERRIE LEVINE, UNTITLED (PRESIDENT, 2), 1979, collage / OHNE TITEL (PRÄSIDENT, 2), Collage. (PHOTO: METROPOLITAN MUSEUM, NEW YORK)

bered imagery, developing processes of signification and new narratives; the second version seems to take a position that essentially treats the pictures as stereotypical formulae designed to reveal different layers of representation. According to Crimp, "...underneath each picture there is always another picture."[7] The gap between these two essays swallowed up not only the artist Philip Smith, whose name is reduced to a mere footnote in the second version, but also non-photographic art forms such as painting or drawing, which are not even mentioned—presumably to avoid tainting the argument of this new generation with the 1978 "New Image Painting" show of recent figurative work at the Whitney Museum.

with Michael Lobel[4] that art history tends to mythologize singular events by styling them as historic turning points, and to describe the birth of a movement as an episode in a linear chronology. The fact that some of the works in the 1977 "Pictures" exhibition—and now included in the show at the Metropolitan Museum—were actually created several years earlier,

him with a list of promising artists, because, as she later pointed out, there was a certain kind of art that deserved to be taken seriously.[5] Only five artists were presented: Troy Brauntuch, Jack Goldstein, Sherrie Levine, Robert Longo, and Philip Smith. In order to get a feeling for the terrain staked out by a whole generation of artists, it is worth taking a look at the essay

However, this is not meant to suggest that Douglas Crimp's exhibition and his two famous essays are the only valid takes on the *Pictures* phenomenon. On the contrary, they are merely the tip of the iceberg. His essays and subsequent writings on postmodern photography very clearly linked post-structuralist theory with emerging art, using a still new and contemporary subject matter as a testing ground. Nor is the significance of the exhibition itself to be underestimated; Matt Mullican maintains that "... the show itself became a marker ...But we all knew it was important. Not the show itself, but the moment the show represented, which we were a part of."[8] For the most part, extending the investigation of a singular historic event immediately raises the question of who is to be included, yet, remarkably, no critic or art historian, as far as I am aware, has ever questioned the wider group context of the Pictures Generation.

So why did the new generation of artists emerge as early as 1974? In 1974, Helene Winer, who ran the Metro Pictures gallery with Janelle Reiring from 1980 onwards, was still director of the Pomona College Museum of Art just outside Los Angeles. There she played an immensely active and influential role, whose importance was not fully recognized at the time. With Richard Hertz's publication of *Jack Goldstein and the CalArts Mafia*,[9] numerous indiscretions involving the art students at the legendary California Institute of the Arts in Valencia, founded in 1961, became common knowledge. We know that Winer and the group's main player, Jack Goldstein, were

a couple and that they moved to New York together in 1974. The entire CalArts Mafia— James Welling, David Salle, Matt Mullican, and Troy Brauntuch—followed suit, though some did keep their studios in Los Angeles. This group formed the core of the so-called Pictures Generation. As students of John Baldessari, unlike their New York friends and the Buffalo artists Robert Longo, Cindy Sherman, Charles Clough, Nancy Dwyer, et al., they were thoroughly familiar with the use of mediated images. These were, in fact, a focal point for a generation disillusioned by Watergate and Vietnam and the first to grow up with television. It was this mix of rumor and trun-

cated history, further cemented by the *CalArts Mafia* book, that ruffled the feathers of some critics. While John Baldessari played an undeniably instrumental role in the formation of this group, it should also be borne in mind that the critical reevaluation of representation is indebted to the achievements of the feminist movement. In the early 70s, feminism was at the very heart of all the changes that eventually led to a new era. Not only was the earliest and perhaps most important class in feminist studies founded at CalArts, with people like David Salle and Suzanne Lacy sharing a studio; it was also feminist art that provided the categories and institutionalized the theories.[10] The fact that New York's latest avant-garde was largely imported from Los Angeles undoubtedly added to the sense of unease. Interestingly, though this is not very widely known, the "Pictures" exhibition was re-imported to Los Angeles, where it made very little impact.[11]

Arguably the sharpest criticism leveled at the exhibition was Howard Singerman's insinuation that Eklund, the curator, had no inkling of theory,[12] and that he accumulated reviews and historical knowledge without actually addressing the discursiveness of many of the works. What sets the Pictures Generation apart is, after all, the fact that criticism is not meant to complement artistic practice, but to be an intrinsic part of it. And therein lies the rub: how can art be historicized when it is so inextricably linked with theory? How would a revisionist appraisal of this art look? Any attempt to rewrite history without taking into account contemporary texts and ideas must be viewed with suspicion. The call to autonomize contextually reflective art is fraught with problems. Shepherd Steiner, writing in the catalogue of the Jack Goldstein retrospective in Frankfurt am Main, betrays a programmatic vehemence, which Eklund fortunately did not indulge in, when he insists on radical corrective measures because the postmodernist fetishization of theory obscures and fundamentally misrepresents the work, adding, in a swipe at Douglas Crimp, that art criticism was effectively blind to its object.[13] Understandable as it may be for a new generation to want to rewrite history, to do so in this case seems akin to, say, stripping Rus-

sian Constructivism of its radical utopian social ideas and presenting it solely in terms of brightly colored abstract composition. If this is the revision of an entire generation of artists, they should rise up in revolt against it.

(Translation: Ishbel Flett)

1) Douglas Crimp quoted in Claudia Gould, Valerie Smith, *5000 Artists Return to Artists Space: 25 Years* (New York: Artists Space, 1998), p. 89.
2) Metropolitan Museum of Art, New York, "The Pictures Generation, 1974–1984," 21 April to 2 August 2009.
3) Ann Goldstein, "In the Company of Others" in Helen Molesworth (ed.), *Louise Lawler, Twice Untitled and Other Pictures* (Cambridge: The MIT Press/Columbus: Wexner Center for the Arts, 2006), p. 133.
4) Michael Lobel, "Outside the Frame" in *Artforum*, vol. XLVIII, no. 1, September 2009, p. 253.
5) See note 1, pp. 60 and 89.
6) *"Pictures,"* exh. cat., Artists Space New York, 1977, and Douglas Crimp, "Pictures," *October*, no. 8 (Spring 1979), pp. 75–88.
7) Ibid, p. 87.
8) See note 1, p. 61.
9) Richard Hertz (ed.), *Jack Goldstein and the CalArts Mafia* (Ojai: Minneola Press, 2003).
10) See Craig Owens, "The Discourse of Others: Feminists and Postmodernism" in Scott Bryson, Barbara Kruger, et al. (eds.), *Craig Owens. Beyond Recognition. Representation, Power, and Culture* (Berkeley: University of California Press, 1992), pp. 166–190.
11) After New York (24.9.–29.10.1977), the exhibition was shown at the Allen Memorial Art Museum, Oberlin, Ohio, (28.2.–25.3.1978), the Los Angeles Institute of Contemporary Art (15.4.–15.5.1978) and the University of Colorado Art Gallery, Boulder (8.9.–6.10.1978).
12) Howard Singerman, "Language Games" in *Artforum*, vol. XLVIII, no. 1, September 2009, p. 257.
13) Shepherd Steiner, "Corrective Measures: Between the Discrete Work and the Corpus of Jack Goldstein" in *Jack Goldstein*, exh. cat. (Frankfurt: Museum für Moderne Kunst, Frankfurt am Main/Köln: Walther König, 2009), p. 13.

LOUISE LAWLER, LIVING ROOM CORNER, ARRANGED BY MR. AND MRS. BURTON TREMAINE SR., NEW YORK CITY, 1984, cibachrome, 28 x 39" / Cibachrom, 71,1 x 99,1 cm. (PHOTO: COURTESY OF THE ARTIST AND METRO PICTURES)

200 ARTWORKS 25 YEARS

PARKETT

PARKETT
EXHIBITION
AT SINGAPORE
TYLER PRINT
INSTITUTE
22 MAY – 10 JULY 2010

 SINGAPORE
TYLER PRINT
INSTITUTE

41 ROBERTSON QUAY SINGAPORE 238236
TEL: +65 6336 3663 FAX: +65 6336 3553
WWW.STPI.COM.SG

YVESSAINTLAURENT

CARL ANDRE
JONATHAN BOROFSKY
CÉLESTE BOURSIER-
MOUGENOT
SOPHIE CALLE
MARK DI SUVERO
SAM DURANT
WAYNE GONZALES
ROBERT GROSVENOR
HANS HAACKE
MICHAEL HURSON
DONALD JUDD
YAYOI KUSAMA
JULIAN LETHBRIDGE
SHERRIE LEVINE

SOL LEWITT
CHRISTIAN MARCLAY
CLAES OLDENBURG &
COOSJE VAN BRUGGEN
WALID RAAD
RUDOLF STINGEL
ATSUKO TANAKA
JOHN TREMBLAY
KELLEY WALKER
DAN WALSH
MEG WEBSTER
ROBERT WILSON
JACKIE WINSOR
BING WRIGHT
CAREY YOUNG

PAULA COOPER GALLERY

534 W 21ST, NEW YORK PAULACOOPERGALLERY.COM

AUGUSTIN

EARS

LUHRINGAUGUSTINE.COM

eyekon intermedia lab www.eyekon

LUKAS & STERNBERG,

LISTE 15
THE YOUNG ART FAIR IN BASEL

June 15–20, 2010

Open Hours Tuesday to Saturday 1 p.m. to 9 p.m.
Sunday 1 p.m. to 7 p.m.

Opening Reception Monday June 14, 5 p.m. to 10 p.m.
Burgweg 15, CH 4058 Basel, Switzerland
T +41 61 692 20 21, info@liste.ch, www.liste.ch
A project in the workshop community Warteck pp

Main Sponsor **E. GUTZWILLER & CIE, BANQUIERS,** Basel

CELEBRATING IT'S 6th APPEARANCE
AT THE 44th ART COLOGNE

ARTISTS / GALLERIES B TIMO BEHN Sebastian Brandl • JÉRÉMIE BENNEQUIN Maud Piquion • CATHERINE BERTOLA Workplace Gallery • HENNING BOHL Johann König • INAKI BONILLAS Sonia Rosso • STEFAN BURGER Marion Scharmann **C** DAN COLEN & NATE LOWMAN Peres Projects **D** JOSEF DABERNIG Andreas Huber • THEA DJORDJADZE Sprüth Magers **F** BERTA FISCHER Karin Guenther Giti Nourbakhsch • MAX FREY Krobath • DORIS FROHNAPFEL M29 • CARLA SCOTT FULLERTON Chert **G** NICOLA GOBBETTO Fonti • GESINE GRUNDMANN Vera Gliem **H** CHRISTIAN HAAKE Katharina Bittel • DAVID HOMINAL Karma International • TILMAN HORNIG Galerie Gebr. Lehmann **J** FOMA JAREMTSCHUK Susanne Zander • KATHARINA JAHNKE & LORNA MACINTYRE Galerie Kamm **K** KNUT KLASSEN Olaf Stüber • PAUL KNIGHT Neon Parc **L** BO CHRISTIAN LARSSON Steinle Contemporary **M** FABIAN MARTI Peter Kilchmann • KATRIN MAYER Antje Wachs • JOSEPHINE MECKSEPER Reinhard Hauff • MICHAEL MÜLLER Aanant & Zoo • MUSÉE IGOR BALUT Ferenbalm-Gurbrü Station **N** JAROMIR NOVOTNY Jiri Svestka Gallery **P** BENEDIKT PARTENHEIMER Klara Wallner **R** PEYMAN RAHIMI Eva Winkeler • THIAGO ROCHA PITTA Andersen's Contemporary **S** SIMONE SCHARDT Christian Lethert • HANNA SCHWARZ Galerie Christian Nagel • PAUL SCHWER Bugdahn und Kaimer **T** ALEX TENNIGKEIT Jette Rudolph **U** FRANCIS UPRITCHARD Kate MacGarry **V** JOHANNES VOGL Janda **W** BEDWYR WILLIAMS Ceri Hand Gallery • SUSANNE M. WINTERLING Parrotta • CLEMENS WOLF Steinek **Z** TOBIAS YVES ZINTEL Barbara Gross **PROJECTS** CIRCUS HEIN • Silberkuppe • Supportico Lopez **INSTITUTIONS** Gesellschaft für Moderne Kunst am Museum Ludwig, Cologne

project management Adelheid Komenda
project consulting Kathrin Luz, Meyer Voggenreiter (Cologne)
project assistance Jana Strippel
installation design meyer voggenreiter projekte and Sebastian Hauser

commissioned by ART COLOGNE / Koelnmesse
project idea by Neumann Luz, Cologne

www.openspace-cologne.com

koelnmesse

2010

Basel / June 14-20

Claramatte Parkhaus,
Klingentalstrasse 25,
4057, Basel, Switzerland

5th
edition

Mexico City
November 24-28

World Trade Center

1st
edition

www.hot-art-fair.com

100 Chairs in 100 days / Martino Gamper

Exhibition picture: Triennale, Design Museum Milano, October – November 2009

Nilufar

alleria Nilufar 20121 Milano 30|32 via della Spiga t +39 02.780193 f +39 02.76007657 agira@nilufar.com www.nilufar.com

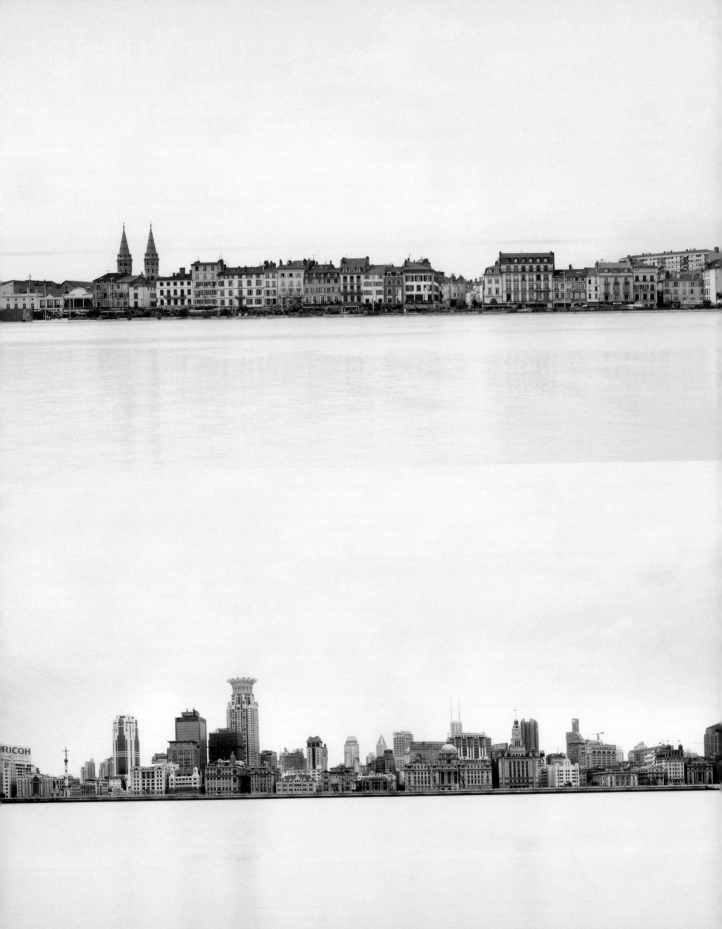

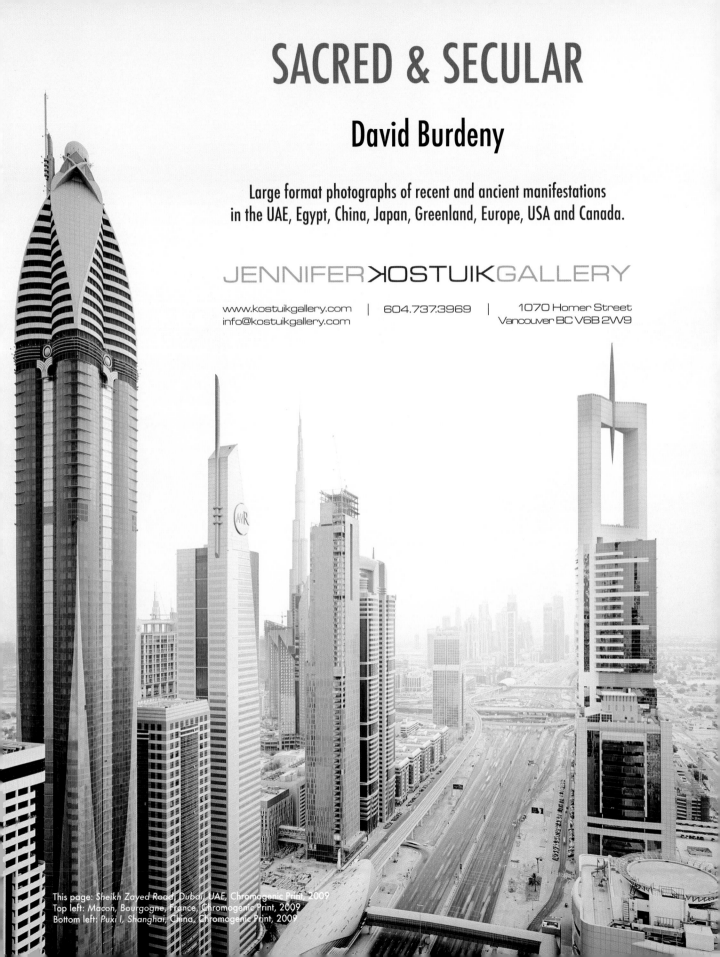

jamileh weber gallery

waldmannstrasse 6 · ch–8001 zurich · phone +41 44 252 10 66
www.jamilehweber.com · info@jamilehweber.com

SIGMAR POLKE

DIE FENSTER IM GROSSMÜNSTER ZÜRICH
THE WINDOWS FOR THE GROSSMÜNSTER ZÜRICH

Texte von / Texts by: Gottfried Boehm, Katharina Schmidt, Marina Warner, Ulrich Gerster / Regine Helbling, Käthi La Roche, Urs Rickenbach, Claude Lambert, Jacqueline Burckhardt / Bice Curiger.

Gebunden, 28 x 20 cm, 272 Seiten, ca. 70 Farbabbildungen
Deutsch-Englische Ausgabe
Parkett Verlag in Zusammenarbeit mit
der Kirchgemeinde Grossmünster
Erscheint Juni 2010

Hardcover, 11 x 8 in., 272 pages, ca. 70 color images
English – German Edition
Parkett Publishers in Collaboration
with Grossmünster Zürich
Available June 2010

ISBN 978-3-907582-27-5, ca. Euro 45.– / CHF 70.–

 Parkett Verlag • Quellenstrasse 27 • CH-8031 Zürich • Tel. 41-44-271 81 40 • Fax 41-44-272 43 01
Parkett • 145 Av. of the Americas • New York • NY 10013 • Phone (212) 673-2660 • Fax (212) 271-0704

DEUTSCHE+GUGGENHEIM

ON VIEW APRIL—OCTOBER 2010

WANGECHI MUTU
30.4. —13.6.

BEING SINGULAR PLURAL:
MOVING IMAGES FROM INDIA
26.6. —10.10

UNTER DEN LINDEN 13/15, 10117 BERLIN, +49 (0) 30 – 20 20 93 – 0
DAILY 10 AM – 8 PM, MONDAYS ADMISSION FREE
WWW.DEUTSCHE-GUGGENHEIM.DE

200 ARTWORKS
25 YEARS
ARTISTS' EDITIONS
FOR PARKETT

new

An authentic and unique document of today's art, this new catalogue raisonné features 200 distinct and diverse artworks made by artists for Parkett since 1984.

- Essays by Susan Tallman, art historian and book author, and Deborah Wye, Chief Curator, Prints and Illustrated Books, Museum of Modern Art, New York
- 200 full-page color reproductions of all Parkett editions
- Color reproductions of 85 Parkett Covers
- Artists' sketches and letters
- Index of all Parkett Spines and Inserts
- Index of all authors and 1400 texts
- Texts in English and Japanese
- 520 pages, 19,4 x 16 cm / 7 $^3/_2$ x 6 $^3/_8$ inches
- $ 45.00, Euro 35.–, CHF 49.– • ISBN 978-3-907582-25-1

Published on the occasion of Parkett's 25 Year Retrospective at the 21st Century Museum of Contemporary Art, Kanazawa, Japan

To order please visit your local art bookshop or order on- or offline at Parkett's addresses below:

"Commissioned by Parkett, the most important artists of our time have created editions that represent the essence of their art or reveal an unexpected dimension ... the works cover every possible medium including painting, photographs, drawings, prints, sculptures, videos, DVDs, and sound pieces."

The Whitechapel Art Gallery, London

"The MoMA collection contains numerous examples of editions by the most significant artists of the modern period ... The editions made for Parkett carry on this rich tradition ..."

Deborah Wye, Chief Curator of Prints, MoMA, New York

Meret Oppenheim, Edition for Parkett 4
(From «200 ARTWORKS, 25 YEARS»)

Parkett Verlag • Quellenstrasse 27 • CH-8031 Zürich • Tel. +41-44-271 81 40 • Fax +41-44-272 43 01
Parkett • 145 Av. of the Americas • New York • NY 10013 • Phone (212) 673-2660 • Fax (212) 271-0704
www.parkettart.com • Catalogue orders: www.parkettart.com/25_years

200
ARTWORKS
25
YEARS

ARTISTS'
EDITIONS
FOR
PARKETT

Parkett

PARKETT
PUBLISHERS

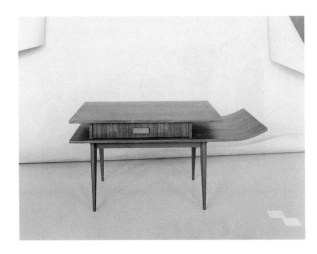

EDITION FOR PARKETT 87
ANNETTE KELM
UNTITLED, 2010
C-print from 4 x 5" negative, on Fuji Crystal Archive
DPII matt, paper size 16 x 20 ⁵/₈", image: 14 ¹/₂ x 19 ¹/₈",
printed by Golab, Berlin.
Edition of 38/XX, signed and numbered certificate.

C-Print ab 4 x 5" Negativ, auf Fuji Crystal Archive DPII matt,
Papierformat 40,5 cm x 52,4 cm, Bild 36,7 cm x 48,6 cm,
gedruckt bei Golab, Berlin.
Auflage 38/XX, signiertes und nummeriertes Zertifikat.

€ 1300 / $ 1700 / CHF 1900

POOH'S TIGGER SAYS THAT A TABLE IS TO PUT
THINGS ON. AND THIS ONE?

EIN TISCH VON UNBEKANNTER HAND
WIRD ZUM OBJEKT DES FORSCHENDEN AUGES.

EDITION FOR PARKETT 87
KATHARINA FRITSCH
APPLE, 2009/10
High speed resin cast, color, hand finished, diameter 5 ¹/₂".
Edition of 48/XII, signed and numbered certificate.

APFEL, 2009/10
Schnellgiessharz, Farbe, handbearbeitet, Durchmesser 14 cm.
Auflage: 48/XII, signiertes und nummeriertes Zertifikat.

€ 1800 /$ 2500 /CHF 2700

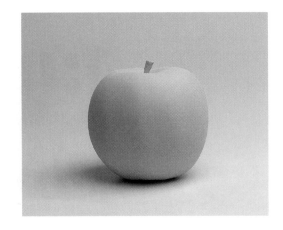

MINIMALISM? CONCEPTUALISM?
THE ORIGINAL SIN REVISITED?

DIE GESCHICHTE DES APFELS AN
DER OBERFLÄCHE DES OBJEKTS.

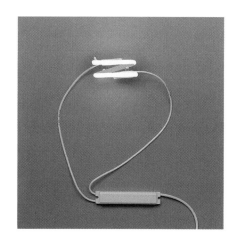

EDITION FOR PARKETT 87
CERITH WYN EVANS
E=Q=U=A=L=S, 2010
Neon light, 5 x 2 x ³/₈", electrical power cable, transformer 6 x ⁷/₈ x ⁷/₈",
with installation guide, production by NEON Line, Vienna.
Edition of 35/XX, signed and numbered certificate.

Neonlicht, 12 x 5 x 1 cm, elektrisches Kabel, Transformer 15 x 2 x 2 cm,
mit Installationsanleitung. Produktion: NEON Line, Wien.
Auflage: 35/XX, signiertes und nummeriertes Zertifikat.

€ 1800 /$ 2600 /CHF 2800

EQUALLY BALANCED: WORDS LEFT AND RIGHT IN
THE MIND OF THE BEHOLDER.

IN DER LEERE DES RAUMS LEUCHTET DER
HINWEIS AUF (UN)BEKANNTE SYMMETRIEN.

EDITION FOR PARKETT 87
KELLEY WALKER
UNTITLED, 2010
Cast in various media (e.g. chocolate, paper pulp, resin),
each unique, with cap worn by artist,
approx. 12 x 7 x 11", approx. 15.5 lbs.
Edition of 35/XX, signed and numbered certificate

Guss in diversen Materialien (Schokolade, Papiermaché,
Harz, u.a.), Unikate, mit vom Künstler getragener Kappe,
ca. 30 x 17,5 x 26 cm, ca. 7 kg.
Auflage 35/XX, signiertes und nummeriertes Zertifikat.

€ 3800 /$ 4900 /CHF 5500

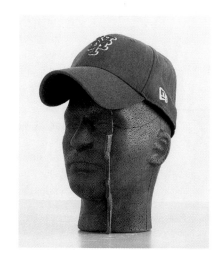

THIS HAT WEARS MORE THAN ONE HEAD

DIE KAPPE DES KÜNSTLERS ALS FIXPUNKT
IM SPIEL WECHSELNDER IDENTITÄTEN.

JEAN-LUC MYLAYNE

NO. PO-65, FACE TO FACE, APRIL/MAY 2001 (Parkett 85)

C-print, transparency, image size: 9 1/2 x 9 1/2", Mounted between Altuglass,
15 x 15 x 2 3/4", 16,5 lb, with 2nd C-Print (diptych), 9 1/2 x 23 5/8" (mounted behind plexi).
Artist designed certificate including a close-up photograph
of the bird facing the apple, 5 1/2 x 5 1/2".
Edition of 38/XXII, signed and numbered certificate

$ 3600 / € 2800

C-print, Diapositiv, Bildformat 24 x 24 cm, Montiert zwischen Altuglas,
38 x 38 x 7 cm, 7,5 kg, mit 2. C-Print (Diptych), 24,2 x 60 cm (hinter Plexi).
Vom Künstler gestaltetes Zertifikat mit einem Ausschnitt
der Photographie von Vogel und Apfel, 14 x 14 cm.
Auflage 38/XXII, signiertes und nummeriertes Zertifikat.

€ 2800 / CHF 4200

NATURE COMMUNES WITH ITSELF,
SUBLIMELY INDIFFERENT TO HUMAN INTERVENTION

ZEUGNIS EINES ALTEN TRAUMS: IM VIS-À-VIS VON VOGEL
UND APFELSPRICHT DIE NATUR MIT SICH SELBST.

ARTISTS' EDITIONS FOR PARKETT SUBSCRIBERS
WWW.PARKETTART.COM

The **PARKETT** Series is created in collaboration with artists, who contribute an original work available exclusively to the subscribers in the form of a signed limited **SPECIAL EDITION**. The available works are also reproduced in each PARKETT issue.

Each **SPECIAL EDITION** is available by order from any one of our offices in New York or Zurich. Just fill in the details below and send this card to the office nearest you. Once your order has been processed, you will be issued with an invoice and your personal edition number. Upon receipt of payment, you will receive the SPECIAL EDITION. (Please note that supply is subject to availability. PARKETT does not assume responsibility for any delays in production of SPECIAL EDITIONS. Postage and VAT not included.)

☐ As a subscriber to PARKETT, I would like to order the following Special Edition(s), signed and numbered by the artist.

PARKETT No.	ARTIST	NAME:
PARKETT No.	ARTIST	ADDRESS:
PARKETT No.	ARTIST	CITY:
PARKETT No.	ARTIST	STATE/ZIP:
PARKETT No.	ARTIST	COUNTRY:
PARKETT No.	ARTIST	PHONE:

☐ I have indicated my way of payment on the reverse side of this form.

Send this form to the PARKETT office nearest you:

PARKETT PUBLISHERS 145 AV. OF THE AMERICAS NEW YORK, NY 10013 PHONE (212) 673-2660 FAX (212) 271-0704
PARKETT VERLAG QUELLENSTRASSE 27 CH-8031 ZÜRICH TELEFON +41-44-271 81 40 FAX +41-44-272 43 01
Visit our website: www.parkettart.com

KÜNSTLEREDITIONEN FÜR PARKETT-ABONNENTEN
WWW.PARKETTART.COM

Die **PARKETT**-Buchreihe entsteht in Zusammenarbeit mit Künstlern, die eigens für die Abonnenten einen Originalbeitrag in Form einer limitierten und signierten **EDITION** gestalten. Diese Editionen sind auch in der Zeitschrift abgebildet und können mit dieser Bestellkarte in jedem unserer Büros in Zürich oder New York bestellt werden. Sie erhalten dann Ihre persönliche Editionsnummer und eine Rechnung. Sobald wir Ihre Zahlung erhalten haben, schicken wir Ihnen Ihre Edition(en). Lieferung solange Vorrat. PARKETT übernimmt keine Verantwortung für allfällige Verzögerungen bei der Herstellung der Vorzugsausgaben. Versandkosten und MwSt nicht inbegriffen.

☐ Ich bin PARKETT-Abonnent(in) und bestelle folgende EDITION(EN), nummeriert und vom Künstler signiert:

PARKETT Nr.	KÜNSTLER/IN	NAME:
PARKETT Nr.	KÜNSTLER/IN	STRASSE:
PARKETT Nr.	KÜNSTLER/IN	PLZ/STADT:
PARKETT Nr.	KÜNSTLER/IN	LAND:
PARKETT Nr.	KÜNSTLER/IN	TEL.:

☐ Meine Zahlungsweise habe ich auf der Rückseite angegeben.

Senden Sie die Bestellkarte an das PARKETT-Büro in Ihrer Nähe:

PARKETT VERLAG QUELLENSTRASSE 27 CH-8031 ZÜRICH TELEFON +41-44-271 81 40 FAX +41-44-272 43 01
PARKETT PUBLISHERS 145 AV. OF THE AMERICAS NEW YORK, NY 10013 PHONE (212) 673-2660 FAX (212) 271-0704
Besuchen Sie unsere Website: www.parkettart.com

☐ I wish to complete my PARKETT library and order the following volumes:

No.

at US $ 32 (USA/Canada), € 30 (Europe, rest of world) each, plus postage. Sold out: No. 1–10, 12, 13, 16–20, 22, 24–27, 29–31, 33, 35–39, 45.

☐ I wish to order the Set of all 50 available Parkett volumes at US $ 990 (USA/Canada), € 900 (Europe, rest of world), plus postage.

☐ I wish to order_____copies of "200 Artworks – 25 Years", the most complete catalogue raisonné of all 200 editions made by artists for Parkett to date, 516 p., with text, 200 color repr., US $ 45.00 (USA/Canada), € 35.– (Europe, rest of world), plus postage.

☐ I wish to order_____copies of the Postcard-Set of Parkett's Artists' Editions, € 32.– /$ 39.00 (excl. postage)

☐ I wish to order_____copies of "Parkett – 20 Years of Artists' Collaborations", € 32.– / $ 39.00 (excl. postage)

☐ I wish to order_____copies of "Sigmar Polke – Windows for the Zurich Grossmünster" (avail. June 2010) € 45.– / $ 65.00, (excl. postage)

For further information also regarding subscriptions please go to www.parkettart.com or contact us at info@parkettart.com.

NAME: _____

ADDRESS: _____

CITY: _____

STATE/ZIP/COUNTRY: _____

TEL.: _____ FAX: _____

E-MAIL: _____

GIFT RECIPIENT: _____

ADDRESS: _____

CITY: _____

STATE/ZIP: _____

COUNTRY: _____

☐ Charge my Visa Card ☐ Mastercard ☐ AMEX

Card No. |__|__|__|__|__|__|__|__|__|__|__|__|__|__|__| Expiration date _____

☐ Payment enclosed (US check or money order) ☐ Bill me

DATE _____

SIGNATURE _____

Send this form to the PARKETT office nearest you:

PARKETT PUBLISHERS 145 AV. OF THE AMERICAS NEW YORK, NY 10013 PHONE (212) 673-2660 FAX (212) 271-0704

PARKETT VERLAG QUELLENSTRASSE 27 CH-8031 ZÜRICH TELEFON +41-44-271 81 40 FAX +41-44-272 43 01

Visit our website: www.parkettart.com

VERVOLLSTÄNDIGEN SIE IHRE PARKETT-BIBLIOTHEK ODER SCHENKEN SIE PARKETT 87

☐ Ich möchte meine PARKETT-Bibliothek vervollständigen und bestelle die folgenden noch erhältliche(n) Bände:

Nr.

zu je € 30 / CHF 45.–, zzgl. Versandkosten (vergriffen: Nr. 1–10, 12, 13, 16–20, 22, 24–27, 29–31, 33, 35–39, 45).

☐ Ich bestelle den Set aller 50 erhältlichen Parkett-Bände zu € 900 (Europa), CHF 1400.– (Schweiz), zzgl. Versandkosten.

☐ Ich bestelle_____Ex. «200 Artworks – 25 Years», den vollständigen Werkkatalog aller 200 von Künstlern für Parkett geschaffenen Editionen. 516 S., mit Texten, 200 Farbabb., € 35.– / CHf 49.–, zzgl. Versandkosten.

☐ Ich bestelle_____Ex. des Postkarten Sets der Parkett-Editionen Euro 32.– / CHF 45.–, zzgl. Versandkosten.

☐ Ich bestelle_____Ex. «Parkett – 20 Years of Artists' Collaborations» € 32.– / CHF 45.–, zzgl. Versandkosten.

☐ Ich bestelle_____Ex. «Sigmar Polke's Fenster für das Zürcher Grossmünster», € 45.– / CHF 70.–, zzgl. Versandkosten. (erscheint Juni 2010)

Für Aboinformationen oder weitere Fragen besuchen Sie bitte www.parkettart.com oder kontaktieren Sie uns via info@parkettart.com.

NAME: _____

STRASSE: _____

PLZ/STADT: _____

LAND: _____

TEL.: _____ FAX: _____

E-MAIL: _____

BESCHENKTE(R): _____

STRASSE: _____

PLZ/STADT: _____

LAND: _____

☐ Ich zahle mit Visa ☐ Eurocard/Mastercard ☐ AMEX

Karten Nr. |__|__|__|__|__|__|__|__|__|__|__|__|__|__|__| Gültig bis_____

☐ Mein Scheck über CHF/€ _____ liegt bei.

☐ Bitte senden Sie mir eine Rechnung.

DATUM _____

UNTERSCHRIFT _____

Senden Sie die Bestellkarte an das PARKETT-Büro in Ihrer Nähe:

PARKETT VERLAG QUELLENSTRASSE 27 CH-8031 ZÜRICH TELEFON +41-44-271 81 40 FAX +41-44-272 43 01

PARKETT PUBLISHERS 145 AV. OF THE AMERICAS NEW YORK, NY 10013 PHONE (212) 673-2660 FAX (212) 271-0704

Besuchen Sie unsere Website: www.parkettart.com

ARTISTS' MONOGRAPHS & EDITIONS / KÜNSTLERMONOGRAPHIEN & EDITIONEN
FOR AVAILABILITY SEE NEXT PAGES / LIEFERBARKEIT SIEHE FOLGENDE SEITEN

Tomma Abts, vol. 84
Franz Ackermann, vol. 68
Eija-Liisa Ahtila, vol. 68
Ai Weiwei, vol. 81
Doug Aitken, vol. 57
Jennifer Allora /
Guillermo Calzadilla, vol. 80
Pavel Althamer, vol. 82
Kai Althoff, vol. 75
Francis Alÿs, vol. 69
Laurie Anderson, vol. 49
John Armleder, vol. 50/51
Richard Artschwager, vol. 23, vol. 46
John Baldessari, vol. 29, vol. 86
Stephan Balkenhol, vol. 36
Matthew Barney, vol. 45
Georg Baselitz, vol. 11
Vanessa Beecroft, vol. 56
Ross Bleckner, vol. 38
John Bock, vol. 67
Alighiero e Boetti, vol. 24
Christian Boltanski, vol. 22
Cosima von Bonin, vol. 81
Monica Bonvicini, vol. 72
Louise Bourgeois, vol. 27, 82
Carol Bove, vol. 86
Olaf Breuning, vol. 71
Glenn Brown, vol. 75
Angela Bulloch, vol. 66
Daniel Buren, vol. 66
Sophie Calle, vol. 36
Maurizio Cattelan, vol. 59
Vija Celmins, vol. 44
Francesco Clemente, vol. 9 & 40/41
Chuck Close, vol. 60
Enzo Cucchi, vol. 1
John Currin, vol. 65
Tacita Dean, vol. 62
Thomas Demand, vol. 62
Martin Disler, vol. 3
Peter Doig, vol. 67
Trisha Donnelly, vol. 77
Marlene Dumas, vol. 38
Olafur Eliasson, vol. 64
Tracey Emin, vol. 63
Urs Fischer, vol. 72
Eric Fischl, vol. 5

Peter Fischli /
David Weiss, vol. 17, 40/41
Sylvie Fleury, vol. 58
Günther Förg, vol. 26 & 40/41
Robert Frank, vol. 83
Tom Friedman, vol. 64
Katharina Fritsch, vol. 25, 87
Bernard Frize, vol. 74
Ellen Gallagher, vol. 73
Isa Genzken, vol. 69
Franz Gertsch, vol. 28
Gilbert & George, vol. 14
Liam Gillick, vol. 61
Robert Gober, vol. 27
Nan Goldin, vol. 57
Dominique Gonzalez-
Foerster, vol. 80
Felix Gonzalez-Torres, vol. 39
Douglas Gordon, vol. 49
Dan Graham, vol. 68
Rodney Graham, vol. 64
Katharina Grosse, vol. 74
Mark Grotjahn, vol. 80
Andreas Gursky, vol. 44
Wade Guyton, vol. 83
David Hammons, vol. 31
Rachel Harrison, vol. 82
Thomas Hirschhorn, vol. 57
Damien Hirst, vol. 40/41
Carsten Höller, vol. 77
Jenny Holzer, vol. 40/41
Rebecca Horn, vol. 13 & 40/41
Roni Horn, vol. 54
Gary Hume, vol. 48
Pierre Huyghe, vol. 66
Christian Jankowski, vol. 81
Ilya Kabakov, vol. 34
Anish Kapoor, vol. 69
Alex Katz, vol. 21, 72
Mike Kelley, vol. 31
Ellsworth Kelly, vol. 56
Annette Kelm, vol. 87
William Kentridge, vol. 63
Jon Kessler, vol. 79
Karen Kilimnik, vol. 52
Martin Kippenberger, vol. 19
Imi Knoebel, vol. 32

Jeff Koons, vol. 19, 50/51
Jannis Kounellis, vol. 6
Yayoi Kusama, vol. 59
Wolfgang Laib, vol. 39
Maria Lassnig, vol. 85
Zoe Leonard, vol. 84
Sherrie Levine, vol. 32
Sarah Lucas, vol. 45
Christian Marclay, vol. 70
Brice Marden, vol. 7
Paul McCarthy, vol. 73
Josiah McElheny, vol. 86
Lucy McKenzie, vol. 76
Julie Mehretu, vol. 76
Mario Merz, vol. 15
Beatriz Milhazes, vol. 85
Marilyn Minter, vol. 79
Tracey Moffatt, vol. 53
Mariko Mori, vol. 54
Malcolm Morley, vol. 52
Sarah Morris, vol. 61
Juan Muñoz, vol. 43
Jean-Luc Mylayne, vol. 50/51, 85
Bruce Nauman, vol. 10
Ernesto Neto, vol. 78
Olaf Nicolai, vol. 78
Cady Noland, vol. 46
Albert Oehlen, vol. 79
Meret Oppenheim, vol. 4
Gabriel Orozco, vol. 48
Tony Oursler, vol. 47
Laura Owens, vol. 65
Jorge Pardo, vol. 56
Philippe Parreno, vol. 86
Mai-Thu Perret, vol. 84
Raymond Pettibon, vol. 47
Elizabeth Peyton, vol. 53
Richard Phillips, vol. 71
Sigmar Polke, vol. 2, 30 & 40/41
Richard Prince, vol. 34, 72
Michael Raedecker, vol. 65
Markus Raetz, vol. 8
Charles Ray, vol. 37
Jason Rhoades, vol. 58
Gerhard Richter, vol. 35
Bridget Riley, vol. 61
Pipilotti Rist, vol. 48, 71

Matthew Ritchie, vol. 61
Tim Rollins & K.O.S., vol. 20
Ugo Rondinone, vol. 52
James Rosenquist, vol. 58
Susan Rothenberg, vol. 43
Thomas Ruff, vol. 28
Edward Ruscha, vol. 18 & 55
Anri Sala, vol. 73
Wilhelm Sasnal, vol. 70
Gregor Schneider, vol. 63
Thomas Schütte, vol. 47
Dana Schutz, vol. 75
Richard Serra, vol. 74
Cindy Sherman, vol. 29
Roman Signer, vol. 45
Andreas Slominski, vol. 55
Josh Smith, vol. 85
Rudolf Stingel, vol. 77
Beat Streuli, vol. 54
Thomas Struth, vol. 50/51
Hiroshi Sugimoto, vol. 46
Philip Taaffe, vol. 26
Sam Taylor-Wood, vol. 55
Diana Thater, vol. 60
Wolfgang Tillmans, vol. 53
Rirkrit Tiravanija, vol. 44
Fred Tomaselli, vol. 67
Rosemarie Trockel, vol. 33
James Turrell, vol. 25
Luc Tuymans, vol. 60
Keith Tyson, vol. 71
Kara Walker, vol. 59
Kelley Walker, vol. 87
Jeff Wall, vol. 22 & 49
Andy Warhol, vol. 12
Rebecca Warren, vol. 78
Gillian Wearing, vol. 70
Lawrence Weiner, vol. 42
John Wesley, vol. 62
Franz West, vol. 37, 70
Rachel Whiteread, vol. 42
Sue Williams, vol. 50/51
Robert Wilson, vol. 16
Christopher Wool, vol. 33, 83
Cerith Wyn Evans, vol. 87
Yang Fudong, vol. 76

87	Katharina Fritsch	m	e
	Annette Kelm	m	e
	Kelley Walker	m	e
	Cerith Wyn Evans	m	e
86	John Baldessari	m	e
	Carol Bove	m	e
	Josiah McElheny	m	e
	Philippe Parreno	m	
85	Maria Lassnig	m	e
	Beatriz Milhazes	m	
	Jean-Luc Mylayne	m	e
	Josh Smith	m	e
84	Tomma Abts	m	e
	Zoe Leonard	m	e
	Mai-Thun Perret	m	e
83	Robert Frank	m	
	Wade Guyton	m	
	Christopher Wool	m	e
82	Pavel Althamer	m	e
	Louise Bourgeois	m	
	Rachel Harrison	m	e
81	Ai Weiwei	m	e
	Cosima von Bonin	m	e
	Christian Jankowski	m	e
80	Allora & Calzadilla	m	
	D. Gonzalez-Foerster	m	e
	Mark Grotjahn	m	
79	Albert Oehlen	m	e
	Jon Kessler	m	e
	Marilyn Minter	m	
78	Ernesto Neto	m	
	Olaf Nicolai	m	e
	Rebecca Warren	m	
77	Trisha Donnelly	m	e
	Carsten Höller	m	e
	Rudolf Stingel	m	
76	Lucy McKenzie	m	e
	Julie Mehretu	m	
	Yang Fudong	m	e
75	Kai Althoff	m	e
	Glenn Brown	m	

	Dana Schutz	m	
74	Bernard Frize	m	
	Katharina Grosse	m	
	Richard Serra	m	
73	Ellen Gallagher	m	
	Paul McCarthy	m	
	Anri Sala	m	e
72	Monica Bonvicini	m	
	Urs Fischer	m	
	Richard Prince	m	
71	Olaf Breuning	m	e
	Richard Phillips	m	e
	Keith Tyson	m	e
70	Christian Marclay	m	e
	Wilhelm Sasnal	m	e
	Gillian Wearing	m	
69	Francis Alÿs	m	
	Isa Genzken	m	
	Anish Kapoor	m	
68	Franz Ackermann	m	e
	Eija-Liisa Ahtila	m	e
	Dan Graham	m	e
67	John Bock	m	
	Peter Doig	m	
	Fred Tomaselli	m	
66	Angela Bulloch	m	e
	Daniel Buren	m	e
	Pierre Huyghe	m	e
65	John Currin	m	
	Laura Owens	m	
	Michael Raedecker	m	
64	Olafur Eliasson	m	
	Tom Friedman	m	
	Rodney Graham	m	
63	Tracey Emin	m	e
	William Kentridge	m	
	Gregor Schneider	m	
62	Tacita Dean	m	e
	Thomas Demand	m	
	John Wesley	m	
61	Liam Gillick	m	

	Sarah Morris	m	e
	Bridget Riley	m	
	Matthew Ritchie	m	e
60	Chuck Close	m	
	Diana Thater	m	e
	Luc Tuymans	m	e
59	Maurizio Cattelan	m	
	Yayoi Kusama	m	
	Kara Walker	m	
58	Sylvie Fleury	m	
	Jason Rhoades	m	
	James Rosenquist	m	
57	Doug Aitken	m	e
57	Nan Goldin	m	
	Thomas Hirschhorn	m	
56	Vanessa Beecroft	m	
	Ellsworth Kelly	m	
	Jorge Pardo	m	e
55	Edward Ruscha	m	
	Andreas Slominski	m	
	Sam Taylor-Wood	m	
54	Roni Horn	m	
	Mariko Mori	m	
	Beat Streuli	m	
53	Tracey Moffatt	m	
	Elizabeth Peyton	m	
	Wolfgang Tillmans	m	
52	Karen Kilimnik	m	e
	Malcolm Morley	m	e
	Ugo Rondinone	m	e
50/51	John Armleder	m	
	Jeff Koons	m	
	Jean-Luc Mylayne	m	
	Thomas Struth	m	
	Sue Williams	m	
49	Laurie Anderson	m	e
	Douglas Gordon	m	
	Jeff Wall	m	
48	Gary Hume	m	
	Gabriel Orozco	m	
	Pipilotti Rist	m	

47	Tony Oursler	m	
	Raymond Pettibon	m	
	Thomas Schütte	m	
46	Richard Artschwager	m	
	Cady Noland	m	
	Hiroshi Sugimoto	m	
45	Matthew Barney		
	Sarah Lucas		
	Roman Signer		e
44	Vija Celmins	m	
	Andreas Gursky	m	
	Rirkrit Tiravanija	m	e
43	Juan Muñoz	m	
	Susan Rothenberg	m	
42	Lawrence Weiner	m	e
	Rachel Whiteread	m	
40/41	Francesco Clemente	m	
	Fischli/Weiss	m	
	Günther Förg	m	
	Damien Hirst	m	
	Jenny Holzer	m	
	Rebecca Horn	m	
	Sigmar Polke	m	
39	Felix Gonzalez-Torres		
	Wolfgang Laib		
38	Ross Bleckner		
	Marlene Dumas		
37	Charles Ray	m	
	Franz West	m	
36	Stephan Balkenhol		
	Sophie Calle		
35	Gerhard Richter		
34	Ilya Kabakov	m	
	Richard Prince	m	
33	Rosemarie Trockel		
	Christopher Wool		
32	Imi Knoebel	m	
	Sherrie Levine	m	
31	David Hammons		
	Mike Kelley		
30	Sigmar Polke		

29	John Baldessari	
	Cindy Sherman	
28	Franz Gertsch	m
	Thomas Ruff	m
27	Louise Bourgeois	
	Robert Gober	
26	Günther Förg	
	Philip Taaffe	
25	Katharina Fritsch	
	James Turrell	
24	Alighiero e Boetti	
23	Richard Artschwager	m
22	Christian Boltanski	
	Jeff Wall	
21	Alex Katz	m
20	Tim Rollins + K.O.S.	
19	Martin Kippenberger	
	Jeff Koons	
18	Ed Ruscha	
17	Fischli/Weiss	
16	Robert Wilson	
15	Mario Merz	m
14	Gilbert & George	m
13	Rebecca Horn	
12	Andy Warhol	
11	Georg Baselitz	m
10	Bruce Nauman	
9	Francesco Clemente	
8	Markus Raetz	
7	Brice Marden	
6	Jannis Kounellis	
5	Eric Fischl	
4	Meret Oppenheim	
3	Martin Disler	
2	Sigmar Polke	
1	Enzo Cucchi	

m = available monograph / erhältliche Monographie, e = available edition / erhältliche Edition
Delivery subject to availability at time of order / Lieferung solange Vorrat

PARKETT IN BOOKSHOPS (Selection)

PARKETT IS AVAILABLE IN 500 LEADING ART BOOKSHOPS AROUND THE WORLD. FOR FURTHER INFORMATION CONTACT:
PARKETT GIBT ES IN 500 FÜHRENDEN KUNSTBUCHHANDLUNGEN AUF DER GANZEN WELT. FÜR WEITERE INFORMATIONEN WENDEN SIE SICH BITTE AN:
PARKETT VERLAG, QUELLENSTRASSE 27, CH-8031 ZÜRICH, TEL. +41-44 271 81 40, FAX 272 43 01, WWW.PARKETTART.COM;
PARKETT, 145, AVENUE OF THE AMERICAS, NEW YORK, N.Y. 10013, PHONE +1 (212) 673-2660, FAX 271-0704, WWW.PARKETTART.COM

NORTH & SOUTH AMERICA, ASIA, AUSTRALIA

DISTRIBUTOR / VERTRIEB
D.A.P. (DISTRIBUTED ART PUBLISHERS)
155 AVENUE OF THE AMERICAS,
2ND FLOOR,
NEW YORK, NY 10013

USA

BEACON, NY
DIA: BEACON
3 BEEKMAN STREET

BERKELEY, CA
BERKELEY ART MUSEUM
2625 DURANT AVENUE

BOSTON, MA
INSTITUTE OF CONTEMPORARY ART
100 NORTHERN AVENUE
TRIDENT BOOKSELLERS
338 NEWBURY STREET

CAMBRIDGE, MA
MIT PRESS BOOKSTORE
292 MAIN STREET

CHICAGO, IL
MUSEUM OF CONTEMPORARY ART
220 EAST CHICAGO AVENUE
QUIMBY'S
1854 W. NORTH AVENUE
SMART MUSEUM OF ART
5550 S. GREENWOOD AVENUE

COLUMBUS, OH
WEXNER CENTER BOOKSTORE
1871 NORTH HIGH STREET

CORAL GABLES, FL
BOOKS & BOOKS
265 ARAGON ROAD

DETROIT
MUSEUM OF CONTEMPORARY ART
4454 WOODWARD AVENUE

HOUSTON, TX
BRAZOS BOOKSTORE
2421 BISSONNET
CONTEMPORARY ARTS MUSEUM
5216 MONTROSE BOULEVARD

LOS ANGELES, CA
MUSEUM OF CONTEMPORARY ART
250, S. GRAND
SKYLIGHT BOOKS
18181 N. VERMONT AVENUE
UCLA / ARMAND HAMMER MUSEUM
OF ART
10899 WILSHIRE BOULEVARD

MIAMI, FL
BOOKS & BOOKS
296 ARAGON AVENUE, CORAL GABLES

MINNEAPOLIS, MN
THE WALKER ART CENTER BOOKSTORE
1750 HENNEPIN AVENUE

NEW YORK, NY
MUSEUM OF MODERN ART
11 WEST 53RD STREET
NEW MUSEUM OF CONTEMPORARY
ART STORE
235 BOWERY
ARTBOOK@PS1
22–25 JACKSON AVENUE
PRINTED MATTER
195 10TH AVENUE
SAINT MARK'S BOOKSTORE
31 3RD AVENUE
SPOONBILL & SUGARTOWN
218 BEDFORD AVENUE
WHITNEY MUSEUM STORE
945 MADISON AVENUE

OAKLAND, CA
DIESEL, A BOOKSTORE
5433 COLLEGE AVENUE

PHILADELPHIA, PA
AVRIL 50
3406 SANSOM STREET

PORTLAND, OR
POWELL'S BOOKS
1005 W. BURNSIDE

PROVIDENCE, RI
RHODE ISLAND SCHOOL OF DESIGN
30 N. MAIN STREET

SAN FRANCISCO, CA
ASF MUSEUM OF MODERN ART
MUSEUMBOOKS
151 3RD STREET, 1ST FLOOR

ST. LOUIS, MO
LEFT BANK BOOKS
399 NORTH EUCLID

SANTA MONICA, CA
ARCANA
1229 3RD STREET PROMENADE
HENNESSEY & INGALLS BOOKS
214 WILSHIRE BLVD

WASHINGTON D.C.
NATIONAL GALLERY OF ART
4TH STREET & CONSTITUTION
AVENUE, NW

CANADA / KANADA

MONTREAL
CANADIAN CENTER FOR ARCHITECTURE
1920 RUE BAILE
OLIVIERI LIBRAIRIE BOOKSTORE
5210 CHEMIN DE LA CÔTE DES NIEGES

TORONTO
ART METROPOLE
788 KING STREET WEST
PAGES BOOKS AND MAGAZINE
256 QUEEN STREET WEST

AUSTRALIA / AUSTRALIEN

SYDNEY
MUSEUM OF CONTEMPORARY ART
140 GEORGE STREET,
THE ROCKS, CIRCULAR QUAY FOYER

ASIA / ASIEN

JAPAN

TOKYO
BOOKS LOGOS / LIBRO CO. LTD
15-1, UDAGAWA-CHO, SHIBUYA-KU

CHINA

BEIJING
TIMEZONE 8 BOOKS & CAFÉ
NO. 4 JIU XIAN QIAO ROAD

SHANGHAI
TIMEZONE 8 BOOKS & CAFÉ
NO. 50 MOGANSHAN ROAD

MEXICO

MEXICO D.F.
HABITA BOOKS BY A & R PRESS
PRESIDENTE MASARYK # 201,
COL. POLANCO/DEL.
MIGUEL HIDALGO

BRAZIL

SAO PAULO
LIVRARIA DA VILA LTDA
RUA FRADIQUE COUTINHO, 915
VILA MADALENA

GREAT BRITAIN / GROSSBRITANNIEN

DISTRIBUTOR / VERTRIEB
CENTRAL BOOKS
99, WALLIS ROAD
LONDON E9 5LN

BIRMINGHAM
IKON GALLERY
1 OOZELLS SQUARE

BRIGHTON
BORDERS BOOKSHOP
CHURCHILL SQUARE SHOPPING CENTRE

BRISTOL
ARNOLFINI BOOKSHOP
16 NARROW QUAY

CARDIFF
CHAPTER ARTS CENTRE
MARKET ROAD

LONDON
ARTWORDS BOOKSHOP
65 A RIVINGTON STREET
BORDERS BOOKSHOP
120–122 CHARING CROSS ROAD
BORDERS BOOKSHOP
203–207 OXFORD STREET
BORDERS BOOKSHOP
N1 CENTRE ISLINGTON
CAMDEN ARTS CENTRE
ARKWRIGHT ROAD
HAYWARD GALLERY
SOUTH BANK CENTRE
THE MALL
SERPENTINE GALLERY
KENSINGTON GARDENS
TATE MODERN
BANKSIDE
WATERSTONE BOOKSELLERS
9/13 GARRICK STREET, WC2
WHITECHAPEL ART GALLERY
80 WHITECHAPEL HIGH STREET

OXFORD
MODERN ART OXFORD
30 PEMBROKE STREET

SCOTLAND / SCHOTTLAND

GLASGOW
TRANSMISSION GALLERY
45 KING STREET

IRELAND / IRLAND

CORK
LEWIS GLUCKSMAN GALLERY
UNIVERSITY COLLEGE

DUBLIN
DOUGLAS HYDE GALLERY
TRINITY COLLEGE

GERMANY / DEUTSCHLAND

DISTRIBUTOR / VERTRIEB
GVA VERLAGSSERVICE GÖTTINGEN
PF 2021
D-37010 GÖTTINGEN

BERLIN
BÜCHERBOGEN AM SAVIGNYPLATZ
STADTBAHNBOGEN 593
GALERIE 2000 KUNSTBUCHHANDLUNG
KNESEBECKSTRASSE 56/58
THEMATISCHE BUCHHANDLUNG
PRO QM
ALMSTADTSTRASSE 48–50

BIELEFELD
THALIA UNIVERSITÄTSBUCHHANDLUNG
OBERNTORWALL 23

BONN
BUCHLADEN 46
KAISERSTRASSE 46

BREMEN
BEIM STEINERNEN KREUZ GMBH
BEIM STEINERNEN KREUZ 1

DÜSSELDORF
MÜLLER & BÖHM
BOLKERSTRASSE 53
WALTHER KÖNIG BUCHHANDLUNG
GRABBEPLATZ 4

FRANKFURT
KUNST-BUCH, KUNSTHALLE SCHIRN
RÖMERBERG 7
WALTHER KÖNIG BUCHHANDLUNG
DOMSTRASSE 6

HAMBURG
SAUTTER + LACKMANN BUCHHANDLUNG
ADMIRALITÄTSTRASSE 71/72

HANNOVER
MERZ KUNSTBUCHHANDLUNG
KURT-SCHWITTERS-PLATZ

KARLSRUHE
HOSER & MENDE
KARLSTRASSE 76

KÖLN
WALTHER KÖNIG BUCHHANDLUNG
EHRENSTRASSE 4

MÜNCHEN
HANS GOLTZ BUCHHANDLUNG
FÜR BILDENDE KUNST
TÜRKENSTRASSE 54
L. WERNER BUCHHANDLUNG
RESIDENZSTRASSE 18

STUTTGART
LIMACHER BUCHHANDLUNG
KÖNIGSTRASSE 28

AUSTRIA / ÖSTERREICH

LINZ
ALEX – EINE BUCHHANDLUNG
HAUPTPLATZ 21
WIEN
ALBERTINA MUSEUM
ALBERTINA PLATZ 1
DER BUCHFREUND
SONNENFELSGASSE 4
PRACHNER
MUSEUMPLATZ 1

SPAIN / SPANIEN

BARCELONA
LAIE – CAIXAFÒRUM
MARQUES DE COMILLAS 6–8

BILBAO
GUGGENHEIM MUSEUM
ABANDOIBARRA ET. 2

MADRID
PUBLICACIONES DE ARQUITECTURA
GENERAL RODRIGO 1

FRANCE / FRANKREICH

PARIS
CENTRE POMPIDOU, FLAMMARION 4
26, RUE JACOB
GALERIE NATIONALE DU JEU DE PAUME
1, PLACE DE LA CONCORDE
LIBRAIRIE DU MUSÉE D'ART MODERNE
9, RUE GASTON DE SAINT-PAUL
CHRISTOPH DAVIET-THERY,
LIVRES&EDITIONS D'ARTISTES
10, RUE DUCHEFDELAVILLE
ARTICURIAL
61, AVENUE MATAIGNE

ITALY / ITALIEN

MILANO
ART BOOK MILANO
VIA VENTURA 5
ROMA
GALLERIA NAZIONALE D'ARTE MODERNA
131, VIA DELLE BELLE ARTI

NORWAY / NORWEGEN

OSLO
THE NATIONAL MUSEUM OF
CONTEMPORARY ART
BANKPLASSEN 4 / SKATTEFOG

SWEDEN / SCHWEDEN

STOCKHOLM
MODERNA MUSEET
SKEPPSHOLMEN

NETHERLANDS, BELGIEM AND LUXEMBURG

DISTRIBUTOR / VERTRIEB
IDEA BOOKS
NIEUWE HERENGRACHT 11
NL-1011 RK AMSTERDAM

NETHERLANDS / NIEDERLANDE

AMSTERDAM
ATHENAEUM NIEUWSCENTRUM
SPUI 14–16
EINDHOVEN
MOTTA
GERGSTRAAT 35
GRONINGEN
SCHOLTENS / WRISTERS BOOKSHOP
FULDENSTRAAT 20
HAARLEM
ATHENAEUM
GED. OUDE GRACHT 70
HENGELO
BROEKHUIS
WEMENSTRAAT 45

BELGIUM / BELGIEN

ANTWERPEN
COPYRIGHT BOOKSHOP
NATIONALSTRAAT 28A
IMS BOOKSHOP
MELKMARK 17
BRUXELLES
PEINTURE FRAICHE
10, RUE DU TABELLON
TROPISMES LIBRAIRIES
GALERIE DES PRINCES 11
GENT
COPYRIGHT BOOKSHOP
JACOBIJNENSTRAAT 8
SMAK
CITADELPARK

LUXEMBOURG / LUXEMBURG

LUXEMBOURG
CASINO LUXEMBOURG
41, RUE NOTRE-DAME

SWITZERLAND / SCHWEIZ

DISTRIBUTOR / VERTRIEB
SCHEIDEGGER&CO. C/O AVA
CENTRALWEG 16
CH-8910 AFFOLTERN A. A.

BASEL
FONDATION BEYELER
BASELSTRASSE 77, RIEHEN
DOMUS HAUS
PFLUGGAESSLEIN 3
KUNSTMUSEUM BUCHHANDLUNG
ST. ALBAN-GRABEN 16
GALERIE STAMPA
SPALENBERG 2
THALIA
FREIE STRASSE 32

BERN
MÜNSTERGASS BUCHHANDLUNG
MÜNSTERGASSE 33
STAUFFACHER BUCHHANDLUNG
NEUENGASSE 25–37

LAUSANNE
EX NIHILO
6, AV. WILLIAM FRAISSE

LUZERN
HIRSCHMATT
HIRSCHMATTSTRASSE 26

ST. GALLEN
RÖSSLITOR BÜCHER
WEBERGASSE 5

WINTERTHUR
VOGEL THALIA BÜCHER
MARKTGASSE 41

ZÜRICH
CALLIGRAMME BUCHHANDLUNG
HÄRINGSTRASSE 4
HOWEG BUCHHANDLUNG
WAFFENPLATZ 1
KUNSTGRIFF BUCHHANDLUNG
LIMMATSTRASSE 270
KUNSTHAUS ZÜRICH
HEIMPLATZ 1
ORELL FÜSSLI BUCHHANDLUNG
FÜSSLISTRASSE 4
SPHÈRES
HARDTURMSTRASSE 66

E X H I B I T I O N S

ZÜRICH

ABBT PROJECTS

Motorenstrasse 14
8005 Zürich

Tel. 043 244 97 22
www.abbtprojects.com
abbtprojects@gmail.com

PARKETT
ausgewählte Künstlereditionen und Publikationen

	April–May 2010
CÉCILE WICK	**June–July 2010**
WALTER PFEIFFER	**October–November 2010**
KLAUDIA SCHIFFERLE	**November–December 2010**

**GALERIE
ANDREA CARATSCH**

Waldmannstrasse 8
8001 Zürich
Tel. 044 272 50 00
www.galeriecaratsch.com
info@galeriecaratsch.com

Please contact the Gallery for further information

MAI 36 GALERIE

Rämistrasse 37
8001 Zürich
Tel. 044 261 68 80
www.mai36.com
mail@mai36.com

IAN ANÜLL	**06.03.–17.04.2010**
MATTHEW BENEDICT	**23.04.–05.06.2010**
LAWRENCE WEINER	**12.06.–31.07.2010**
MAGNUS PLESSEN	**26.08.–16.10.2010**
ART 41 BASEL	**16.06.–20.06.2010**

MARK MÜLLER

Gessnerallee 36
8001 Zürich
Tel. 044 211 81 55
www.markmueller.ch
mail@markmueller.ch

DUANE ZALOUDEK «Nomad Song»	
Raum 3: STEFAN GRITSCH «Trophies»	**06.03.–10.04.2010**
GIACOMO SANTIAGO ROGADO «praesens et tangere»	
Guestroom: Artists from Studio Warehouse Glasgow	
	17.04.–05.06.2010
FRANCOIS MORELLET	**12.06.–17.07.2010**
CHRISTINE STREULI	**28.08.–23.10.2010**
ART 41 BASEL	**16.06.–20.06.2010**

BOB VAN ORSOUW

Limmatstrasse 270
8005 Zürich
Tel. 044 273 11 00
www.bobvanorsouw.ch
mail@bobvanorsouw.ch

a cutlet vaudeville show	
MARCEL VAN EEDEN	**27.03.–22.05.2010**
HALUK AKAKÇE	**05.06.–24.07.2010**
ART 41 BASEL	**16.06.–20.06.2010**

E X H I B I T I O N S

ANNEMARIE VERNA	Neptunstrasse 42	EINIGE GROSSE FORMATE /	
	8032 Zürich	A FEW LARGE FORMATS	**17.02.–13.03.2010**
	Tel. 044 262 38 20	IN PLACE OF LOVE	
	www.annemarie-verna.ch	GLEN RUBSAMEN	**20.03.–08.05.2010**
	office@annemarie-verna.ch	REE MORTON	**18.05.–10.07.2010**
		ART 41 BASEL	**16.06.–20.06.2010**

NICOLA	Limmatstrasse 275	SLAWOMIR ELSNER	**20.03.–01.05.2010**
VON SENGER	8005 Zürich	Vernissage	**19.03.2010**
	Tel. 044 201 88 10	TERRY RODGERS	**15.05.–10.07.2010**
	www.nicolavonsenger.com	Vernissage	**14.05.2010**
	info@nicolavonsenger.com	ARCANGELO SASSOLINO	**28.08.–16.10.2010**
		Vernissage	**27.10.2010**

JAMILEH WEBER	Waldmannstrasse 6	DARRYL POTTORF	
	8001 Zürich	Paintings	**March–April 2010**
	Tel. 044 252 10 66	GALLERY ARTISTS	**May–July 2010**
	www.jamilehweber.com	ART 41 BASEL	**16.06.–20.06.2010**
	info@jamilehweber.com		

BASEL

NICOLAS KRUPP	Erlenstrasse 15	DANI JAKOB	**05.03.–01.05.2010**
	4058 Basel	JOANNE GREENBAUM @ SCHÜRMANN, BERLIN	
	Tel. 061 683 32 65		**30.04.–26.06.2010**
	www.nicolaskrupp.com	HEIMO ZOBERNIG	**08.05.–26.06.2010**
	nic@nicolaskrupp.com	ART 41 BASEL, ART GALLERIES	**16.06.–20.06.2010**

LUZERN

GALERIE URS MEILE	Rosenberghöhe 4	THE WINGS OF LIFE ART	
	6004 Luzern	HE YUNCHANG	**12.02.–17.04.2010**
	Tel. 041 420 33 18	XIA XIAOWAN	
	www.galerieursmeile.com	THREE DIMENSIONAL	**07.05.–24.07.2010**
	galerie@galerieursmeile.com	STEPFATHER HAS AN IDEA	
		XIE NANXING	**27.08.–16.10.2010**
		HONG KONG	
		INTERNATIONAL ART FAIR	**27.05.–30.05.2010**
		ART 41 BASEL	**16.06.–20.06.2010**

KAI ALTHOFF I ALLORA & CALZADILLA I MIROSLAW BALKA
MATTHEW BARNEY I ROBERT BECHTLE I ALIGHIERO E BOETTI
JAN DIBBETS I CARROLL DUNHAM I CECILIA EDEFALK
LUCIANO FABRO I GARY HILL I THOMAS HIRSCHHORN
JIM HODGES I HUANG YONG PING I CAMERON JAMIE
ANISH KAPOOR I SHARON LOCKHART I ANDREW LORD
SARAH LUCAS I VICTOR MAN I MARIO MERZ I MARISA MERZ
DAVE MULLER I WANGECHI MUTU I JEAN-LUC MYLAYNE
SHIRIN NESHAT I CATHERINE OPIE I DAMIÁN ORTEGA
WALTER PICHLER I LARI PITTMAN I MAGNUS PLESSEN
RICHARD PRINCE I UGO RONDINONE I ROSEMARIE TROCKEL
PALOMA VARGA WEISZ I ANDRO WEKUA
ESTATE OF JACK SMITH

GLADSTONE GALLERY

gladstonegallery.com

Galerie Daniel Buchholz · **Fasanenstraße 30** · **10719 Berlin**
Tel +49-30-88 62 40 56 Fax +49-30-88 62 40 57
post@galeriebuchholz.de · www.galeriebuchholz.de

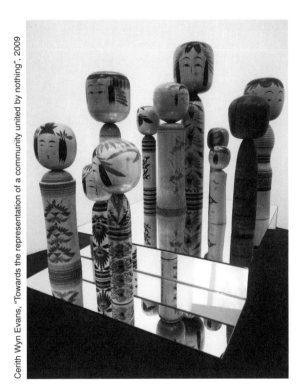

Cerith Wyn Evans, "Towards the representation of a community united by nothing", 2009

Tomma Abts
Cosima von Bonin
Tony Conrad
Aaron Curry
Enrico David
Simon Denny
Lukas Duwenhögger
Thomas Eggerer
Cerith Wyn Evans
Vincent Fecteau
Morgan Fisher
Isa Genzken
Jack Goldstein
Julian Göthe
Richard Hawkins
Jochen Klein
Jutta Koether
Michael Krebber
Mark Leckey
Sam Lewitt
Lucy McKenzie
Henrik Olesen
Paulina Olowska
Silke Otto-Knapp
Mathias Poledna
Florian Pumhösl
de Rijke / de Rooij
Frances Stark
Josef Strau
Stefan Thater
Cheyney Thompson
Wolfgang Tillmans
Danh Vo
Katharina Wulff

Galerie Daniel Buchholz
Neven-DuMont-Str. 17 · 50667 Köln
Tel +49-221-257 49 46 Fax +49-221-25 33 51
post@galeriebuchholz.de · www.galeriebuchholz.de
Daniel Buchholz & Christopher Müller

AMAR KANWAR
MARCH 16 — APRIL 24

THOMAS STRUTH
MAY 5 — JUNE 19

MARIAN GOODMAN GALLERY

24 WEST 57TH STREET NEW YORK, NY 10019
TEL: 212-977-7160 FAX: 212-581-5187 WWW.MARIANGOODMAN.COM

KEN PRICE

MATTHEW MARKS GALLERY, NEW YORK

berlin@haunchofvenison.com
www.haunchofvenison.com

Nicolas Provost
12 Feb — 3 Apr

LONDON

6 Burlington Gardens
London W1S 3ET
United Kingdom

T + 44 (0) 20 7495 5050
F + 44 (0) 20 7495 4050
london@haunchofvenison.com
www.haunchofvenison.com

Jitish Kallat
15 Feb — 27 Mar

Chiharu Shiota
19 Feb — 27 Mar

Rina Banerjee
9 Apr — 15 May

Glasnost: Soviet Non-Conformist Art from the 1980s
16 Apr — 26 Jun

NEW YORK

1230 Avenue of the Americas
between 48th and 49th Street
20th Floor
New York, NY 10020

T + 1 212 259 0000
F + 1 212 259 0001
newyork@haunchofvenison.com
www.haunchofvenison.com

Your History is Not Our History
New York in the 1980s
5 Mar — 1 May

BERLIN

Heidestrasse 46
10557 Berlin
Germany

T + 49 (0)30 39 74 39 63
F + 49 (0)30 39 74 39 64
berlin@haunchofvenison.com
www.haunchofvenison.com

Nicolas Provost

www.haunchofvenison.com

Nicolas Provost
12 Feb — 3 Apr

LONDON

6 Burlington Gardens
London W1S 3ET
United Kingdom

T + 44 (0) 20 7495 5050
F + 44 (0) 20 7495 4050
london@haunchofvenison.com
www.haunchofvenison.com

Jitish Kallat
15 Feb — 27 Mar

Chiharu Shiota
19 Feb — 27 Mar

Rina Banerjee
9 Apr — 15 May

Glasnost: Soviet Non-Conformist Art from the 1980s
16 Apr — 26 Jun

NEW YORK

1230 Avenue of the Americas
between 48th and 49th Street
20th Floor
New York, NY 10020

T + 1 212 259 0000
F + 1 212 259 0001
newyork@haunchofvenison.com
www.haunchofvenison.com

Your History is Not Our History
New York in the 1980s
5 Mar — 1 May

BERLIN

Heidestrasse 46
10557 Berlin
Germany

T + 49 (0)30 39 74 39 63
F + 49 (0)30 39 74 39 64
berlin@haunchofvenison.com
www.haunchofvenison.com

Nicolas Provost

BHARTI KHER FOR
HAUSER & WIRTH

TOBIAS ZIELONY
LE VELE DI SCAMPIA

KOCH OBERHUBER WOLFF

GALLERY WEEKEND BERLIN 30 APRIL – 2 MAY

ART COLOGNE BOOTH C-039 21 – 25 APRIL

KOW–BERLIN.COM

SARAH MORRIS
IT'S ALL TRUE
24.3.-30.4. 2010
MEYERKAINER
WWW.MEYERKAINER.COM

GALERIE URS MEILE
BEIJING · LUCERNE

LUCERNE: 12.02.10 – 17.04.10
THE WINGS OF LIFE ART **HE YUNCHANG**

LUCERNE: 07.05.10 – 24.07.10
XIA XIAOWAN THREE DIMENSIONAL

LUCERNE: 27.08.10 – 16.10.10
STEPFATHER HAS AN IDEA **XIE NANXING**

BEIJING: 30.01.10 – 04.04.10
QIU SHIHUA
JULIA STEINER A TENSE TURN

BEIJING: 22.05.10 – 09.07.10
STEPFATHER HAS AN IDEA **XIE NANXING**
IAN ANÜLL

BEIJING: 04.09.10 – 31.10.10
SHAN FAN

HONG KONG
INTERNATIONAL
ART FAIR
27.05.10 - 30.05.10

ART 41 BASEL
16.06.10 - 20.06.10

ARTISTS
AI WEIWEI · CHEN HUI · DING YI · DU JIE · HE YUNCHANG (A CHANG
L/B (LANG/BAUMANN) · LI DAFANG · LI ZHANYANG · LIU DING ·
REMY MARKOWITSCH · MENG HUANG · NIE MU · QIU SHIHUA ·
SHAN FAN · ANATOLY SHURAVLEV · TRACEY SNELLING ·
JULIA STEINER · NOT VITAL · WANG QINGSONG · WANG XINGWEI ·
WENG FEN (WENG PEIJUN) · XIA XIAOWAN · XIA XING · XIE NANXING

Beijing: 104, Caochangdi Cun, Cui Gezhuang Xiang, Chaoyang District, PRC-100015 Beijing/China, phone +86 (0)10 643 333 93, fax +86 (0)10 643 302 03
Lucerne: Rosenberghöhe 4, 6004 Lucerne/Switzerland, phone +41 (0)41 420 33 18, fax +41 (0)41 420 21 69
galerie@galerieursmeile.com, www.galerieursmeile.com

GALERIA ▪ HELGA DE ALVEAR

DR. FOURQUET 12, 28012 MADRID. TEL:(34) 91 468 05 06 FAX:(34) 91 467 51 34
e-mail:galeria@helgadealvear.com www.helgadealvear.com

JANUARY 14 – MARCH 13

ETTORE SPALLETTI

MARCEL DZAMA

MARCH 25 – MAY 22

JANE & LOUISE WILSON

CALLUM INNES

MAY 27 – JULY 31

JAMES CASEBERE

THE COMPREHENSIVE BOOK SERIES FEATURING CONTEMPORARY ARTISTS.

PARKETT, Quellenstrasse 27, CH-8031 Zürich
Telefon +41-44-271 81 40, Fax 41-44-272 43 01
PARKETT, 145 Av. of the Americas, New York, NY 10013
phone (212) 673 2660, fax (212) 271 0704
www.parkettart.com

THE PARKETT SERIES WITH CONTEMPORARY ARTISTS
DIE PARKETT–REIHE MIT GEGENWARTSKÜNSTLERN

art forum berlin

Die Internationale Kunstmesse

07.10.– 10.10. 2010

Messegelände Berlin, Eingang Masurenallee
Messedamm 22, 14055 Berlin
T. +49 / 30 / 30 38 20 76, F. +49 / 30 / 30 38 20 60
art@messe-berlin.de, www.art-forum-berlin.de

|||||| Messe Berlin

30.1.–18.4.2010
Fiona Tan
Rise and Fall
Hugo Suter
Fotografien 1969–2009

CARAVAN 1/2010
Ausstellungsreihe für
junge Kunst: Nathalie Bissig

30.1.–1.8.2010
Abstraktionen II

13.5.–1.8.2010
Ugo Rondinone
Die Nacht aus Blei

CARAVAN 2/2010
Ausstellungsreihe für
junge Kunst

*Aargauer Kunsthaus

Aargauerplatz CH-5001 Aarau
Di–So 10–17Uhr Do 10–20Uhr
www.aargauerkunsthaus.ch

Oscar Tuazon

Manuel Burgener

Kunsthalle Bern
–
13.2. – 25.4.2010

Dienstag bis Freitag 11 – 18 h
Samstag/ Sonntag 10 – 18 h

Helvetiaplatz 1
CH-3005 Bern
T +41 31 350 00 40
F +41 31 350 00 41
www.kunsthalle-bern.ch

Oscar Tuazon *ASS TO MOUTH*, 2009. Courtesy the artist and Balice Hertling, Paris

**Susan Hefuna – Bharti Kher – Fred Tomaselli:
Zwischen den Welten
1. Mai – 27. Juni 2010**

www.kunstmuseumthun.ch
Hofstettenstrasse 14, 3602 Thun
Di–So 10–17 Uhr, Mi 10–21 Uhr
Bild: Fred Tomaselli, „Untitled (Photogram #2)", 2007, Private Collection, London, UK

Kunstmuseum Thun

TATIANA TROUVÉ:
A STAY BETWEEN
ENCLOSURE AND SPACE
November 21, 2009 – February 21, 2010
Opening: November 20, 2009, 6pm

WHILE BODIES GET MIRRORED
– AN EXHIBITION ABOUT MOVEMENT,
FORMALISM AND SPACE
With a.o. Anetta Mona Chişa & Lucia Tkáčová, Martin Soto Climent,
Maya Deren, William Forsythe, Julian Goethe, Delia Gonzalez,
Babette Mangolte, Anna Molska, Kelly Nipper, Paulina Olowska,
Silke Otto-Knapp, Mai-Thu Perret, Hanna Schwarz
March 6 – May 30, 2010
Opening: March 5, 2010, 6pm

ARS VIVA 09/10 –
GESCHICHTE / HISTORY:
MARIANA CASTILLO
DEBALL, JAY CHUNG &
Q TAKEKI MAEDA,
DANI GAL
June 13 – July 31, 2010
Opening: June 12, 2010, 6pm

COLLECTION
MIGROS MUSEUM
FÜR GEGENWARTSKUNST
June 13 – July 31, 2010
Opening: June 12,
2010, 6pm

migrosmuseum
FÜR GEGENWARTSKUNST
ZÜRICH

The migros museum für gegenwartskunst
is an institution of the Migros Culture Percentage.
Tue/Wen/Fri 12am-6pm, Thu 12am-8pm,
Sat/Sun 11am-5pm
Limmatstrasse 270, 8005 Zurich
T+41 44 277 20 50, F +41 44 277 62 86
www. migrosmuseum.ch,
info@migrosmuseum.ch

NALINI MALANI

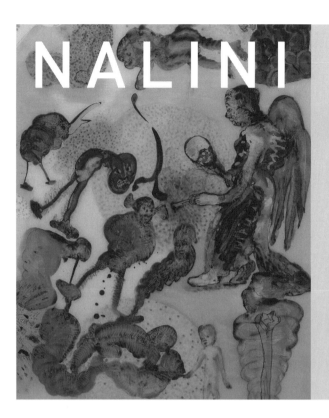

Splitting the Other
20.3 - 6.6.2010

mcb-a
MUSÉE CANTONAL
DES BEAUX-ARTS LAUSANNE

www.mcba.ch Switzerland

ELAD LASSRY
PARALLEL:
CHRISTODOULOS PANAYIOTOU
13 FEBRUARY UNTIL 25 APRIL 2010

ROSEMARIE TROCKEL
STARTING 8 MAY 2010

KUNSTHALLE ZÜRICH
LIMMATSTRASSE 270 CH-8005 ZÜRICH
TEL +41 44 272 15 15 FAX +41 44 272 18 88
INFO@KUNSTHALLEZURICH.CH WWW.KUNSTHALLEZURICH.CH
TUE/WED/FRI 12pm–6pm THU 12pm–8pm SAT/SUN 11am–5pm

IAN ANÜLL
6. MÄRZ - 17. APRIL 2010

MATTHEW BENEDICT
23. APRIL - 5. JUNI 2010

LAWRENCE WEINER
12. JUNI - 31. JULI 2010

MAGNUS PLESSEN
26. AUGUST - 16. OKTOBER 2010

ART 41 BASEL

MAI 36 GALERIE ZÜRICH MAI36.COM

Plattform10

8.4.— ewz-Unterwerk Selnau
17.4. Zürich

**Muriel Baumgartner / Raphael Bottazzini /
Fabien Clerc / Oscar De Franco / René Fahrni /
Bina Gnädinger / Viktor Korol / Nicholas
Leverington / Jon Merz / Stéphanie Raimondi /
Marie-Luce Ruffieux / Sebastien Verdon /
Martina-Sofie Wildberger**

⟶ **www.kunstwollen.ch**

galerie bob van orsouw limmatstrasse 270 ch-8005 zurich
phone +41 (0)44 273 11 00 mail@bobvanorsouw.ch www.bobvanorsouw.ch

march 27
until **marcel van eeden**
may 22, 2010 a cutlet vaudeville show

june 5
until **haluk akakçe**
july 24, 2010

art basel, june 16–20, 2010

MÄRZ BIS APRIL, 2010

JEAN-FRÉDÉRIC SCHNYDER

MAI BIS JUNI, 2010

MARTIN BOYCE / STEVEN SHEARER

JULI BIS AUGUST, 2010

SUE WILLIAMS

GALERIE EVA PRESENHUBER

WWW.PRESENHUBER.COM
TEL: +41 (0) 43 444 70 50 / FAX: +41 (0) 43 444 70 60
LIMMATSTRASSE 270, POSTFACH 1517, CH-8031 ZÜRICH
ÖFFNUNGSZEITEN: DI- FR 12-18, SA 11-17

Art | Basel | Miami Beach
2–5 | Dec | 10

Vernissage | **December 1, 2010** | **by invitation only**
Catalog order | Tel. +1 212 627 1999, www.artbook.com

The International Art Show – La Exposición Internacional de Arte
Art Basel Miami Beach, MCH Swiss Exhibition (Basel) Ltd., CH-4005 Basel
Fax +41 58 206 31 32, miamibeach@artbasel.com, www.artbasel.com

Art|41|Basel|16–20|6|10

Vernissage | **15. Juni 2010** | **nur mit Einladung**
Art Basel Conversations | **16. bis 19. Juni 2010** | von 10 bis 11 Uhr
Katalogbestellung: Tel. +49 711 44 05 204, Fax +49 711 44 05 220, sales@hatjecantz.de

The International Art Show – Die Internationale Kunstmesse
Art 41 Basel, MCH Messe Schweiz (Basel) AG, CH-4005 Basel
Fax +41 58 206 26 86, info@artbasel.com, www.artbasel.com

GENERAL PROGRAMME. 1900*2000 PARIS. AD HOC VIGO. AICON GALLERY LONDON. ALEX DANIELS-REFLEX AMSTERDAM. ALEXANDER AND BONIN NEW YORK. ÁLVARO ALCÁZAR MADRID. ANDRE SIMOENS GALLERY KNOKKE. ANGELS BARCELONA BARCELONA. ANTHONY REYNOLDS GALLERY LONDON. ARARIO GALLERY SEOUL. BARBARA GROSS GALERIE MUNICH. BÄRBEL GRÄSSLIN FRANKFURT. BENVENISTE CONTEMPORARY MADRID. BERNARD BOUCHE PARIS. CAIS GALLERY SEOUL. CÀNEM CASTELLÓN. CAPRICE HORN BERLIN. CARLES TACHÉ BARCELONA. CARLOS CARVALHO - ARTE CONTEMPORANEA LISBON. CARRERAS MÚGICA BILBAO. CASA TRIÁNGULO SAO PAULO. CASAS RIEGNER BOGOTÁ. CATHERINE PUTMAN PARIS. CAYÓN MADRID. CHARIM GALERIE VIENNA. CHRISTOPHER GRIMES SANTA MONICA. DAN GALERIA SAO PAULO. DISTRITO 4 MADRID. DNA GALERIE BERLIN. EDWARD TYLER NAHEM FINE ART, L.L.C. NEW YORK. ELBA BENÍTEZ MADRID. ELISABETH & KLAUS THOMAN INNSBRUCK. ELVIRA GONZÁLEZ MADRID. ESPACIO MÍNIMO MADRID. ESPAIVISOR - GALERÍA VISOR VALENCIA. ESTIARTE MADRID. ESTRANY - DE LA MOTA BARCELONA. EVELYN BOTELLA MADRID. FAGGIONATO FINE ARTS LONDON. FARÍA FÁBREGAS CARACAS. FILOMENA SOARES LISBON. FÚCARES MADRID. GANA ART GALLERY SEOUL. GEORG KARGL VIENNA. GEORG NOTHELFER GALERIE BERLIN. GRIMM AMSTERDAM. GRITA INSAM VIENNA. GUILLERMO DE OSMA MADRID. GUY BÄRTSCHI GENEVA. HANS MAYER DUSSELDORF. HAUNCH OF VENISON LONDON. HEINRICH EHRHARDT MADRID. HEINZ HOLTMANN COLOGNE. HILGER MODERN / CONTEMPORARY VIENNA. JAVIER LÓPEZ MADRID. JOAN PRATS BARCELONA. JORGE MARA-LA RUCHE BUENOS AIRES. JUANA DE AIZPURU MADRID. KLAUS GERRIT FRIESE STUTTGART. LA CAJA NEGRA MADRID. LA FÁBRICA MADRID. LEANDRO NAVARRO MADRID. LELONG PARIS. LEME SAO PAULO. LEYENDECKER SANTA CRUZ DE TENERIFE. LUCÍA DE LA PUENTE LIMA. LUCIANA BRITO GALERIA SAO PAULO. LUIS ADELANTADO VALENCIA. MAI 36 GALERIE ZURICH. MAIOR POLLENÇA. MAISTERRAVALBUENA MADRID. MAM MARIO MAURONER CONTEMPORARY ART VIENNA VIENNA. MANUEL OJEDA LAS PALMAS. MARIO SEQUEIRA BRAGA. MARK MÜLLER ZURICH. MARLBOROUGH GALLERY MADRID. MARTA CERVERA MADRID. MAX ESTRELLA MADRID. MAX WIGRAM GALLERY LONDON. MEESSEN DE CLERCQ BRUSSELS. MICHAEL JANSSEN BERLIN. MIGUEL MARCOS BARCELONA. MOISÉS PÉREZ DE ALBÉNIZ PAMPLONA. MORIARTY MADRID. NÄCHST ST. STEPHAN ROSEMARIE SCHWARZWÄLDER VIENNA. NOGUERAS BLANCHARD BARCELONA. OLIVA ARAUNA MADRID. ORIOL GALERIA D'ART BARCELONA. PALMA DOTZE VILAFRANCA DEL PENEDÉS. PELAIRES PALMA DE MALLORCA. PILAR PARRA & ROMERO MADRID. POLÍGRAFA OBRA GRÁFICA BARCELONA. PROJECTESD BARCELONA. RAFAEL ORTIZ SEVILLA. RONMANDOS GALLERY AMSTERDAM. SABINE KNUST MUNICH. SENDA BARCELONA. SIBONEY SANTANDER. SLEWE AMSTERDAM. SOLEDAD LORENZO MADRID. SOLLERTIS TOULOUSE. STUDIO TRISORIO NAPLES. T20 MURCIA. THADDAEUS ROPAC PARIS. THE PARAGON PRESS LONDON. THOMAS SCHULTE BERLIN. TIM VAN LAERE ANTWERP. TOMAS MARCH VALENCIA. TONI TÀPIES BARCELONA. TRAVESÍA CUATRO MADRID. TRAYECTO VITORIA. VANGUARDIA BILBAO. VISTAMARE BENEDETTA SPALLETTI PESCARA. WALTER STORMS GALERIE MUNICH.WETTERLING GALLERY STOCKHOLM. ZINK MUNICH.

ARCO 40. ADN GALERÍA BARCELONA. ADORA CALVO SALAMANCA. ALEJANDRO SALES BARCELONA. ALEXANDRA SAHEB BERLIN. ALFREDO VIÑAS MÁLAGA. ART NUEVE MURCIA. ATM CONTEMPORARY - GALERÍA ALTAMIRA GIJÓN. BACELOS VIGO. BEIJING SPACE BEIJING. BIE & VADSTRUP COPENHAGEN. BIRGIT OSTERMEIER BERLIN. BITFORMS GALLERY NEW YORK. BRIGITTE SCHENK COLOGNE. CASADO SANTAPAU MADRID. CHINA TODAY BRUSSELS. CHRISTIAN LETHERT COLOGNE. DEL SOL ST. ART GALLERY SANTANDER. ESPACIO LÍQUIDO GIJÓN. FACTORÍA COMPOSTELA (C5 COLECCIÓN) SANTIAGO DE COMPOSTELA. FONSECA MACEDO PONTA DELGADA. FORMATO CÓMODO MADRID. GABRIEL ROLT AMSTERDAM. GIMPEL FILS LONDON. JM MÁLAGA. JUAN SILIÓ SANTANDER. KAI HILGEMANN BERLIN. KASHYA HILDEBRAND ZURICH. KUCKEI + KUCKEI BERLIN. LA ACACIA LA HABANA. MARIBEL LÓPEZ GALLERY BERLIN. MICHEL SOSKINE MADRID. MIRTA DEMARE ROTTERDAM. MS MADRID. NF NIEVES FERNÁNDEZ MADRID. OREL ART PARIS. PACIARTE CONTEMPORARY BRESCIA. PERUGI ARTECONTEMPORANEA PADOVA. PROJEKTRAUM VIKTOR BUCHER VIENNA. PROMETEOGALLERY MILAN. RAIÑA LUPA BARCELONA. RAQUEL PONCE MADRID. ROSA SANTOS VALENCIA. RUBICON GALLERY DUBLIN. SANDUNGA GRANADA. SERVANDO LA HABANA. SIMYO GALLERY SEOUL. STELLA LOHAUS

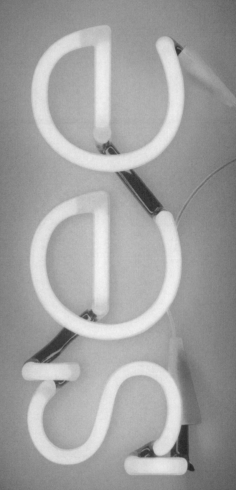

|29 *INTERNATION*
CONTEMPORARY ART F

FEBRUARY 17 TO
2010_ *FERIA DE MAD*
GENERAL PUBLIC FROM FRIDA

ORGANISE

IFEMA
Feria
Madr

AR
CO
ma
drid_

10_ LOS ANGELES

The Armory Show New Art by Living Artists – Pier 94

ARMORY FOCUS:BERLIN

Armory Focus, a new section dedicated to the best established and emerging galleries from a notable art community, premieres with selections from Berlin: Galerie Guido W. Baudach · Buchmann Galerie · carlier | gebauer · COMA · Galerie Crone · Galerie Cinzia Friedlaender · Johnen Gallery · Johann König · KLEMM'S · Tanya Leighton Gallery · Loock Galerie · Christian Nagel · Galerie Giti Nourbakhsch · Produzentengalerie: ph-projects · Reception · Galerie Aurel Scheibler · Esther Schipper · Galerie Thomas Schulte · Galerie Barbara Thumm · Galerie Barbara Weiss · Wentrup · Galerie Barbara Wien

AUSTRALIA: Anna Schwartz Gallery, Melbourne **AUSTRIA:** Galerie Grita Insam, Vienna · Georg Kargl Fine Arts, Vienna · Galerie Krinzinger, Vienna · Galerie Nikolaus Ruzicska, Salzburg · Layr Wuestenhagen Contemporary, Vienna **BELGIUM:** Baronian_Francey, Brussels · hoet bekaert gallery, Ghent · Zeno X Gallery, Antwerp **BRAZIL:** Luciana Brito Galeria, São Paulo · RHYS/MENDES, Belo Horizonte **CHINA:** Boers-Li Gallery, Beijing **CZECH REPUBLIC:** Jiri Svestka Gallery, Prague · VERNON, Prague **DENMARK:** Galleri Bo Bjerggaard, Copenhagen · Galleri Christina Wilson, Copenhagen **FINLAND:** Galerie Anhava, Helsinki **FRANCE:** art: concept, Paris · Cortex Athletico, Bordeaux · Galerie Frank Elbaz, Paris · gdm, Paris · Galerie Laurent Godin, Paris · Galerie Hussenot, Paris · Galerie In Situ Fabienne Leclerc, Paris · Galerie Jousse Entreprise, Paris · Yvon Lambert, Paris · Loevenbruck, Paris · gabrielle maubrie, Paris · Galerie Nathalie Obadia, Paris · Galerie Emmanuel Perrotin, Paris · Praz-Delavallade, Paris · Galerie Thaddaeus Ropac, Paris · Galerie GP & N Vallois, Paris · Galerie Anne de Villepoix, Paris **GERMANY:** Arndt, Berlin · carlier | gebauer, Berlin · Galerie EIGEN + ART, Berlin · Galerie Michael Janssen, Berlin · Galerie Ben Kaufmann, Berlin · L.A. Galerie - Lothar Albrecht, Frankfurt · Figge von Rosen Galerie, Cologne · Sies + Höke, Dusseldorf · Jacky Strenz, Frankfurt am Main · Van Horn, Dusseldorf · VOGES GALLERY, Frankfurt/Main **GREECE:** The Apartment, Athens · The Breeder, Athens · Ileana Tounta Contemporary Art Center, Athens **ICELAND:** i8 Gallery, Reykjavik **IRELAND:** Green On Red Gallery, Dublin · Kerlin Gallery, Dublin · mother's tankstation, Dublin **ISRAEL:** Dvir Gallery, Tel Aviv · Noga Gallery of Contemporary Art, Tel Aviv **ITALY:** Galleria Continua, San Gimignano / Beijing / Le Moulin · Galleria Raffaella Cortese, Milan · Massimo De Carlo, Milan · Galleria Lorcan O'Neill, Rome · Magazzino, Rome · MONITOR, Rome · Lia Rumma, Milan · Galleria Franco Soffiantino, Turin · Studio La Città, Verona **JAPAN:** island+Venice Projects, Tokyo · Gallery Side 2, Tokyo · Mizuma Art Gallery, Tokyo · TARO NASU, Tokyo **LEBANON:** GALERIE SFEIR-SEMLER, Beirut and Hamburg **SOUTH KOREA:** Kukje Gallery, Seoul · ONE AND J. Gallery, Seoul **THE NETHERLANDS:** Galerie Akinci, Amsterdam · Galerie Ron Mandos, Amsterdam · Diana Stigter, Amsterdam · Upstream Gallery, Amsterdam **NEW ZEALAND:** Starkwhite, Auckland **PORTUGAL:** Filomena Soares Gallery, Lisbon **ROMANIA:** Galeria Plan B, Cluj **RUSSIA:** Aidan Gallery, Moscow · Regina Gallery, Moscow **SOUTH AFRICA:** Goodman Gallery, Johannesburg · Michael Stevenson, Cape Town **SPAIN:** Nogueras Blanchard, Barcelona · OLIVA ARAUNA, Madrid · Parra & Romero, Madrid · Galerie Senda, Barcelona **SWEDEN:** Andréhn-Schiptjenko, Stockholm · Galleri Magnus Karlsson, Stockholm · Galleri Charlotte Lund, Stockholm · Milliken, Stockholm **SWITZERLAND:** Galerie Guy Bärtschi, Geneva · Faye Fleming & Partner, Geneva · Claudia Groeflin Galerie, Zurich · HAAS & FISCHER, Zurich · Hauser & Wirth, Zurich **TURKEY:** Dirimart, Istanbul **UNITED KINGDOM:** Ancient & Modern, London · Pilar Corrias Gallery, London · Corvi-Mora, London · greengrassi, London · Hales Gallery, London · Herald St, London · IBID PROJECTS, London · Ingleby Gallery, Edinburgh · Alison Jacques Gallery, London · Simon Lee Gallery, London · Josh Lilley, London · Lisson Gallery, London · Victoria Miro, London · The Modern Institute / Toby Webster Ltd, Glasgow · MUSEUM 52 LONDON, London · Other Criteria, London · Paragon Press, London · SEVENTEEN, London · White Cube, London · Max Wigram Gallery, London · Wilkinson, London · Workplace, Gateshead **UNITED STATES:** 303 Gallery, New York · Angles Gallery, Santa Monica · Peter Blum Gallery, New York · Bortolami, New York · Rena Bransten Gallery, San Francisco · BROADWAY 1602, New York · CANADA, New York · David Castillo Gallery, Miami · Cerealart, Philadelphia · Lisa Cooley, New York · DCKT Contemporary, New York · Elizabeth Dee, New York · Eleven Rivington, New York · Derek Eller Gallery, New York · Ronald Feldman Fine Arts, Inc., New York · Zach Feuer Gallery, New York · MARC FOXX, Los Angeles · Foxy Production, New York · Honor Fraser, Los Angeles · Fredericks & Freiser, New York · Friedman Benda, New York · James Fuentes, New York · Gering & López Gallery, New York · Laurel Gitlen (Small A Projects), New York · Greenberg Van Doren Gallery, New York · Kavi Gupta, Chicago · Richard Heller Gallery, Santa Monica · Rhona Hoffman Gallery, Chicago · Horton Gallery, New York · I-20, New York · Jenkins Johnson Gallery, San Francisco · Harris Lieberman, New York · Paul Kasmin Gallery, New York · Sean Kelly Gallery, New York · Nicole Klagsbrun Gallery, New York · Leo Koenig Inc., New York · David Kordansky Gallery, Los Angeles · Andrew Kreps Gallery, New York · Lehmann Maupin, New York · Yossi Milo Gallery, New York · Murray Guy, New York · Mihai Nicodim Gallery, Los Angeles · Carolina Nitsch, New York · NYEHAUS, New York · Parker Jones, Los Angeles · Parkett Publishers, New York · Peres Projects, Los Angeles · Friedrich Petzel Gallery, New York · Pierogi, Brooklyn · Postmasters Gallery, New York · Simon Preston, New York · Ratio 3, San Francisco · Redling Fine Art, Los Angeles · Daniel Reich Gallery, New York · RENTAL, New York · Lora Reynolds Gallery, Austin · Roberts & Tilton, Culver City · Nicholas Robinson, New York · Jack Shainman Gallery, New York · Altman Siegel, San Francisco · Sikkema Jenkins & Co., New York · Fredric Snitzer Gallery, Miami · Richard Telles Fine Art, Los Angeles · Leslie Tonkonow Artworks + Projects, New York · Two Palms, New York · Rachel Uffner Gallery, New York · Susanne Vielmetter Los Angeles Projects, Los Angeles · Wallspace, New York · Pace Wildenstein, New York · Bryce Wolkowitz Gallery, New York · David Zwirner, New York

The Armory Show — Modern Art of the 20th Century – Pier 92

CANADA: Christopher Cutts Gallery, Toronto **DENMARK:** Faurschou, Copenhagen **FINLAND:** Galerie Forsblom, Helsinki **FRANCE:** A.L.F.A., Paris · JGM. Galerie, Paris · Galerie Maeght, Paris · Galerie Daniel Templon, Paris **GERMANY:** : DIE GALERIE, Frankfurt/ Main · Levy Galerie, Hamburg · Michael Schultz Gallery, Berlin · Springer & Winckler Galerie, Berlin · Galerie Thomas, Munich **ITALY:** G.A.M. Galleria d'Arte Maggiore, Bologna · Giorgio Persano, Turin **SWEDEN:** Wetterling Gallery, Stockholm **UNITED KINGDOM:** Alan Cristea Gallery, London · E & R Cyzer, London · HackelBury Fine Art, London · Sims Reed, London **UNITED STATES:** Adler & Conkright Fine Art, New York · Armand Bartos Fine Art, New York · Babcock Galleries, New York · Bonni Benrubi Gallery, New York · Jonathan Boos, Bloomfield Village · Mark Borghi Fine Art, New York · Valerie Carberry Gallery, Chicago · Chowaiki & Co., New York · Danese, New York · Cecilia de Torres, Ltd., New York · DC Moore Gallery, New York · Edelman Arts, New York · Leslie Feely Fine Art, New York · Fleisher/Ollman Gallery, Philadelphia · Forum Gallery, New York · Barry Friedman, Ltd., New York · Gana Art, New York · Bernard Goldberg Fine Arts, New York · James Goodman Gallery, New York · James Graham & Sons, New York · Nohra Haime Gallery, New York · Hirschl & Adler Modern, New York · Jacobson Howard, New York · Leonard Hutton Galleries, New York · David Klein Gallery, Birmingham · Knoedler & Company, New York · Robert Koch Gallery, San Francisco · Alan Koppel Gallery, Chicago · Locks Gallery, Philadelphia · Marlborough Gallery, New York · Mary-Anne Martin/Fine Art, New York · McCormick Gallery / Vincent Vallarino Fine Art, Chicago and New York · Jerald Melberg Gallery, Charlotte · Mixografía, Los Angeles · Edward Tyler Nahem Fine Art, New York · Frey Norris Gallery, San Francisco · Richard Norton Gallery, Chicago · Jonathan O'Hara Gallery, New York · Gerald Peters Gallery, New York and Santa Fe · Ricco/Maresca Gallery, New York · Yancey Richardson Gallery, New York · Michael Rosenfeld Gallery, New York · Marc Selwyn Fine Art, Los Angeles · Senior & Shopmaker Gallery, New York · Sicardi Gallery, Houston · Bruce Silverstein Gallery, New York · Gary Snyder/Project Space, New York · Spanierman Modern, New York · Allan Stone Gallery, New York · Hollis Taggart Galleries, New York · Tasende Gallery, La Jolla · Meredith Ward Fine Art, New York · Washburn Gallery, New York · Amy Wolf Fine Art and Elrick-Manley Fine Art, New York **VENEZUELA:** Faría Fábregas Galería, Caracas

March 4–7 · Piers 92 and 94 · New York

thearmoryshow.com · armoryartsweek.com

kostengünstig

Digitaldruck, der begeistert, durch Qualität, Geschwindigkeit und Preis.

www.digitalprofi.ch

Zürichsee
Druckereien AG

Seestrasse 86 | CH-8712 Stäfa
Telefon 044 928 53 24 | Fax 044 928 53 10
info@zsd.ch | www.zsd.ch

REED SEIFER
DESIGN

**SPECIALIZING IN GRAPHIC DESIGN AND IDENTITY SERVICES
FOR ARTISTS, GALLERIES, ARTS INSTITUTIONS &
ALL ARBITERS OF GOOD TASTE**

NEW BUSINESS INQUIRIES:
**BEGIN@REEDSEIFER.COM +1 212 262 6329
REEDSEIFER.COM**

RECENT WORK: "RESORT FASHION – STYLE IN SUN-DRENCHED CLIMATES"
A 288 PAGE HARDCOVER TITLE PUBLISHED BY RIZZOLI NEW YORK

CARA BARER

"Tesserae"
Fotofest, Solo Exhibition
Design Works Gallery
March, 2010
Galveston, Texas
designworks-gallery.com

Solo Exhibition
Hulse/Warman Gallery
August, 2010
Taos, New Mexico
hulsewarmangallery.com

New Work
Andrea Schwartz Gallery
November, 2010
San Francisco, California
asgallery.com

"1966"
Limited Edition, Archival Pigment Print
www.carabarer.com

Mark Bradford
February 11 – April 4, 2010

Dave McKenzie
April 15 – May 9, 2010

Sergej Jensen
July 29 – October 10, 2010

Disembodied
February 11 – April 11, 2010

Restless Empathy
May 20 – July 18, 2010

Marlo Pascual
July 29 – October 3, 2010

CONNECT/
Download the Bee Tagg application to any mobile
phone with a camera at http://getbeetagg.com
After download, open app and point camera at
the QR code image above.

aspenartmuseum

590 North Mill Street, Aspen, Colorado 81611
970.925.8050
aspenartmuseum.org

The Association Kunsthalle Marcel Duchamp,
Cully, Switzerland, presents:

Marcel Duchamp
and the Forestay Waterfall

Opening Reception and Concert: 6 May 2010, 6 pm

Symposium: 7–9 May
Exhibitions: 7 May – 13 June

Program and Sponsors
http://www.bxb.ch/kunsthalle/

Organized and curated by Stefan Banz & Caroline Bachmann
In collaboration with the Philadelphia Museum of Art and ECAL / University of Art and Design Lausanne

Ingeborg Lüscher
Magician Photos / Zaubererfotos
6. 2.–18. 4. 2010

Reference and Affinity
Art of the 21st Century from the Collection
Referenz und Neigung
Kunst des 21. Jahrhunderts aus der Sammlung
27. 2.–27. 6. 2010

Stefan à Wengen. The Mission
30. 4.–1. 8. 2010

Olaf Breuning. „yes? no?"
30. 4.–1. 8. 2010

SIGNS OF LIFE
Ancient Knowledge in Contemporary Art
LEBENSZEICHEN
Altes Wissen in der zeitgenössischen Kunst

Adel Abdessemed, Marina Abramovic, Sanford Biggers, Louise
Bourgeois, Peter Buggenhout, Nathalie Djurberg, Amar Kanwar,
Bharti Kher, Sigalit Landau, Tea Mäkipää, Ana Mendieta, Mariella
Mosler, Kiki Smith, Nancy Spero, Philip Taaffe, Su-Mei Tse
14. 8.–21. 11. 2010

Kunstmuseum Luzern Museum of Art Lucerne
www.kunstmuseumluzern.ch

2010

March 6–April 24
**Tobias Madison
Andro Wekua
Carissa Rodriguez**

May 5–June 26
**Richard Phillips
Adolf Dietrich**

July 7–August 28
Summer Camp

September 15–November 13
Roman Signer

November 23–January 30, 2011
**Rita Ackermann
Harmony Korine**

SI

**Swiss Institute / Contemporary Art
495 Broadway, 3rd Floor
New York, NY 10012**

ROOF

Luis Camnitzer

11. März bis 4. Juli 2010, Daros Exhibitions

Limmatstrasse 268, 8005 Zürich, Do 12–20 Uhr, Fr–So 12–18 Uhr, www.daros-latinamerica.net

DAROS

Rufo Criado
Variación reflejo 030909.
Caja de Luz. Impresión digital
en backlight sobre metacrilato
Diámetro 100 cm

RUFO CRIADO "En la distancia verde"
GEORGES ROUSSE "El mundo ilustrado"
GABRIEL KONDRATIUK – Cuatro Paredes

del 5 de febrero al 16 de mayo de 2010

**CENTRO DE ARTE
CAJA DE BURGOS**

Caja de Burgos
Obra Social

CAB. Centro de Arte Caja de Burgos
C. Saldaña s/n 09003 Burgos - Spain Tel. +34 947 256 550
contacta@cabdeburgos.com www.cabdeburgos.com

NST DES 21. JAHRHUNDERTS
AUS PRIVATEN SAMMLUNGEN
NEUGIERIG?
S 2. MAI 2010 IN BONN

LIAM GILLICK
EIN LANGER SPAZIERGANG...
ZWEI KURZE STEGE...*
1. APRIL BIS 8. AUGUST 2010 IN BONN

* ONE LONG WALK...TWO SHORT PIERS

BUNDESKUNSTHALLE.DE
NST- UND AUSSTELLUNGSHALLE DER BUNDESREPUBLIK DEUTSCHLAND
EUMSMEILE BONN · FRIEDRICH-EBERT-ALLEE 4 · 53113 BONN · TEL. 0228 9171-200

JOHANNA DIEHL

February - April
Berlin

YVONNE ROEB

May - July
Berlin

GALERIE WILMA TOLKSDORF

Hanauer Landstrasse 136
60314 Frankfurt / M
+49 69 43 05 94 27
fra@wilmatolksdorf.de

Zimmerstrasse 88-89
10117 Berlin
+ 49 30 20 05 88 12
office@wilmatolksdorf.de

DAMIEN HIRST

THEOLOGY, PHILOSOPHY, MEDICINE, JUSTICE

FEBRUARY – APRIL 2010

GALERIE ANDREA CARATSCH WALDMANNSTRASSE 8 CH-8001 ZÜRICH
TEL +41-44-272 5000 FAX +41-44-272 5001 WWW.GALERIECARATSCH.COM

ggag | GREENAWAY ART GALLERY : AUSTRALIA in association with GAGPROJECTS : BERLIN www.greenaway.com.au

ARIEL HASSAN

TODAY ALL YOUR PLANS ARE GOING TO BE SUCCESSFUL

March 2010

HALLE
IMIKNOEBEL
WEISS-SCHWARZ

MARCH–MAY 2010

OPENING OF THE ADDITIONAL
GALERIE THADDAEUS ROPAC
HALLE
VILNIUSSTR. 13 SALZBURG

GALERIE THADDAEUS ROPAC
SALZBURG AUSTRIA MIRABELLPLATZ 2 TEL: 43 662 881 393 FAX: 43 662 881 3939 WWW.ROPAC.NET

GALERIE NÄCHST ST. STEPHAN
ROSEMARIE SCHWARZWÄLDER

HELMUT FEDERLE

CURATED BY ROMAN KURZMEYER

12 MAR – 28 APR 2010

Grünangergasse 1/2, A-1010 Wien, Tel +43 1 512 12 66
galerie@schwarzwaelder.at, www.schwarzwaelder.at